CHINESE FILM CLASSICS, 1922–1949

CHINESE FILM CLASSICS,

1922–1949

Christopher Rea

Columbia University Press New York

Columbia University Press wishes to express its appreciation for assistance given by the University of British Columbia and by the Chiang Ching-kuo Foundation for International Scholarly Exchange and Council for Cultural Affairs in the publication of this book.

Columbia University Press
Publishers Since 1893
New York Chichester, West Sussex
cup.columbia.edu
Copyright © 2021 Columbia University Press
All rights reserved

Library of Congress Cataloging-in-Publication Data
Names: Rea, Christopher G., author.
Title: Chinese film classics, 1922–1949 / Christopher Rea.
Description: New York : Columbia University Press, [2021] |
 Includes bibliographical references, filmography, and index.
Identifiers: LCCN 2020035683 (print) | LCCN 2020035684 (ebook) |
 ISBN 9780231188128 (hardcover) | ISBN 9780231188135 (trade paperback) |
 ISBN 9780231547673 (ebook)
Subjects: LCSH: Motion pictures–China–Reviews. |
 Motion pictures–China–History–20th century.
Classification: LCC PN1993.5.C4 R43 2021 (print) | LCC PN1993.5.C4 (ebook) |
 DDC 791.43095109/042–dc23
LC record available at https://lccn.loc.gov/2020035683
LC ebook record available at https://lccn.loc.gov/2020035684

Columbia University Press books are printed on permanent
 and durable acid-free paper.
Printed in the United States of America

Cover image: Art Deco rendering of the Chinese character "Ying" 影 (film), from the masthead of the Nanking University–based monthly magazine *Film & Radio* (*Ying yin*) 6, nos. 5/6 (August 1947). Artist unknown. Courtesy of the C. V. Starr East Asian Library, University of California, Berkeley

Cover design: Milenda Nan Ok Lee

Contents

Figures

Acknowledgments

A community of scholars, librarians, friends, family, and film enthusiasts made this project possible. My thanks to everyone who shared films with me and helped me learn more about them.

I first saw most of these films in a graduate seminar taught by David Der-Wei Wang in the early 2000s, and I have liked them ever since. One goal of the Chinese Film Classics project is to encourage archives to restore more Republican-era films and make high-quality copies available to the general public. The unavailability of some extant films and the low quality of many others in the public domain remain significant barriers to wider appreciation of early Chinese contributions to the cinematic arts.

I am grateful to Jennifer Crewe at Columbia University Press for suggesting this project in the first place, and to my fantastic editors, Christine Dunbar, Christian Winting, and Kathryn Jorge. Thank you, Milenda Nan Ok Lee for perfecting the cover design, Mary Curioli for copyediting, Ben Kolstad for project management, and Fred Leise for preparing the index.

Liu Yuqing and Yao Jiaqi contributed to the research that went into both this book and my translations of the subtitled films. I am grateful to Jiaqi also for serving twice as teaching assistant for my University of British Columbia course, "Chinese Film Classics."

Jordan Levine was my partner in the multiyear project of creating video lectures about these films, which are viewable, along with subtitled films, in a free online course available at chinesefilmclassics.org. Rumee Ahmed made production of those videos possible. I am grateful to him and to other members of the UBC Department of Asian Studies and the UBC Dean of Arts Office for their support, and to Julie Wei for her work on learning analytics.

Brian Bernards and Qian Ying kindly invited me to present research related to this project at the University of Southern California and Columbia University, respectively. Bao Weihong, Yomi Braester, Russell Campbell, Guo Ying, Wilt Idema, Henry Jenkins, Andrew F. Jones, Dorothy Ko, Shiamin Kwa, Diana Lary, Hui Liu, Hans van de Ven, Gary Wong, Wu Meng, and Xu Lanjun each contributed advice and research leads that enhanced this study and expanded my appreciation of early twentieth-century cinema. A special thanks to Michael Berry and Ang Lee.

Deborah Rudolph made accessing and using materials from the Fonoroff Collection at UC Berkeley's East Asian Library a dream. I thank her for her assistance during my research trips to Berkeley, Taylor Ovca for scanning materials for me, and Paul Fonoroff for making his collection available to scholars. I would also like to acknowledge over a decade of research assistance from Liu Jing, Shaun Wang, and Phoebe Chow at UBC's Asian Library.

Patricia Rea copyedited and proofed the entire manuscript. Thanks, mom and dad, for your constant support and encouragement. Peregrin and Permenia, I especially enjoyed our extra time together during the extraordinary final months of finishing this book. And there would be no book at all without Julie Wang, my companion for life, to whom this book is dedicated.

CHINESE FILM CLASSICS, 1922–1949

Introduction

This book introduces fourteen extant feature films produced in China up to 1949. Each chapter focuses on one film, offering a synopsis, analysis of artistic accomplishment and cultural significance, and a selection of further viewings and readings. Films discussed in part 1 are silent or have only dubbed sound on disk; those in part 2 were produced with live recorded sound, usually with dubbed songs and sound effects too. All are black and white.

This book's basic proposition is that early Chinese filmmakers made contributions to the cinematic arts that deserve wider recognition. It is a film-viewing companion for multiple readerships, especially people new to Chinese cinema history or to the discipline of film studies. It explains historical, cultural, cinematic, and social contexts and glosses technical terms. This book might be read as a guide to analyzing cinematic form that uses Chinese examples. Each chapter is also a brief history of an individual film.

For researchers, this book builds on previous scholarship to offer original interpretations of well-known films. It shares new discoveries—a sex joke appearing in both *Laborer's Love* (1922) and *The Great Road* (1934); *Sports Queen's* (1934) debt to *The Kid From Spain* (1932) and *Footlight Parade* (1933); the similar openings of *Street Angels* (1937) and *The Merry Widow* (1934); an allusion to a real-life political assassination in *Song at Midnight* (1937); and many connections between cinema and

popular culture. Significant research remains to be done on Chinese cinema history, and this book offers a few new leads.

A third envisioned readership is people familiar with American or other cinemas who are interested in Chinese contributions to the art form. Early Chinese filmmakers were deeply influenced by foreign films. Most of the films screened in China before 1949 were from Hollywood—the proportion in 1929 was as high as 90 percent[1]—and some filmmakers trained in the United States. Intertextual resonances abound between Chinese and American films of this era, and with European and Russian films too. Still, certain symbols, motifs, character types, and narrative conventions are unique to, or especially prevalent in, Chinese films. This book shows how, at the level of the film text, Chinese filmmakers adopted, adapted, influenced, or differed from conventions appearing in other cinematic cultures.

The recommended viewings and readings offer avenues for readers to deepen their appreciation of these films. Chapters and appendix 1 list only extant films; the filmography includes lost films too. As this book is introductory, it only gestures toward many ongoing discussions about Chinese cinema, whose early history I summarize at the end of this introduction.

HOW TO WATCH THE FILMS

Free English-subtitled versions of the fourteen films of focus are available on the playlist "Chinese Film Classics," created under the YouTube channel Modern Chinese Cultural Studies. So are several other films listed in appendix 1 and the filmography. Additional information about early Chinese cinema is available on the website chinesefilmclassics.org, which contains an open-access, self-paced course that integrates with the structure of this book. Each course module includes the subtitled film, a pair of video lectures, and additional resources such as clips and stills, historical materials, and links to other studies.

The company Qiaojiaren (Guangzhou Beauty) distributes DVD and VCD versions of dozens of early films in mainland China. Many unsubtitled films can be found on Bilibili.com, Youku.com, and YouTube. English-subtitled DVDs of several films are also commercially available in North America and Europe, including via the British Film Institute

and Cinema Epoch. Viewers should be aware that many copies of these films (physical and digital) are incomplete for a variety of reasons, including poor storage or censorship; I highlight a few examples below.

THE SCOPE OF THIS BOOK

Films of focus all began production in the Republic of China (ROC, 1912–1949), a political designation that excludes colonial Hong Kong, Japanese-occupied Taiwan (1895–1945), and the People's Republic of China (PRC). I have not included any films made in post-Retrocession Taiwan, the period between Japan's surrender to the Allies in 1945 (when Taiwan became part of the ROC) and the Nationalists' full-scale retreat to Taiwan in 1949.

Three films are clearly products of two political eras: *Spring River Flows East* (1947), *Wanderings of Three-Hairs the Orphan* (1949), and *Crows and Sparrows* (1949). The copy of *Spring River* discussed in this book contains text onscreen stating that the film was re-edited ("cleaned up," *zhengli*) in 1956. Until we can see a 1947 edit, we will not know exactly what was changed; we can only make inferences based on the available film, reviews, the published screenplay, and the 1949 novel version. A copy of *City Scenes* (1935) distributed by Qiaojiaren is missing the opening credits along with scenes featuring the actress Lan Ping, including one in which her character jumps up and down in delight at the Shanghai gold exchange. Lan is now better known as Jiang Qing, the fourth wife of Mao Zedong, and her excision from that film-text is a clear example of politically motivated censorship that occurred at some point after the fall of the Gang of Four in 1976. More research is necessary to determine which copies of other films in circulation were modified (and how) between their original release and their later rereleases.

Wanderings and *Crows* both began production in Shanghai before the People's Liberation Army (PLA) occupied the city on May 25, 1949, and finished production later that year. Both films premiered after the proclamation of the PRC on October 1, 1949: *Wanderings* on October 30, 1949, and *Crows* (advertisements for which appeared in December 1949[2]) in early 1950. Both films are reminders that cinema and national politics do not follow identical timelines, and that film texts cannot always be forced into simple political categories. While I follow convention in putting a

date (note: of production, not premiere) after the title of each film, the chapters offer reasons to take a flexible approach in dating these films.

The book focuses exclusively on feature films, not documentaries— though a few, including *Playthings* (1933), *The Great Road, Sports Queen, Spring River Flows East*, and *Crows and Sparrows*, selectively mimic documentary style or incorporate newsreel footage. The year 1922 marks the release of the earliest-known extant full film produced by Chinese filmmakers, *Laborer's Love*. Chinese filmmakers made hundreds of films before that date, but those films are either lost or have yet to emerge from the archive. The end date of 1949 is dictated primarily by political history but also by cinema history, as the change in government did lead to dramatic changes in the film industry. Privately run studios either ceased operations, moved to Hong Kong, or were nationalized and became a part of the new Party-state cultural bureaucracy.

That process did not occur overnight—new cultural policies were enforced more consistently beginning in 1952—and some film historians regard the period from 1947 to 1952 as a second golden age of Chinese filmmaking. While a full account of changes in that period's industry lies mostly outside the scope of this book, I draw attention to a few political shifts that can be detected in *Wanderings* and *Crows*, both of which conclude with statements welcoming the new regime.

NEW EYES ON THE CLASSICS

In *Bluebeard's Eighth Wife* (1938), Gary Cooper's character walks into a bookstore and asks for "something to put me to sleep." Shop clerk: "Oh, what you want are the classics!" Mark Twain, conversely, described a classic as "a book which people praise and don't read."[3] My hope is that you will watch (and rewatch) these films first, read the chapters second, and only then decide which are praiseworthy and which are snooze-worthy.

Thousands of films were made in China before 1949.[4] My selection criteria are artistic accomplishment, critical reception, historical significance, and availability. The first criterion is unapologetically subjective: I have included only films that I like. Is the film good *as a film*? Does it use film form to tell a compelling story or create a memorable impression through image and/or sound? In each case, I answer *yes* and explain

my reasons. I discuss films in chronological order by date of release, because doing so helps us to understand genealogy and influence, not because films made later are necessarily better. I reject the teleology of improvement implicit in the "history of development" (*fazhan shi*) paradigm that dominates film historiography in mainland China. Nor do I believe that older is better or that only films made before New China can be considered classics. My priority is to identify, consider, and explain the merits of each individual text in terms of the possibilities of film form.

In putting film form first, *Chinese Film Classics* differs from studies concerned primarily with the politics of the film, the history of a certain studio, the oeuvre of a particular filmmaker, filmmakers' self-appraisals, the opinions of reviewers, or box office performance. Memoirs by influential filmmakers such as Sun Yu, Xia Yan, and Zheng Junli, for example, tend to emphasize ideology over entertainment, glossing over or omitting to mention aspects of their films that might be embarrassing or politically incorrect. All understate their debts to foreign films. Taking into account a wide variety of sources enriches our ability to assess films' significance. So does an understanding of the technological possibilities and limitations of the era. The form of the finished product currently available is, however, my primary basis for appraising artistry.

One argument I elaborate in each chapter is that the film has formal elements that are innovative or exemplary. *Goddess* (1934) and *Spring in a Small Town* (1948) both display admirable narrative restraint. *The Great Road* is a genre-defying romp with a talented ensemble. *New Women* (1935) combines outstanding cinematography, editing, set design, and performance. *Street Angels* charms with romance, humor, and a fantastic soundtrack. *Hua Mu Lan*'s (1939) versatile star gives a charismatic performance of identity shifting within a polarized wartime environment. *Long Live the Missus!* (1947) is scripted, shot, and edited into a tightly plotted urbane comedy. *Spring in a Small Town* is a visual, acoustic, and psychological masterpiece. *Crows and Sparrows* is ingeniously structured and features three of the era's best villains.

No film is perfect. Filmmakers contended with military disruptions, inadequate equipment and capital, underdeveloped distribution networks, a dearth of screenplays, and censorship. Still, an outstanding performance, innovative cinematography, profound symbolism, or

brilliant editing, to me, sometimes justifies inclusion of a film that might have, say, a hackneyed plot, well-worn themes, or distasteful ideology. I point out elements shared by multiple films, in part, to highlight outstanding uses of a certain motif. These intertextual patterns indicate trends worthy of further study. It is not my ambition to make all of the films fit together.

The influential canon "Best 100 Chinese Motion Pictures," ranked by 101 judges, was announced at the Twenty-Fourth Hong Kong Film Awards in 2005, on the centennial of the landmark film *Dingjun Mountain* (1905). The list includes eight of the films discussed in this book (rankings are given in parentheses):

Spring in a Small Town (1)
Street Angels (11)
Spring River Flows East (27)
Goddess (29)
The Great Road (30)
Playthings (70)
Song at Midnight (77)
Long Live the Missus! (81)

as well as three other films dating from 1949 or earlier:

Sorrows of the Forbidden City (1948) (37)
Bittersweet Middle Age (1949) (71)
Lights of Myriad Homes (1948) (91)[5]

Other canons are implicit in studies by the scholars whose names appear in the bibliography and whose opinions influence my appraisals. Practical considerations have led me to discuss fewer films in more depth. Appendix 1 lists several other extant films I believe have a claim on classic status.

These include the silent films *Cave of the Silken Web* (1927), a special effects–laden supernatural adventure, and the magnificent melodrama *Love and Duty* (1931), co-starring Ruan Lingyu and Jin Yan; Wang Renmei's hits *Wild Rose* (1932) and *Song of the Fishermen* (1934); and *Twin Sisters* (1934), which stars Butterfly Wu (Hu Die) in the twin title roles.

Two Stars (1931) deserves special mention as an artistically and historically significant sound-on-disk film whose image is extant but whose sound is not. *Two Stars* showcases the importance of the songstress in 1930s cinema, contains self-reflexive depictions of the film industry (with cameos by Sun Yu and Cai Chusheng), and includes fictionalized portrayals of the influential father–daughter team of composer Li Jinhui and singer/actor Li Minghui. Still, the lack of sound means that a crucial part of the text is missing; see studies by Kristine Harris, Jean Ma, and Paul Pickowicz for insights into this important film.

I discuss only in passing important filmmaking trends, like the martial-chivalry (*wuxia*) craze of the 1920s. *Fire Burns Red Lotus Temple* (1928–1931), a series of eighteen special effects–intensive martial arts films starring Butterfly Wu, was a sensation, but the films are almost completely lost. Some historians estimate that for four years, such films accounted for "approximately 60 percent of Chinese domestic film production."[6] *The Red Heroine* (1929), an extant representative of the genre, is available online with original Chinese-English intertitles. *Hua Mu Lan*, discussed in chapter 9, represents a second coming of the *wuxia* genre, as well as the wartime rise of allegorical costume dramas. Fei Mu's *Confucius* (1940) is another exemplary film of the war era available with English subtitles.

Phony Phoenixes (1947), a farcical comedy directed by Sang Hu, I have excluded, because the picture and sound quality of the copy I possess is low. Other films or copies will hopefully emerge from the archives to alter this list. Again, I believe that no canons should be taken for granted and that every viewer should develop and articulate their own standards of judgment.

What can early Chinese films teach us about appraising cinematic works of art? Quite a lot, especially if we work outward from text, to immediate context, to a history of reception. Canons can sharpen or dull critical engagement. At their worst, they are overbearing or dismissive, limited by their fixation on a political ideology or the narcissism of their creators. The term "classic" is often prejudiced by the beholder's own time horizon. A. O. Scott quips that, "An old song is one that was on the radio two summers ago [and] a classic is the one you danced to at your prom."[7] In this case, step one is to make these films more accessible; *then* we can debate which are relics and which artworks.

In focusing on films as texts, this book does not attempt a comprehensive history of the industry, of filmmaking "movements," or of audiences. I discuss cast, crew, exhibition, and reception selectively to illustrate films' symptomatic, referential, and implicit meanings. As Ross Melnick points out, in the United States, film exhibitors' "live performances, musical accompaniment, and other material framed, enhanced, subverted, complicated, and in many other ways altered the original meaning of the silent feature film."[8] Exhibition context is equally important for these films, which were shown in cinemas across China, in colonial Hong Kong and Singapore, and British Malaya. A few, like *Hua Mu Lan*, screened in Japan or North America. Some premiered on significant anniversaries: *Playthings* just before National Day 1933; *New Women* and *Hua Mu Lan* during the Lunar New Year holiday period, in 1935 and 1939, respectively; *Spring River Flows East* on the eve of National Day 1947; *The Great Road* on January 1, 1935. Fictional performances on National Day occur in both *Goddess* and *Spring River*. Readers interested in more extensive discussion of how films were promoted, exhibited, and reviewed might consult studies by the scholars listed in the bibliography.

Here are two more reasons to pay attention to these films, besides their quality as stand-alone works of art. First, they provide unique perspectives on the history of global cinema. Republican Chinese films draw from, respond to, and often diverge from films produced in Berlin, Hollywood, Paris, and London. We see moral melodramas, Art Deco graphics, Expressionist sets, Eisensteinian montage, Laurel and Hardy slapstick, and any number of classical Hollywood soft-focus close-ups. We hear Western orchestral music, jazz, and folk songs. In *Goddess*, Ruan Lingyu, the "Chinese Garbo," appears in front of an ad for "Garbo Brand" cigarettes. Viewers familiar with Victor Fleming, D. W. Griffith,[9] Buster Keaton, Harold Lloyd, Ernst Lubitsch, and V. W. Murnau will find here familiar editing, performance, and other cinematic techniques.

Take Lubitsch. *New Women* (1935) contains a shot of an attempted kiss in a round mirror likely inspired by two shots in *Trouble in Paradise* (1932). (A similar mirror appears in *Begonia* [1943].) *Wanderings of Three-Hairs the Orphan* begins with a predawn scene of an old man shoveling refuse; *Trouble in Paradise* begins with a predawn scene of an old man dumping garbage. In *Paradise*, a woman remarks that her rival in love paid 125,000 francs for a handbag but only 100,000 for a

man. Three-Hairs (Sanmao) once attempts to sell himself for 100,000 yuan, while a foreign doll sells for 10 million. In *Bluebeard's Eighth Wife*, a couple meets in a shop haggling over a pair of pajamas; in *Long Live the Missus!*, a couple meets in a shop haggling over pineapples. *Diary of a Homecoming* (1947) (see appendix 1) features an exchange of slaps between husband and wife (and mock-triumphant music) similar to the *Taming of the Shrew* scene in *Bluebeard*.[10]

Yet in the Chinese films we also find linguistic jokes, character archetypes, performance styles, songs, costuming, references to external events, and political messaging found nowhere else. Filmmakers like Fei Mu express indigenous aesthetics such as *you* (contemplative movement) through mobile framing, achieving an effect akin to a gaze traveling horizontally across a landscape scroll. Zhang Shichuan and Sun Yu both include visual puns based on Chinese expressions. The *erhu* fiddle heard in *Street Angels*; the popular and operatic compositions sung in *The Great Road* and *Song at Midnight*; the *qipao* dresses and convoluted plot line of *Long Live the Missus!*; and the poetry embedded in *Spring River Flows East* are just a few examples of Chinese contributions to cinematic form.

Second, as might be expected, the films and filmmaking personnel of the Republican era influenced later Chinese filmmaking. It is impossible to gain a full understanding of the history of Maoist cinema, or the cinema cultures of midcentury colonial Hong Kong, Nationalist Taiwan, or southeast Asia without knowing the names, faces, voices, and styles of Republican cinema. Directors Zheng Junli, Cai Chusheng, and Wu Yonggang, screenwriters Xia Yan and Hong Shen, and actors such as Bai Yang, Li Wei, Shangguan Yunzhu, Shi Yu, Yin Xiucen, Zhao Dan, and Zhou Xuan continued their careers in the PRC. Others, such as directors Ma-Xu Weibang and Richard Poh, screenwriters Eileen Chang and Ouyang Yuqian, and producers Runme Shaw, Run Run Shaw, and S. K. Chang went to Singapore and Hong Kong, which in the 1960s saw an echo boom of films with titles inspired by Shanghai classics. The midcentury moment in Chinese cinema history is ripe for rediscovery.

A BRIEF HISTORY OF CHINESE CINEMA UP TO 1949

Chinese participation in moving pictures occurred virtually simultaneously with other parts of the world. Months after the Lumière

brothers premiered their first films in Paris in December 1895, films were being screened in China—the first known exhibition took place in a Shanghai teahouse in August 1896—and foreign camera operators were soon roaming the provinces both to shoot footage and to exhibit films. "Actualités," which purported to show scenes from everyday life, staged vignettes, and documentary-style recordings of performances were among the early types of films shot in China. The first public film exhibition in the capital of Peking occurred in 1902, shortly after an abortive private screening for the empress dowager during which the camera caught fire.

A few turn-of-the-century films can be viewed online, including the sixty-five-second *Nankin Road, Shanghai (1901)*, from the British Film Institute, and a forty-seven-minute film from the University of London Archives, which shows a variety of staged vignettes, including hog butchers, barbers, monkey trainers, lion dancers, marching soldiers, vendors, beggars, opium smokers, temples, opera performers, a funeral parade, and Qing officials receiving a foreign delegation.[11]

Early Chinese filmmaking entrepreneurs include the proprietors of Beijing's Fengtai Photo Studio, which between 1905 and 1908 recorded newsreels and scenes from Peking opera. Their opera film *Dingjun Mountain* (1905) is typically cited as the first Chinese-made film. Fengtai moved its operations to Shanghai in 1909, a year which also saw the founding of "the first professional company in Chinese film history," the Asiatic Film Company.[12] Moving images of China began to travel around the world in unprecedented volume in the 1910s. Benjamin Brodsky's multipart *A Trip Through China* (1912–1916), one of the earliest feature-length documentary films shot in China, was screened extensively in North America.[13]

From the 1890s to the mid-1920s, films in China were exhibited primarily in existing venues, such as teahouses, theaters, and amusement halls, or under temporarily erected tents. Spanish exhibitor Antonio Ramos opened China's first cinema house, Shanghai's Hongkew Cinema, in 1908. In the 1920s, foreign and Chinese entrepreneurs began investing in cinema construction at a consistent pace, such that by the 1930s, major cities such as Shanghai, Nanking (Nanjing), Tientsin (Tianjin), Canton (Guangzhou), Beiping (Beijing), and Hankow (Hankou) formed a national distribution network. By 1929, seven cities had a total

of 233 cinemas. "Shanghai alone housed 53 movie theaters, with a total seating capacity of 37,110."[14] By 1949, according to historian Paul Clark, cinemas in China numbered around five hundred.

Foreign films dominated screens. According to one count of movie ads in Shanghai's biggest newspaper, during the first half of 1925, the city "had 1935 screenings of 256 films, 219 of which were foreign films and 37 Chinese."[15] Announcers would narrate silent foreign films to audiences, and translate the title cards live. Not all foreign sound films were subtitled in Chinese, so cinemas would often distribute lobby cards to moviegoers with a synopsis of the film and perhaps information about its cast.[16]

Southeast Asia was a crucial market for the Chinese film industry from early days. Selling one print in Singapore or Manila could save a struggling studio. Strong demand for Chinese films in the 1920s prompted the founding of hundreds of domestic film companies, most of which were short-lived. According to historian Zhiwei Xiao, in 1925 alone, 176 new studios were registered, 144 of which were in Shanghai. While most of these studios never actually produced a film, the overall increase in supply made prices per copy plummet by over two-thirds, bankrupting many.[17]

Unique (Tianyi), one of the survivors of this onslaught of competition, became a major midcentury player after the founders moved their bases of operations to Singapore and Hong Kong and rebranded as Shaw Brothers Studios. Star Motion Picture Company (Mingxing), founded in 1922, also survived by the skin of its teeth and went on to produce no fewer than 175 films (including *Laborer's Love*) during its sixteen-year history.[18]

Star is notable also for the diversity of its production staff, which included the popular novelist Bao Tianxiao, Harvard-educated screenwriter Hong Shen, underground communist screenwriter Xia Yan (later deputy minister of culture under Mao Zedong), and Yao Sufeng, who had close ties to the Nationalist government.[19] Other studios, too, drew creative talent from the spheres of popular literature, the stage, song-and-dance troupes, and the recording industry, often without regard to political ideology.

The film industry stabilized after the National Revolutionary Army in 1928 concluded a successful military campaign against the militarists

who controlled various parts of China and moved the national capital to Nanking. The industry's consolidation in the late 1920s culminated in the creation, in 1930, of United Photoplay Service (U.P.S.), an amalgamation of three smaller studios, better known by its Chinese name, Lianhua.

The period from 1928 to 1937, the year when China declared war against Japan, was one of rapid growth. Production boomed as Lianhua and other big players expanded staff and studios. Thousand-seat picture palaces and an array of colorful pictorial magazines drew crowds to the latest releases. China's first sound-on-disk film, *Songstress Red Peony*, premiered at The Grand Theater in Shanghai on March 15, 1931. Sound film became a novelty attraction, boosted by the gramophone industry, and audiences increasingly went to theaters not just to see their favorite stars but also to hear them talk and sing.

Chinese filmmaking during the 1930s was centered in the foreign settlements of Shanghai. Yet the Shanghai phenomenon was fueled by talent and capital from the Cantonese-speaking south, including Guangdong, Macao, and Hong Kong. Producer Lo Ming-yau (Luo Mingyou) and producer-director Lai Man-Wai (Li Minwei) are two of the southerners who shaped the industry. Ruan Lingyu was born in Shanghai to a Cantonese family. Nancy Chan (Chen Yunshang) was born in Guangzhou and began her career in Hong Kong before moving to Shanghai to star in *Hua Mu Lan*. Composer Sinn Sing Hoi (Xian Xinghai), who scored *Song at Midnight*, was born in Macao and educated in Singapore before moving to Shanghai, and later Yan'an. Films such as *Two Stars*, *Yihjanmae* (1931), and *Long Live the Missus!* feature Cantonese characters or southern plot lines.

The Shanghai industry fractured during the Anti-Japanese War. Some personnel stayed in the occupied city, but most of the big stars and directors dispersed to British Hong Kong or to the Nationalists' wartime capital of Chungking (Chongqing). Filming resumed in all three cities in straightened circumstances, but filmmakers in Japanese areas, including in the puppet state of Manchukuo (established 1932), had the best access to film stock and equipment. Material constraints are evident in even the best of the wartime films, many of which were shot on cramped, rudimentary sets. Audiences fractured too. *Hua Mu Lan* was a box-office smash across a war-torn Asia, but copies were also

burned in Chungking by agitators who considered the filmmakers traitors for having collaborated with Occupation authorities.

In 1947, with government support, the Chinese film industry reconsolidated in Shanghai but struggled under the twin pressures of hyperinflation and civil war. The military situation impeded the mobility of personnel, film stock, and equipment, and the ability of film crews to shoot on location. Making a film about politics risked offending one side or the other. The rapid depreciation of paper currency also made it more expensive to be a filmmaker or a moviegoer.

If, for example, you picked up a copy of *Film Pictorial* (*Dianying huabao*), a movie fanzine published by Law Bun's (Luo Bin) company Universal Publisher, on January 1, 1946, the newsstand price was 300 yuan.[20] You would have been better off taking out an annual subscription at the 20 percent discount offered on that date, because the price of issue 2 jumped by 33 percent to 400 yuan, and then doubled to 800 yuan for issue 3. (The price rose so abruptly after issue 3 was sent to the printers that the new price was pasted over the old one.) After issue 4, *Film Pictorial* experienced the first of a dozen interruptions to its production schedule during its three-year run. The cost of an issue rose to 1,700 yuan by December 1946 and 15,000 yuan by December 1947. After peaking at 200,000 yuan in July 1948, *Film Pictorial* had to be bought with the new gold-backed yuan. Even then, the price continued to skyrocket from half a gold yuan in November 1948 to 600,000 gold yuan in May 1949. Shortly thereafter, Law moved his business to Hong Kong.

Government involvement has been a major factor in the Chinese film industry since at least the late 1920s. A Central Film Censorship Committee (CFCC) founded in 1931 discouraged "superstitious" genres such as flying-swordsman *wuxia* (banned in 1934) and prohibited films from criticizing Japan by name or explicitly promoting Communism. The government would restrict violators' access to film stock, just as they limited noncompliant publishers' access to paper. Foreign films that ran afoul of local mores, such as Harold Lloyd's *Welcome Danger* (1930), which contained offensive racial caricatures, also were subject to government bans. Censors reportedly cut Yue Feng's *Angry Tide of the China Sea* (1933) so severely that one reviewer quipped that its title should be changed to *Nothing Happened on the China Sea*.[21] According to one historian, by 1935 "the film industry was all but destroyed

by censorship," as the CFCC used the anti-*wuxia* policy as a pretext to raid and shut down studios with suspected Communist agents.[22] Censorship pressures ratcheted up again during the civil war, when government anti-Communism was at its height. Clark notes that "of the 162 Chinese-made films (including short subjects) submitted for censorship from October 1945 to September 1948, 48 had to be cut." The makers of *Crows and Sparrows* allegedly hid the real script and showed the censors a fake script, but shooting was halted anyway.

The Nationalist government also incentivized studios to make films promoting nationalism, patriotism, hygiene, athleticism, militarism, and muted forms of resistance to imperialism. Sun Yu's films explicitly promote Nationalist activities such as the Northern Expedition (*Daybreak*) and the New Life Movement (*Sports Queen*), or, like in *Goddess*, channel ideological campaigns to different purposes. The government funded *Spring River Flows East* and, notwithstanding the film's overwhelming negativity about Chungking corruption, awarded it the Chiang Kai-Shek Film Prize.

The following chapters say more about how various political, social, and economic forces shaped individual films. They offer not the final word on any film, but an invitation to further watching, reading, and research. I hope you will treat this book as a jumping-off point for further explorations of Chinese cinema.

NOTES

1. Paul Clark, *Chinese Cinema: Culture and Politics Since 1949* (Cambridge: Cambridge University Press, 1987), 7. American film companies setting up distribution organizations in Shanghai included Universal (1928), Paramount (1929), MGM (1930), 20th Century Pictures (1931), Warner Bros. (1932), Columbia (1934), RKO (1935), and United Artists (1937). Dou Xingbin, *Lianhua yingye gongsi yu Zhongguo 30 niandai dianying yanjiu* [Research on United Photoplay Service and cinema in 1930s China] (Beijing: Zhongguo shehui kexue chubanshe, 2018), 72–73.
2. See the back page of *Qingqing dianying* (*Chin-Chin Screen*) 17, no. 24 (December 10, 1949).
3. Epigraph to chapter 25 of Mark Twain, *Following the Equator* (1888).
4. According to one 2006 estimate, about 6 percent (67 films) of the roughly 1,100 feature films made in China up to July 1937 survive. Peter Rist, "Visual Style in the Silent Films Made by the Lianhua Film Company [United Photoplay Service]

in Shanghai: 1931–35," in *One Hundred Years of Chinese Cinema: A Generational Dialogue*, ed. Haili Kong and John Lent (Norwalk, Conn.: EastBridge, 2006), 5, 14n6.

5. Hkfaa.com, "The Best 100 Chinese Motion Pictures," accessed October 21, 2020, http://www.hkfaa.com/news/100films.html.

6. John Christopher Hamm adds: "The flood of martial arts films flowed from some fifty different studios, many of them small and newly established to capitalize on the craze, and the output was enthusiastically received by Chinese audiences throughout Southeast Asia as well as within the country." John Christopher Hamm, *The Unworthy Scholar from Pingjiang: Republican-Era Martial Arts Fiction* (New York: Columbia University Press, 2019), 133. Bao Weihong, drawing on the same source, cites year-by-year production statistics for "martial arts and god-spirit films": 1928: 30 films; 1929: 85 films; 1930: 69 films; 1931: 43 films; 1932: 14 films. Weihong Bao, *Fiery Cinema: The Emergence of an Affective Medium in China, 1915–1945* (Minneapolis: University of Minnesota Press, 2015), 389n2.

7. A. O. Scott, *Better Living Through Criticism: How to Think About Art, Pleasure, Beauty, and Truth* (New York: Penguin, 2017), 24.

8. Ross Melnick, *American Showman: Samuel "Roxy" Rothafel and the Birth of the Entertainment Industry, 1908–1935* (New York: Columbia University Press, 2014), 23.

9. Eleven Griffith films were shown in Shanghai between 1922 and 1924. Hou Yao's film *Xixiang ji* (1927), adapted from the Yuan dynasty play *Romance of the Western Chamber*, was given the English title *Way Down West* to capitalize on the success of Giffith's *Way Down East* (1920). On "Griffith fever" of the 1920s, see the studies cited in Qijun Han, "Melodrama as Vernacular Modernism in China: The Case of D. W. Griffith," *Scope: An Online Journal of Film and Television Studies*, no. 26 (February 2014).

10. Laikwan Pang notes that *If I Had a Million* (1933), which Lubitsch codirected, inspired the plot of Zhang Shichuan's *The New Year's Gift* (1937). Laikwan Pang, *Building a New China in Cinema: The Chinese Left-Wing Cinema Movement, 1932–1937* (New York: Rowman and Littlefield, 2002), 208. Sadō Tadao finds similarities between *Long Live the Missus!* and Lubitsch's *The Marriage Circle* (1924). Pei-yin Lin, "Comicality in *Long Live the Mistress* and the Making of a Chinese Comedy of Manners," *Tamkang Review* 47, no. 1 (December 2016): 110.

11. Search on YouTube for "Nankin Road, Shanghai (1901)—China on Film BFI National Archive" and "SOAS film archive—rare footage of life in China in the early twentieth century." Other early films made by foreigners in China are listed in the appendix of Jay Leyda, *Dianying/Electric Shadows: An Account of Films and Film Audiences in China* (Cambridge, Mass.: MIT Press, 1972).

12. Clark, *Chinese Cinema*, 6–7; Fu Yongchun, "Movie Matchmakers: The Intermediaries Between Hollywood and China in the Early Twentieth Century," *Journal of Chinese Cinemas* 9, no. 1 (2015): 10.

13. Brodsky's (1877–1960) film series is discussed extensively in Liao Jinfeng, *Buluosiji yu huobanmen: Zhongguo zaoqi dianying de kuaguo lishi* [Brodsky and companies: a transnational history of Chinese early cinema] (Taipei: Rye Field, 2015). Excerpts can be viewed at archive.org and preservation.org.

14. Cui Shuqin, *Women Through the Lens: Gender and Nation in a Century of Chinese Cinema* (Honolulu: University of Hawai'i Press, 2008), 4.

15. Fu Yongchun, "From 'Parrot' to 'Butterfly': China's Hybridization of Hollywood in Distribution Systems in the 1920s and 1930s," *Journal of Chinese Cinemas* 8, no. 1 (2014): 3.

16. Clark, *Chinese Cinema*, 7, 8, 20. Some lobby cards are held in the Fonoroff Collection at University of California, Berkeley's East Asian Library.

17. Zhiwei Xiao, "Film Censorship in China, 1927–1937" (PhD diss., University of California, San Diego, 1994), 43. Clark characterizes Chinese filmmaking efforts of the 1920s as "undercapitalized and overambitious. At least 164 production companies were established between 1921 and mid-1930, mostly in Shanghai, but also in Guangzhou (Canton), Tianjin, Beijing, and Dalian. Less than one-third (53) of them actually made any films during the decade. By July 1930 scarcely more than a half dozen of these companies were still active. Levels of production were also erratic: Between 1921 and 1922, when one source reports that 140 new production companies were registered, a mere six films were made. More than fifty films appeared in 1926 and again in 1927, and in the following two years slightly fewer films were released." Clark, *Chinese Cinema*, 7.

18. Count based on appendix 1 in Huang Xuelei, *Shanghai Filmmaking: Crossing Borders, Connecting to the Globe, 1922–1938* (Leiden: Brill, 2014).

19. Zhang Yingjin mentions these individuals in his survey review: Zhang, "Introduction: Film History and Historiography," *Journal of Chinese Cinemas* 10, no. 1 (2016): 40. For details on Star personnel in the 1930s, see Huang, *Shanghai Filmmaking*, chap. 3.

20. UC Berkeley's East Asian Library holds almost a complete run of this periodical, missing only two issues (vol. 2, no 6; vol. 2, no 9).

21. Cheng Jihua, *Zhongguo dianying fazhan shi* [A history of the development of Chinese cinema] (Beijing: Zhongguo dianying chubanshe, 1963), 1:278; Hu Jubin, *Projecting a Nation: Chinese National Cinema Before 1949* (Hong Kong: Hong Kong University Press, 2003), 110–111; Laikwan Pang, *Building a New China in Cinema*, 58 (translation modified).

22. Stephen Teo, *Chinese Martial Arts Cinema: The Wuxia Tradition*, 2nd ed. (Edinburgh: Edinburgh University Press, 2009), 43.

SOURCES/FURTHER READING

Anderson, Edward, and Robin Baker. "Boxers and Barbers: Filming in the Late Qing Dynasty." In *Electric Shadows: A Century of Chinese Cinema*, ed. James Bell, 14–15. London: British Film Institute, 2014.

Bao, Weihong. *Fiery Cinema: The Emergence of an Affective Medium in China, 1915–1945*. Minneapolis: University of Minnesota Press, 2015.

Clark, Paul. "Film and Chinese Society Before 1949." In *Chinese Cinema: Culture and Politics Since 1949*. Cambridge: Cambridge University Press, 1987, 4–24.

Fan, Victor. "From the Shadow Play to Electric Shadows." In *Electric Shadows: A Century of Chinese Cinema*, ed. James Bell, 8–13. London: British Film Institute, 2014.

Fu Hongxing, ed. *Zhongguo zaoqi dianying yanjiu* [Studies of early Chinese cinema]. 2 vols. Beijing: Zhongguo guangbo dianshi chubanshe, 2013.

Fu Yongchun. "From 'Parrot' to 'Butterfly': China's Hybridization of Hollywood in Distribution Systems in the 1920s and 1930s." *Journal of Chinese Cinemas* 8, no. 1 (2014): 1–16.

——. "Movie Matchmakers: The Intermediaries Between Hollywood and China in the Early Twentieth Century." *Journal of Chinese Cinemas* 9, no. 1 (2015): 8–22.

Hu Jubin. *Projecting a Nation: Chinese National Cinema Before 1949*. Hong Kong: Hong Kong University Press, 2003.

Huang Xuelei. *Shanghai Filmmaking: Crossing Borders, Connecting to the Globe, 1922–1938*. Leiden: Brill, 2014.

Pang, Laikwan. *Building a New China in Cinema: The Chinese Left-Wing Cinema Movement, 1932–1937*. New York: Rowman and Littlefield, 2002.

Xiao, Zhiwei. "Film Censorship in China, 1927–1937." PhD diss., University of California, San Diego, 1994.

Zhang, Yingjin. *Chinese National Cinema*. New York: Routledge, 2008.

Zhang Zhen. *An Amorous History of the Silver Screen: Shanghai Cinema, 1896–1937*. Chicago: University of Chicago Press, 2005.

PART ONE

Silent Films

Laborer's Love
(*Laogong zhi aiqing* 勞工之愛情)

Alternative title: *A Fruit-Flinging Romance* (*Zhiguo yuan* 擲菓緣)
Director: Zhang Shichuan
Screenplay: Zheng Zhengqiu
Studio: Mingxing
Date of release: October 5, 1922
22 minutes, 3 reels
Cast: Cheng Cheh Ku (Zheng Zhegu), Yu Ying, Zheng Zhengqiu (credited as Cheng Kung [Mr. Zheng]), T. M. Loh (Lu Tie[min?])

SYNOPSIS

Carpenter Zheng has moved to Shanghai from the south and changed trades to become a fruit peddler. Zheng takes a fancy to the daughter of Doctor Zhu, whose office is located opposite his fruit stall. The couple court by sending tokens of affection—fruit, a handkerchief—from one stall to another via a cylindrical tool holder on a line. When Miss Zhu is harassed by local ruffians, Carpenter Zheng comes to her aid and beats them up. He then proposes marriage to her, and she refers him to her father for approval, but the response is discouraging. Doctor Zhu tells Carpenter Zheng that he will marry his daughter to the man who can help him improve his anemic business. Back home, Zheng daydreams about a happy future with his lady love, but his reverie and his attempts

to sleep at night are interrupted by the rowdies in the All-Night Club, which is located directly above his room. Inspiration strikes, and Zheng makes a deal with Doctor Zhu. Using his carpentry skills, Zheng creates a device that enables him to convert the outdoor staircase leading up to the nightclub into a slide with a pull and back into a staircase with a push. When patrons leave the club and start walking down the staircase, he turns it into a slide and brings them down in a heap. The injured parties make their way directly to Zhu's office. Zheng sees that business has become so good for the Zhus that he offers to help, and the three of them rapidly process patients together. With money piled up, Zhu accepts Zheng as his son-in-law and Zheng goes down on his knees in thanks.

A COMIC SHORT

Laborer's Love's claim to fame is thanks in part to luck: it is the earliest complete film made in China by Chinese filmmakers currently known to survive in its entirety. Moving pictures, including actualities (showing everyday scenes) and staged vignettes, had been filmed and exhibited in China since the 1890s. *Dingjun Mountain* (1905), featuring a stage performance by Peking opera star Tan Xinpei, is often cited as the first Chinese-made film. It and many other early films are now unavailable due to material degradation, domestic unrest, and war. Numerous prints were destroyed, for example, during the 1932 Japanese bombing of Shanghai, which hit Mingxing (Star) and several other studios.

Its fortuitous preservation aside, *Laborer's Love* is a classic of its kind: the comic short. In terms of genre, it might be considered a slapstick comedy, a mischief comedy, or a romantic comedy. In terms of mode, the film straddles two categories: the cinema of attractions and narrative cinema. Cinema of attractions (or attraction) is a term originally used to describe a mode of exhibitionism common in the first decade or so of cinema (ca. 1895–1906). More broadly, it can be applied to films that repeatedly disrupt their own fictional story-world to grab the viewer's attention. Techniques might include gags, novelty props, special visual effects, sound effects, images that draw attention to the text's artifice (such as an actor looking at the camera), or some other type of spectacular display. (In silent films like *Laborer's Love*, the

spectacle is visual; sound films may create sonic spectacle using sound effects.) Narrative cinema, in contrast, draws the viewer into the film's diegesis (fictional story-world), rather than calling attention to the storytelling itself.

Laborer's Love appeals with both attraction and narrative, because it unfolds a story, but it also contains performances, props, and camera tricks whose primary function is to create spectacle. In other words, this film aims to satisfy through offering both a narrative arc leading to a happy conclusion and a series of visual gags and images that give pleasure in and of themselves. On levels of both story and spectacle, *Laborer's Love* offers more than might be apparent at first glance.

To begin with, Carpenter Zheng (credited in an intertitle as Cheng the Fruit-Seller) resembles "The Boy," also known as "The Glasses," the young, optimistic striver at the center of many 1920s film comedies made by the American actor and director Harold Lloyd (figure 1.1).

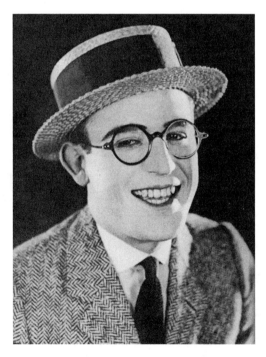

FIGURE 1.1 Harold Lloyd
Source: Wikimedia Commons

Laborer's Love (Laogong zhi aiqing 勞工之愛情)　23

Lloyd was one of the most famous, popular, and high-earning film stars of the silent era. In China in the 1920s he was even more popular than Charlie Chaplin.[1] Mingxing Studio, founded in 1922, produced *Laborer's Love* as part of a comedy trilogy; *The King of Comedy Visits Shanghai* features a Chaplin look-alike, and *Uproar in a Bizarre Theater*, a double of Harold Lloyd.[2] *Laborer's Love*, too, pays tribute to Lloyd and tries to capitalize on his popularity through the characterization of Carpenter Zheng and a few specific motifs (an element in a film that is repeated in a significant way) drawn from Lloyd's recent films.

The first of these is the eyeglasses worn by Doctor Zhu, which Miss Zhu unintentionally sends to Zheng along with her handkerchief. When Zheng discovers the spectacles in the container, he puts them on, adopting the Lloyd look (figure 1.2). Doctor Zhu is severely nearsighted. A point-of-view shot (figure 1.3) from Zheng's perspective shows the blurred vision that has rendered him so disoriented. This is one moment

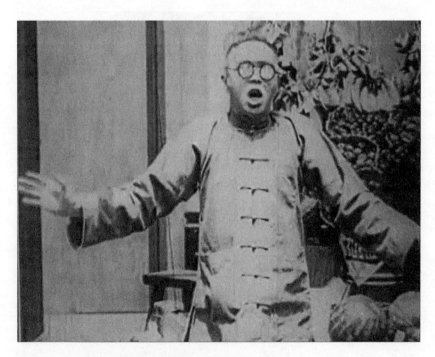

FIGURE 1.2 Carpenter Zheng (Cheng the Fruit-Seller)
Source: Author

FIGURE 1.3 Point-of view shot
Source: Author

in the film when spectacle and narrative converge on one motif, the glasses. The abrupt cut to the blurry point-of-view shot draws attention to the very act of looking (spectacle), while Zheng's donning Zhu's glasses anticipates Zheng's later step into Zhu's role as a doctor (story). Add in the Harold Lloyd imagery, and the spectacles become a motif three times over: as spectacle (pun intended), as story, and as allusion to a comic icon.

Lloyd-style glasses became a popular commodity in the 1920s and were emblematic of a modern, young gentleman. Screenwriter Zheng Zhengqiu, who appears in the role of Doctor Zhu, in real life also wore the Lloyd-style glasses that both Carpenter Zheng—same surname—and Zhu wear in the film. Zheng's son, Zheng Xiaoqiu, wears the same glasses in his role as a scholarly young man in *Fate in Tears and Laughter* (1932). Thick circular lenses also appear on the rich husband in *Love and Duty* (1931) and on stock buffoon characters, like the greedy father figure in *Don't Change Your Husband* (1928) and the ugly husband in *The Orphan of the Storm* (1929).

FIGURE 1.4 Connection device
Source: Author

A second Lloyd-inspired motif is the container on a line that Zheng and Miss Zhu use to communicate between stalls (figure 1.4). When Zheng wants to send over a gift, he puts it in this contraption and swings it over. During their second exchange, after Zheng has pelted a harasser with fruit and driven him away, Miss Zhu sends him her handkerchief—a traditional token of female affection—along with her father's glasses.

Such "connection devices" are common in early slapstick films around the world. They create unexpected, improbable, and unpredictable relationships among the people onscreen. In the early French film *The Sprinkler Sprinkled* (1895), a man is watering his garden with a hose and a boy comes along and steps on it, cutting off the flow of water. When the puzzled gardener looks into the hose, the boy removes his foot and sprinkles the sprinkler—the hose being the connection device that creates the relationship between the two characters.

Connection devices appear in innumerable comic shorts through the 1910s. They are seen in the cartoons of Rube Goldberg, one of the most popular American cartoonists from the 1910s to the 1930s, who drew elaborate contraptions that perform simple tasks (known as Rube Goldberg machines). They also appear in later films, such as Charlie Chaplin's *Modern Times* (1936), in which an assembly line not only connects workers but even consumes them.

Laborer's Love borrows the line connection device from Harold Lloyd's *Never Weaken* (1921), which appeared just one year earlier. In the opening scene, Lloyd's character is literally fishing for a bride, dangling a ring on a string from one office window to a young woman the next window over (figure 1.5). In both films, the connection device serves a romantic purpose. In both films, too, this virtual connection between characters precedes a physical connection later on. A third motif that *Laborer's Love* borrows from Lloyd also comes from *Never Weaken*: the love interest works for a doctor whose business is bad, and the young man contrives to bring him new patients. In both films, slapstick ensues.

FIGURE 1.5 *Never Weaken* (1921)
Source: Archive.org

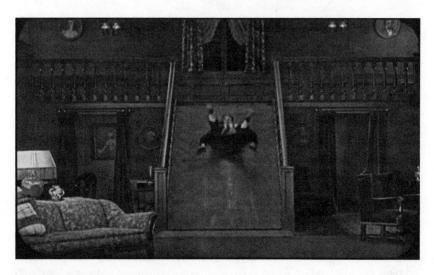

FIGURE 1.6 *The Haunted House* (1921)
Source: Archive.org

The staircase that turns into a slide was inspired by silent film comedian Buster Keaton's *The Haunted House* (1921) (figure 1.6), in which the trick contraption adds an element of unpredictability to a prolonged chase sequence. (At the end, it reappears in a dream of Keaton walking up a staircase to Heaven, only for St. Peter to pull a lever and send him sliding down to Hell.) Tricky staircases were a popular trope in cinema for decades, appearing in films such as Keaton's *The Electric House* (1922) (as a variable-speed escalator), the action-comedy *Woman Warrior White Rose* (1929), and *Hellzapoppin'* (1941) (as a slide down to Hell).

The object of all the trickery in *Laborer's Love* is, as its title implies, love. The romantic young couple overcoming the resistance of parents is a time-honored comic plot around the world. Parental objection is generally to the prospective son- or daughter-in-law's identity, poverty, or inferior social class. The young couple either triumphs in defiance of the older generation, or, as in this case, wins the parent(s) over, resulting in a comedy of reconciliation that makes everyone happy. One long-standing Chinese model for a romantic happy ending is the grand finale (*da tuanyuan*), in which the young lovers are united in the presence of an authority figure, such as a father or the local magistrate.

Doctor Zhu, however, is a travesty of an authority figure. His interests are purely mercenary. He disdains Zheng's offer of fruit when he comes a-courting, but this turns out to be because he is holding out for a more lucrative bribe (which Zheng ingeniously procures). The filmmakers also paint this medicine man in broad strokes as a stereotypical quack. One of Zhu's most amusing sequences is his encounter with a fellow swindler: Zhu feels the man's stomach and says that his serious condition calls for an "immediate operation." The man turns out to have hidden under his robe a dubious Chien Loong era vase which he offers to sell for cheap; the exasperated Zhu offers to sell him an "antique" brush holder (called an "ink spill" in the English intertitle) in return. The episode is a miniature equilibrium farce, in which neither trickster gains advantage over the other, and comic justice has the evenly matched parties separate empty handed.

Grand finale endings in late imperial fiction and drama typically have the young man acquire not just a bride but also good career prospects. He has usually placed first in the imperial examinations and can look forward to a career as an official. *Laborer's Love* parodies this convention. At the end, the carpenter steps into the clinic to lend a hand in treating patients and effectively becomes a doctor. The process of career reinvention and social climbing is so compressed that it becomes a send-up of the drama of the romantic hero triumphing over obstacles: here, an improvised gadget to bring bad guys down (the staircase-slide) helps the good guy up.

In drawing on a well-established narrative model, in using familiar tropes like the charlatan doctor, and in implicitly affirming the patriarchy (the young lovers agree that dad needs to approve their match), *Laborer's Love* might seem traditional. Yet the story of a young striver who uses his own ingenuity and resourcefulness to achieve his goals also expresses an ethos that could be interpreted as modern. At the center of *Laborer's Love* is a self-made man. Carpenter Zheng is a figure of optimism, and his success represents a triumph of the go-getting attitude, a stark departure from the view that one's trajectory is controlled by fate.

Here, both young lovers display initiative in making their own match. Miss Zhu sends her father's glasses to Zheng as if she is sending over a token of her father's favor. Though the gesture is unintentional,

she seems to be replacing his authority. Returning the glasses to their rightful owner becomes Zheng's opportunity to introduce himself to his future father-in-law. Miss Zhu also signals her own desire by walking over to Zheng's shop. The narrative of *Laborer's Love* suggests that one's fate is what one makes of it—all it takes is intelligence and initiative.

TOOLS AND TRICKS OF THE TRADE

Laborer's Love is about more than just young love and family ethics. It displays positive images of craftsmanship and, in doing so, makes an implicit argument for the value of creativity, problem solving, and artisanal labor. Carpenter Zheng turns work into play, and into display (as Xinyu Dong points out in her article on the film), and he has fun in using tools and tricks of his trade to work toward achieving a personal desire, which we also enjoy as spectators.

In the first images we see of Carpenter Zheng, he is using his carpentry tools to process fruit: using a plane to peel sugar cane and using a ruler to measure the girth of a watermelon and a saw to cut it. These unconventional behaviors create a comedy of incongruity but also indicate the qualities that will help Zheng triumph later on: resourcefulness and creativity. In the sequence of Zheng sawing the melon, a symbolic visual motif also hides in plain sight. "Split the melon" (*po gua*) is a slang expression for taking a women's virginity, and the image anticipates Zheng's later union with Miss Zhu. The gleeful smile on Zheng's face as he opens the melon implies not just the joy of labor but also sexual desire (figure 1.7).

The centerpiece of the film is the back-to-back sequences of Carpenter Zheng's construction and use of the staircase-slide. Necessity is the father-in-law of this invention: the rowdy patrons of the All-Night Club above his bedroom are making it impossible for Zheng to sleep, with their mah-jongg playing and brawling, so he thinks up a way to silence them. He also realizes that the invention he has in mind will solve his bigger problem of marriage. Prudently, he makes a deal with his prospective father-in-law before he sets to work measuring and sawing away in his bedroom.

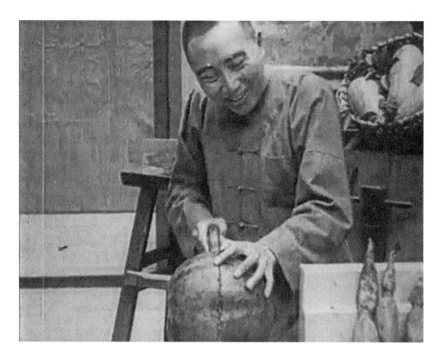

FIGURE 1.7 Splitting the melon
Source: Author

We then see a fast-forward sequence of Zheng installing the stair-case-slide from top to bottom, step by step (figure 1.8). (The effect is achieved by altering the frame rate, shooting the sequence with fewer frames per minute and then playing it back at a normal speed.) Besides generating surprise and amusement, this trick cinematography sequence also calls the viewer's attention to one of the film's themes: labor. As Zhang Zhen notes in her 2005 book, it highlights two types of labor at once: the carpenter's and the filmmaker's. A cut back to normal speed then takes us behind the staircase, where we see Zheng testing out his contraption before putting it to use. In other words, the shot gives us a behind-the-scenes perspective, from which we get to see the labor that an artisan uses to take others for a ride.

This eye-catching sequence underscores the fact that some tricks of the trade in *Laborer's Love* are created not by a character but by the

FIGURE 1.8 Building the staircase-slide
Source: Author

filmmakers, but it is not the first special effect in the film. When Carpenter Zheng is in his room daydreaming of himself together with Miss Zhu (and then of her father, which wipes the smile off his face), this mental image is represented in the top-left part of the screen through trick cinematography (figure 1.9). To create this matte shot, the filmmakers shot two images and then combined them in a laboratory during postproduction.

The double moving image is a cinematic version of a type of novelty photograph that had existed since at least the late nineteenth century. In cities around the world, you could go to a photography studio and purchase an image of yourself interacting with a double (or multiple) of yourself, thanks to the magic of multiple-exposure photography. In early twentieth-century China, you could, for example, pose pouring yourself tea or playing chess with yourself or driving yourself in a car (figure 1.10). This genre of photograph was known in Chinese as the "split-self photograph" (*fenshen xiang*) or the "two-me's photo" (*erwo tu*), and it often

FIGURE 1.9 Matte shot
Source: Author

FIGURE 1.10 A "two-me's photo"
Source: Author

involved the subject assuming multiple identities, a type of fantasy role play. In *Laborer's Love*, one of the "two-me's photos" shows current-Zheng imagining future-Zheng. In his case, the fantasy comes true.

Matte shots and other types of superimposition, in which two or more shots are placed on top of each other such that all are visible simultaneously, are used extensively in later films, such as *Way Down West* (1927), *Red Heroine* (1929), *Sports Queen* (1934), *Goddess* (1934), *The Great Road* (1934), *Song at Midnight* (1937), and *Love Everlasting* (1947), to represent memories, the conscience, fantasies, ghosts, and simultaneous action.

The other notable cinematic trick in the film is the fast-forward sequence in Doctor Zhu's office (figure 1.11). The comical progression of patients builds toward two final, more elaborate, medical treatments involving stretching and hammering human beings. The fast-forward pacing here recalls the staircase-slide construction sequence, as well as

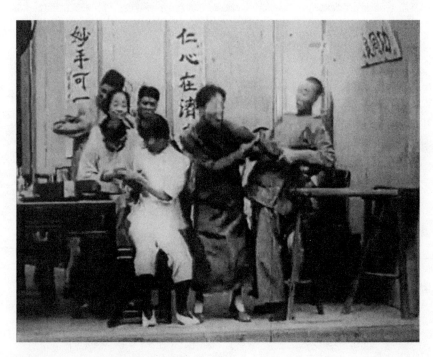

FIGURE 1.11 Assembly line of patients
Source: Author

the subsequent images of victims sliding to their doom. This repeated use of fast-forward turns trick cinematography itself into a motif. The treatment scene in the doctor's clinic establishes another motif as well: the theme of treating people not as people (or patients) but as products. The staircase-slide is a disassembly line that breaks them; the jerky assembly line in Doctor Zhu's office puts them back together again.

Film historians have pointed out that *Laborer's Love*'s representations of playfulness and of work as play may be regarded not just as themes but as an artistic disposition. Carpenter Zheng may be taken as analogous to the filmmaker, who treats the camera as both a tool and a toy; who generates pleasure for both himself and his viewers; and who profits by doing so. A filmmaker, like a carpenter or any other artisan, knows how to look at raw materials in a certain way and how to use tools to craft them into a work. A film that might appear to be simply a slapstick romantic comedy, viewed another way, also contains a self-affirmation of the value of filmmaking as a cultural labor of love.

The film's opening intertitle, which provides a synopsis in both Chinese and English, draws our attention to yet another significant quality of *Laborer's Love*: this film was made for a bilingual market. Not only did the filmmakers have in mind the possibility of export, but they even added English language jokes to the intertitles that do not appear in the Chinese, as when a drunk patron of the All-Night Club, standing at the top of the staircase-slide, exclaims: "I feel so good I could fly!" (Chinese: "Ah! What a fine dinner.")

The surviving print of *Laborer's Love* is imperfect. The margins are cut off, resulting in stunted framing. There is some damage to the celluloid, which occasionally occludes the image; and some frames are missing, making for jerky pacing in some sequences (such as the opening intertitle). Credits are missing. Other imperfections are attributable not to historical loss but to the limitations of the filmmakers' budget or skill. Several match-on-action edits, such as in the object-exchange sequences, violate the 180-degree rule by having the object or actor enter on the same side of the frame they exited in the previous shot, thereby creating spatial discontinuity. The slide does not convert back to the staircase smoothly. Zheng replaces the spectacles on Zhu's face twice. At the beginning of one shot, the actors pause before starting to climb the stairs toward the door of the All-Night Club—one of several

editing errors in the film—a moment at which one can virtually hear the director calling "Action!"

Dozens of comic shorts were made in China up to the 1920s but, as mentioned earlier, *Laborer's Love* is one of the few that exists to give us an impression of the era's filmmaking. Bilingual Chinese-English inter-titles also appear in extant silent films such as *The Pearl Necklace* (1926), *Don't Change Your Husband, Red Heroine, The Orphan of the Storm, Love and Duty* (1931), and *Two Stars* (1931). Motifs reappearing in later Chinese films include staircases, which are used to comic effect in *Sports Queen* and *Wanderings of Three-Hairs the Orphan* (1949), and urban working-class or underclass people, who feature in *Playthings* (1933), *Daybreak* (1933), *The Great Road, Street Angels* (1937), and *Crows and Sparrows* (1949). In these later films, the tone changes from comedy to tragicomedy. Filmmakers of the 1930s and 1940s were keenly interested in representing the ups and downs of life for "petty urbanites," especially in the metropolis of Shanghai, and generally did so by alternating humor with pathos.

What distinguishes *Laborer's Love* from many of these later films is not just its shorter length, more rudimentary technological accomplishment, or greater emphasis on humor. It also expresses a different aesthetic, a can-do charisma. When a carpenter becomes a fruit seller, a fruit seller a doctor, or a dramatist a filmmaker, the process is aided by an amateur's embrace of experimentation. *Laborer's Love* displays labor as a playful and pleasurable process, and it rewards the ingenuity and resourcefulness of those with little means. Rough and ready is a virtue when the goal is to show off—look what can be done!

NOTES

1. Translations of foreign filmmakers' names were inconsistent in Republican China. Harold Lloyd's name was transliterated into Chinese as *Haluo'er Lao'ai* 哈羅兒勞愛 (among other renderings), but he was more commonly known as *Luoke* 羅克 or *Luke* 魯克, after his character Lonesome Luke. Chaplin's name was transliterated variously as *Quepolin* 卻潑林, *Zhuobielin* 卓別林, and *Zhuobieling* 卓別靈. See, for example, the front-page advertisement for an event involving a Chaplin-Lloyd double bill and a new play by Zheng Zhengqiu, in *Shenbao* 17637 (April 2, 1922), and a feature about "Luke-style glasses" in *The Saturday*: Yingren

影人, "Luoke shi de yanjing" 羅克式的眼鏡, *Libailiu* 101 (1921), 39-40. The following discussion of Harold Lloyd and Buster Keaton's influence on *Laborer's Love* partly draws on Xinyu Dong, "The Laborer at Play: *Laborer's Love*, the Operational Aesthetic, and the Comedy of Inventions," *Modern Chinese Literature and Culture* 20, no. 2 (Fall 2008): 1–39.

2. All three films premiered at Shanghai's Olympic Theater in 1922, *Uproar in a Bizarre Theater* on January 26, and both *Laborer's Love* and *The King of Comedy Visits Shanghai* on October 5. Huang Xuelei, *Shanghai Filmmaking: Crossing Borders, Connecting to the Globe, 1922–1938* (Leiden: Brill, 2014), 287, 292, 295.

SOURCES/FURTHER READING

Dong, Xinyu "The Laborer at Play: *Laborer's Love*, the Operational Aesthetic, and the Comedy of Inventions." *Modern Chinese Literature and Culture* 20, no. 2 (Fall 2008): 1–39.

Gunning, Tom. "Crazy Machines in the Garden of Forking Paths: Mischief Gags and the Origins of American Film Comedy." In *Classical Hollywood Comedy*, eds. Kristine Brunovska Karnick and Henry Jenkins, 87–105. New York: Routledge, 1995.

Mellen, Joan. *Modern Times*. London: British Film Institute Publishing, 2006.

Rao Shuguang. *Zhongguo xiju dianying shi* [A history of Chinese film comedy]. Beijing: Zhongguo dianying chubanshe, 2005, 29–35.

Rea, Christopher. "Play." In *The Age of Irreverence: A New History of Laughter in China*, 40–77, 214–227. Oakland: University of California Press, 2015.

Tseng, Li-Lin. "Electrifying Illustrated News: Zheng Zhengqiu and the Transformation of Graphic Arts Into Dramatic Cinema, 1910–1935." *Twentieth-Century China* 41, no. 1 (2016): 2–28.

Zhang Zhen. "Teahouse, Shadowplay, and *Laborer's Love*." In *An Amorous History of the Silver Screen: Shanghai Cinema, 1896–1937*, 89–117, 371–376. Chicago: University of Chicago Press, 2005.

FURTHER VIEWING

The Electric House. Buster Keaton and Edward F. Cline, directors. 1922.

The Haunted House. Edward F. Cline and Buster Keaton, directors. 1921.

Modern Times. Charles Chaplin, director. 1936.

Never Weaken. Fred C. Newmeyer and Sam Taylor, directors. 1921.

The Orphan of the Storm (*Xue zhong guchu* 雪中孤雛). Zhang Huimin, director. 1929.

Poor Daddy (*Pa laopo* 怕老婆), aka *The Heroic Son* (*Erzi yingxiong* 兒子英雄). Dumas Young (Yang Xiaozhong), director. 1929.

The Sprinkler Sprinkled (*L'Arroseur arrosé*). 1895. Multiple versions.

Playthings (Xiao wanyi 小玩意)

Alternative English titles: *Little Toys*, *Small Toys*
Director/screenplay: Sun Yu
Studio: Lianhua
Date of release: October 8, 1933
103 minutes, 11 reels
Cast: Ruan Lingyu, Li Lili, Liu Jiqun, Yuan Congmei, Luo Peng, Tang Tianxiu, Han Langen, Yin Xiucen

SYNOPSIS

Sister Ye is a toymaker living in a bucolic river town in southern China around 1920. Her handicrafts are at the center of a cottage industry that supports her husband, Old Ye, their young daughter, Zhu'er (Pearly), and toddler son, Yu'er (Jade), as well as dozens of families in the community. Neighbors esteem her for her creativity, while her personal beauty and charisma attract both frivolous and earnest suitors. Among the latter is the handsome college student Yuan Pu, a rich, westernized young man who offers to take her to Shanghai, Paris, and Switzerland. Though attracted to him, she persuades him instead to pursue engineering studies abroad. Artisan toymakers like her are losing their livelihood due to competition from mass-produced foreign toys, and she

urges him to learn how to strengthen China's industries. He agrees and leaves for Germany. Then Old Ye has a heart attack while selling toys with the peddler Mantis out on the street during fighting by rival warlord armies. As Old Ye dies in his wife's arms, a man takes advantage of the distraction to kidnap Jade. He later sells the boy to a rich family in Shanghai, pretending the boy is his orphaned nephew. In 1921, civil war breaks out and the townsfolk flee to Shanghai. Upon arrival, Sister Ye urges her companions to resume work making toys. Ten years pass. Following the Mukden Incident of 1931, Japan attacks Shanghai, and Sister Ye and her comrades struggle to sell their toys amid competition from "imperialists." Meanwhile, Mr. Yuan has returned from abroad and set up the Great China Toy Factory, which is toured by Ye's lost son and his adoptive mother. In January 1932, the Japanese attack Shanghai again, and the bombardment and street fighting reaches Sister Ye's neighborhood. As the tide of battle turns against the Chinese soldiers, the group prepares to flee, but Pearly convinces them to stay and support the troops. An enemy plane bombs the Red Cross and the seventeen-year-old Pearly remarks on her deathbed that she has "many more playthings to invent before I die." Ye collapses in grief. Another year passes, and Lunar New Year 1933 finds Ye selling toys on the streets of Shanghai. Her son, escorted by a chauffeur, comes over, but mother and son do not recognize one another. Moved by his expressions of patriotism, she gives him two toys for free. She then mistakes the sound of New Year's firecrackers for gunfire and cries out a warning loud enough to alarm revelers in a nightclub, who run out onto the street. As she continues to rave about how China must resist aggression, the bystanders' alarm turns to approval, and they applaud her words. Yuan arrives and, recognizing Ye, tells a policeman that he will take care of her. The film ends with a close-up of Ye shouting into the camera.

A GRAND DRAMA WRIT SMALL

Playthings, which began production in late spring of 1933 and was released on the eve of National Day, pays tribute to the soldiers who had fought against the Japanese Army in two recent conflicts. On September 18, 1931, the Japanese military sabotaged a rail line in northern China and

blamed it on Chinese guerillas, and then used the pretext to annex three provinces in the northeast, overcoming armed resistance from Chinese soldiers. The Mukden Incident, or September 18 Incident, marked a new, more aggressive phase of Japan's imperialist ambitions in East Asia and ushered in a state of undeclared war between China and Japan.

On January 28, 1932, Japanese planes began bombing Shanghai in retaliation for anti-Japanese activities in the city. The ensuing Battle of Shanghai not only escalated hostilities between the two nations, but also destroyed important cultural institutions, including major libraries, publishing houses, and film studios. On February 18, 1932, Japan proclaimed the founding of Manchukuo ("Manchu State"), later installing the deposed Qing emperor Puyi, an ethnic Manchu, as emperor.

These and other recent historical events are mentioned with text onscreen. Fighting between warlord troops in 1921 is shown under the title "Civil War!" The Battle of Shanghai is framed with: "The heroism of our troops during the battle of January 28, 1932 shocked the world and rallied the spirits of the nation. Every day of the weeks that followed was a desperate and bloody struggle!" A title card preceding the final scene reads: "A year has passed in a flash in our metropolis. It is January 28, 1933 and the fighting has already moved from Shanghai to other places, so that what ushers in the New Year is another type of fire and smoke—fireworks!" The plot, in other words, brings us right up to the production time of the film.[1]

While commenting on a dire military situation, *Playthings* also decries foreign economic exploitation and its effects on common people. It does so by harnessing both the charisma of a melancholy heroine who leads a band of humble artisans and the symbolic potential of toys, developing the toy/play leitmotif (a central repeated theme, image, or idea) into a narrative device. This section makes three arguments. First, playthings (and toymakers themselves) symbolize vulnerability— of workers, of children, and of China. Toys are also vectors of economic relationships, including the livelihood of artisans, competition from industrial producers, and the threat of obsolescence. Third, the film explicitly links toys with weapons and implies that play aids work, including the work of national defense. The next section turns to toys' functions as connection devices, as objects of fun with their own intrinsic value, and as vehicles for praising indigenous ingenuity.

Playthings begins with bucolic shots of a river and canals, of one family's home life, and close-ups of various toys and the laborers who make and sell them. The camera follows a fisherman who offers his catch to Sister Ye. We later see roadside vendors, such as a purveyor of stinky tofu (a cameo by composer Nie Er), which Ye and Pearly enjoy while holding their noses. In this rural idyll, inhabitants engage in a simple, playful, communal way of life. As in other Sun Yu films, such as *Wild Rose* (1932) and *Daybreak* (1933),[2] the idealized portrait presages a contrast to the evils of the city (Shanghai). Sun Yu later called his idiom "revolutionary romanticism." The idealization of country life nevertheless drew criticism from leftist screenwriter Xia Yan, who claimed it whitewashed the real hardships experienced by the rural population even before foreign aggression.[3]

Early scenes turn the film into a virtual toy shop (figure 2.1).[4] We see hand-painted boy figurines, a bobblehead doll of a bewhiskered old

FIGURE 2.1 Virtual toy shop
Source: Author

man with dark glasses, an old man's head that pops out of the jar like a jack-in-the-box, a circular handheld fan, a pump-action bamboo tube water gun, a painted mask, a row of baskets holding a duck and chicks that can be pulled back and forth on a string, and a drum and cymbal duo played with a pull-string. These sequences exude the sentiment that a personal, authentic way of life is worth cherishing.

The emphasis on pull-string toys in early scenes establishes the metaphor of playthings being manipulated (figure 2.2). People as playthings is a theme appearing in George Abbot's *The Cheat* (1931), Wu Yonggang's *Goddess* (1934), Cai Chusheng's *New Women* (1935), and *Wanderings of Three-Hairs the Orphan* (1949). *Playthings* represents toymakers as subjects with their own agency. Their insistence on *not* becoming manipulated or expendable contrasts with the short-sightedness of the Xiaos in *Crows and Sparrows* (1949), commodity speculators who are

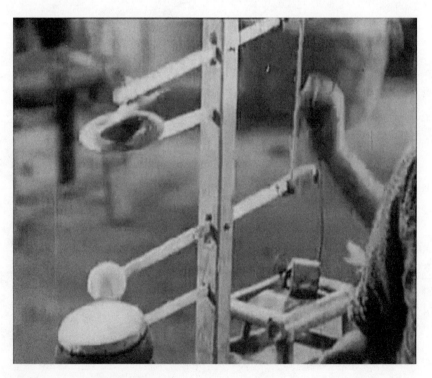

FIGURE 2.2 Pull-string toys
Source: Author

eventually ruined by larger economic forces. Unlike Old Tongbao, the silkworm farmer in *Spring Silkworms* (1933), Sister Ye understands these forces and shares her knowledge. She once notes that rich children nowadays favor mass-produced toys, and later remarks that if their toys are not better than foreign ones they will starve. Ye makes little toys but sees the big picture.

Since around 1911, industrialists and politicians had promoted "Buy domestic" campaigns to encourage consumers to shore up Chinese industry. Slogans, advertisements, and exhibitions framed buying Chinese as a patriotic act, as well as an economic necessity to keep wealth from flowing overseas. *Spring Silkworms, Street Angels* (1937), *Lights of Myriad Homes* (1948), and *The Lin Family Shop* (1959) (based on a story published in 1932) are just a few films alluding to the baleful effects of foreign capitalism. *Playthings* dramatizes the peril of *not* buying Chinese by showing the negative effects on producers. Rather than indict consumers (which could offend the audience), the film instead renders producers as sympathetically as possible.

The Sister Ye character conveys—and attempts to reconcile—several proven narrative modes: family melodrama centering on a suffering woman; romance between young lovers; and appeals for self-sacrifice in a time of national crisis. Husbands are unnecessary: Old Ye, though good-natured and honest, is ineffectual and relatively superfluous. (Moviegoers might have remembered Liu Jiqun's role as a timid husband in *Poor Daddy* [1929].) After his death, Sister Ye does not remarry.

Instead of conjugal love, we have "revolution plus love," a formula common since the New Culture Movement of the mid-1910s. This affective sleight-of-hand taps into the audience's desire for romance and then redirects the plot toward a progressive social message. Medium shots of Sister Ye and Yuan Pu together show them as a handsome and intimate couple (figure 2.3). (One old man comments that Ye and her fat husband are like a flower stuck in a cow patty.) Yuan addresses her familiarly by her given name, Xiuxiu. She smiles and leans against him. At first, Yuan, with his Western suit and slicked-back hair, appears as a playboy, and Ye his prospective girl-toy. A single monologue from her persuades him to convert his ardor for her to laboring to save China's poor. "That," she concludes, "is the Mr. Yuan we so love and respect."

FIGURE 2.3 Sister Ye and Yuan Pu
Source: Author

The didactic moment shows a charismatic representative of the working class seducing an intellectual into devoting his talents to a cause greater than personal gratification. Flirtation leads to national salvation. Their lingering farewell is shot in medium close-up to emphasize their restrained passion, and Yuan takes his leave with a promise that he will always love her in his heart even as he commits his body to hard work for eight or nine years. The scene offers a cathartic moment, without violating the taboo of adultery.

In 1921, the main threat to the toymakers is internecine fighting. A montage of civil war shows burning houses, rampaging soldiers, guns, swords, bayonets, corpses, and fleeing villagers. (Sun Yu reused several shots for the "New Song of Fengyang" sequence in *The Great Road* [1934].) An elliptical edit, skipping ten years of story time, then takes us to the infamous year of 1931.

Fans would recognize the improbability of the casting of the following scenes, which have twenty-three-year-old Ruan Lingyu playing the mother of eighteen-year-old Li Lili. (Ruan, with blackened teeth, is more convincing as the mother of Chen Yanyan in *Love and Duty* [1931].) Li was still developing her mischievous screen persona, also seen in *Daybreak*, *Sports Queen* (1934), and *The Great Road*. Two old men predict that Pearly will follow in Ye's footsteps and become a master artisan whose toys are better than foreign ones.

Yuan Pu by then has realized the traditional ideal of becoming a virtuous merchant who shares the wealth by investing in his community, in this case by founding the Great China Toy Factory. A montage (filmed at a real Chinese toy factory) shows molds of dolls, balls, tanks, machine guns, cannons, and electric trains. The images suggest that China can compete with foreign industry. But they beg the question: Is cottage creativity amenable to mass production? Feng Zikai, one of modern China's most famous artists, remembered that as a child he was less interested in mass-produced toys of fixed shape than he was in clay toys that could be reshaped with his own hands and imagination.[5] What would happen to Sister Ye's artisanal innovation if it were channeled into Mr. Yuan's factory?

Then there is the personal melodrama of striking contrasts and coincidences. Yuan gives a tour of his factory to Ye's kidnapped son and the prosperous Shanghai missus who adopted him (figure 2.4). "Even if his parents were alive, I'd never be willing to part with him!" she declares. The boy goes home laden with gifts. The prosperous capitalist, alone in his mansion, is troubled by memories of the woman he left behind. A flashback sequence shows his trip back to her village, where he discovered that there's been no news of her since the war. Meanwhile, in 1931, a title card tells us, Sister Ye and her comrades struggle "heroically" under "the imperialists' increased incursions into the Chinese market" (as if they are not now also competing with Yuan). At the temple fair, medium-long shots of Pearly and her handicrafts display alternate with extreme long shots (stock footage) of teeming crowds.

Following the temple scene, an extraordinary sequence frames the 1932 Battle of Shanghai within the leitmotif of toys. Parallel editing alternates shots of boys playing with toy airplanes, tanks, cannons, and battleships with shots from newsreel footage of actual battleships and

FIGURE 2.4 The stolen son at the toy factory
Source: Author

fictionalized representations of aircraft, tanks, and street combat. Many graphic matches juxtapose toys and weapons (figure 2.5).

A link between toys and weapons is also made through mimicry. In the first scene of Sister Ye out in the community, a tofu vendor grabs her arm. An army of neighborhood boys comes to her defense, spraying the man with a water gun, shooting him with a peashooter, and using their swords and guns to drive him into a puddle. Sister Ye then demonstrates yet another new toy she invented: a monkey that puts on a mask with the pull of a string. Intercut shots show the tofu vendor mimicking the monkey toy by covering his face with a mask.

When Pearly wishes aloud that she and her mother had the means to open a mechanized factory so that they could build "thousands of warships and planes a day," the film takes on an overtly ventriloquistic quality. The next toy she picks up is a row of soldiers on an extendable scissor base that advance and retreat at will. The camera zooms

FIGURE 2.5 Graphic matching of toys and weapons
Source: Author

in on Ye's troubled face as she considers her daughter's question about whether Shanghai consumers of Western toys would dare to fight foreigners. She reflects that factories could probably produce real planes if only people weren't so "selfish"—the closest the film comes to criticizing its audience.

Toys transform not only into symbols of China's military aspirations but also into vehicles for satire. One of the first toys shown in the film is a bewhiskered bobbleheaded old man with glasses. During the war, Pearly demonstrates two bobbleheads kowtowing before a tiger, and another pair bowing to its tail. She predicts that such sycophants will end up in the tiger's belly.

Many Republican films depict battles. *Playthings* also depicts soldiers in leisure moments, including relaxing to the music of a phonograph, kidding around, and singing jolly songs. One fat civilian (played by Yin Xiucen) mugs and grimaces as he helps Mantis (played by Han Langen) fill sandbags. In *The Great Road*, Sun Yu would again inject moments of respite from the earnest work of national construction and defense.

Play, it is made clear, should stop short of taking sexual liberties, as when Pearly repeats her mother's action of getting revenge on a man who is getting touchy-feely. While she is sewing a fat soldier's torn uniform, he touches her face and she jabs his backside with her needle. Yet the ensemble looks on benignly at these hijinks, and Sister Ye comments, "I really like these soldiers! When they're fighting they go all out and when they're not they're really naughty!" Ponderous comparisons of toys and weapons notwithstanding, the film stops short of declaring war to be a mere game. Games are a respite from war, and play can help soldiers fight harder. The soldiers' rallying cry at the Jiangnan front is "Playthings! Charge!"

THE PERIL AND PROMISE OF PLAYTHINGS

Like many of Sun Yu's films, *Playthings* inculcates political messages through both direct intellectual appeal (text on screen) and affective strategies meant to stir emotions. Pathos and playfulness combine into a mode of tragicomedy, before a melodramatic ending. Toys serve multiple comedic functions, including as connection devices (see chapter 1)

that link together characters, on-screen and off-screen spaces, and segments of narrative. These "little" gadgets, gimmicks, and novelties are also represented as having intrinsic value in generating fun for its own sake, distinct from their symbolic or utilitarian value. Collectively, they constitute a ludic encomium of Chinese creativity.

Novelty toys shape the form of the film. One graphic match signals the passage of ten years, as we see a teenaged Pearly, blowing on a pinwheel as a girl and then the propeller of a toy fighter plane as a teenager. One of her favorite toys is a two-handed pair of scissors supporting a row of cut-out soldiers, which she makes advance and retreat; another is an extendable scissors-grabber, which she uses to grab things from off-screen. Both gag objects cut the screen space diagonally, the grabber suggesting a desire to extend one's grasp beyond the immediate and the visible (figure 2.6).

FIGURE 2.6 A toy for extending one's grasp
Source: Author

Visual compositions exude a playful use of the toy-like potential of the film camera itself. Early scenes include tracking shots along towpaths and rivers and on boats. Several shots during the village playground sequence linger on a small Ferris wheel that seats four children at once. Like the scissor-grabber, a wheel of children in profile repeatedly move in and out of the foreground of the frame. Dynamic shapes in motion come on display again in *Sports Queen*, which features extensive use of geometric shapes in screen wipes and blocking.

Toys are presented as expressive and affective objects. In her first appearance, Sister Ye, awoken by her husband, wipes away her daughter's tears (a gesture reversed as Pearly dies). A close-up shot shows a tear on her hand, which she playfully flicks across the room onto a painted mask, which shortly reappears in a slapstick sequence. Ye then encourages her family members not to look so "pitiful." As in *Peach Girl* (1931), Ruan Lingyu's character is cast as charismatic yet melancholy.

Sister Ye's first appearance in the community establishes her as its central figure. Outgoing yet self-possessed, she is neither bound by traditional gender roles that would keep her housebound nor stepping out merely to become an object of public consumption. She projects her own agency and desire, as when she repairs a handsome man's shirt and even—generating a frisson of public intimacy—biting off the thread as others look on. We see a community of artisans engaged in happy labor of painting, chiseling, testing, and selling their wares.

Lianhua often used the aura of playful camaraderie to promote patriotic or socially progressive agendas, while showcasing its ensemble of acting talent. When Sister Ye yields her leadership role to her daughter, Pearly encourages fellow toymakers to make "useful" things, and then pauses in her speech to snip off the hairs growing out of a mole on Mantis's face—a visual gag consistent with Pearly's claim that they must get rid of the extraneous. As if to reinforce the message bodily, Pearly promptly climbs onto a platform, and then leads the village children in calisthenics. (Li Lili was to reappear as physical role model in *Sports Queen*.) Playful self-strengthening (*ziqiang*) also takes the form of tug-of-war.

The playground sequence generates an atmosphere of good cheer while showcasing Li Lili's physicality and woman-child persona. Pearly both mimics and is mimicked by the village kids. A child's pants fall down as he follows her calisthenics stretches. When Pearly follows

children down the slide, she tears her shorts and covers her embarrass-
ment by sitting in a basket.

The toy–weapon/play–work dialectic recalls the political philoso-
phy of *ti-yong*: to retain a Chinese essence (*ti*) while using (*yong*) West-
ern things and ideas. Following the Opium Wars, Chinese political
theorists often portrayed international relations as a Darwinian contest
that China was losing, necessitating a new approach that was flexible
but preserved national integrity. Reformist Qing officials advocated
adapting *ti-yong* (a formulation dating back to the third century) to keep
the absolute reality of being Chinese constant while selectively adopt-
ing methods from abroad. Modern education reformers became keenly
interested in "science games," "physical games," and "edifying games." A
book entitled *Toys and Education* (1933) appeared shortly before *Play-
things'* release. *Playthings* draws on the *ti-yong* binary—most explicitly
when Sister Ye urges Mr. Yuan to study abroad—but adds a third dimen-
sion of play, which is not strictly utilitarian.

Andrew Jones calls the final sequence, in which Sister Ye goes
insane, "surely one of the most powerful in the history of Chinese cin-
ema."[6] Her sudden insanity is immediately preceded by an exchange on
the street (figure 2.7). Her son arrives and asks: "Are all of these toys
made in China?" She nods. He chooses the scissor-extension soldiers
and the airplane that were once Pearly's favorites. When Ye asks about
his uniform he responds: "I'm wearing the uniform of the Scouts of
China. When I grow up, I'm going to save China." (On the Scouts, see
chapter 3.) She refuses his money, which she says should stay with the
nation's saviors. They salute each other and he departs.

Jones points out that the scene of the destitute mother giving toys to
the long-lost son she does not recognize is an ironic "non-transaction."
The poor mother refuses payment for her handiwork from her (now)
rich son, who is himself "stolen goods." The scene is no Communist fan-
tasy of the working classes rising to save China. Instead, the working
class sacrifices itself yet again so that the bourgeoisie can take the lead
in the undefined future.

Ruan Lingyu gives an affecting performance as a woman bereft of
family and livelihood and shell-shocked by war who projects her trauma
into the public sphere with a Cassandra-like outburst (figure 2.8). Sister
Ye's final act is to inspire a crowd with delusional fervor. She is knocked

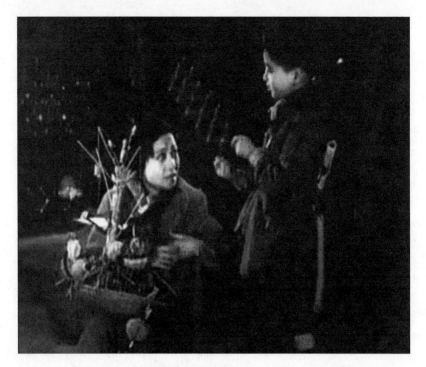

FIGURE 2.7 Giving the dead daughter's favorite toy to the stolen son
Source: Author

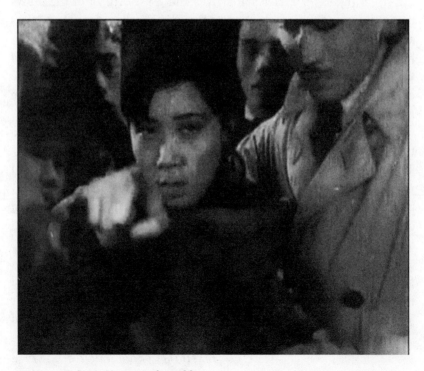

FIGURE 2.8 Sister Ye warns the public
Source: Author

to the sidewalk and, hearing firecrackers, shouts, "The enemy is coming!," setting off a temporary panic among the New Year's revelers. In her hands she operates the extending soldiers toy and imagines that the soldiers are real.

The implications of Yuan Pu's return at this moment are ambiguous. The earlier nostalgic images of local crafts suggest an agenda of protectionism. Perhaps petty ingenuity (*xiao congming*)—here, the invention of clever toys—could be powerful if projected to a national level. The reunion of Ye and Yuan dangles the possibility of a best-case scenario: that she will recover her senses and marry her creativity with his industrial capital to realize China's dream of economic self-determination.

The final shots, however, suggest that such a happy outcome is improbable. Visions of toys and soldiers are superimposed over Ye's anxiety-ridden face. Running back and forth, she calls out for united resistance, provoking disquiet in bystanders. Then, for several minutes of silent screen time, she looks into the camera and points and rails at us. The crowd eventually applauds her passion, but her inspiring words are left to our imagination (figure 2.9).

The scene of a crowd responding positively to a deranged street woman is unique in Republican cinema. Later films, such as *Wanderings of Three-Hairs the Orphan*, again and again emphasize the callous indifference of passersby to the plight of unfortunates on the street. *Playthings* and *Three-Hairs* both end with the message that we should at least emulate the spirit of subalterns who persist despite their misfortune. Three-Hairs does not get his parents back, but he ends up embraced into the larger family of communist New China. In *Playthings* (as, later, in *Goddess*), a woman's future, represented by her son, has been taken away from her, leaving her "the evolutionary remnant of a triumphal history that has yet to unfold."[7]

Playthings is significant not only for its elaboration of the toy motif and for Ruan's performance, but also for a type of narrative irresolution symptomatic of films of the 1930s and 1940s. The pattern appears in Sun Yu's films of the early 1930s, in films made of the eve of war like *Street Angels* and *Crossroads* (1937), and Civil War–era films like *Spring in a Small Town*. Such films tend to end not with a conclusion but with a gesture. They express a momentary sense of hope or despair or exhaustion in lieu of emphatic resolution. Though varying in tone from the bathetic

FIGURE 2.9 The public applauds Sister Ye
Source: Author

or the maudlin to the sublime, they share the honesty of admitting that the future is uncertain.

NOTES

1. *Playthings* premiered on October 8, 1933 at Shanghai's Carleton Theater. See the half-page advertisement in *Shenbao* 21727 (October 7, 1933), 4.
2. *Wild Rose* premiered at Shanghai's Peking Theatre on April 28, 1932, and *Daybreak* premiered at Shanghai's Peking Theater on February 2, 1933. See the advertisements in *Shenbao* 21214 (April 26, 1932), 10; *Shenbao* 21480 (January 31, 1933), 23.
3. Sun Yu, *Yinhai fanzhou: Huiyi wode yisheng* [A boat drifting on the seas of cinema: a memoir] (Shanghai: Shanghai wenyi chubanshe, 1987), 75; Hu Jubin, *Projecting a Nation: Chinese National Cinema Before 1949* (Hong Kong: Hong Kong University Press, 2003), 100.
4. The film-as-toy-store model anticipates *Pinocchio* (1940), as well as more recent productions, such as the Star Wars (1977–), *Toy Story* (1995–), *Lego Movie* (2014–),

and Marvel Universe film series/franchises. Chinese musical films of the 1930s, such as Sun Yu's *The Great Road*, were routinely accompanied by phonograph releases, but *Playthings*, to my knowledge, did not exploit its merchandising opportunity.

5. Geremie R. Barmé, *An Artistic Exile: A Life of Feng Zikai (1898–1975)* (Berkeley: University of California Press, 2002), 23.

6. Andrew F. Jones, *Developmental Fairy Tales: Evolutionary Thinking and Modern Chinese Culture* (Cambridge, Mass.: Harvard University Press, 2011), 138.

7. Jones, *Developmental Fairy Tales*, 145–146.

SOURCES/FURTHER READING

Fernsebner, Susan R. "A People's Playthings: Toys, Childhood, and Chinese Identity, 1909–1933." *Postcolonial Studies* 6, no. 3 (2003): 269–293.

Gerth, Karl. *China Made: Consumer Culture and the Creation of the Nation.* Cambridge: Harvard University Asia Center, 2003.

Hong, Guo-Juin. "Meet Me in Shanghai: Melodrama and the Cinematic Production of Space in 1930s Shanghai Leftist Films." *Journal of Chinese Cinemas* 3, no. 3 (2009): 215–230.

Jones, Andrew F. "Playthings of History." In *Developmental Fairy Tales: Evolutionary Thinking and Modern Chinese Culture*, 126–146, 228–232. Cambridge, Mass.: Harvard University Press, 2011.

Mao Dun. "The Shop of the Lin Family." In *Spring Silkworms and Other Stories*, trans. Sidney Shapiro, 113–163. Beijing: Foreign Languages Press, 1956.

Rea, Christopher. "Play." In *The Age of Irreverence: A New History of Laughter in China*, 40–77, 214–227. Oakland: University of California Press, 2015.

Sun Yu. *Yinhai fanzhou: Huiyi wode yisheng* [A boat drifting on the seas of cinema: a memoir]. Shanghai: Shanghai wenyi chubanshe, 1987.

FURTHER VIEWING

The Cheat. George Abbot, director. 1931.
Daybreak (*Tianming* 天明). Sun Yu, director. 1933.
Goddess (*Shennü* 神女). Sun Yu, director. 1934.
The Lin Family Shop (*Lin jia puzi* 林家鋪子). Shui Hua, director. 1959.
Pinocchio. Ben Sharpstein and Hamilton Luske, directors. 1940.

Sports Queen (*Tiyu huanghou* 體育皇后)

Alternative English titles: *Queen of Sports, The Athletic Queen*
Director/screenplay: Sun Yu
Studio: Lianhua
Date of release: April 14, 1934
85 minutes, 10 reels
Cast: Li Lili, Zhang Yi, Yin Xu, Bai Lu, Wang Moqiu, Gao Weilian, He
 Feiguang, Shang Guanwu, Li Junpan, Han Langen, Liu Jiqun, Yin
 Xiucen

SYNOPSIS

Lin Ying, a girl from the Zhejiang countryside, takes a steamer to Shang-
hai to stay with her uncle and aunt and visit her businessman father.
From the docks, they and Ying's childhood friend, Yun Yan, drive to her
uncle's house, where Auntie introduces Ying to a suitor, the dandified
and westernized Young Master Gao. Rather than pursue romance, Ying
follows Yan's suggestion to enroll in the Jing Hua (Competitive China)
Women's Sports Academy. There Yan introduces Ying to her hunky
elder brother, Yun Peng, who coaches track. When the school princi-
pal sees the novice Ying outpace experienced students on the track,
he directs Peng to give her special training. Ying proves to be an eager

student and a natural athlete. She flirts with Peng, but he represses his own attraction and advises her to focus on her training. Ying breaks several records at a national competition and is feted by the principal, her family, and Young Master Gao, who trumpets her "glory" in the newspaper he owns. Success goes to Ying's head. She spends class time responding to fan mail and goes out partying at night. Ying gets back on track only after Peng rescues her at the end of a bad date with a frivolous college boy. A trio of rival classmates, led by double record-holder Ai Cheng, come up with a win-at-all-costs scheme to beat Ying at the Far Eastern Qualifying Trials. But during a heat against Ying, one of them, whose doctor had advised rest, has a heart attack and collapses. Ying, chastened by the girl's dying words that she "didn't understand the true athletic spirit," holds back during the final and allows Ai Cheng to win. Peng, on the track with Ying afterward, nods his approval, and they vow to combat elitism in sports. A montage follows of hundreds of people marching and doing synchronized calisthenics.

NO MORE BOUND FEET

Sports Queen begins with a dedication to those "diligent warriors who strive to maintain the true athletic spirit." The film, which Lianhua Studio promoted in English as *The Athletic Queen*, was made during a wave of national interest in athletics and stars the inimitable Li Lili.

This chapter discusses *Sports Queen* first in relation to the public persona of its leading lady; China's emerging modern sports culture; and the film's storytelling, particularly its coming-of-age narrative. The second section focuses on how the film balances politics and entertainment, fiction and documentary, and discusses its influence on later films.

Li Lili (sometimes credited as L. L. Lay) was known to film audiences from films like *Daybreak* (1933) and *Playthings* (1933), as well as from pictorial magazines. Qian Zhenzhen, as her parents named her, was born into a show business family: her father was a screenwriter-director and her mother an actor. As a teenager, she became the adopted daughter of the famous composer Li Jinhui and performed in his Bright Moon Song-and-Dance Troupe, which toured China and southeast Asia. Li Lili, Wang Renmei, and Hu Die (aka Butterfly Wu) were the

troupe's "three outstanding singer-dancers" who went on to become movie stars in the 1920s and 1930s.

During the peak of her onscreen career in the 1930s, Li was promoted heavily in the press as a healthy, athletic, and patriotic model of new womanhood. She was a "sweet big sister" to be looked up to, cherished, and emulated.[1] What supposedly set Li apart from other magazine beauties was that she didn't just pose in a bathing suit—she really did swim, as well as run, ride a bicycle, and attend sports meets. She was part star, part athlete, and—like her onscreen characters—all patriot. Progress, as Li represented it, required bodily commitment. One 1930s publicity photograph shows Li from a low angle in shorts with her arms outstretched and her eyes aloft and carries an inscription in her handwriting: "You have a body—put it to work!" (figure 3.1).

The 1930s was the age of the modern female sports icon. In pictorial magazines like *The Young Companion*, *Lin Loon Ladies' Magazine*, and *The Women's Pictorial*, track-and-field stars, diving and swimming champions, archers, bodybuilders, and aviatrixes appeared alongside politicians and other cultural celebrities (figure 3.2). Cinema and sports came together in print culture when two magazines merged to form *Silverland Sports World* (1930).

Historian Yunxiang Gao notes that the fame of sportswomen tended to be ephemeral, lasting not long beyond the surge of publicity that accompanied their victories.[2] The visual iconography of the sports star, however, had a lasting influence on cinema. Actresses (and a few actors) posed on magazine covers with tennis rackets, on bicycles, astride horses, and in other sporty scenarios. *Sports Queen* represents a convergence of the sports star and the movie star, linking both to entertainment and nationalism.

This "sports queen" is a sprinter, and the choice seems to be a deliberate response to an earlier cultural practice that literally hobbled women: footbinding. In the nineteenth century, footbinding was widespread, especially among the upper classes. Western missionaries vilified the practice as barbaric, a symbol of China's cultural backwardness and cruelty toward women. By the 1930s, footbinding (an allusion to which appears in *Hua Mu Lan* [1939]) was still practiced but widely regarded as anachronistic. *Lin Loon* routinely featured photo spreads comparing staid traditional women unfavorably with

FIGURE 3.1 Li Lili: "You have a body—put it to work!"
Source: Author

unfettered modern women. A track champion is as far as one can get from bound feet.

Lin Ying's physicality is on display in her dramatic entrance. Upon the ship's arrival at the Shanghai docks, her family cannot find her among the disembarking passengers. Finally, her father looks up to discover, with a start, that she has climbed the smokestack (figure 3.3).[3] He

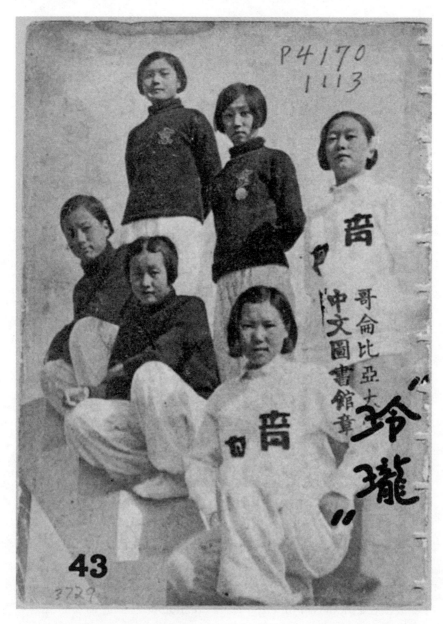

FIGURE 3.2 Magazine sportswomen
Source: Courtesy of the C. V. Starr East Asian Library, Columbia University

FIGURE 3.3 Lin Ying climbs a smokestack like a tree
Source: Author

chides her after she climbs back down, but Ying replies, in her first line of dialogue, "What're you so surprised about? Back in the countryside I used to climb big trees dozens of times a day!" The exchange suggests that Lin Ying's name is symbolic. "Lin" literally means "forest." Her family members call her Ying'er, a homophone for "infant." Her personality is playful and innocent—a child of nature. Ying 瓔 also sounds like "to win" (*ying* 贏), and Ying proves to be a natural winner when she channels her abundant energy into sports.

Li Lili was often typecast as a healthy, natural, innocent girl, culminating in *Back to Nature* (1936), which responded to a craze launched by *Tarzan the Ape Man* (1932). (Several Chinese *Tarzan* films were made during the war.) Her characters reproach the pervasive decadence of urban society. Either her charismatic primal energy overwhelms the status quo or else she ends up corrupted or victimized by its dark forces. In *Sports Queen*, Ying's first impression of Shanghai is that its people are either porcine or emaciated, living in palaces or doghouses.

A coming-of-age plot arc features a young person who surmounts challenges to become more physically and morally mature, a process clearly divided into narrative segments. We see Ying taking classes in sports physiology, choral singing, and athletic principles. (Sun Yu called *Sports Queen* "my only cinematic creation featuring an intellectual protagonist."[4]) At the blackboard, Yun Peng (Cloud-Riding Roc) exhorts students to strengthen China by embodying "the true athletic spirit" (*tiyu de zhen jingshen*). *Jingshen*, or "spirit," is the film's keyword for ideology, and it measures Ying's subsequent actions against this abstract principle.

In her first test on the track, Ying can barely walk in the cleated shoes. Despite starting well after the firing gun, she crosses the line first, beating the champion Ai Cheng. The "Special Training" section shows Ying receiving catch-up lessons on the track and on long-distance runs, with Mr. Yun bicycling alongside. One excursion turns into something of a date. Taking a rest, the sweaty Ying asks to borrow Mr. Yun's handkerchief (a traditional romantic token). He gives it to her reluctantly and chides her for looking in her compact and putting on makeup—vanity being anathema to the athletic spirit. She obediently wipes off the makeup with his handkerchief. The camera shows Ying in close-up, cuddling up to Mr. Yun, putting her hands on his brawny arms, and telling him that she will learn whatever he teaches. Ill at ease, Yun cuts the rest short. While this handsome single man is presented as eye candy, he is also a model of restraint. He keeps his romantic interest to himself and makes no advances on his star pupil.

"The Results of Special Training" shows a montage of Ying triumphing in several sprint events at a sports meet and breaking several national records. At the celebratory banquet back in Shanghai, Young Master Gao (given name Soaring High, the son of a vice minister) makes a speech saying that Ying brings glory not just to China but to the entire world. He presents her with an enormous silver trophy (figure 3.4), a photograph of which appears in his (fictional) newspaper, *Great China Daily*.

The theme of sports royalty then turns explicitly ironic. A group of tramps is shown sitting around a campfire reading of this "national glory" in Gao's newspaper. One wonders aloud, "Glory! How much does that cost per pound? Is glory something you can eat?" Another, played by Sun Yu himself,[5] is a former champion university sprinter who now

FIGURE 3.4 The newspaperman's trophy
Source: Author

works as rickshaw puller (figure 3.5). As his companions tease him, the man is provoked to rage: he stands up shouting and the camera zooms in on his livid face. In a film that trumpets nationalism and patriotism, Sun Yu personally injects an ideology of identification with the socio-economic resentment of the lower classes. The scene verges on communist sympathizing—a risky move following the Nationalist government's anti-communist purges of 1927. Intercut with the dizzying spectacle of superimposed animated trophy cups flying about, the tramp scene projects a specter of class rage.

"The Price of Glory" sequence unfolds a parable about individual success leading to individual vice that imperils a greater cause. Thanks to the intervention of a mentor, the at-risk individual is put back on the correct path and disaster is averted.

One of Ying's new admirers is Hu Shaoyuan, a rich young man and soccer star who owns his own chauffeured car. Ying traipses off to meet

FIGURE 3.5 Sun Yu as a destitute former champion sprinter
Source: Author

Hu and his carful of buddies at the school gates. An outing to a game extends to an evening dance at the Youth Club.[6] Peng, alone on his bed, holds the handkerchief she used to wipe her sweat, as superimposed images of their outing represent his thoughts. "She's a rich young lady," he tells himself. Past curfew, Ying is getting uneasy, as her drunk companion presses champagne on her. On the drive home, he tells her she is insufficiently "modern" (*modeng*) when she rejects his advances. True to his name, which is a homophone for both "fox" and "tiger," Hu is a predator. When Ying gets out of the car to walk herself home, Hu pursues her threateningly. Fortunately, Yun appears and pushes Hu back into his car.

Ying is saved from the fate of the heroine in William O'Connor's *The Primrose Path* (1930), who is expelled from school after being led astray by a football star. Yet even at this didactic moment in the plot, Li Lili's mischievous personality bursts through in winking asides. Ying pretends to be cold to compel Yun to the chivalrous gesture of lending

her his jacket. She responds to Yun's admonition, "Talk less, work more" by babbling away, before catching herself and quieting down.

Young Master Gao is another example of the film's persistent refusal to moralize with a straight face. He begins as a mere buffoon but morphs into a personification of the corrupting influence of the press (a theme played with a heavier hand in *New Women* [1935]). His newspaper publishes a photograph of a "Golden Crown of the Sports Queen," which Gao says is waiting for Ying to claim it. It is this lure of glory that spurs Ying's three rivals and kills one of them.

BODIES, SHAPES, AND A NATION IN MOTION

Sports Queen is also notable for how it balances political messaging and entertainment; for the documentary style it interweaves with fictional storytelling; and the precedents it set that were followed by later films.

Sports Queen uses its female star to introduce the larger structure of institutionalized modern athletics and to link it to the aspirational ideology of nation-building. The film's premiere on April 14, 1934 was timed to coincide with the opening of the real Far Eastern Qualifying Trials in Shanghai that month.[7] At several points, the film also expresses refrains promoted by the New Life Movement, launched by the Nationalist government that February. The campaign hoped to instill patriotism, Confucian obedience to authority, and hygienic modernity in the populace. It promoted moral and physical conditioning through militarism and sports, and involved anti-vice campaigns against gambling, prostitution, nightclub dancing, and "degeneracy." In Lin Ying's first conversation with her father, she tells him: "Daddy, I know why China's not strong! First and foremost it's because people's bodies are weak!"

Sports were closely tied to modern politics. Before the 1911 revolution, China had martial arts (*wushu*); after the advent of the Republic of China in 1912, they were rebranded as national arts (*guoshu*). In 1933, the leading political figure Dr. Chu Minyi, the chairman of the Commission for the Establishment of National Hygiene, posed shirtless in beefcake photos for the magazine *Modern Student*.[8] *Jianshen* (working out) and *jianmei* (healthy beauty; later, bodybuilding) became buzzwords. *Healthy Beauty Monthly* magazine released its first issue in 1934,[9] and in 1941, the Shanghai Fitness Academy (*Shanghai jianshen*

xueyuan) released a special-interest magazine on bodybuilding, *Jian li mei*, which might be translated as *Health, Power, Beauty* or as *The Beauty of a Robust Physique*.

In 1937, Dr. Chu made a short demonstration film of Chinese athletics (viewable online), in which he performs tai chi, pushing hands (*tuishou*), hackey-sack, archery, and various hybrid calisthenics and resistance exercises. Bowing to the camera at the beginning of the film, Chu wears the green uniform and wide-brimmed hat of the Scouts of China (*Zhonghua minguo tongjun*). This patriotic youth organization, akin to the Boy Scouts of America, was founded in 1912 and formally recognized by the Nationalist government in 1934. Groups of scouts appear several times in *Sports Queen* (figure 3.6), including as a marching band in the stands during a montage of the trials and again marching in formation at the end of the film.[10] This organization meant to inculcate conformity, discipline, and patriotism in the young male

FIGURE 3.6 Scouts of China in *Sports Queen*
Source: Author

generation. *Sports Queen* extends the message of self-strengthening the nation to women and harnesses their charisma to the cause.

That charisma was to be of a specific type. Li Lili's healthy female body projected an alternative to the slinky sensuality of Chinese-American actress Anna May Wong, a global celebrity who had a mixed reception in China. Wong wore silks and smoked in shadowy interiors; Li dressed for physical activity and got air in her lungs in the great outdoors. Wong penciled her eyebrows and wore makeup; Li appeared in her "natural" state. One slinked in high heels, the other ran barefoot. Li's robust physique and upbeat personality also appears in films like *Playthings* as a contrast to the delicate, fragile and melancholy persona of Ruan Lingyu.

While promoting healthy patriotism, *Sports Queen* also offers various types of visual pleasure, not least—her wholesome persona notwithstanding—the "frisky" and "spontaneous sexuality" of the star.[11] We see cute children, including the boy-actor Li Keng who appears as the son in *Goddess*, and animals, notably the white dog Ying capers around with and teaches to beg for treats. (A similar breed appears in Leo McCarey's *The Awful Truth* [1937] and Zhang Junxiang's *Diary of a Homecoming* [1947].) Amid the crowd at the track, 1930s moviegoers would also recognize cameos by Zheng Junli, Gao Zhanfei, Wang Guilin, and Wang Renmei, the female lead in the recent hit *Wild Rose* (1932).

One early comic set piece involves both slapstick and verbal humor. The straightlaced and skinny Young Master Gao, who arrives at the Lins' while Ying is playing with the dog upstairs, is a foil to Ying's strong body and outgoing personality. Invited over by Ying's aunt, who hopes to set them up, he has the surprise of his life when Ying barrels down the stairs and jumps into his arms, knocking him onto a sofa. After picking his gift candies and flowers off the floor, he recites his prepared courtship speech, which sends Ying into a fit of giggles. "Daddy," she asks, "Why does he keep talking about *mi'shi* [secret shit, a homophone of Miss] and *piren* [fart people, a homophone of Your Humble Servant]?" Her dad jokes, "Ying, Shanghai is full of secret shit and fart people!"

The comedy continues at school, where the perky Ying's studious note-taking is contrasted, twice, with the cross-eyed stare of a dull classmate. When groundskeeper Big Bug (played by chubby Yin Xiucen) appears, he is carrying a rake, the weapon of Piggy in the Ming novel *Journey to the West*. Big Bug and Little Hairy (played by skinny Han

Langen), reappear throughout the film for comic relief and to comment on the main action. One of the most striking edits occurs at the end of the girls' dormitory sequence, when a shot of the back of women in their underclothes brushing their teeth at washbasins tilts down to their posteriors and then dissolves to show the wiggling rumps of Big Bug and Little Hairy. The graphic match converts erotic pleasure into comic pleasure, as the pair mimic the hygienic modernity that the female athletes have just modeled for us.

Another type of visual pleasure derives from cinematography emphasizing geometric shapes. Screen wipes (a transition where one shot replaces another in a moving line or shape) in various patterns—clockwise curved spirals, diagonal straight lines, and trapezoids—dominate the sports meet montages, such that we see not just bodies in motion but also shapes in motion. At the dark moment following Qiuhua's death, when Ying decides not to run in the afternoon, a high-angle shot shows Jing Hua athletes lying in a circle on a divan with their heads together and legs out. The shot turns bodies into geometric shapes in a manner similar to Busby Berkeley's high-angle and bird's-eye view shots of showgirls in Depression-era musicals like *Footlight Parade* (1933). (Similar shots appear in the Dan Duyu films *Cave of the Silken Web* [1927] and *Living Immortal* [1934],[12] and in Yuan Muzhi's *City Scenes* [1935].)

Sports Queen also gives viewers a look inside the novel institution of a women's sports academy. Several of the girls sport stereotypical "co-ed" costumes, with beanies and scarves. The intertitle "A New Life" is followed by a sequence that shows us where these young women sleep, change, toilet, and bathe. A series of crane shots and tracking shots show the girls springing into action with the wake-up bell, doing stretches and bicycling their legs in the air in bed, washing faces and brushing teeth at a double row of basins, and taking showers.

That particular sequence was likely inspired by *The Kid From Spain* (1932) (figures 3.7–3.8), in which Betty Grable's character, lying in bed, looks at the camera and says "We're opening this story / by giving you a peek / into a dormitory / where all the pretty co-eds sleep." The song-and-dance number that follows, choreographed by Berkeley, features the Goldwyn Girls as college students getting out of bed, taking a dip in the pool, and changing in the morning. A female dormitory scene also appears in *Footlight Parade*.[13] *Sports Queen* adapts this setting

FIGURE 3.7 Women's dormitory sequences in *The Kid From Spain* . . .
Source: Author

FIGURE 3.8 . . . and *Sports Queen*
Source: Author

with attention to symmetry, albeit less stylized than Leo McCarey's. And whereas both pre-Code Hollywood films confront the viewer with sexuality, Sun Yu's sequence features more naturalistic acting and cinematography, panning from girls at the washbasin to a row of steamy showers where one girl passes the soap to another.

The soap may well have been Lux Toilet Soap, which the multinational corporation Unilever recruited movie stars to endorse in both Hollywood and China. Li Lili appeared in Lux ads in 1935 (figure 3.9);

FIGURE 3.9 Li Lili pitches Lux Toilet Soap
Source: *Lianhua huabao* (*UPS Pictorial*) 5, no. 8 (April 16, 1935). Courtesy of the C. V. Starr East Asian Library, University of California, Berkeley

Ruan Lingyu, Butterfly Wu, Chen Yanyan, and other stars also endorsed the product. (*Song of China* [1935], in which Chen Yanyan appears, shows orphans practicing good soapy hygiene.) Li later appeared in full-page advertisements for running shoes. Li's role as an icon of hygienic modernity breaks the fourth wall when Ying, brushing her teeth, looks directly into the camera-mirror, which zooms in on her perfect teeth. *Sports Queen*, in other words, is simultaneously a product of cinematic culture, national politics, and consumer culture.

Like pin-up girl Grable, whose legs were insured for $1 million as a publicity stunt, Li Lili was famous for her legs. A *Sports Queen* production still from the dormitory sequence shows Li in the foreground lying on a bed with her legs splayed in the air. In the scene of Ying preparing for her date with Mr. Hu, she changes from her school clothes into a *qipao*, nylons, and high heels. Her cousin and her classmates watch with disapproval, but the camera invites voyeurism with an extended shot of a raised stockinged thigh, reminiscent of one of Joan Blondell's scenes in *Footlight Parade*.[14]

Politics shapes not only the theme of *Sports Queen* but also its form. Especially in its second half, the film shifts from drama to documentary. Several shots emphasize the role of media, as Lin Ying, the smiling principal, and other athletes repeatedly pose for the cameras (figure 3.10). Shots of the press covering the Trials imbue the film with a self-referential quality—as if it is a newsreel in the making—alluding to the filmmaker's own role in capturing the nation's athletic progress on camera for the public.

During track-and-field scenes, plot recedes and spectacle comes to the fore. A montage builds anticipation of the trials by showing images of velocity, convergence, and spectacle. We see the Shanghai Bund, docks, and a pair of rushing trains superimposed at a canted angle to form an *X* (an image inspired by the opening scene of F. W. Murnau's *Sunrise* [1927]). Repeated low-angle shots show flags representing different provinces. Panning shots show runners, followed by a low-angle shot of the first finisher. This blend of feature film and documentary styles employs sports cinematography and editing techniques later used on an epic scale in Leni Riefenstahl's *Olympia* (1938).

Sports Queen is set in the present day and refers to real people and events. The Far Eastern Championship Games, which Lin Ying does

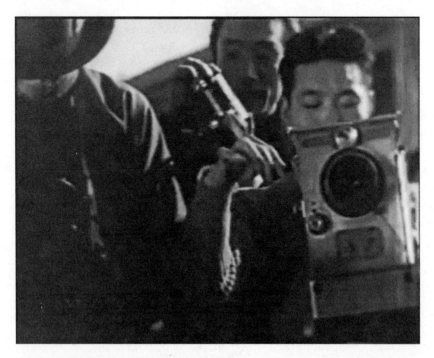

FIGURE 3.10 Posing for the cameras
Source: Author

not qualify for, was an actual sporting event, the precursor to today's Asian Games. Begun in 1913, it held its final competition in Manila in 1934, the 1938 Osaka games being cancelled due to war. Young Master Gao's newspaper carries remarks by Cheng-ting Thomas Wang (Wang Zhengting), chairman of the 1934 Games, who had served as China's foreign minister and premier, and who later became the first Chinese member of the International Olympic Committee. One of the textbooks on Lin Ying's desk is *A Brief World History of Physical Education* (1931), by Zhang Jiwu, director of physical education at Nankai University and High School.

The transition from drama to documentary is completed in the final minutes of the film, which cut from Ying and Yun on the track to shots of Scouts of China marching in formation and mass calisthenics on sports fields (figure 3.11). Filling the screen with bodies creates the type of visual pleasure seen in many Hollywood spectaculars, but

FIGURE 3.11 Mass calisthenics at the end of *Sports Queen*
Source: Author

the ideological call is to national unity and synchronized action of the body politic.

Several elements of *Sports Queen* reappear in *New Women*. Yin Xu, who plays the butch Yun Yan in this film, is typecast in a similar role in *New Women* as the working-class heroine Aying. Wang Moqiu, who plays the petty rival Ai Cheng, reappears in *New Women* as the insincere and corrupt Mrs. Wang. In both films, Yin's and Wang's characters are foils to the heroine.

The two films are also similar in their representation of heterosexual romance. In *Sports Queen*, Ying flirts with Yun Peng who chastises her for wearing makeup; in *New Women*, Wei Ming drapes hers arms over Yu Haichou in her apartment, but he rebuffs her advances, and she calls him an "iceberg." Both films contrast a forward young woman with a reserved, self-possessed man.

Sports Queen established the female athlete film in China. In 1957, director Xie Jin revived this theme during the cultural thaw of the Hundred Flowers Movement with *Woman Basketball Player No. 5*. Xie's film is set in a girls' school and features a male coach teaching a young female standout athlete how to be a better team player. Xie's film also includes scenes of daily life in a women's dormitory and peppy girls in short-shorts. (Xie Jin's 1960 film *The Red Detachment of Women*, which features scenes of mass female training in a military context, also presents the spectacle of collective female exercise.) Though subtitled "the story of a good basketball team," *Woman Basketball Player No. 5* devotes extensive narrative time to the male coach and his misfortunes in the bad old days.

The 1961 Mandarin-language Hong Kong film *Sports Queen* (original in English title: *Beauty Parade*) combines the original *Sports Queen's* formula of female athleticism, physical attractiveness, and comedy with *Woman Basketball Player No. 5's* focus on basketball. The film, starring Kitty Ting (Ding Hao), begins with a title card advising that the film is meant to promote athletics, but it plays up classmate rivalries and comedies, with bonus pratfalls by Liu Enjia. An opening montage has an archer puncturing a basketball with an arrow and a swimmer jumping off the starting blocks in a dress. The first we see of the heroine, she is slopping pigs in her village. Initially mocked as a rustic, she wins over her classmates with her charm and her athletic prowess, lifting the basketball team to victory. Curiously, the filmmakers gave this wholesome girl-athlete a name that, since the publication of a 1942 novella, had been synonymous with raw female sexual desire and suffering: Guo Su'e.[15] Variations notwithstanding, these films all testify to the enduring cinematic appeal of sportswomen, and filmmakers' interest in using them to illustrate the transformative power of athletics.

NOTES

1. The press later applied this "sweetie" epithet to Huang Zongying (see chap. 14).
2. Yunxiang Gao, *Sporting Gender: Woman Athletes and Celebrity-Making During China's National Crisis, 1931–45* (Vancouver: UBC Press, 2013), 127–165.
3. The low-angle shot of the smokestack is reminiscent of similar shots in *Marius* (1931), which is set on the Marseille waterfront.

4. Sun Yu, *Yinhai fanzhou: Huiyi wode yisheng* [A boat drifting on the seas of cinema: a memoir] (Shanghai: Shanghai wenyi chubanshe, 1987), 104. Sun recounts in his memoir (33–34) that in middle school he once filled in for a classmate for one leg of the 400-meter relay race but collapsed before the finish and vomited. He nevertheless remained keen on sports.

5. Sun Yu, *Yinhai fanzhou*, 105.

6. The car and dancing scenes resemble those in the 1934 talkie version of *The Road to Ruin*. Dissipated or unreliable college boys also appear in *Don't Change Your Husband* (1928) and *New Women* (1935).

7. Sun Yu, "Xie zai *Tiyu huanghou* gongying qian" 寫在"體育皇后" 公映前 [Written before the premiere of *Sports Queen*], *Xinwen bao*, April 14, 1934, 8; "Jincheng ying *Tiyu huanghou*" 金城映"體育皇后" [*Sports Queen* premieres at the Lyric], *Xinwen bao*, April 16, 1934, 14.

8. The photo is captioned "The Physique of Athletics Expert Dr. Chu Minyi" ("Tiyu zhuanjia Chu Minyi boshi zhi tige" 體育專家褚民誼博士之體格), *Xiandai xuesheng* [Modern student], no. 3, issue 1 (1933).

9. An ad for issue 1 of *Jianmei yuekan* appears in its sister publication (same editor), *Chin-Chin Screen*, the same issue of which (vol. 1, no. 4 [July 15, 1934]) carries an interview with Li Keng, the child actor in *Goddess* (1934) who makes a cameo in *Sports Queen*.

10. Cowherders wear a similar wide-brimmed hat and uniform in a rumble with cattle rustlers in *The Peach Girl* (1931). Scouts also appear in *Playthings* and *Wanderings of Three-Hairs the Orphan* (1949).

11. Paul G. Pickowicz, *China on Film: A Century of Exploration, Confrontation, and Controversy* (Lanham, Md.: Rowman and Littlefield, 2012), 52.

12. Circular blocking is on display in several production stills from *Living Immortal*, a lost musical film, reprinted in *Qingqing dianying* 6 (1934).

13. *The Kid From Spain* opened at Shanghai's Capitol and Lyceum Theaters on March 29, 1933, and *Footlight Parade* at Shanghai's Cathay on February 17, 1934. *The China Press*, March 26, 1933, 10; *North-China Daily News*, February 18, 1934, 4.

14. Parallel editing alternates shots of Blondell's character in the bedroom preparing to go out, and her roommate stealing her date in the next room. As she listens in, she puts two nylons on one leg by mistake. Leggy starlets in more explicitly sexualized costumes and scenarios appear in pre-Code Chinese films of the 1920s. *The Red Heroine* (1929), for example, features sexploitation scenes, including one in which several scantily clad harem women strip the heroine naked in front of the commander and his leering henchman.

15. On the "overtly sexual" title character of Lu Ling's 路翎 1942 story *Hungry Guo Su'e* (*Ji'e de Guo Su'e* 飢餓的郭素娥), see chapter 7 in Kirk A. Denton, *The*

Problematic of the Self in Modern Chinese Literature: Hu Feng and Lu Ling (Stanford, Calif.: Stanford University Press, 1998).

SOURCES/FURTHER READING

Denton, Kirk A. "The Power of the People: Myth and Cosmology in *Children of the Rich* and *Hungry Guo Su'e.*" In *The Problematic of the Self in Modern Chinese Literature: Hu Feng and Lu Ling*, 221–256. Stanford, Calif.: Stanford University Press, 1998.

Edwards, Louise. "Localizing the Hollywood Star System in 1930s China: *Linglong* Magazine and New Moral Spaces." *Asian Studies* 1, no. 1 (September 2015): 13–37.

Fan, Victor. "The Cinema of Sun Yu: Ice Cream for the Eye . . . But with a Homo Sacer." *Journal of Chinese Cinemas* 5, no. 3 (November 2011): 219–252.

Gao, Yunxiang. "Sex, Sports, and 'National Crisis,' 1931–1945: The 'Athletic Movie Star' Li Lili (1915–2005)." *Modern Chinese Literature and Culture* 22, no. 1 (2010): 96–161.

——. *Sporting Gender: Woman Athletes and Celebrity-making During China's National Crisis, 1931–45*. Vancouver: UBC Press, 2013.

Li, Cheuk-to. "Eight Films of Sun Yu: A Gentle Discourse on a Genius." *Cineyama* 11 (1991): 53–63.

Macdonald, Sean. "Li Lili: Acting a Lively Jianmei Type." In *Chinese Film Stars*, eds. Mary Farquhar and Yingjin Zhang, 50–66. Abington, U.K.: Routledge, 2010.

Morris, Andrew D. *Marrow of the Nation: A History of Sport and Physical Culture in Republican China*. Berkeley: University of California Press, 2004.

Pickowicz, Paul G. "The Theme of Spiritual Pollution in Chinese Films of the 1930s." In *China on Film: A Century of Exploration, Confrontation, and Controversy*, 43–71. Lanham, Md.: Rowman and Littlefield, 2012.

Rea, Christopher. Chap. 8 of "A History of Laughter: Comic Culture in Early Twentieth-Century China." PhD diss., Columbia University, 2018.

FURTHER VIEWING

Beauty Parade (*Tiyu huanghou* 體育皇后). Tang Huang, director. 1961.
Footlight Parade. Lloyd Bacon, director. 1933.
The Kid From Spain. Leo McCarey, director. 1932.
Olympia. Leni Riefenstahl, director. 1938.
Playthings (*Xiao wanyi* 小玩意). Sun Yu, director. 1933.

The Red Detachment of Women (*Hongse niangzi jun* 紅色娘子軍). Xie Jin, director. 1960.

The Road to Ruin. Dorothy Davenport (credited as Mrs. Wallace Reid) and Melville Shyer, directors. 1934.

Sunrise: A Song of Two Humans. F. W. Murnau, director. 1927.

Woman Basketball Player No. 5 (*Nülan wuhao* 女籃五號). Xie Jin, director. 1957.

Goddess (*Shennü* 神女)

Alternative English title: *The Goddess*
Director/screenplay: Wu Yonggang
Studio: Lianhua (first studio)
Date of release: December 7, 1934
85 minutes, 10 reels
Cast: Ruan Lingyu, Li Keng, Zhang Zhizhi, Li Junpan

SYNOPSIS

A young woman works as a streetwalker in 1930s Shanghai to support herself and her infant son. One night, to avoid a police sweep, she runs into the room of a man who demands that she have sex with him in return for not turning her in. The man and two of his buddies later track her down to her apartment, and he moves in with her. "From then on, the Boss viewed her as his exclusive property," and he steals her earnings to support his gambling habit. She moves out to avoid him and looks for a respectable job, but fails in both attempts. Pawning jewelry to buy her son a toy, she returns to her new apartment to discover that the thuggish gambler has tracked her down. Worse, he has kidnapped her son, whom he returns only when she agrees to submit to him. Years pass, and she enrolls her son at a private elementary school. The boy thrives, but

other kids bully him and call him a "bastard." At a school talent show, one of the woman's neighbors gossips about her disreputable profession, and the parents write to the principal demanding that her son be expelled. The principal goes to her home in person to investigate, and she admits that she has been selling her body to support her son, but she demands why he should be denied an education. The principal relents and tries to persuade the school board that her son should be allowed to stay. They refuse, he resigns, and the boy is expelled. The distraught mother plans to take her son somewhere "where nobody knows who we are," but she discovers that the thug has found her secret stash of savings and gambled the money away. She strikes him over the head with a bottle, inadvertently killing him, and is sentenced to twelve years in prison. The former principal who stuck up for her son reads about the case in the newspaper and comes to visit her in prison, where he tells her that he will adopt her son and raise him personally. She requests that when her son is older, the principal tell him that his mother is dead. Alone in her cell, she sees a vision of her beaming child, but the image, and her own smile, fade.

LEGENDS OF THE FALL

Goddess (1934) is the most celebrated Chinese film of the silent era. Premiering to acclaim in Shanghai on December 7, 1934,[1] it tells the story of a young woman who sacrifices everything for her son, only to end up separated from him forever. *Goddess* is an exemplary melodrama centering on the figure of a "fallen" woman, and it captures a remarkable performance by twenty-four-year-old star Ruan Lingyu at her most radiant. Ruan joined the film industry as a teenager. On-screen, she exuded beauty, glamour, and vulnerability and was often cast the role of a suffering woman. Off-screen, her romantic relationships with two men, one a gambler, became fodder for tabloids. *Goddess* is iconic in multiple senses. It creates a compelling image of the figure of the fallen woman, and by extension of Shanghai as a corrupt metropolis,[2] and it cemented the iconography of Ruan Lingyu herself as a screen "goddess" in her prime who was to die by her own hand just a few months later. *Goddess* itself, in turn, came to be emblematic of the glamor and pathos of Shanghai cinema's first golden age.

The film's title carries a double meaning: *shennü* suggests a supernatural female (a *nüshen*), but the term in 1920s Shanghai was also a euphemism for prostitute. The virtuous prostitute was a familiar trope. One of modern China's first best sellers was the 1895 translation of Alexander Dumas fils' *La dame aux camellias* (1848), a novel about a beautiful, free-spirited, but doomed Parisian courtesan. The story was later adapted into stage plays and films, including *A Lady of Shanghai* (1925) and two called *New Camellia* (1913 and 1927). *Goddess* shares with the Dumas novel an emotional register of pathos, sympathy, condescension, and sexual titillation, all wrapped up in a rescue fantasy.

Fallen woman films, which focus on the figure of a sexually transgressive and suffering woman, were a fixture of silent cinema. They tend to share the moral premise that woman's sexuality should be confined to marriage, and to dramatize the perils of crossing that boundary. The consequences are particularly severe for the woman, who, having borne an illegitimate child or become a prostitute, suffers social ostracism, poverty, abuse, disease, even death. Some films, like *Damaged Goods* (1919), present the woman's "fall" as a result of external circumstances such as poverty or coercion, and offer a sympathetic (if often condescending) portrait of women as victims of an unfair socioeconomic order. Others, like *The Road to Ruin* (1928),[3] remade as a talkie in 1934, blame the woman for her own weakness, stupidity, wantonness, or moral degeneracy. *A Flapper's Downfall* (1927), now lost, produced by Great Wall Pictures, was likely an early Chinese contribution to the genre.[4] This didactic genre traded in sensational subject matter and often pandered to prurient interests. Many films presented themselves as unflinchingly realistic cautionary tales (for women of good family and their male protectors) while offering an eyeful. Wu Yonggang recalled in his memoir that D. W. Griffith's *Way Down East* (1920), in which Lillian Gish's character is tricked into a sham marriage and abandoned while pregnant, was a formative influence on his filmmaking.

Goddess draws on such genre conventions in its depictions of female sexual victimization, abuse, abandonment, and rescue. It puts questions of womanhood, and especially motherhood, front and center. The film opens with the word *Goddess* superimposed on an Art Deco relief of a naked woman, her hands tied behind her back, leaning forward over the figure of a naked child (figure 4.1): an image of female sexuality,

FIGURE 4.1 Relief of naked woman and child
Source: Author

vulnerability, motherhood, and protectiveness that reappears as the background of later intertitles.

The acting credits are superimposed over a photograph of goddess and son. The opening intertitle, superimposed over the Art Deco relief, offers a clear opinion about this woman's double life:

> The Goddess . . . struggling within the vortex of life . . . On the nighttime streets, she is a cheap prostitute . . . When she holds her child in her arms, she is a divine and pure mother . . . In both lives, she shows great moral character.

"Maternal melodramas" about the mother who sacrifices all for her child, had been a Hollywood staple since the 1920s. In China, they chimed with the Confucian prescription that every woman strive to be a "virtuous wife and good mother" (*xianqi liangmu*). China's National-ist government revived this conservative model of womanhood when

it launched the New Life Movement in February 1934. The movement sought to remold the Chinese body politic into healthy, hygienic, productive, and obedient citizens. Government campaigns targeted vices such as gambling and debauchery, while promoting marital monogamy, childbirth, and physical or military education for the young. Many of these elements are on display in films like *Maternal Radiance* (1933) and *Sports Queen* (1934), which shows a female track star almost falling prey to frivolous college boys, before her male coach puts her back on the path to health, sporting accomplishment, and self-sacrifice not for personal gain but for the nation.

New Life Movement policies applied to films, whose scripts had to pass a censorship board. Government representatives even showed up on the set of *Goddess*, and Wu Yonggang claimed in his memoir that he was not able to show as much of the woman's life as he would have liked. If Hollywood's obsession in the 1930s was adultery, the focus of public discussion in China was women's sexual behavior. Shanghai, the center of the print and film industries, was also the center of China's sex trade. The city had tens of thousands of prostitutes, and streetwalkers (called "wild chickens" or "pheasants") were a conspicuous presence. Government anti-vice campaigns of the 1930s—like the police sweep represented in *Goddess* (figure 4.2)—pushed many sex workers into the foreign concessions, which fell outside Chinese legal jurisdiction.

The plot of *Goddess* alludes to another long-standing model of idealized womanhood besides "virtuous wife and good mother." (Note that a husband does not enter the picture, so the woman has no chance to be a "virtuous wife.") This is the legend of "Mencius's mother," who worked against great odds to raise her son properly. Mencius's mother moved house three times (about 2,300 years ago) to keep her son away from bad influences. Thanks to her conscientious attention to his upbringing, he became a scholar and later the Confucian sage, after whom is named one of the Five Classics of Chinese moral philosophy, *The Mencius*. The mother in *Goddess* (who moves house once, almost twice) follows a pattern of repeated sacrifice: she makes a bodily sacrifice by turning to prostitution; she suffers abuse by a thug; and she suffers humiliation from persistent social stigma. Once imprisoned, she sacrifices her personal happiness by giving her son away. How should we respond to her sacrifices?

FIGURE 4.2 Police sweep
Source: Author

One answer is conveyed through the elderly principal who stands up for her son's rights and interests. He speaks directly at the camera (and audience) from a position of respectability and authority (figure 4.3): "It's true the child's mother is a streetwalker, but this is due to broader social problems. . . . Education is our responsibility, and we must rescue this child from adversity."

Still, this voice presents its own problems. Film historians have tended to view *Goddess* as presenting a conservative moral vision, with an establishment male authority figure speaking for the victimized woman and ultimately stepping in as a surrogate father to her son. The narrative leaves the patriarchal system unchanged and asserts the primacy of male agency. The father displaces the mother.[5] This film, however, is not called *Father*, but *Goddess*, and its classic status, I believe, rests less on its ideology than on its creation of an iconic image: a woman struggling amid everyday life in the city.

FIGURE 4.3 The principal lectures toward the camera
Source: Author

THE POETRY AND PATHOS OF THE URBAN EVERYDAY

Goddess has moments of melodrama but avoids histrionics. It tempers its tone by nesting images of the "goddess" within a restrained, minimalist depiction of everyday urban life.

The opening sequence figuratively zooms in, shot by shot, on the life of a woman—from the rooftops of Shanghai at nightfall, to the lighting of the streetlamps, to her window, and then into the room where we see her toiletries, her dresses hanging on the wall, and other personal belongings, including a child's doll. A dissolve finally reveals the protagonist, and the camera tilts up from a crib to show her already dressed for going out, rocking her child to sleep in her arms. She looks toward the clock, and the camera cuts to show that it is 8:45 when she puts her child in his crib. She takes a last look at herself in the mirror before asking a neighbor across the landing to keep an eye on her son.[6] She steps out the front door onto the street, and then into a rickshaw that takes her off into the night. This sequence (figure 4.4), lasting about three-and-a-half

FIGURE 4.4 Three shots from a sequence introducing a daily routine

Source: Author

minutes, takes us rapidly into her private world, cataloguing the mundane objects, spaces, and routines of one individual, as if to say: this is just an ordinary life in the city.

We next see a composite shot of the flashing neon lights of Shanghai, followed by a montage of iconic images of the streets: a passing tram car, people on a busy sidewalk in front of a window display of a mannequin in a swimsuit, and a fortune-teller. The woman then appears in front of the giant *dang* 當 sign of a pawnshop (a motif that reappears later), a juxtaposition that seems to represent visually that she is pawning herself. It is at this moment that the woman we have just met is revealed to be a streetwalker. Smoking a cigarette, she strolls back and forth waiting for a customer.

This simple scene seems to contain a hidden message. Behind the stall of "Iron Mouth Zhang" is an advertisement for Greta Garbo Brand Cigarettes.[7] Some critics would later hail Ruan, whose character is shown smoking in this scene, as a Chinese Garbo.

The following shots help to establish the personality of the man who is to have a transformative influence on her life: a large fellow in the middle of a crowd who settles an argument by slugging a man in the stomach. He and his buddies leer at her as they swagger off. She appears in two shots next to the Garbo ad, intercut with a shot of the neighbor checking on the baby (figure 4.5). She then sidles up next to a man smoking on the sidewalk; noticing her presence, he throws down his cigarette and walks away. Immediately, a bum picks it up and takes drag, just as a policeman walks up behind the two of them. The bum scrams and she saunters away and soon encounters a customer. Again, a few shots over a few minutes convey the typicality of this woman's nights: the bustle, the dangers, and the inevitable conclusion.

A new day dawns to see the goddess making her way back home. Wu Yonggang's set design again seems to contain a hidden meaning. The morning-after shot frames her between two brass plates bearing the name of the building from which she has emerged, Noble Rewards (*juelu* 爵祿), a homophone for *juelu* 絕路—dead end.

Arriving at her apartment, the unnamed woman wearily takes off her shoes and picks up her crying child. From home to work to home—these first ten minutes establish a pattern of alternating interiors and exteriors, private and public spheres. In a close-up, the woman looks up and off-screen right, and then a cut shows a Shanghai neon nightscape,

FIGURE 4.5 The "Chinese Garbo" next to an ad for Garbo Cigarettes
Source: Author

as if the city is appearing before her eyes for a brief flickering moment. A cut takes us back to the streets where the police, in another rapid montage, are conducting a sweep, for what we do not know. The woman, now wearing a white dress, abruptly appears—her costume signaling a time jump between shots (an ellipsis)—and the police chase becomes personal. The woman runs past that same mannequin in the window and into the room of the wrong man.

The next scene shifts to the perspective of the thug, who takes a break from a gambling session to look out the window. His eyes widen and he breaks into a grin. The Shanghai nightscape shown before reappears, but what makes him smile is a vision of the goddess, smiling and radiant over the city of night (figure 4.6). The matte image, made using the same double-exposure technique used in *Laborer's Love* (1922), juxtaposes city and woman. Seen through the eyes of this lustful man, the city itself is personified as a sexually inviting woman who is out there and available.

FIGURE 4.6 Woman and city of night beckon
Source: Author

The film repeats motifs to different emotional or psychological effect. We were first introduced to our heroine through shots showing her belongings.[8] When the thug appears in her first apartment, we see him first in the mirror. In the second apartment, his entrance is again communicated indirectly through an object: a shot shows his hat and quickly pans right over to where "the Boss" stands staring at her and rocking in place menacingly.

The man is often framed, as he is here, from a low angle in medium close-up, which emphasizes his larger-than-life presence. He literally takes up more of the screen space. Once her son is returned to her arms, she picks up the new toy she had dropped on the floor only to discover that it is broken.[9] She looks up at the thug, and the camera cuts to a shot of the mother crouching with her child framed between the man's legs (figure 4.7).[10] Like the legendary Monkey King turning somersaults, she will never, he tells her, escape from the palm of his hand.

FIGURE 4.7 Framing male domination
Source: Author

An intertitle signals that a few years have passed. The son, now a boy, is first seen playing guess fingers with children on the street.[11] An old woman hollers down from the window: "How many times have I told you you're not to play with that bastard anymore?" In fact, the negative influence flows in the opposite direction: the big boys are teaching the little kid how to gamble. Back home, the camera shows his mother as a picture of domesticity (figure 4.8). She makes him a healthy meal, watches him eat, and rocks him to sleep. Interspersed shots of the same Shanghai nightscape and a clock show the pressures of her nocturnal work intruding on the domestic scene.

After she finds a hiding place for her money, an intertitle moves us to the next sequence of narrative, which has the boy beginning primary school. One day, her son comes home and demonstrates for her the calisthenics the teachers taught him and then orders his mother to do the exercises while he counts out loud. This plot element responds to the

FIGURE 4.8 The domestic goddess
Source: Author

New Life Movement, which encouraged people to be healthy citizens (see chapter 3). The next scene is of a big boy on the schoolyard encouraging his classmates to pelt the little kid with the epithet "bastard." (The "bastard" is shown to be an attentive and enthusiastic student who listens respectfully in the front row and bows to the principal, while the bully plays with things under the desk and ignores the lesson.) The point is clear: however healthy a citizen may want to be, he or she can still be harmed by prejudiced people in society.

Editing is brisk. Sometimes a shot of only a few seconds, like the overhead shot of the woman picking up a new client on the street, transitions between scenes. Shots of Shanghai's neon nightscape, inserted into scenes set in the woman's apartment, repeatedly contrast the vast, opaque city with the proximate and concrete image of one struggling individual. The alternation of interior and exterior scenes mimics the goddess's double life.

The editing of the school talent show scene brings together the atomized narrative of the woman and her child and a broader narrative of social intolerance. Shots of the stage alternate with shots of the audience reaction, especially the woman's beaming face, conveying a sense of harmony and unity between performer and audience. This breaks down when her neighbor starts gossiping to the others about her profession; the cuts then seem to contrast the innocence of the children with the depravity of the judgmental adults.

Dissolves, a type of soft edit also used extensively by filmmakers Fei Mu and Zheng Junli, create a sense of dynamism within a single scene and between scenes. At the climactic moment when the woman hits the thug over the head, through the consequences that follow, a series of dissolves convey the goddess's disorientation, from delivering the fatal blow through to her court sentencing to her arrival in jail, while speeding the narrative toward its conclusion.

Strong side lighting, especially in the woman's apartment, captures every facial contour and change of expression, heightening the emotional intensity of her exchanges with the thug, the principal, and her son. Much of her emotional appeal to the principal is shown in frontal shots, so that she looks into our eyes as she asks, "Why doesn't my child deserve to go to school?" The principal, reporting back on the results of his investigation, gives us an explicit answer: "This is the result of a broader social problem. We can't fault her moral character, much less her child's." "As responsible educators, it behooves us all the more to save this mother's child from a bad environment." The theme echoes Confucius, who in chapter 15 of the *Analects*, called for "education without discrimination" (*youjiao wulei*). The principal's rational and measured lecture to his skeptical colleagues is also shot head-on, creating a visual parallel between the marginalized woman and the male authority figure.

After her son is thrown out of school, we see the pair of them at home looking off-screen, and a cut shows the Shanghai nightscape—it is mother and son against the city. Discovering her money gone from its hiding place, she steps outside, walking purposefully toward the camera. Superimposed images of neon lights seem to recede before her. When she confronts the thug, close-up shots show her determination, defiance, and contempt.

Goddess is far from unique in dramatizing the lives of society's unfortunates. In showing how the other half lives, films like *Daybreak* and *Playthings* purport to reveal society's hypocrisies and cruelties, while appealing to viewers' better natures. One key difference between *Goddess* and *New Women*, with which it is often compared, is *Goddess*'s aesthetic of restraint. We never learn the names of the characters, and Wu Yonggang leaves their backstories to our imagination.

The set, which Wu himself designed on a modest budget, shows the simplicity of the goddess's living quarters: a bed, a table, a few chairs, a hot water bottle, a couple of dresses, and a few other possessions are all she has. When the fat, towering man is in the room with her, the interior space becomes claustrophobic. Set design, like characterization, is stripped down to bare iconography: this is a space in which four nameless people—a woman, her child, a male oppressor, and a male savior—act out an elemental moral drama.

FIGURE 4.9 The aura of the gaze
Source: Author

The ending offers little comfort. The woman is incarcerated, and her vision of her smiling child fades like an ephemeral illusion. I would suspect, however, that for most viewers it is not the ending that sticks with us. Society, in this film, is a foil to the goddess herself: we see her interact with neighbors, men on the street, parents, authority figures, her child—and we see her, a few times, look directly at us. In most of her close-ups, however, she looks away (figure 4.9)—to the future, to the world outside, or to beseech the heavens. In the end, the Goddess is alluring, perhaps because her image is before us, but her gaze eludes us and remains her own.

NOTES

1. The film premiered at Shanghai's Lyric Theater (Jincheng da xiyuan). Shi Gu 石谷, "Guanyu *Shennü*" 關於神女 (About *Goddess*), *Shibao*, December 6, 1934, 8.

2. *Shanghai Express* (1932) includes two sex workers, one Chinese (played by Anna May Wong) and one British (played by Marlene Dietrich), the latter of whom now goes by "Shanghai Lily," and who blames her degeneration on the place: "Five years in China is a long time." Lily Wong, *Transpacific Attachments: Sex Work, Media Networks, and Affective Histories of Chineseness* (New York: Columbia University Press, 2018), 56.

3. *The Road to Ruin* premiered at Shanghai's Pantheon Theater on April 20, 1929. See advertisements in that day's issue of *The China Press* (p. 7) and *Xinwen bao* (p. 8).

4. Great Wall (Changcheng) was founded in Brooklyn and moved to Shanghai in 1924. An ad for *A Flapper's Downfall* is reprinted in Paul Fonoroff, *Chinese Movie Magazines: From Charlie Chaplin to Chairman Mao, 1921–1951* (Oakland: University of California Press, 2018), 18.

5. A similar displacement ends *Love and Duty* (1931), in which Ruan also plays a sexually transgressive, self-sacrificing mother. After her suicide, a shot of her three bereft children in front of her portrait calling "Ma! Ma! Ma!" cuts away to linger on the tearful face of her estranged husband.

6. Notice the continuity editing error in this sequence of shots: she has her pearls on while holding her child, then puts them on again while looking in the mirror.

7. As of this writing, the website kongfz.com displays photographs of a pair of Republican-era metal cigarette tins showing a profile of a Western woman on the side, and on the bottom the English word "Garbor" [*sic*] in relief along with

the Chinese brand name, *Jiabao pai xiangyan* 嘉寶牌香菸, which uses the same characters used for Greta Garbo's name.

8. The dresses on the wall later reappear as evidence of her profession when the principal, having received letters of complaint from parents, does a home inspection.

9. The motif of the vulnerable toy had appeared in *Playthings* (1933) and would reappear in *New Women* (1935), both starring Ruan Lingyu. A broken toy appears in George Abbot's *The Cheat* (1931), in which a predatory man (with Orientalist proclivities) keeps a cabinet of dolls representing his female sexual conquests. When a woman refuses him, he smashes the doll on the floor. *The Cheat* screened in Hong Kong in 1932. Paul Fonoroff, *Chinese Movie Magazines*, 110.

10. A similar shot is used in Ma-Xu Weibang's *Begonia* (1943) to signify male–male predation. A low shot shows a row of opera students framed by the legs of a warlord, who is visiting their school to single out the young male performer of female roles whom he hopes to "befriend." The *Begonia* premise, novelized by Lillian Lee (Li Bihua) in 1985, inspired a similar exploitation plotline in Chen Kaige's *Farewell, My Concubine* (1993).

11. Actor Lai Hang (Li Keng), son of filmmaker Lai Man-wai (Li Minwei) and actress Lim Cho Cho (Lin Chuchu), appeared (often alongside his mother) in many Lianhua productions of the 1930s, including *Sports Queen* (1934) and *Song of China* (1935).

SOURCES/FURTHER READING

Campbell, Russell. " 'Fallen Woman' Prostitute Narratives in the Cinema." *Screening the Past*, uploaded November 12, 1999. https://web.archive.org/web/20110308080040 /http://www.latrobe.edu.au/screeningthepast/firstrelease/fr1199/rcfr8b.htm.

——. *Marked Women: Prostitutes and Prostitution in the Cinema*. Madison: University of Wisconsin Press, 2006.

Cavell, Stanley. *Contesting Tears: The Hollywood Melodrama of the Unknown Woman*. Chicago: University of Chicago Press, 1997.

Hansen, Miriam Bratu. "Fallen Women, Rising Stars, New Horizons: Shanghai Silent Films as Vernacular Modernism." *Film Quarterly* 54, no. 1 (Fall 2000): 10–22.

Harris, Kristine. "*The Goddess*: Fallen Woman of Shanghai." In *Chinese Films in Focus: 25 New Takes*, ed. Chris Berry, 111–119. London: British Film Institute Publishing, 2003.

Henriot, Christian. *Prostitution and Sexuality in Shanghai: A Social History, 1849–1949*. Trans. Noël Castelino. Cambridge: Cambridge University Press, 2001.

Hershatter, Gail. *Dangerous Pleasures: Prostitution and Modernity in Twentieth-Century Shanghai*. Berkeley: University of California Press, 1999.

Hjort, Mette. "Ruan Lingyu: Reflections on an Individual Performance Style." In *Chinese Film Stars*, eds. Mary Farquhar and Yingjin Zhang, 32–49. Abington, U.K.: Routledge, 2010.

Jacobs, Lea. *The Wages of Sin: Censorship and the Fallen Woman Film, 1928–1942*. Madison: University of Wisconsin Press, 1991.

Meyer, Richard J. *Ruan Lingyu: The Goddess of Shanghai*. Hong Kong: Hong Kong University Press, 2005.

Pang, Laikwan. "Women's Stories On-screen versus Off-screen." In *Building a New China in Cinema: The Chinese Left-Wing Cinema Movement, 1932–1937*, 113–137. New York: Rowman and Littlefield, 2002.

Reynaud, Bérénice. "*Centre Stage*: A Shadow in Reverse." In *Chinese Films in Focus II*, ed. Chris Berry, 48–55. London: British Film Institute/Palgrave Macmillan, 2008.

——. "The 'New Woman' Question in Chinese Cinema." In *Electric Shadows: A Century of Chinese Cinema*, ed. James Bell, 94–101. London: British Film Institute, 2014.

Rothman, William. "*The Goddess*: Reflections on Melodrama East and West." In *Melodrama and Asian Cinema*, ed. Wimal Dissanayake, 59–72. Cambridge: Cambridge University Press, 1993.

Wang, Yiman. "*The Goddess*: Tracking the 'Unknown Woman' from Hollywood through Shanghai to Hong Kong." In *Remaking Chinese Cinema Through the Prism of Shanghai, Hong Kong, and Hollywood*, 18–47. Honolulu: University of Hawai'i Press, 2013.

Wong, Lily. "Over My Dead Body: Melodramatic Crossings of Anna May Wong and Ruan Lingyu." In *Transpacific Attachments: Sex Work, Media Networks, and Affective Histories of Chineseness*, 48–76. New York: Columbia University Press, 2018.

Wu Yonggang. *Wode tansuo yu zhuiqiu* [My explorations and pursuits]. Beijing: Zhongguo dianying chubanshe, 1986.

Xiao, Zhiwei. "Wu Yonggang and the Ambivalence in the Chinese Experience of Modernity: A Study of His Three Films of the Mid-1930s." *Asian Cinema* 9, no. 2 (Spring 1998): 3–15.

Zhang, Yingjin. "Prostitution and Urban Imagination: Negotiating the Public and the Private in Chinese Films of the 1930s." In *Cinema and Urban Culture in Shanghai, 1922–1943*, ed. Yingjin Zhang, 160–180. Stanford, Calif.: Stanford University Press, 1999.

FURTHER VIEWING

The Cheat. George Abbott, director. 1931.

New Women (Xin nüxing 新女性). Cai Chusheng, director. 1935.

The Road to Ruin. Norton S. Parker, director. 1928.

The Road to Ruin. Dorothy Davenport (credited as Mrs. Wallace Reid) and Melville Shyer, directors. 1934.

Stella Dallas. Henry King, director. 1925.

Waves Wash Over the Sand (*Lang taosha* 浪淘沙). Wu Yonggang, director. 1936.

Way Down East. David W. Griffith, director. 1920.

The Great Road (Dalu 大路)

Alternative English titles: *The Big Road, The Highway*
Director/screenplay: Sun Yu
Studio: Lianhua (second studio)
Date of release: January 1, 1935
103 minutes, 10 reels, dubbed sound
Music: Nie Er
Cast: Jin Yan, Chen Yanyan, Li Lili, Zhang Yi, Zheng Junli, Luo Peng, Han Langen, Zhang Zhizhi, Shang Guanwu, Liu Qiong, Liu Jiqun, Hong Jingling

SYNOPSIS

Big Brother Jin, a strapping man in his twenties, is the leader of a team of road workers in the 1930s. Both of his parents died of exhaustion on the road when he was young: his mother while the family was fleeing their village, his father ten years later due to overwork on a road crew. Jin and his buddies are laid off for fighting on the job in Shanghai and resolve to build new public roads for China in the interior. They spend several years crisscrossing the country doing national construction. At a roadside restaurant they befriend Jasmine and Orchid, two attractive and vivacious young women who support their endeavor. They joke

around, flirt, sing for each other, share meals and picnics, and generally enjoy each other's company. The road crew's efforts are interrupted, however, by the local strongman, Deputy Hu, who is secretly colluding with "the enemy." Hu has designs on Orchid, who is in love with one of the workers, Xiao Luo, and also on Orchid's self-appointed big sister, Jasmine. Then Chinese soldiers arrive and announce that the enemy is on the move and that the roadbuilding must accelerate so that the army can get through to the front. Ordered by an enemy agent to sabotage progress, Hu invites Jin and his male comrades to a banquet at his mansion and attempts to bribe them to stop work. When they reject him, he throws them into his dungeon and has them tortured. Jasmine and Orchid, whom Hu has invited to his mansion, pretend to be friendly and get him drunk. On the pretext of going to the kitchen to cook him a special dish, they locate the dungeon and throw a pair of scissors down to Jin, who frees himself and the others, one of whom dies during the escape. While Jasmine keeps Hu occupied, Orchid goes out and raises the alarm. The army arrives and arrests Hu, accepting evidence of his treachery gathered by Jasmine. The freed workers and Jasmine build the road to completion, only to be strafed by enemy planes. They die on the finished road, and the army drives off to battle. Orchid, looking out over the corpses, envisions the spirits of the dead workers rising up and singing as they resume their roadbuilding work.

ROADWORK (AND PLAY) AHEAD

The Great Road is one of the more unusual Chinese films of the 1930s, and one of the sexiest. Director Sun Yu called it his "representative work" and described it as an anti-imperialist expression of "revolutionary romanticism."[1] These descriptions, however, fail to capture the complexity and appeal of a genre-defying film that also includes songs, slapstick comedy, and full frontal male nudity.

Shortly after the People's Liberation Army entered Shanghai in May 1949, *Chin-Chin Screen* magazine reported that Sun Yu planned to write and direct for Kunlun Studio a new version of his "famous film." *The New Great Road*, it said, would depict the people's enthusiastic support of the PLA crossing the Yangtze River.[2] Sun Yu does not mention this project in his memoir, and the film apparently was never produced.

The Great Road was shot as a silent film but designed with a soundtrack. It begins with a song. In a prologue, a shirtless, strapping young man at the head of a group of road workers walks up to the camera and begins to sing (figure 5.1)

Bang bang bang!
Ha ha ha ha! Bang!
We are the roadbuilding pioneers!

Over montage of landscape images, interspersed with shots of the singing road workers, lyrics appear the bottom of the screen. Without a road, people cannot get through; so if mountains stand in the way, they will blow them up. Song and image present happy—even exultant—collective labor. Lyrics reinforce the image of honest work for the nation. But "Roadbuilding Pioneers" and the film's three other songs, "The Song of the Great Road," "New Song of Fengyang," and "Yanyan's Song," are also there to mobilize consumers. They were released as a Pathé phonograph album (which Sun says sold well[3]) to coincide with *The Great*

FIGURE 5.1 "Roadbuilding Pioneers"
Source: Author

Road's premiere on January 1, 1935—an integration of cinema and gramophone culture later perfected with films like *Street Angels* (1937).

The mood of the next scene is much bleaker: Jin's parents are seen in extreme long shot, carrying their infant child across a barren wasteland in an attempt to escape the famine in their village.[4] Father says that they would never have left if he had known how hard the road was; mother replies that to turn back would mean death. She dies anyway and her husband buries her by hand. Two narrative ellipses bring us forward three years, to Jin's father holding his son while working on a road crew, then ten years, when he collapses on the job, and finally twenty years later, when Jin himself pulls the road-flattening wheel. Despite their heavy labor, he and his companion, Xiao Luo, smile as they trudge along. They spot a mechanical steamroller driving by, and Xiao Luo utters a line that turns out to be prophetic: "Big Brother Jin, if I could drive a mechanical steamroller one day, I would die without regrets!"

Jin Yan, the male lead, was born in Korea and raised in China, and was one of the most popular leading men of the 1930s Chinese screen. Male protagonists in 1920s films tended to be cultured and effeminate; Jin Yan and Gao Zhanfei (of *Daybreak* [1933] and *Orchid of the Empty Valley* [1934]) represented a new ideal of athletic, working-class manliness and sexiness.[5] The press likened Jin to Rudolph Valentino, heartthrob star of *The Four Horsemen of the Apocalypse* (1921) and *The Sheik* (1921).

Big Brother Jin (Jin Ge) refers to the actor's actual name, as do the names of several other characters: Zhang Yu is played by Zhang Yi; Zheng Jun is played by Zheng Junli; Luo Ming (aka Xiao Luo) is played by Luo Peng; Little Han the Sixth is played by Han Langen; Big Zhang is played by Zhang Zhizhi (different character, same pronunciation); Liu Zhang is played by Liu Qiong; and Hong Jin is played by Hong Jingling. Moli (Jasmine) shares the same "li" in the given name of Li Lili; and Chen Yanyan, as Orchid, sings to Xiao Luo a love song about flying and twittering swallows (*yan*).[6]

Chin-Chin Screen magazine cited *The Great Road* as an example of Chinese filmmakers copying the "all the cast" method of Hollywood films like *Dinner at Eight* (1933).[7] Lianhua publicity presented the cast as a menagerie (figure 5.2): Jin Yan as dragon, Chen Yanyan as sparrow, Li Lili as parrot, Zheng Junli as tiger, Zhang Yi as lion, Luo Peng as

FIGURE 5.2 *The Great Road* zoo
Source: Lianhua huabao (*UPS Pictorial*) 5, no. 1 (January 1, 1935), inside back cover. Courtesy of the C. V. Starr East Asian Library, University of California, Berkeley

leopard, Liu Jiqun as badger, Han Langen as monkey, Hong Jingling as fox, Shang Guanwu (who plays Mr. Hu) as giraffe (for *pan* 攀, suggesting both social-climbing, *gaopan* 高攀, and philandering, *panzhe* 攀折), and Zhang Zhizhi as elephant.[8]

The first roadwork scenes introduce members of the ensemble one by one, including the heroic Jin, his idealistic buddy Xiao Luo, the pessimist Zhang Yu, and the boorish Big Zhang. Zhang Zhizhi, who plays Big Zhang, was often typecast as the lustful bully, most notably as the "Boss" in *Goddess* (1934). Here, his character is introduced throwing rocks from the back of a truck at two young women. Zheng Jun reprimands him for "messing around" (*hu nao*) which, "will give people a headache when they see a worker." Zheng further predicts that a ruffian will end up a "slave of a vanquished country" (*wang guo nu*)—an epithet for people seen as contributing to their country's subjugation to foreign powers. In this case, "messing around" leads to a fight, and to five of them losing their jobs. But the mood of the men is generally upbeat: even when unemployed they still kid around, their running gag being a morale-boosting face wipe-and-chin punch, complete with sound effect.

After Jin and his buddies are laid off, they look for new work in a village filled with storytellers, peddlers, vendors, blacksmith, and other working-class people as well as unfortunates like Little Han the Sixth, who is caught trying to steal food. Jin intervenes to save the starving man. Unable to find work, Jin calls for all the able-bodied people to head to "the interior" to build a "public road" (*gong lu*). Dozens heed his call and they set off the next morning. An animated map shows roads stretching as far west as Ningxia and then crisscrossing populated eastern provinces such as Zhejiang and as far south as Guangdong. Where this hard-working team gets the resources to carry out these years of roadbuilding is never explained.

"The Song of the Great Road" serves as a sound bridge leading into a new part of the narrative, which introduces Orchid (Ding Xiang) and Jasmine (Moli), working in the kitchen of a restaurant near the roadwork site. Orchid tosses flour and water onto the dough, as she rolls a rolling pin to the rhythm of the men's unison singing outside. Jasmine teases Orchid for spacing out while listening to the singing of her beau, Xiao Luo, and Orchid responds by waving a rolling pin at her and

saying: "Jasmine, you're so bad! I'll tell Daddy to send you back home to be a flower-drum singer again!"

Jasmine is played by Li Lili, whom the Chinese press nicknamed "Sweet Big Sister." Li was known for her healthy, athletic persona and her winning smile. Pictorial magazines promoted Li as a modern beauty with an outgoing personality and robust physicality. She had recently starred in *Sports Queen* (1934) as a champion runner who learns about the true athletic spirit (see chapter 3). As Jasmine, she is a playful, mischievous, and optimistic leader of this ensemble of road builders.

Li Lili's first scene establishes Jasmine as expressive, flirtatious, sexy, and dominant. After the banter about Xiao Luo, Orchid throws an ear of corn, and Jasmine pulls off the tassel and uses it as a moustache, smiling and mugging for the camera. When Orchid's father, the restaurant proprietor, Old Ding, appears, Jasmine puts the corn husk on his head, reemphasizing her mischievous personality. The phallic rolling pin, the moustache, and the capping of the boss suggest that her vigor is even masculine (figure 5.3).

Back out on the road, Jin is again pulled into the role of mediator when the foreman threatens to beat a worker for slacking, and drag him off to face the local tyrant, Deputy Hu.[9] In this archetypical scene of the powerful bullying the weak, Jin's powerful physique, as well as the superior numbers of the road workers, gives the foreman pause. The barely restrained mob, seething with indignation and on the cusp of thrashing an oppressor, was to become a stock scenario in films of the Mao era. Hu and his henchman, looking on, take note of the potential troublemaker and the two young women.

A carnivalesque scene shows the restaurant at lunchtime, filled with workers bantering with the young women. A mix of close-ups, long shots, tracking shots, and reaction shots conveys a sense of high spirits and ebullient conviviality. Romance is subordinated into general mirth. Xiao Luo asks Orchid for tea, but Jasmine redirects the energy from the pair to the ensemble. Intercepting the cup, Jasmine sets off a scrum when she has Orchid sip tea and then declares it "sweet." The scene establishes Orchid as an object of desire and Jasmine as the ringmaster of this rollicking circus. The broken teacup, reconstituted by many hands, is an image of fractured unity, anticipating the film's mind-over-matter ending (figure 5.4).

FIGURE 5.3 Orchid and Jasmine banter with rolling pin and corn
Source: Author

FIGURE 5.4 Orchid and Jasmine sweeten the tea
Source: Author

Jasmine sings a ballad to entertain the workers, stepping in for Orchid, whom the men have been teasing for being sweet on Xiao Luo. The atmosphere leading up to this moment has been one of unbridled comedy. Jasmine used to sing for her supper, a past Jin alludes to when he says "You're so ferocious! . . . You're a flower-drum singer who has seen a lot of the world (*pao bian jianghu*)—sing!" The request seems abrupt, as if Jin is forcing Jasmine back into an old role she has left behind, but she takes it in stride: she will sing so long as her friends make the music.

"New Song of Fengyang" tells a grim tale in the voice of an itinerant singer: The arrival of a new ruler brings famine and suffering to the common people, who sell their children. Neglected levees break, and innumerable people "end up in the bellies of fishes." Fengyang flower-drum singing is a performing art dating back to the Ming dynasty and associated with a region of Anhui Province often flooded by the Yellow River. Shots of the restaurant, where Jasmine sings, her friends drum, and others listen, alternate with montages of the devastation she sings of: refugees, flooded residences, rampaging soldiers, and lurching tanks. (Several shots are reused from 1933's *Playthings*.) The shots of inundated villages and farmland are likely documentary footage from the 1931 Yangtze and Huai River floods, which devastated central China and killed between four hundred thousand and four million people.[10]

A similar sequence occurs in *Street Angels*, in which a songstress sings a ballad of hardship that caused her to flee her hometown. "Song of the Four Seasons" pairs images of armed conflict with the plaintive tale of the singer. (Li Lili would play a singer-dancer exiled from Manchuria in the Hong Kong wartime production *Orphan Island Paradise* [1939].) Yet unlike Xiao Hong, who pouts her way through her numbers, Jasmine smiles while singing her tale of woe; and whereas Xiao Hong (who has her own big sister) is portrayed as girlish and vulnerable to male predators, Jasmine is a fierce protector of her "little sister" Orchid. The stage persona of the smiling songstress continues after the song when she puts on her best smile for Deputy Hu's henchman, Hong, only to make faces behind his back. Her smile later proves to be the undoing of Hong's master.

Hong arrives at the restaurant just as Jasmine sings lines that bring the story up to the present: "Before, warlords fought over the

land / Now come midget devils, bayonets in hand." "Midget devils" was a common slur for the Japanese invaders, and the identity of "the enemy" is later underscored in the scene of Hu meeting an agent, with an interpreter present.

Jasmine is characterized as a figure who controls desires: she is desirable to comrades and predators alike; she protects the innocent Orchid from those who covet her; and she projects her own desires. This is evident in two eye-catching sequences following the restaurant scene. Jasmine watches Orchid attempting to perm her hair (and singeing her ear in the process) and teases her about her romance. Jasmine then picks her up and carries her around, collapsing into an embrace in a chair. Orchid asks Jasmine to whisper to her which man she loves the most, and Jasmine replies: "Why whisper? I want to shout it out: I love them all!" As they cuddle up (figure 5.5), Jasmine explains what she loves about each man, each of whom is shown in medium close-up. Her answers sublimate individual romantic love to love of the collective. But

FIGURE 5.5 Cuddles and love talk
Source: Author

throughout the recital, the two women's bantering physical contact is homosocial bordering on homoerotic: Orchid keeps her hand on Jasmine's breast and nuzzles her nose against her cheek as Jasmine rocks her on her lap.

In the next scene, Jasmine and Orchid deliver lunch to the group of men, only to find them bathing and playing in the river, naked. Looking down from the bluff, Orchid quickly looks away, but Jasmine, her eyes alive with the humor of the moment, hollers to them (figure 5.6). The men react with alarm, jumping off the rocks and into the water and beg the women to leave.[11] In contrast to the embarrassed Orchid, Jasmine finds the whole scene hilarious and cannot tear her eyes away. When the men come out of the water naked, it is the usually passive Orchid who has to drag off the reluctant Jasmine.

The snack they share also alludes to erotic desire. The two women deliver two watermelons, and the two manliest men—Jin and Zhang Yu—break them open. To "split the melon," as mentioned in chapter 1, is a metaphor for taking a woman's virginity. Following a scene in which Jasmine has said that she loves all of the men, the riverside ogling and the melon orgy seem like instant gratification. The risqué joke, however, is presented in an atmosphere of good, clean fun.

CENSORS, GHOSTS, AND MARTYRS OF THE NATION

For all its playfulness, *The Great Road* took political risks in a new era of censorship. The Shanghai Board of Film and Theater Censors was founded in 1928 and the Ministry of the Interior promulgated Thirteen Regulations on Film, which went into effect (though with uneven enforcement) in 1929; these were supplanted in 1930 by a new set of sixteen regulations. The Film Censorship Statute, China's first film censorship law, went into effect in November 1930.

Zhiwei Xiao notes that the law specifically prohibited "showing the unclothed human body below the breasts and above the thigh"—a standard that *The Great Road* does not comply with—but was soon revised to allow censors more flexibility. Female nudity virtually disappeared from Chinese screens in the 1930s. In contrast, "according to one estimate [from 1932], prior to 1931 there had been ten Chinese made films with scenes of female nudity" and many more foreign ones.[12] Regulations also

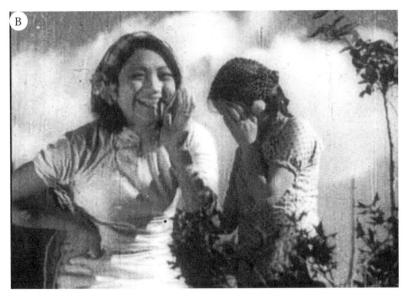

FIGURE 5.6 Watching the bathers
Source: Author

prohibited films from depicting ghosts and other superstitious beliefs and practices.

Censors' main concern was politics. An idealized image of collective labor could be interpreted as espousing communism, which both the Nationalist government and the Japanese occupiers saw as a threat. Whereas Lianhua's recent hit musical *Song of the Fishermen* (1934) focused on class suffering,[13] *The Great Road* represents military affairs. As in *Hua Mu Lan* (1939), the mix of genre elements (like songs and action) and coded dialogue represents an effort to entertain and make a political statement while avoiding censorship.

Lianhua publicized a filmmaking agenda of enlightening and educating the people, resisting foreign economic invasion, and "championing the virtues embedded in our national culture." Supernatural ghost films were out. Sun Yu, who had trained in drama at University of Madison–Wisconsin and taken classes in cinematography, film editing, and screenwriting at the New York Institute of Photography, directed a dozen films for Lianhua between 1930 and 1937. *Daybreak*, starring Li Lili, another film that pushed political boundaries, appeared on the black list of the Anti-Communist League, notwithstanding its endorsement of the Northern Expedition.[14]

In the first scene of Jin working alongside his comrades, he kids around with the happy Xiao Luo on his right and then asks the perennially straight-faced Old Zhang on his left: "If you're gloomy all day will we be able to recover lost territory?" The phrase *shou fu shi di* appeared in headlines in the 1930s to refer to the land that Japan had annexed. Jin—the man in the middle—appears as an allegorical unifier whose purpose is to bolster the morale of optimist and pessimist alike. Left-wing critics nevertheless criticized the depiction of singing, playful workers as unrealistic.[15]

A major change in mood comes immediately after Orchid's nighttime serenade of Xiao Luo, a set-piece musical interlude showcasing "little bird" Chen Yanyan.[16] From an atmosphere of fun, the narrative shifts abruptly to wartime action. An army officer rides up and announces that soldiers of "the enemy nation" (*di guo*) have landed in China and begun an attack. Big Zhang asks why they would do so, as "the enemy nation has already gobbled up such a large piece of territory"—a clear

reference to Manchuria. Xiao Luo responds that the enemy is "insatiable." Later shots of airplanes overhead are just dark shadows with no insignia, but Chinese audiences in 1934 would have been clear that the unnamed enemy was Japan.

In 1937, the government of the Japanese puppet state Manchukuo would launch the Manchurian Motion Picture Association to compete with the Shanghai-based Chinese film industry, boasting a large production budget, state-of-the-art equipment, and its own fanzines. An editorial in *Manchurian Film* singled out *The Great Road* as an example of the type of communist-sympathizing film that the Manchukuo productions would counter.[17] Perhaps they noticed the thematic resemblance to the Long March, a military retreat from the Nationalist army that the Chinese Communist Party began in Jiangxi Province in October 1934 and that continued for more than 6,000 miles, along various routes, until October 1935. Sun Yu conceived and shot most of his film before the Long March began, but the theme of martyrdom on a new, self-made road resonates.

The action sequences in the latter half of the film are decidedly pulpy, involving dungeon torture, a daring rescue, a torch-wielding mob, stage blood, and a novelty weapon. Jasmine's skills as a songstress/counterespionage agent come into full play in the tiger's lair. She takes Orchid to infiltrate Hu's place and get him drunk, first on their smiles, then on wine.[18] When a serving girl refuses to take them down to the dungeon, Jasmine threatens to cut her throat with a pair of scissors. Jasmine's status as the wonder woman of action is confirmed when she throws the scissors down to Jin and then ties up the serving girl with her own pants sash.

In this fantasy, a working girl raises the alarm, the masses are moved to action, and the army sees justice done. Jasmine not only manages to trap the "traitor to the nation" (*mai guo zei*), but also to produce the check he received as evidence of his treachery. Similar scenes of dungeon torture, infiltration of the bad guy's lair, and the public indignation of the oppressed held in check only by the authority of the army or the state reappear in later Communist films such as *The White-Haired Girl* (1950) and *The Red Detachment of Women* (1960). What disappears is the crosscurrent of humor we see in Jasmine's mischievous smile or Zhang Yu's dying gesture of a face swipe.

In the final sequence, Jasmine pulls ropes alongside the men, singing as they get the road back on track. Xiao Luo, fulfilling his dream, rides a mechanical steamroller. What might have been a conventional dénouement takes a surprising turn in the last five minutes of the film, when the roadbuilding party is suddenly strafed by an enemy airplane. A rapid montage of low-angle shots of the airplanes, extreme close-ups of victims' eyes and mouths, point-of-view shots from the airplane, and long shots of the carnage represent the deadly attack in just a few seconds. Jin, lying wounded among his dead or dying colleagues, manages to shoot down the enemy plane with a rifle. He crawls over to Jasmine and, for the first time, just as they die, holds her hand.

Old Ding, looking on, laments their death, but Orchid replies, "No, they're not dead!" and a vision appears. Superimposition shows the souls of the dead workers rising up from their corpses and proceeding with their roadwork, with Xiao Luo driving a ghost steamroller (figure 5.7),

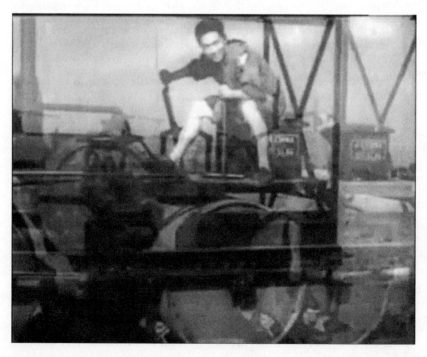

FIGURE 5.7 The ghost steamroller
Source: Author

singing "Soon we will complete the great road to freedom!" Though individuals may be killed, the spirit of collective work for the nation will continue on.

The patriotic message, however, is somewhat eclipsed by the novelty image. As in *Laborer's Love* (1922), the cinema of attractions interrupts the narrative. The resurrection sequence is also inconsistent with Lianhua's stated opposition to ghost films. *The Great Road* creates a new type of ghost: the undying collective spirit of national construction. Dominating the final shot is yet another type of specter that breaks through the diegesis—the giant, superimposed face of rising star Chen Yanyan.

NOTES

1. Sun Yu, *Yinhai fanzhou: Huiyi wode yisheng* [A boat drifting on the seas of cinema: a memoir] (Shanghai: Shanghai wenyi chubanshe, 1987), 75, 106.

2. "At the same time [as it is resuming production of *Crows and Sparrows*], Kunlun is preparing to welcome the new situation by developing new works. Filming is to begin on *The New Great Road*. *The Great Road* is a famous film from over a decade ago that represents the creativity of the working people and received wide acclaim. Now, its screenwriter-director, Sun Yu, is preparing to shoot an adapted version whose content will relate to the People's Liberation Army's fording of the Yangtze River and show how the working people enthusiastically aided their war effort. The flower-drum song about Fengyang from the original film is to be adapted into the waist-drum dances and rice-sprout songs of welcome common in the Liberated Areas." "Sun Yu choubei daoyan *Xin de dalu* yingpian 孫瑜籌備導演《新的大路》影片 [Sun Yu preparing to direct film *The New Great Road*], *Qingqing dianying* (*Chin-Chin Screen*) 17, no. 15 (July 10, 1949), 18. A notice also appears in *Dagongbao* (June 26, 1949), 3.

3. Sun Yu, *Yinhai fanzhou*, 124. Two intertexts confirm the soundtrack's popularity. A line from "Roadbuilding Pioneers" appears around minute 33 in Yuan Muzhi's *City Scenes* (1935), produced by the new studio Denton; the omnibus film *Lianhua Symphony* (1937) is framed with a chorus of studio personnel singing "The Song of the Great Road" and "Roadbuilding Pioneers."

4. Similar images of vulnerable humans in a barren landscape also appear in the Russian film *Storm Over Asia* (1928) and *Waves Wash Over the Sand* (1936), in which a criminal (Jin Yan) and a policeman (Zhang Zhizhi) are stranded together on a desert island.

5. Zhiwei Xiao, "Constructing a New National Culture: Film Censorship and the Issues of Cantonese Dialect, Superstition, and Sex in the Nanjing Decade," in *Cinema and Urban Culture in Shanghai, 1922–1943*, ed. Yingjin Zhang (Stanford, Calif.: Stanford University Press, 1999), 197. Jin was not just working class onscreen. His salary was around 320 yuan a month, whereas a dancing girl in 1930s Shanghai could earn as much as 1,100 yuan. Weihong Bao, *Fiery Cinema: The Emergence of an Affective Medium in China, 1915–1945* (Minneapolis: University of Minnesota Press, 2015), 38.

6. Similar naming occurs in other films; e.g., in *The Peach Girl* (1931), Jin Yan's character is also surnamed Jin (King).

7. See the two-page spread on the film in *Chin-Chin Screen* 1, no. 6 (September 15, 1934); the issue features separate spreads on Chen Yanyan and Li Lili.

8. "*Dalu* li de 'wanshengyuan'" 大路裏的"萬牲園" (*The Great Road* zoo), *Lianhua huabao* (*UPS Pictorial*), 5, no. 1 (January 1, 1935), inside back cover.

9. Hu Bangban is a homophone for vicious [or tiger-like] collaborator, a connotation confirmed when Hu is revealed to be working for the enemy and a porcelain tiger appears in the first shot of his mansion.

10. Director Cheng Bugao made a documentary film about the flood in 1931 and reused some of the footage in his feature film *Torrent* (1933). Weihong Bao, *Fiery Cinema*, 167–172.

11. Chris Berry observes that "the whole scene is strangely like an inverse of the famous swimming scene at the beginning of *Blonde Venus*," a 1932 film starring Marlene Dietrich, in which a group of male hikers come across six naked women in a lake. Chris Berry, "The Sublimative Text: Sex and Revolution in *Big Road* [The highway]," *East-West Film Journal* 2, no. 2 (1988): 78.

12. Zhiwei Xiao, "Film Censorship in China, 1927–1937." PhD diss., University of California, San Diego, 1994, 114, 243–244.

13. Han Langen's character in *The Great Road*, Little Han the Sixth, is once shown with a monkey, alluding to his earlier role as Little Monkey in *Song of the Fishermen* (1934), which also features Shang Guanwu and Hong Jingling as master and henchman, respectively. *Song of the Fishermen* premiered at Shanghai's Lyric Theater on June 14, 1934. "Jincheng dashuaxin hou mingtian gongying *Yuguang qu*" 金城大刷新後明天公映《漁光曲》 [*Song of the Fishermen* to premiere tomorrow at the newly refurbished Lyric Theater], *Xinwen bao*, local news supplement (June 13, 1934), 9.

14. Zhiwei Xiao, "Film Censorship in China, 1927–1937," 168.

15. Hu Jubin, *Projecting a Nation: Chinese National Cinema Before 1949* (Hong Kong: Hong Kong University Press, 2003), 102.

16. Chen Yanyan appeared on the cover of numerous movie magazines in the 1930s, including *Chin-Chin Screen*, May 15, 1934; *UPS Pictorial* 5, no. 2 (February 1935);

Xiandai dianying (*Modern Screen*) no. 4 (1933); and *Yisheng dianying yu yinyue* (*Nee Sung Movie and Music Monthly*), June 1, 1935. She reappears in Fei Mu's *Song of China* (1935) as the good daughter of a virtuous patriarch (Shang Guanwu) with a wastrel son (Zhang Yi).

17. Rixuan 日宣 (Promote Japan), "Suo wang yu woguo zhi yinghua" 所望於我國 之映畫 [What I expect of films of our nation], *Manzhou yinghua* (*Manchurian Film*) (Chinese edition), December 1937, 7.

18. Li Lili had recently played a seductive espionage agent role in *Daybreak* (1933). At a banquet with enemies of the Northern Expedition, she caresses one man's face and holds a second man's hand under the table while playing footsie with a third. Chen Yanyan's character reluctantly uses sex for espionage against a warlord in *Girl Martyr of an Isolated City* (1936).

SOURCES/FURTHER READING

Altman, Rick. *Silent Film Sound*. New York: Columbia University Press, 2004.

Berry, Chris. "The Sublimative Text: Sex and Revolution in *Big Road* [The highway]." *East-West Film Journal* 2, no. 2 (1988): 66–86.

Cho, Pock-rey. "The Emperor of Shanghai Movies of the 1930s: Jin Yan (1910–1983)." *Asian Cinema* 14, no. 2 (Fall/Winter 2003): 206–214.

Li, Cheuk-to. "Eight Films of Sun Yu: A Gentle Discourse on a Genius." *Cineyama* 11 (1991): 53–63.

Meyer, Richard J. *Jin Yan: The Rudolph Valentino of China*. Foreword by Robert Dallek. Hong Kong: Hong Kong University Press, 2009.

Pang, Laikwan. "Masculinity and Collectivism: Romancing Politics." In *Building a New China in Cinema: The Chinese Left-Wing Cinema Movement, 1932–1937*, 91–112. New York: Rowman and Littlefield, 2002.

Xiao, Zhiwei. "Film Censorship in China, 1927–1937." PhD diss., University of California, San Diego, 1994.

FURTHER VIEWING

Blonde Venus. Joseph von Sternberg, director. 1932.

Daybreak (*Tianming* 天明). Sun Yu, director. 1933.

Dinner at Eight. George Cukor, director. 1933.

Girl Martyr of an Isolated City (*Gucheng lienü* 孤城烈女). Wang Cilong, director. 1936.

Lianhua Symphony (*Lianhua jiaoxiangqu* 聯華交響曲). Situ Huimin, Fei Mu, Tan Youliu, Shen Fu, and He Mengfu, directors. 1937.

The Red Detachment of Women (*Hongse niangzi jun* 紅色娘子軍). Xie Jin, director. 1960.

The Red Heroine (*Hong xia* 紅俠). Weng Yih Ming (Wen Yimin), director. 1929.

Song of the Fishermen (*Yuguang qu* 漁光曲). Cai Chusheng, director. 1934.

Storm Over Asia. Vsevolod Pudovkin, director. 1928.

Street Angels (*Malu tianshi* 馬路天使). Yuan Muzhi, director. 1937.

The White-Haired Girl (*Baimao nü* 白毛女). Wang Bin and Shui Hua, directors. 1950.

New Women (Xin nüxing 新女性)

Alternative English titles: *New Female, New Woman*
Director: Cai Chusheng
Screenplay: Sun Shiyi
Studio: Lianhua (second studio)
Date of release: February 3, 1935
106 minutes, dubbed sound
Music: Nie Er
Cast: Ruan Lingyu, Zheng Junli, Yin Xu, Wang Naidong, Tang Tianxiu

SYNOPSIS

A young woman named Wei Ming, a migrant to Shanghai, meets an old school acquaintance who now goes by the married name of Mrs. Wang. Wei Ming supports herself by teaching music at a private girls' school and is on friendly terms with her neighbor Li Aying, who teaches classes to female factory workers. Wei Ming hides from friends and acquaintances alike that she is a single mother with a daughter, whom her elder sister is raising somewhere else. Wei has written a novel called *The Grave of Love*, which her friend Yu Haichou, an editor, has commissioned for publication. The manager of the press, Yu tells her, became interested in the novel only when he spotted Wei Ming's photograph

and decided to exploit the beautiful image of this "woman-author." The playboy Dr. Wang, who is married to Wei Ming's old classmate and who sits on her school's board of directors, attempts to seduce Wei Ming by taking her to a cabaret and getting her drunk. When Wei Ming rejects his advances, he takes revenge by getting her fired from her teaching job. Then Wei Ming's young daughter, whom Wei's sister has brought to Shanghai, falls critically ill with pneumonia. In an attempt to raise money to save her child, Wei Ming agrees to prostitute herself once, but she flees when she encounters her client: Dr. Wang. When Dr. Wang forces his way into Wei Ming's apartment, Li Aying punches him out. Still, the destitute mother cannot afford a doctor to save her child, who dies, and Wei Ming takes a lethal dose of sleeping pills. Dr. Wang meanwhile has recruited a journalist to shame Wei Ming in the press as a prostitute with an illegitimate child. The journalist arrives at Wei's home while she is being treated by a doctor and then prints a sensational story about her suicide. Yu Haichou arranges an ambulance. Aying reads the news in the late edition and rushes to the hospital and stays at Wei's bedside until Aying has to go teach a singing class. Wei Ming cries out, "I want to live!" but dies anyway. Meanwhile, the publisher and journalist agree to sponsor a funeral as a publicity stunt to boost sales. In the final scene, Dr. Wang drives off in his car with a new paramour snuggled against him. He casually throws a copy of the newspaper reporting Wei Ming's death out the window, and it is trampled underfoot into the mud by the female workers whom Aying is leading out of the factory.

SENSATIONAL NEW WOMEN

New Women was conceived of and marketed as a "problem film" about "the woman question." Its story was inspired by the 1934 suicide, at age twenty-one, of actress Ai Xia. Ai, who had appeared in films such as *A Modern Woman* (1933) (for which she wrote the screenplay) and *Spring Silkworms* (1933), had felt hounded by the press about her personal life[1] and swallowed opium. As presented in the film, the woman question is really a series of questions: What is the current reality of women's status in China? Who are China's new women? And what should their lives be like?

Cinema both reflected and propelled women's new conspicuousness. Confucian social mores dictated that women be modest and confine their sphere of activity largely to the home. Yet in the late Qing, and more rapidly after the founding of the Republic of China in 1912, the grip of tradition started to loosen. New educational and employment opportunities coincided with the rise of a modern popular press; together, these institutions put women in the public eye more than ever before. These changes were helped along, and sometimes instigated, by social reformers who advocated for equality of the sexes, free love and free marriage, equal rights to property and inheritance, and freedom from prejudice and discrimination.

By the 1930s, films, photographs, and an array of newspapers and magazines had produced a vibrant star culture, which turned glamorous and fashionable young women into fetish objects. (In the film, Wei Ming, in addition to teaching music, also writes for a pictorial magazine, which asks to print her photograph alongside her writings.) Ruan Lingyu, like many other actresses, appeared in film fanzines, and pictorials like *Lin Loon Ladies' Magazine* and *The Young Companion*. The new visibility of women contributed to making them a focus of public discussion, and a subject of art. Ruan, for example, appeared in several films, including *Love and Duty* (1931), *The Peach Girl* (1931), *Playthings* (1933), *Three Modern Women* (1933), and *Goddess* (1934), showing contemporary women's romantic and career aspirations in conflict with external expectations.

New Women is at once a product of these cultural and economic trends and part of a movement for equality of the sexes that had been going on for decades. Lianhua Studio mounted a publicity campaign for the film (which it marketed in its bilingual fanzine as *New Female*) that condemned passive "old" women and lauded "new" women who pursue self-determination. But the film suggests that working women in the public eye still face desperate challenges.

New Women premiered at Shanghai's Lyric Theater on February 7, 1935, during the Lunar New Year holiday. A week and a half earlier, Shanghainese were treated to a performance of the full film soundtrack by the Bershadsky Orchestra, with composer Nie Er conducting and a bevy of Lianhua actresses in attendance, including Ruan Lingyu and Li Lili. The event was broadcast live from the Chinese-Western Pharmacy,

which took the opportunity to promote the skin-whitening cream supposedly favored by Ruan.[2] Yet the film also became a sensation for a reason unrelated to its melodramatic plot, artistic accomplishment, ardent polemics, or the advance publicity campaign. On March 8, Ruan Lingyu committed suicide. The unexpected death became a media spectacle, with suicide notes and photographs of the star-studded funeral and the memorial parade through Shanghai reprinted across the country.[3] While the suicide echoed that of Ai Xia, Ruan was a bigger star, and the timing of her death was symbolic, occurring on International Women's Day.

Like Ai, Ruan cited slander as a force driving her to suicide. Ruan's suicide note contained a line that became famous: "Gossip is a fearful thing" (*ren yan ke wei*). The phrase echoes *New Women*'s indictment of participants in a predatory media culture, especially the tabloids that fuel the celebrity of stars but prey on their misadventures. In the event, Ruan's suicide created buzz for *New Women* and boosted its box office.

This uncanny intertwining of fact and fiction—two real suicides with a fictional suicide in between—contributed to the making of a cultural legend. Like the poet Xu Zhimo, who died in an airplane crash in his prime in 1931, Ruan Lingyu has become a symbol of the glamor, romance, and unfulfilled potential of Republican China, and her story has been endlessly retold, including in Stanley Kwan's 1991 biopic, *Center Stage* (*Ruan Lingyu*).

New Women is also sensational visually. Wipes, split screens, matte shots, and other types of superimposition create a fast-paced narrative and dynamic visual composition. When Wei Ming is in Dr. Wang's car on the way to the cabaret (figure 6.1), her face appears on the right-hand side of the screen, while in the center appears another screen, representing the car window, on which we see projected Wei Ming's flashback to how she first met Dr. Wang at the school where she teaches, when they were introduced by the principal.[4] The memory appears like a movie within the movie.

The neon lights of Shanghai that signal Wei Ming's mental return to the present seem to leave her disoriented, and she awakens from her reverie to discover with a shock that Dr. Wang has put his arm around her. Her vertigo returns in the nightclub when, reeling from the champagne, she is horrified by a burlesque performance of a girl being whipped by a cowboy. The scene is reminiscent of the cabaret performance in Charlie

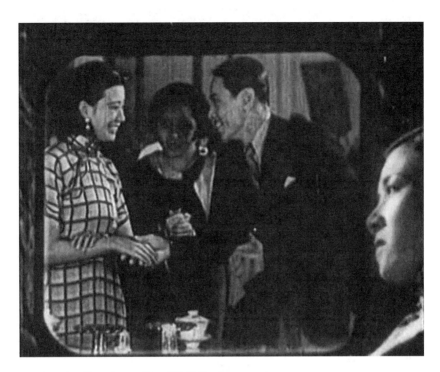

FIGURE 6.1 Superimposition: Wei Ming's memories
Source: Author

Chaplin's *City Lights* (1931). But whereas Chaplin's depiction of acted male-on-female violence is followed by knockabout farce, *New Women*'s is followed by a terrifying hallucination. Wei Ming sees herself in the body of the female white Russian dancer, who has returned to the stage dressed as a prisoner in shackles. Wei Ming stands up, knocking her champagne glass to the floor, and, pursued by Dr. Wang, stumbles over to put her head on a block of ice—an object that calls to mind Yu Haichou, whom Wei Ming had once referred to as an "iceberg." The editing and cinematography convey that urban sensations are visceral and dangerously destabilizing—and that Shanghai's predators use these effects to exploit women (figures 6.2–6.4).

When Dr. Wang offers Wei Ming a diamond ring—worth ten times the amount she needs to cure her child—the closing gates of a hospital, in canted framing, the rocking sign of a pawn shop, and a close-up of the diamond are superimposed over Wei's face. Placing the need, method,

FIGURE 6.2 The nightclub scene: chained dancer
Source: Author

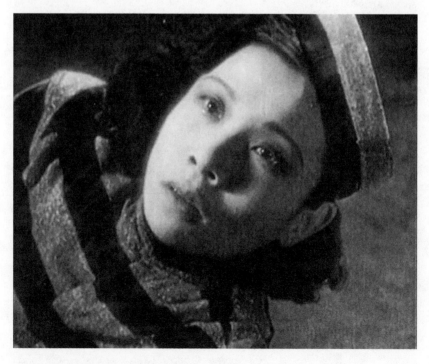

FIGURE 6.3 The nightclub scene: hallucination
Source: Author

FIGURE 6.4 The nightclub scene: ice
Source: Author

and object before Wei Ming's face renders her moral dilemma in stark visual terms: she need only "pawn" herself to a libertine to save her child. She refuses.

Superimposition appears so often that the technique itself becomes a motif. In one scene, Mrs. Wang suspects her husband of infidelity when she finds a torn-up picture on the floor. She pieces it back together, and when she puts in the final piece, the eyes, Wei Ming's animated face moves and smiles out at her from the torn fragments. *New Women*'s cinematography, editing, and symbolism create a sense of simultaneity, velocity, and emotional intensity, while reinforcing the feeling that for some new women, life is an out-of-body experience.

DOUBLE STANDARDS AND TRIPLE LIVES

The visual motifs of a toy, photographs, and mirrors convey the idea that women are forced to live multiple lives and are held to a double

standard. As in *Goddess*, the female protagonist is defined in relation to the roles of mother and prostitute, though also to the professions of teacher and author. The first time we see Wei Ming, she is sitting on a tram holding a toy, which reappears in later scenes: a "never-fall woman" (*budao de nüxing*) (figure 6.5), which always rights herself no matter how many times—or how hard—she is pushed over. The toy both alludes to and seems to mock women's aspirations: it implies that women exist as objects as well as subjects, not just as people but also as playthings. In *Playthings* (which also features a never-fall toy), Ruan Lingyu's character is a member of a community of toymakers whose livelihood is being ruined by mass-produced imports; in *New Women*, it is women being victimized by men. Ruan's death did not dissuade *Chin-Chin Screen* magazine from playfully applying the "never-fall" motif to a pantheon of resilient male movie directors later that year (figure 6.6).

The visual motif of Wei Ming's photograph reinforces the idea that women lead double lives, as human beings and as images. The

FIGURE 6.5 The "never-fall woman" toy
Source: Author

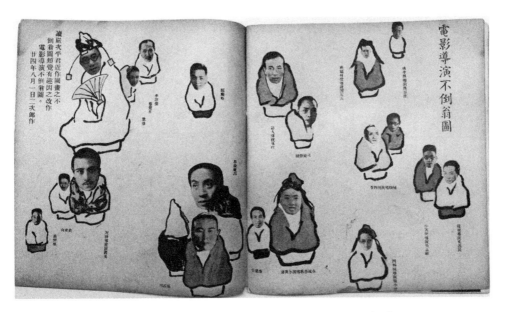

FIGURE 6.6 "Never-fall Film Directors," including Sun Yu, Cai Chusheng, Fei Mu, Ma-Xu Weibang, Shi Dongshan, Situ Huimin, Shen Xiling, Wu Yonggang, Wen Yimin, Bu Wancang, and Zhang Shichuan, a collage by Ercilang appearing in *Qingqing dianying* (*Chin-Chin Screen*) (September 5, 1935).
Source: Courtesy of the C. V. Starr East Asian Library, University of California, Berkeley

photograph first appears inconspicuously as a wall decoration in her apartment; it reappears in many later scenes above and behind her, as if looking over her shoulder as a reminder of her split selves. When the publisher handwrites the word "Miss" next to Wei Ming's name on the book cover, we see her photograph in close-up (figure 6.7). The repeated focus on this flat image suggests that it is not *who* a woman is, but rather *how* she is viewed, that determines her fate. The photograph becomes a ubiquitous presence that haunts Wei Ming's life and hastens her death. As people, women have their own hopes, goals, desires, and agency to realize them. As images, they are passive: people look at images, judge them, and use them for their own purposes.

Adding to this irony is Wei Ming's profession as an author. She has had short works published in newspapers and magazines and is looking to publish her first novel. Yu Haichou, the commissioning editor, tells her that the press has agreed to publish it but only at a low royalty rate of 10 percent, and with no advance. Popular culture texts of the 1930s

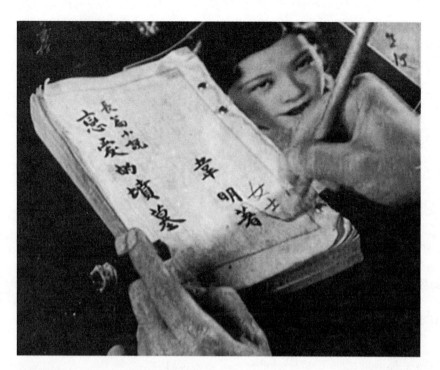

FIGURE 6.7 "Miss" Wei Ming, author
Source: Author

often represented women as agents of consumption—shopping, leisure, clothing, fashion—or as objects of consumption themselves. Wei Ming is a writer, and therefore a producer, but one who is still subject to exploitation. Talent alone turns out to be not enough: she will not be allowed to produce, and to earn, until she also gives the public what it wants to consume, which is her flat image. Put another way, the film suggests that women, even when they try to produce, are forced into being objects of consumption. The undertow of popular culture is ever ready to pull women down.

Mirrors are another motif. Around minute 12:30, Wei Ming looks at herself in the mirror. A cut shows Dr. Wang doing the same in his apartment, such that the mirror becomes a visual connection between them. Haichou leaves her apartment, and Wei Ming bursts into tears under a birdcage—a common symbol of female or domestic entrapment—containing a pair of birds. The lovelorn young woman then sits down in front

of a mirror, plucking petals off a rose. Dr. Wang enters, reflected in the mirror, as Wei Ming wipes away her tears and stands to greet him. A reverse shot shows the photograph and the never-fall woman next to Wei Ming as she, perhaps to spite Haichou, accedes to Dr. Wang's invitation to go out for nocturnal amusement. The mirror reappears when the editor of the pictorial magazine for which Wei Ming has been writing, taking advantage of her financial desperation, looks at himself in one mirror and is seen trying to kiss her in another. A similar sequence of mirror shots appears in *Trouble in Paradise* (1932) (figures 6.8 and 6.9).

Wei Ming starts to see in the mirror not just the superficial exterior that everyone else sees but also the pain, guilt, and hopelessness she feels inside. When she agrees to "be a slave for one night" to save her child, her sister watches the sad spectacle of Wei Ming looking in the mirror through a window next door.[5] The following close-ups of Wei Ming, told to smile through tears for her client, treat the film camera

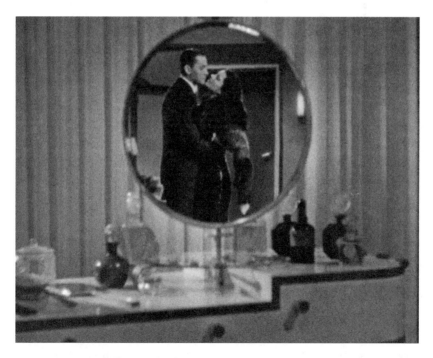

FIGURE 6.8 Mirror kiss in *Trouble in Paradise*
Source: Author

FIGURE 6.9 Mirror kiss in *New Women*
Source: Author

itself—and us in the cinema audience—as a mirror to her conscience, albeit one that can only look on helplessly. These three motifs—the never-fall woman toy, the photograph, and the mirror—each contribute to the pathos of the striving, but fatally oppressed new woman.

Mrs. Wang, the former classmate Wei Ming encounters on the tram, is the second type of new woman we see in the film. Wang *taitai*, as she tells Wei Ming she prefers to be known now, is a woman who has married and, by conventional standards, married well. The stereotypical *taitai*, as further discussed in chapter 10, is a bourgeois housewife, a lady of leisure who is financially dependent on her husband and who flaunts her superior social status through conspicuous consumption. Mrs. Wang looks down on a working woman like Aying, rolls her eyes at Wei Ming's messy apartment, and disdains the cigarette she's offered, preferring to smoke the superior brand she's brought with her. In her first scene with Dr. Wang, she complains of being a "rich missus in name only," having to ride the bus while her husband uses his limo. Later, her

melodramatic show of sobbing over Dr. Wang's philandering ends in exultation when he promises her a new car, completing the caricature of the hypocritical, materialistic *taitai*.

Li Aying represents a different model of new womanhood entirely. Unlike the selfish Mrs. Wang, she is hearty, extroverted, and authentic. As shown by the work schedule she posts on her wall, she maintains an ambitious and regimented work routine of teaching singing, reading, writing, and other topics to female union workers of a silk factory. Unlike Wei Ming, she is represented not as a flat, passive image but as an active bodily force—one that is constantly singing, moving, gesticulating, fighting. The first time we see her, Aying is rinsing her hair in a spigot by the door to the apartment building, and she suddenly looks up to greet Wei Ming with an uninhibited smile and a wave (figure 6.10).

Interspersed within the nightclub scene are sequences of Aying teaching a singing class. A diagonal split screen puts the faces of the

FIGURE 6.10 First view of Li Aying
Source: Author

singers above a montage of Shanghai scenes, as if their voices are carrying over the entire city. The contrast between diligent study/work and degenerate pleasure-seeking is reinforced by a sequence of parallel editing of nightclub and labor scenes, interspersed series of clockwise wipes over a clockface showing the passing of the night. (A similar sequence alternating a clockface and dancing bodies, with dissolves instead of wipes, appears in part 1 of the six-part film *Fate in Tears and Laughter* [1932].) As Wei Ming lies in the hospital, between life and death, Aying tries to buck up her spirits by reminding her that suicide is the choice of the weak and will only earn scorn. But Aying cannot keep the vigil; she has to go back to work.

In one visually arresting scene, Aying encounters Wei Ming outside their apartment building at nighttime, and as Aying walks out of the frame, her shadow on the wall looms larger and larger over Wei Ming: the strong new woman literally overshadows the weak one (figure 6.11).

FIGURE 6.11 One new woman overshadows another
Source: Author

Aying had a vision of the two of them partnering up as a productive pair: having written the lyrics to a "Song of the New Woman," she asks Wei Ming to score it. But it is not to be: Wei Ming's piano is soon repossessed. In the climactic and literally striking sequence when Dr. Wang forces his way into Wei Ming's apartment, Aying's dynamic physicality is conveyed through the close-up canted framing of her beating up Dr. Wang—culminating in her headbutting the camera. The camera angle, close distance, and movement create a strong sense of physical intensity.

What about Wei Ming's love interest? Yu Haichou is played by Zheng Junli, who appears in the ensemble of *The Great Road* (1934) and went on to direct the civil war–era masterpieces *Spring River Flows East* (with Cai Chusheng, 1947) and *Crows and Sparrows* (1949). Haichou is an eligible bachelor with a white-collar job, as well as a gentleman, but he is no sweep-her-off-her-feet romantic; he is a moralist who dampens her ardor. The first time we see them alone in her apartment, it is Wei Ming who cannot keep her hands to herself. She lights him a cigarette, perches herself by his side, casts a look at herself in the mirror, and invites him to go out dancing. She is all smiles, while he maintains a brooding demeanor and chides her for "hedonism." In this film about women, it is a man's warning about moral peril that goes unheeded. Haichou himself remains passive, once telling Wei Ming: "I wish you could spend more time with people like Aying." Indeed, when Wei Ming is threatened in her home, it is Aying and not Haichou who comes to her rescue. As in *Goddess*, single mothers are pariahs, and Wei Ming is too ashamed to tell Haichou about her child until it is too late. Chiming in with Aying, Haichou tells the dying Wei Ming that she will only be able to get revenge if she puts aside her "cynicism" and acts like a "never-fall woman."

In the Communist-era classic *The Red Detachment of Women* (1960), a man appears as a moralist, a savior, and a catalyst to female action; in *New Women*, no white knight appears. As Wei Ming dies, Haichou looks on with grim resignation. She once called him an "iceberg" for resisting her charms. In *Blonde Venus* (1932), a pre-Code "fallen-woman film," Marlene Dietrich's character is once described as "cold as the proverbial iceberg." *New Women* reverses the motif: it is Haichou who is frigid and Wei Ming who, leaning against a block of ice at a cabaret, needs cooling off. Her death confirms his fear that one can end up "cremated" in the fires of passion.

New Women is a silent film on the cusp of the sound era about silenced women yearning to be heard. According to film historian Bao Weihong, 1934 was "the last year before the total conversion to sound in the Chinese film industry."[6] *New Women* was shot as a silent film, but with sound in mind: dubbed dialogue, sound effects, singing, and orchestral music were added in postproduction. By the early 1930s, China was already importing foreign talkies and was on the verge of producing its own films with live recorded sound. Dubbed films like *The Great Road* and *New Women* were part of the transition to the talkies, a promise realized just before the outbreak of the Anti-Japanese War with films like *Song at Midnight* (1937) and *Street Angels* (1937). In 1934, when *New Women* was shot, silent film conventions such as heavy makeup, close-ups on facial expressions, conspicuous visual symbols, and intertitles still dominated Chinese feature filmmaking. Animated words, in Chinese characters, appeared on the screen to represent important lines of dialogue.

Sound is a key theme in *New Women*. Two of the three new women are music teachers: Wei Ming teaches piano and Aying teaches singing to female factory workers. Wei Ming and Mrs. Wang likely met in music school.

In the nightclub scene where Wei Ming sees herself in chains, we get a close-up shot of the cover of the sheet music of the song the orchestra is playing: "Peach Blossom River" (by the real-life composer and bandleader Li Jinhui), with an illustration of a naked woman holding a heart.[7] Aying later tells Wei Ming that she plans to borrow the tune of this decadent song and add new lyrics that will have a redeeming social message. In real life, during the Anti-Japanese War and after the founding of the People's Republic of China, the Communist Party would use precisely this technique of adding revolutionary lyrics to folk or pop culture melodies for propaganda purposes.

The sonic motif returns when the animated words "Save me!" and "I want to live!" grow out of the mouth of the dying heroine (figure 6.12). This special effect first appears around minute 6, when the landlady summons Wei Ming to the shared telephone in the hallway by calling out, "Phone call for Miss Wei in the parlor!" (This same landlady later tries to prostitute her tenant to the caller, Dr. Wang.) In the hospital scene, the words burst from the mouth of the dying woman like a newspaper

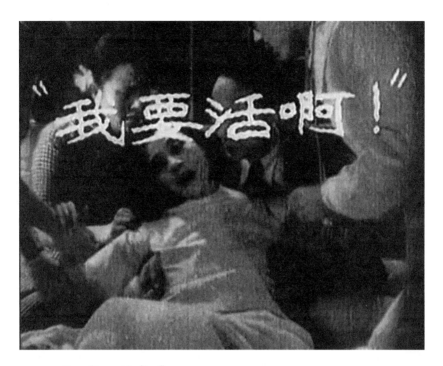

FIGURE 6.12 "I want to live!"
Source: Author

headline. The cinematographic effect seems to break through the fictional story-world (or diegesis) of the film to address the movie audience directly. But, as Kristine Harris notes, the silent "showing" of this utterance is represented as more reliable than the journalistic "telling" of the news media. Bao Weihong adds that, given the technological epoch, Wei Ming's "I want to live!" could also be taken as a commentary on "the silent film medium, threatened [by sound cinema] but seeking an emphatic resurrection."[8]

Wei Ming's outburst is doubly muted, as she dies and is silenced for good. Her daughter does not live even to become a woman, much less a "new" one. Only the press and her publisher benefit. Wei Ming's death quickly becomes yesterday's news. Dr. Wang throws the newspaper out of his car as he drives away with his new mistress, and it is trampled underfoot by factory workers. We see a factory whistle, a shot of Li Aying leading a class in choral singing, and a montage sequence showing

Aying and her fellow workers leaving the factory. But the masses, like Aying, remain a cipher. The closing sequence suggests that women like Aying will lead China's women into the future, and speak—or sing—for their silenced compatriots, but it leaves open the question: how?

NOTES

1. To give one example of the contemporary media climate: *Chin-Chin Screen*, a magazine dedicated to "promoting domestic films and introducing the lives of movie stars," published not only gossip about film stars, but also their home addresses, the license plate numbers of their cars, photographs of their employment contracts, and information about their children born out of wedlock.

2. The infomercial for the live event, radio broadcast, and cosmetics promotion is titled "*Xin nüxing* gequ jinri bosong" 新女性歌曲今日播送 [Radio Broadcast Today of Songs from *New Women*], *Shenbao* 22188 (January 27, 1935), 13. The film's opening is advertised in *Shenbao* 22193 (February 7, 1935), 28. The Lunar New Year began on February 4.

3. Two suicide notes and many photographs from the funeral, along with written tributes, appear, for example, in *Lianhua huabao* 5, no. 7 (1935).

4. This technique appears in many Hollywood films of the era, as well as in earlier Chinese films, such as *Don't Change Your Husband* (1928), starring Wang Naidong and Tang Tianxiu, who play Dr. Wang and Wei Ming's sister, respectively, in *New Women*.

5. At the moment she agrees to prostitute herself to save her child, Wei Ming cries into her tea and then drinks it—a reference to "eating bitterness" (*chi ku*), bitterness being a common metaphor for suffering, and also a key word in *Long Live the Missus!* (1947).

6. Weihong Bao, *Fiery Cinema: The Emergence of an Affective Medium in China, 1915–1945* (Minneapolis: University of Minnesota Press, 2015), 193.

7. In *Yihjanmae* (1931), also known as *A Spray of Plum Blossoms*, Ruan Lingyu's character, Julia, is first shown singing "I am Willing!" ("Wo yuanyi"), accompanied on the piano by Li Lili's character. An intertitle calls her a "modern modern" (*modeng nüxing*), the transliteration *modeng* and the Art Deco illustration of a partially clad young woman on the sheet music both conveying a sense of frivolous, decadent modernity.

8. Kristine Harris, "The *New Woman* Incident: Cinema, Scandal, and Spectacle in 1935 Shanghai," in *Transnational Chinese Cinemas: Identity, Nationhood, Gender*, ed. Sheldon H. Lu (Honolulu: University of Hawai'i Press, 1997), 297, quoted in Weihong Bao, *Fiery Cinema*, 193. Animated words growing out of a character's mouth also appear in the opening shot of the silent *wuxia* film *Red Heroine*

(1929), in which a villager runs up to the camera and shouts a warning of invading soldiers, an effect which, in Zhang Zhen's words, "acknowledges martial arts film's roots in oral storytelling." Zhang Zhen, *An Amorous History of the Silver Screen: Shanghai Cinema, 1896–1937* (Chicago: University of Chicago Press, 2005), 229.

SOURCES/FURTHER READING

Bao, Weihong. *Fiery Cinema: The Emergence of an Affective Medium in China, 1915–1945*. Minneapolis: University of Minnesota Press, 2015.

Chang, Michael G. "The Good, the Bad, and the Beautiful: Movie Actresses and Public Discourse, 1920s–1930s." In *Cinema and Urban Culture in Shanghai, 1922–1943*, ed. Yingjin Zhang, 129–159. Stanford, Calif.: Stanford University Press, 1999.

Chow, Eileen, trans. Film script of *New Woman*. MCLC Resource Center Publication, 2004. http://u.osu.edu/mclc/online-series/new-woman.

Edwards, Louise. "Localizing the Hollywood Star System in 1930s China: *Linglong* Magazine and New Moral Spaces." *Asian Studies* 1, no. 1 (September 2015): 13–37.

Harris, Kristine. "The *New Woman* Incident: Cinema, Scandal, and Spectacle in 1935 Shanghai." In *Transnational Chinese Cinemas: Identity, Nationhood, Gender*, ed. Sheldon H. Lu, 277–302. Honolulu: University of Hawai'i Press, 1997.

Hong, Guo-Juin. "Framing Time: New Women and the Cinematic Representation of Colonial Modernity in 1930s Shanghai." *positions: east asia cultures critique* 15, no. 3 (Winter 2007): 553–580.

Otto, Elizabeth, and Vanessa Rocco, eds. *The New Woman International: Representations in Photography and Film from the 1870s Through the 1960s*. Foreword by Linda Nochlin. Ann Arbor: University of Michigan Press, 2011.

Pang, Laikwan. "Women's Stories On-screen versus Off-screen." In *Building a New China in Cinema: The Chinese Left-Wing Cinema Movement, 1932–1937*, 113–137. New York: Rowman and Littlefield, 2002.

Reynaud, Bérénice. "The 'New Woman' Question in Chinese Cinema." In *Electric Shadows: A Century of Chinese Cinema*, ed. James Bell, 94–101. London: British Film Institute, 2014.

Wang, Yiman. "To Write or to Act, That Is the Question: 1920s to 1930s Shanghai Actress-Writers and the Death of the 'New Woman.'" In *Chinese Women's Cinema: Transnational Contexts*, ed. Lingzhen Wang, 235–254. New York: Columbia University Press, 2011.

Weinbaum, Alys Eve, Lynn M. Thomas, Priti Ramamurthy, Uta G. Poiger, and Madeline Yue Dong, eds. *The Modern Girl Around the World: Consumption, Modernity, and Globalization*. Durham, N.C.: Duke University Press, 2008.

FURTHER VIEWING

Blonde Venus. Joseph von Sternberg, director. 1932.

Goddess (*Shennü* 神女). Wu Yonggang, director. 1934.

Long Live the Missus! (*Taitai wansui* 太太萬歲). Sang Hu, director. 1947.

The Peach Girl (*Taohua qixue ji* 桃花泣血記). Richard Poh (Bu Wancang), director. 1931.

Playthings (*Xiao wanyi* 小玩意). Sun Yu, director. 1933.

The Red Detachment of Women (*Hongse niangzi jun* 紅色娘子軍). Xie Jin, director. 1960.

Spring Silkworms (*Chun can* 春蠶). Cheng Bugao, director. 1933.

Yihjanmae (*Yi jian mei* 一剪梅). Richard Poh (Bu Wancang), director. 1931.

Sound Films

Song at Midnight (*Yeban gesheng* 夜半歌聲)

Alternative English titles: *Midnight Song, Midnight Singing*
Director/screenplay: Ma-Xu Weibang
Studio: Xinhua
Date of release: February 20, 1937
120 minutes
Music: Sinn Sing Hoi (Xian Xinghai)
Lyrics: Tian Han
Cast: Hu Ping, Jin Shan, Zhou Wenzhu, Shi Chao, Xu Manli, Gu Menghe,
 Wang Weiyi

SYNOPSIS

One stormy night in 1926, the Angel Theater Troupe arrives at a condemned theater, which they have rented for a series of performances. Sun Xiao'ou, the male lead in a new musical, is having trouble learning his lines for its theme song, "Romance of the Yellow River," and rehearses on stage alone. Suddenly, a shadow looms up, and a powerful voice begins singing the lines to him. The ancient caretaker of the theater informs Xiao'ou that the voice belongs to Song Danping, a famous actor who for a decade has been thought dead. Though initially spooked by the disembodied voice, Xiao'ou realizes that it is teaching him his

part. Xiao'ou learns the song well, and the show triumphs. Xiao'ou goes backstage to thank his unseen benefactor, and follows the voice up a stairwell to a tower room, where he encounters a hooded figure, who tells his backstory: in 1913, he was a revolutionary named Jin Zijian, but in 1916, pursued by enemies, he went into hiding as an actor and changed his name to Song Danping. Flashbacks show that Danping was in love with a young woman named Li Xiaoxia (Xia, for short), but that her gentry father listened to the slander of Danping's rival, Tang Jun, and had Danping tortured. When Xia rejected Tang, he had his henchman throw acid on Danping's face. Danping survived, but the bandages came off to reveal his face to be hideously scarred. Filled with rage and self-loathing, Danping had Xia informed that he was dead. The news drove her insane. Since then, he has sung his "Song at Midnight" to Xia, lamenting their separation and suffering. With the arrival of Xiao'ou, Danping feels new hope for the political cause—and the woman—he has hidden from for so long. Song Danping once composed and sang a song of "Hot Blooded" revolution; now, Sun Xiao'ou sings Danping's new version of the same song to thunderous acclaim. But Tang Jun, who owns the theater, has set his eyes on Xiao'ou's girlfriend and fellow actor, Lü Die. One night, Tang attacks her in her dressing room and, when Xiao'ou arrives, aims a gun at him but ends up shooting her. Danping emerges from the shadows to confront his old nemesis, and the two of them fight their way up to the tower room as the theater audience begins to riot. Tang plunges out the window to his death, and Danping swings on a rope down to the stage. Xiao'ou returns to the stage to plead for calm, but the audience sets off after the monstrous apparition. Out on the streets, the audience (along with soldiers who have discovered Danping's identity as a member of the Revolutionary Party) becomes a torch-wielding mob and pursues Danping to an abandoned tower, which it sets alight. Just as Danping leaps to his death in the river, Xia, at home, suddenly regains her sanity and her memory. Xiao'ou vows that they will realize Danping's hopes, and the two of them stand together and gaze toward the rising dawn.

HISTORIAN OF THE STRANGE

Song at Midnight was marketed as a breakout genre film: China's first horror-musical. The film had a spectacular opening on a rainy February

20, 1937, at Shanghai's Lyric Theater. An enormous coffin was placed outside the theater, over which loomed a larger-than-life image of the grotesque phantom singer, with green light bulbs in place of eyes. The press got in on the hype, claiming that the ad had frightened a child to death and advising moviegoers to leave their children at home.[1] *Song at Midnight* promised not just a good story, with romance, drama, and pathos, but also a thrilling and chilling sensory experience, with gothic horror, hair-raising suspense, and as its title suggests, music.

The title, theme, mood, setting, and spooky atmospherics all inspired many later films. In Shanghai in 1941, Ma-Xu Weibang shot a sequel, which does not survive; in 1956, he filmed a new version for the Shaw Brothers Studio in Hong Kong. Other versions were made in Hong Kong in 1962, 1963, and 1995. In the PRC, *Song of Midnight* was resurrected as the title of a 1985 film and a 2005 TV drama, with new stories.

This chapter first examines how the film builds suspense, leading up to the unveiling of the monstrous phantom, as well as how it creates a unique genre mix of song, history, and monstrosity. It then focuses on *Song's* politics of horror, including its multiple sensational revelations and allegorical possibilities.

Song at Midnight's lurid makeup and spooky, nocturnal atmospherics drew on a long history of cinematic horror dating back to the German classic *Nosferatu* (1922). Ma-Xu had previously directed and starred in films about strange, bizarre or uncanny—*guai* 怪—creatures, including *The Strange Lover* (*Qingchang guairen* [1926]) and *The Stranger of Dark Night* (*Heiye guairen* [1928]). Ma-Xu drew inspiration from Hollywood films such as *The Hunchback of Notre Dame* (1923) and *The Phantom of the Opera* (1925), both of which starred Lon Chaney, "The man of 1000 faces," as the scary title character. Advertisements for *Song at Midnight* presented Ma-Xu as Chaney's Chinese counterpart—a master of grotesque transformation.

As historians Leo Ou-fan Lee and Zhang Zhen point out, the film is not shot in a strictly realist mode but shares stylistic elements with German expressionist cinema.[2] It also borrowed tropes from recent Chinese cinema. Many early Chinese sound films use the word "song" (*ge*) in the title, and the motifs of the grotesquely scarred revolutionary, his handsome double, the intertwining of love and revolution, and nightmarish atmospherics appeared just one year earlier in *Hearts United in Life and Death* (1936).[3]

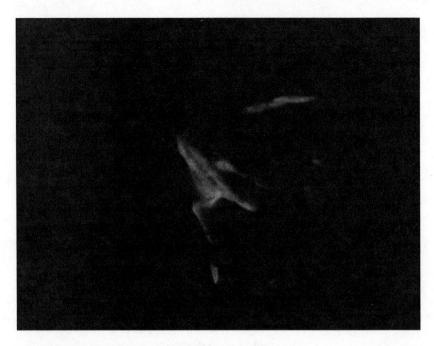

FIGURE 7.1 Establishing a spooky ambience
Source: Author

The first few minutes establish a spooky ambience. A shot of the moon against the sky dissolves into a long shot of an abandoned theater. As the bombastic soundtrack gives way to a lulling harp, the camera draws close to a public notice dated August 1926 stating that the theater will be demolished. A cat darts by. Abruptly, an enormous hand reaches out of the shadows (figure 7.1), and a long shot reveals that it belongs to a sinister-looking figure who emerges from the door holding aloft a lantern that shines on his haggard features and long fingernails. The next shot, of a triangular shadow moving across the wall, is ambiguous: Is it this old man's, or someone else's? A jarring cut confronts us with the face of another man, in medium close-up, lit from below, leering at the camera. The first old man, the theater caretaker, arrives and produces a note from his pocket stating that the Angel Theatrical Troupe is scheduled to arrive that night. (The same point-of-view shot is repeated five times to give the viewer time to read the letter.) A gust of wind blows out a lantern and disperses the two men.

FIGURE 7.2 The disembodied singer
Source: Author

As in *Street Angels* (1937), released five months later, the first song begins just a few minutes into the film, but unlike in *Street Angels* we do not see the singer at first.[4] The shadow of a cloaked, hooded figure looms in front of a crumbling wall. and a deep voice begins to sing a song of a lonely man wandering and singing in the night, as lyrics appear at the bottom of the screen (figure 7.2). At the mention of the night watchman, an abrupt cut interrupts the song and a watchman walks by with a lantern, banging the midnight hour on a gong. The song resumes and another apparition appears: a young woman clad in white, with a candle-bearing, hunchbacked old woman at her side, walks forward toward the windows as if in response to the singer's question: "Who will wait with me until the dawn?"

The mysterious singer addresses the young woman with metaphors of their shared solitude: she is moon, he is a cold star nearby: she is a tree on the hill, he a withered branch. He sings that though he looks hideous, he is determined to speak aloud for injustice. "I would emulate

that 'castrated historian' / who wrote of the injustices among mankind," he sings, likening himself to Sima Qian, who wrote *The Records of the Grand Historian*, China's most famous work of historiography, after being castrated for an alleged political crime. The singer, too, is a martyr. His "Song at Midnight" climaxes with rage that billows like waves.

Scholar David Der-wei Wang (2004) has written of modern Chinese literature as being haunted by "the monster that is history" in the form of repeated cycles of trauma, suffering, violence, and cruelty. *Song at Midnight*, too, dramatizes a story of repeated harm to the revolutionary cause, as personified by two young men. The phantom represents a repressed history of monstrosity, confined to the attic, awaiting its chance to reemerge. His role as a storyteller also calls to mind another historian: Pu Songling, the author of China's most famous collection of ghost stories, *Strange Tales from a Chinese Studio* (1740). Pu called himself the Historian of the Strange (*yishizhe*), and Song Danping is a Strange Historian two times over; he sings and speaks of strange events, and he himself is an unusual being. His nocturnal relationship with a ghostly maiden in white, conducted through sound as each remains in isolation, too, seems like an uncanny twist of the Scholar-Beauty romances of traditional Chinese fiction, one with no happy ending in sight. The theater where their love first blossomed is a ruin. Yet this strange historian turns out to be no mere teller of tales, as he uses his own maimed body to protect the next generation from being victimized as he was.

Song at Midnight establishes a strong acoustic theme with its title song, a busy orchestral soundtrack, and extensive use of atmospheric sound effects to simulate wind, rain, and thunder. The Angel Troupe's arrival at the theater, for example, is accompanied by a cascade of violins. Despite the storm, the scene is jolly, with a hubbub of excited voices. The troupe's entrance into the theater interior, in contrast, takes place in suspenseful silence. The old caretaker—the foremost in a cast of picturesque supporting characters, with flowing hair and long whiskers—limps along with his long fingernails clutching his lantern, leading the crowd down a dark passageway. For over a minute of screen time, the only sound comes from shuffling footsteps and the wind. A string twangs as a snake falls from the cobwebs to the stage. Mice skitter across the floor. With another twang, the crowd looks up to see a pair of corpses hanging above the stage in midair. An actress screams, but it's just a pair of dummies.

The next day, the troupe leader announces that they will be rehearsing a new operetta. Set in the Song dynasty, "Romance of the Yellow River" concerns lovers on opposite sides of the river—a waiting woman, named Treasure, and a man who sings of being like a "little bird who cannot return to its nest." The theme of this play-within-a-play returns at the end of the film, which features a watery death.

The first musical number, "Song at Midnight," already established Danping's voice as a controlling force: when he sings of rain, waves, or a watchman, they appear before our eyes. When Danping teaches Xiao'ou how to sing "Romance of the Yellow River," the disembodied voice starts to control the direction of the story. A brief scene shows Xiao'ou triumphing onstage, and he returns to backstage to thank his mentor. Following a mysterious voice up to a tower room, a discordant crash of piano wires conveys Xiao'ou's shock and horror at the dark, faceless figure who turns around, picks up a candle, and walks over to examine Xiao'ou's face (figure 7.3). "Don't be afraid," he says, "I am

FIGURE 7.3 Sun Xiao'ou and Song Danping meet face-to-shroud
Source: Author

human. I am the same as you—a man with blood, flesh, and soul." With pent-up urgency, he unburdens himself of his backstory as the revolutionary Jin Zijian.

This moment of encounter matches the voice to a body and intertwines spectacle and narrative. The truth of the mysterious phantom is revealed step by step, with both the unfolding of the backstory, and the unveiling of his scars, taking place in stages, with increasing suspense. Danping shows Xiao'ou a photo of himself from 1913 (figure 7.4)—thirteen years ago—and we see a young man furiously galloping to escape from some unknown pursuer.

Here is where the film brings together horror and history. The year 1913 was two years after the Republican Revolution, which toppled the Qing dynasty and founded the Republic of China. The Republic was weak, led by the military strongman Yuan Shikai, who had pushed aside Provisional President Sun Yat-sen and muscled his way into power. In 1916, Yuan attempted to make himself emperor of a new Empire of China.

FIGURE 7.4 Jin Zijian in 1913
Source: Author

Yet Yuan's imperial ambitions were already apparent in 1913, when provinces opposed to Yuan's abuses of power attempted to overthrow him in what became known as the Second Republican Revolution.

Jin Zijian was a member of the Revolutionary Party (*gemingdang*, not to be confused with the Kuomintang, or Nationalist Party), and thus likely a participant in the Second Revolution, and a victim of its aftermath. Jin's chosen stage name, Song Danping, also shares a surname with Song Jiaoren, the leader of the Nationalist Party who was assassinated in 1913 on the cusp of becoming prime minister. The pictorial magazine *The True Record* (1913) published documentary evidence linking the murder to Yuan Shikai, who promptly shut it down. Whatever the true story, the murder set back China's democratic hopes for decades. *Song at Midnight* alludes to this recent history by dramatizing, in a flashback sequence, an assassination attempt on a man named Song.[5]

Sun Xiao'ou arrives at the theater in the year 1926, during the Warlord Era. Only in 1928 would most of the northern warlords be suppressed, leading to a decade of relative political stability. In 1926, however, things are still looking dark for China, a new dawn is a distant hope, and revolutionaries are still singing a "song at midnight."

Xiao'ou demands to see his face, but the phantom is not ready yet. He tells the next part of his story, about how in 1916 he went undercover as an actor and performed the play *Hot Blooded* (*Re xue*), about European revolutionaries.[6] A flashback shows the dashing young man singing onstage to thunderous applause. But after the show, Xia warns Danping about the plot against him.

The torture scene exemplifies the film's theme of hidden suffering and visible scars. The emphasis is on spectatorship of suffering rather than the process of victimization, including reactions of Xia, her father, and Tang Jun. As in other scenes, the focus is on the witnesses and perpetrators of atrocity. Immediately after the whipping, Xia condemns Tang, and he retaliates with the acid attack.[7]

We next see Danping at the home of the troupe leader, Mr. Zhong (played by Li Junpan, the principal in *Goddess* [1934]), and his wife and young daughter, his head and hands swathed in bandages. The doctor advises that Danping should recover within a week. Mr. Zhong tells Danping that they preserved the bottle as evidence against Tang Jun, but Danping is reluctant to prosecute, because he wants to protect Xia.

The detail, again, echoes the Song Jiaoren case: having a true record is not enough to prosecute the guilty.

THE POLITICS OF HORROR

The scene of Song Danping's recovery day combines suspense and melodrama, leading up to the reveal of the hideous transformation. Like in the 1925 film *Phantom of the Opera*, the unveiling occurs precisely at the film's halfway point. Let's take a close look at the scene, which confronts the viewer literally and viscerally with the horror of historical violence, before turning to the second half of the film, which contains several more sensational revelations.

Song Danping's entire head and hands are swathed in bandages. Zhong's daughter admires herself in a mirror, trying on a flower (figure 7.5). Old Zhang, the caretaker, arrives with a gift from Xia, and Danping

FIGURE 7.5 Girl with flower
Source: Author

pleads with Zhong to take off his bandages so that he can see the flowers and read the letter. She will be coming to visit him the next day. As Zhong unwinds the bandages from Danping's head, the camera stays fixed on the onlookers, as we hear Danping's voice urging haste.

The storm raging outside climaxes as the final bandage comes off. The girl screams and all four retreat in horror. The suspense is drawn out: we see only reaction shots and the back of Danping as he stumbles forward to a mirror, next to which is a vase of flowers. A dissolve gradually reveals his scarred face, and he picks up a candle to gaze upon his own hideous visage. The mirror represents another doubling: it is as reflection that the man is first seen as distorted apparition, a self as virtual as Jin Zijian's photograph. Danping knocks down the candles and uses the flower vase to smash the mirror (figure 7.6). As he rages around the room, intercuts show the horrified reactions of Old Zhang and Mr. Zhong.[8]

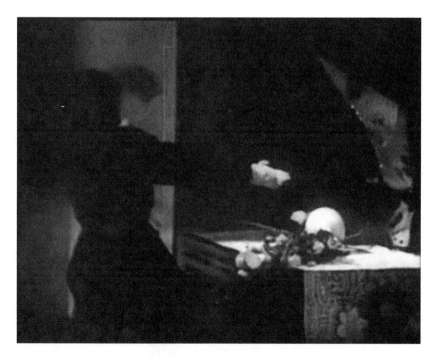

FIGURE 7.6 Danping uses a flower vase to smash his mirror image
Source: Author

Xia's reaction to the news of Danping's death reenacts his shock and hysteria. Her nervous breakdown is conveyed through a montage of canted framings, giddy superimposed images, and blurred focus combined with the thundering crash of piano wires. She finally collapses and spits blood. We then see Old Zhang breaking the news of Xia's mental collapse to Danping, who remains off-screen.

These extended flashbacks are followed by a second unveiling of scars. With a sonic crash, Danping tears off his head covering and again unveils his hideous scar, imploring Xiao'ou to use his voice to comfort Xia in his stead. Back at Xia's residence, we see a long-haired, pale-faced woman in a ghostly white robe drawn to the balcony at night by the voice of an apparition, an image similar to the scene of Ellen sleepwalking in *Nosferatu* (figures 7.7 and 7.8).

Xia looks out to see Xiao'ou standing in the woods as Danping's doppelgänger, reenacting their rendezvous of a decade earlier. Xiao'ou speaks on behalf of Danping who looks on from a hiding place in the

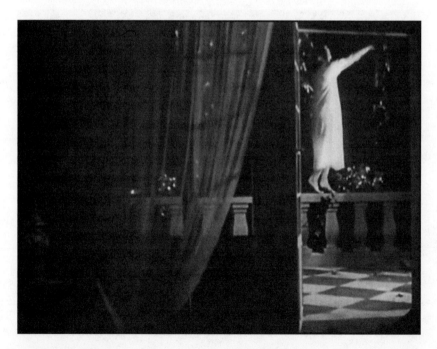

FIGURE 7.7 Woman in white on a nighttime balcony in *Nosferatu*
Source: Archive.org

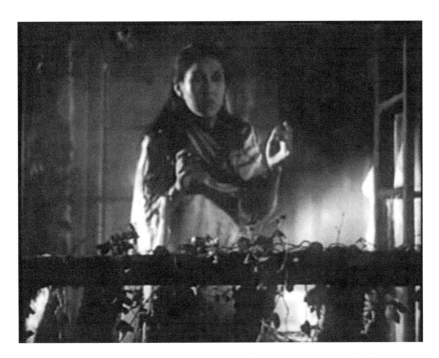

FIGURE 7.8 Woman in white on a nighttime balcony in *Song at Midnight*
Source: Author

woods. Xiao'ou advises Xia not to be scared, to believe that Danping will always be by her side, until the dawn arrives. Unlike Cyrano de Bergerac in Edmond Rostand's famous play (made into a film in 1925), Xiao'ou does not court the woman on another man's behalf, but entreats her to live with optimism. Alone in the cobwebbed, misty woods, she repeats the word "Dawn (*guangming*) . . . dawn . . . dawn."

Light was a stock metaphor for political optimism in dark times. The "bright tail" (*guangming de weiba*) was a "flimsy" convention in many left-wing films of the 1930s,[9] though some films, like *Daybreak* (1933), make light a leitmotif. *Song at Midnight* repeats the word *guangming*, meaning bright or dawn, in the dialogue several times. The dialectic of shadow and light, common in the horror genre, here also suggests a rhetoric of hidden secrets and revelation of the truth.

The focus on marginalized figures intertwines the fantastic and the mundane. The Angel Troupe can barely afford to inhabit a physical space that is on the brink of death: the old theater is condemned to be

demolished. Even the respite of this temporary refuge from the [political] storm for these angels is cut short. Box office receipts decline, and the troupe faces eviction. The plot point is self-referential, as many of the film's actors came from the theater world and were familiar with the profession's economic precariousness.

Performers being economically and sexually exploited is an enduring trope in modern Chinese cinema, also appearing in *The Little Angel* (1935), *Street Angels* (1937), Ma-Xu's two-part film, *Begonia* (1943), Xie Jin's *Two Stage Sisters* (1964), and Chen Kaige's *Farewell, My Concubine* (1993), which was partially inspired by *Begonia*.[10] Star stage performers were popular and attractive, but also prey to the moneyed, entitled patrons who might seek to exploit them for sex or politics. Even Peking opera star Mei Lanfang was forced to respond to coercion during the Japanese occupation of China. To avoid performing his famous female roles for the invaders, he grew a moustache.

Song at Midnight dramatizes this physical threat via Tang Jun. When he menaces Lü Die (Green Butterfly), history looks set to repeat itself. The "respectable" class who abuse their wealth and power are the true monsters of history. Lü Die's rebuff of Tang Jun, and Xiao'ou's misunderstanding, is dealt with perfunctorily, as the plot accelerates toward a conclusion. Tang attacks Lü in her dressing room. Crosscutting shows the tortured hero at the *Hot Blooded* climax onstage. Events then converge backstage as Xiao'ou stops Tang's attempted rape of Lü, Tang shoots her in his arms, and Song Danping suddenly looms out of the shadows to confront Tang. During the extended fight sequence, the tension literally escalates, with the pair grappling all the way up to Danping's tower room. Meanwhile, the play stops and audience members chase the fighting pair upstairs. Following Tang's plunge to his death, Danping escapes by swinging down to the stage on a rope. The long-hidden phantom literally takes center stage with a melodramatic entrance, but the exposure precipitates his demise. Xiao'ou takes the stage and yells at the crowd, "He's a man, not a demon!" (figure 7.9). But his calls go unheeded. To Danping, revival of his show offered hope of revival of the revolution, but rousing theatricality backfires, and the "hot-blooded" emotion of the audience ends up destroying the author of the show.

The final chase sequence, which uses extensive canted framing, superimposition, and match on action editing, is one of the most

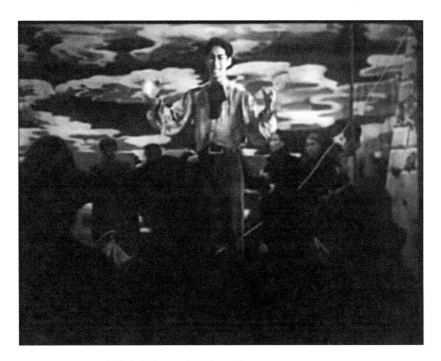

FIGURE 7.9 Xiao'ou's failed appeal to the audience
Source: Author

melodramatic in early Chinese cinema. Reminiscent of the ride of the Ku Klux Klan in D. W. Griffith's *The Birth of a Nation* (1915), a torch-wielding mob chases the phantom from the theater through the streets to an abandoned tower, which the mob sets alight. Cascading orchestral music and intercut shots of crashing waves heighten the tension. Two intercut sequences show Xia relapsing into madness. Then, just as the burning phantom plunges from the tower inferno into the river, Xia suddenly awakens from her "dream" (just as Ellen awakens after the death of the vampire in *Nosferatu*). The mob purges the ghastly apparition from its midst; Danping's melodramatic death also exorcises Xia's trauma and allows her to regain her sanity and memory.

The climax and denouement bring together spectacle, romance, doubling, symmetry, and light triumphing over dark. The final shot shows Xiao'ou and Xia at the edge of a cliff, together, staring off toward the dawn. Xiao'ou once asked Lü Die what she would do if she and he were forced to part, and she replied that she would commit suicide. In

the end, Lü Die dies protecting her man, who later steps in as the protector of a dead man's woman. A young "angel," Xiao'ou, takes the place of an older martyr who had been treated like a devil. The play-within-a-play was called "Romance of the Yellow River," and Song Danping's last gesture appears to be to throw himself into that sublime symbol of China, the Yellow River.

Five months after *Song at Midnight*'s release, China plunged into open war with Japan. The film's mood of trepidation, horror, and menace, combined with its ambiguous political message, seems to express a sense of dread about a country on the verge of war. The play-within-a-play, set during the Song dynasty, is the type of historical allegory that was to flourish during the war as resistance ventriloquism. *Song at Midnight*, too, invites a political interpretation by presenting a long-suffering political activist who asks the current generation to fulfill an uncompleted revolutionary mission. As film scholar Yomi Braester points out, "as a wound that has healed but yet remains visible, [Danping's] scar is an apt metaphor for the underground revolutionary's liminal presence."[11]

The film anticipates the logic of inevitable revolutionary succession (*zi you houlai ren*), explicit in many communist-era films, but with a twist. Braester notes that the off-screen phantom teaches the young actor not only how to sing the revolutionary songs of old but also how to fulfill the destiny that the phantom himself was not able to realize. The triumphant restaging of *Hot Blooded* as "Song Danping seemingly come back to life" presents revolutionary inheritance as self-consciously theatrical. Yet the repugnant scar undermines the effectiveness of political theater. Danping's monstrous reappearance overwhelms the promise of forward progress, and the audience is agitated only to bay for the "hot blood" of the maimed revolutionary, not of the assailants who made him so ghoulish. At the crucial moment, when the stage play is collapsing and the real drama is afoot, Xiao'ou's voice fails to overcome the audience's revulsion at the sight of monstrosity.

In this 1937 film, a devilish apparition—viewed by the unsympathetic mob as a demon (*yaoguai*)—is killed off, but an enlightened representative of the next generation vows that his spirit will live on. After China declared war against Japan, the invaders were referred to as "devils" (*gui*), an epithet that excoriated their inhumanity. Dehumanizing rhetoric also prevailed during many political campaigns of the 1950s

and 1960s, infamously at the beginning of the Cultural Revolution in 1966, when the *People's Daily* exhorted the masses to "sweep away all ox demons and snake spirits." As *Song at Midnight*'s coded ideology implies, those who claim to be purging evil often end up perpetrating evil on the scapegoats they create.

NOTES

1. A full-page advertisement announced the film's opening in *Shenbao* 22913 (February 20, 1937), 24. The February 21 ad screams "ALLEYS ARE RIFE WITH TALK OF A 'WALKING CORPSE!'" and adds, "Despite drenching rain, people thronged to the cinema yesterday, and showings were sold out half an hour before opening." *Shenbao* 22914 (February 21, 1937), 26. According to one report, *Song* saw full houses, three showings a day, for three days, setting a new box-office record at the Lyric. *Xinwen bao* (February 25, 1937), local news section, 5. Premiere publicity details, and a poster from the film's run at the Capitol (Luguang) in May, appear in Zhang Zhen, *An Amorous History of the Silver Screen: Shanghai Cinema, 1896–1937* (Chicago: University of Chicago Press, 2005), 299–300. A different Capitol (Luguang) Theater, in Chengdu, screened the film in 1956. Yomi Braester, *Witness Against History: Literature, Film, and Public Discourse in Twentieth-Century China* (Stanford, Calif.: Stanford University Press, 2003), 83–84.

2. Lee calls the film "a masterful adaptation of German expressionist cinema"; Zhang judges that stylistically it "shows more affinity with German expressionist drama and cinema" than with American cinema. Leo Ou-fan Lee, "The Urban Milieu of Shanghai Cinema, 1930-40: Some Explorations of Film Audience, Film Culture, and Narrative Conventions," in *Cinema and Urban Culture in Shanghai, 1922–1943*, ed. Yingjin Zhang (Stanford, Calif.: Stanford University Press, 1999), 96. Zhang Zhen, *An Amorous History*, 298.

3. Zhang Zhen, *An Amorous History*, 308, 331.

4. We do later see Song Danping sing as a young man, in flashback sequences. As Zhang Zhen (*An Amorous History*, 318) notes, actor Jin Shan lip-synched to the recorded voice of singer-composer Shen Jialun—a different type of phantom song.

5. The character is the same in Song Jiaoren, Song Danping, and Song dynasty but *not* the same word as the song (*ge*) appearing in the film's title.

6. A play titled *Hot Blooded* was performed by Chinese members of the Spring Willow Society in Japan in 1907. Bonnie S. McDougall and Kam Louie, *The Literature of China in the Twentieth Century* (New York: Columbia University Press, 1997), 161.

7. The motif of nitric acid for (attempted) disfiguring of a handsome male actor's face appears in *The Singing Beauty* (Chen Kengran, director, 1931). In Chen's film, according to Zhang Zhen, the actor is stopped from burning his own face, which instead ends up getting scarred in a car accident. Zhang Zhen, *An Amorous History*, 310. A (fake) vial of acid as the weapon of a love-rival also appears in Cecil B. DeMille's *Why Change Your Wife?* (1920).

8. A theatrical mirror-smashing scene appears in the suicide scene in *Song of the Fishermen* (1934), preceded by an extended superimposition showing the distraught man's memories of the wife who left him.

9. Laikwan Pang, *Building a New China in Cinema: The Chinese Left-Wing Cinema Movement, 1932–1937* (New York: Rowman and Littlefield, 2002), 207.

10. In *Begonia* (1943), a male opera star who stars in female roles becomes an object of sexual interest to a warlord. The actor has a secret affair with the woman who was forced to become one of the warlord's concubines and helps her (and their love-child) to escape his clutches. A shot of the female impersonator putting on his makeup in the mirror is recreated in *Farewell, My Concubine*, which also drew on Lillian Lee's (Li Bihua's) novelization of *Begonia*.

11. Yomi Braester, *Witness Against History*, 87.

SOURCES/FURTHER READING

Braester, Yomi. "Revolution and Revulsion: Ideology, Monstrosity, and Phantasmagoria in 1930s Chinese Cinema." In *Witness Against History: Literature, Film, and Public Discourse in Twentieth-Century China*, 81–105. Stanford, Calif.: Stanford University Press, 2003.

Chua, John. "Something Borrowed, Something New: *Ye Ban Ge Sheng* (*Song at Midnight*) and the Cross-Cultural Reinterpretation of Horror in Twentieth Century China." *Asian Cinema* 16, no. 2 (Fall/Winter 2005): 122–146.

Leroux, Gaston. *The Phantom of the Opera* (1909–1910). English translation at Project Gutenberg. http://www.gutenberg.org/files/175/175-h/175-h.htm.

Pu Songling. *Strange Tales from a Chinese Studio*. Trans. John Minford. New York: Penguin, 2006.

Robinson, David. "Return of the Phantom: Maxu Weibang's Ye Ban Ge Sheng." In *Fear Without Frontiers: Horror Cinema Across the Globe*, ed. Steven Jay Schneider, 39–43. Goldaming, UK: FAB Press, 2003.

Rostand, Edmond. *Cyrano de Bergerac* [1897]. Ed. and trans. Carol Clark. New York: Penguin Classics, 2006.

Wang, Yiman. "Mr. Phantom Goes to the East: History and Its Afterlife, from Hollywood to Shanghai and Hong Kong." In *Remaking Chinese Cinema Through the*

Prism of Shanghai, Hong Kong, and Hollywood, 113–141. Honolulu: University of Hawai'i Press, 2013.

——. "The Phantom Strikes Back: Triangulating Hollywood, Shanghai, and Hong Kong." *Quarterly Review of Film and Video* 21 (2004): 317–326.

Zhang Zhen. "Song at Midnight: Acoustic Horror and the Grotesque Face of History." In *An Amorous History of the Silver Screen: Shanghai Cinema, 1896–1937*, 298–344, 405–411. Chicago: University of Chicago Press, 2005.

FURTHER VIEWING

Begonia (*Quhaitang* 秋海棠). Ma-Xu Weibang, director. 1943.

The Birth of a Nation. D. W. Griffith, director. 1915.

Cyrano de Bergerac. Augusto Genina, director. 1925.

Farewell, My Concubine (*Bawang bieji* 霸王別姬). Chen Kaige, director. 1993.

The Hunchback of Notre Dame. Wallace Worsley, director. 1923.

Mid-Nightmare (*Yeban gesheng* 夜半歌聲). Chau Feng Yuen (Yuan Qiufeng), director. 1962.

Nosferatu: A Symphony of Horror (*Nosferatu, eine Symphonie des Grauens*). F. W. Murnau, director. 1922.

The Phantom Lover (*Xin Yeban gesheng* 新夜半歌聲). Ronny Yu Yan-tai (Yu Rentai), director. 1995.

The Phantom of the Opera. Rupert Julian, director; uncredited co-directors: Lon Chaney, Edward Sedgwick, Ernst Laemmle. 1925.

Two Stage Sisters (*Wutai jiemei* 舞台姊妹). Xie Jin, director. 1964.

Street Angels (*Malu tianshi* 馬路天使)

Alternative English titles: *Street Angel, Angels in the Street*
Director/screenplay: Yuan Muzhi
Studio: Mingxing
Date of release: July 21, 1937
90 minutes, 10 reels, sound
Cast: Zhao Dan, Zhou Xuan, Wei Heling, Zhao Huishen, Wang Jiting,
Qian Qianli, Yuan Shaomei

SYNOPSIS

Autumn 1935. Xiao Hong, a young woman in her late teens, and her elder sister, Xiao Yun, have fled their home in northeast China due to armed conflict and ended up in the slums of Shanghai. There they live with a married couple who run a teahouse and who abuse and exploit them. They compel Xiao Hong to sing for customers and force Xiao Yun to work as a streetwalker. Xiao Hong is in love with Chen Shaoping, a poor young man who works occasionally as a musician. Shaoping lives across the alley with his friend Wang, who sells newspapers, and three other friends who work as barbers and peddlers. Sometimes, they share a duet across the alley, with Xiao Hong singing and Shaoping playing the fiddle. Xiao Hong's singing for the teashop customers attracts the

attention of a thug known as Mr. Gu. At one point, Shaoping is misled into thinking that Xiao Hong has jilted him for Gu; drunk, he forces her to sing for him like any other customer. Xiao Hong is distraught, but when she overhears Gu arranging to buy her from the teashop proprietor, she runs away and, reconciling with Shaoping, moves with him and his friends to a new apartment in a secret location. Shaoping and Wang want to protect Xiao Hong by filing a lawsuit against her "parents," but at a lawyer's office they discover that legal representation is beyond their means. Xiao Yun, harassed by the police and abused by her foster father (who has raped her), is in love with Wang and wants to move in with them too. Shaoping refuses, because she is a prostitute. Xiao Hong and Shaoping get married in a common-law ceremony in the apartment, but the group cannot pay the rent and faces eviction. Despite offering a special promotion, the barber shop, three months behind on rent, is forced to close. Meanwhile, Xiao Hong's foster father and Gu hunt Shanghai for her. They corner Xiao Yun, who refuses to reveal Xiao Hong's whereabouts, and her foster father throws a knife at her heart. Her friends and Xiao Hong find the injured Xiao Yun, who dies in the apartment just as Wang returns to report "I didn't have enough money. The doctor wouldn't come."

THE TALKIES AND THE SINGIES

Street Angels is a film that reminds us that sometimes it's not about the story, or the image; sometimes it's about the song. Set in the "slums of Shanghai," *Street Angels* represents the lives of the urban underclass. The film links this sociology—through images and dialogue—to national issues, including economic policy and military conflict. The film also features, right from the beginning, music. The most important part of the soundtrack is a pair of songs, sung by the young star Zhou Xuan, which have remained popular ever since. So in *Street Angels*, what we hear is arguably as important as what we see.

This chapter focuses on two distinctive elements of *Street Angels*: sound and sociopolitical commentary. The film entertains sonically with songs, instrumental numbers, sound effects, and humorous dialogue. Sound is also a theme to comment on current affairs. The first part of this chapter discusses the emergence of sound in the Chinese film

industry, leading lady Zhou Xuan, who plays the songstress Xiao Hong, and her two songs, "Song of the Four Seasons" (*si ji ge*) and "Songstress at the Ends of the Earth" (*tianya genü*). The second section discusses other acoustic characters who are defined through sound, and explores how Yuan Muzhi uses sound and image to make a broader critique, presenting the urban underclass—and even China itself—as unable to make its voice heard.

Recorded sound was first added to film in 1926, and *The Jazz Singer* (1927), starring Al Jolson, was the first full-length sound film. (Earlier films were often accompanied in cinemas by live music or narration.) The first "talkie," as the title *The Jazz Singer* implies, was also a "singie," with several extended song sequences. On-screen singing was a sensation and quickly gave rise to new genres, such as the musical. *The Jazz Singer* was shown in China in 1929, and the first Chinese sound-on-disk films were produced in 1931.[1] Films like *The Great Road* (1934)—which begins with a song—and *New Women* (1935) were shot silent and had dubbed sound added later. By the late 1930s, Chinese studios were producing more films, like *Song at Midnight* (1937), that mixed dubbing with live-recorded sound.

The advent of sound film presented both opportunities and challenges. Now filmmakers could use theme songs as a draw—advertisements never failed to highlight musical numbers—and audiences could hear voices and sound effects. Sound expanded cinema's reach to illiterate audiences who could not read intertitles or subtitles. The problem was that some actors (by popular standards, at least) did not sound as good as they looked and needed voice coaching to smooth out their accents. The dialogue in late 1930s films can sound a bit stilted. A "national language" (*guoyu*) was still in the process of being standardized too, so just *how* to speak was still up in the air.

For most Chinese audiences, it seems, sound enhanced the appeal of cinema. Musicals were extremely popular. Chinese productions such as *Song of the Fishermen* (1934), "Chinese Shirley Temple" Hu Rongrong's star vehicle *The New Year's Gift* (1937), and *March of Youth* (1937), use music to express pathos of the disadvantaged, to delight with catchy tunes, and to promote militarism. Also in 1937, Lianhua Studio produced a genre sampler called *Lianhua Symphony*, using a musical metaphor for filmmaking and showing studio personnel singing in unison.

In 1927, the same year that *The Jazz Singer* was released, the writer Yu Dafu quipped that "ice cream and cinema are the crystallization of twentieth-century century culture": both provide mass gratification for a low price. In 1933, another critic claimed that China had two kinds of films: "hard" films, which force ideology down audiences' throats, and "soft" films, which are like "ice cream for the eyes, a sofa for the soul."[2]

Street Angels offers ice cream for the eyes—and ears—but no sofa for the soul. Yuan Muzhi, a dramatist, had starred in *Plunder of Peach and Plum* (1934) (his screen debut, which he wrote), and *Children of the Storm* (1935)—a patriotic film in which Yuan sang the song, written by twenty-three-year-old composer Nie Er, that later became the national anthem of the People's Republic, "March of the Volunteers." Yuan's films all deal with present-day social issues, but *Street Angels* offers no happy ending for the angels of Shanghai's streets.

Street Angels shares many elements with Yuan's experimental directorial debut, *City Scenes* (1935), including ensemble comedy, montages, songs, landlords pressing tenants for rent, and a keen interest in how people from different walks of life struggle to survive in Shanghai. An early sound film, *City Scenes* employs many conventions of the silent era, including visual gags, mimicry as an acting style (dumb shows), extensive use of comic sound effects—elements that reappear in *Street Angels*. The first montage of Shanghai in both films uses the same musical score and shares a few shots. *Street Angels*, which achieves a better balance of song, spectacle, and narrative, confirms that Yuan appreciated the power of sound for entertainment. It also shows that, like many of his contemporaries, he used songs to convey discontent about social and political realities.

Malu tianshi is often translated as *Street Angel*, but I prefer *Street Angels* for a couple of reasons. The first is to distinguish Yuan's film from the 1928 silent film (with dubbed soundtrack) *Street Angel*, whose leading lady, Janet Gaynor, won an Oscar for Best Actress. Yuan's film draws its title from that Frank Borzage film, which premiered in Shanghai on January 9, 1929,[3] as well as the plot of a young female runaway who ends up on the streets and falls in love with a young man (a painter in Borzage's film). The lovable ensemble surrounding Xiao Hong includes her sister and protector, Xiao Yun, who could be viewed as a fallen angel. In the March 1, 1937 issue of *Star Fortnightly*, a studio fanzine, a

production still showing Shaoping and his buddies is captioned "angels in a little noodle shop."[4]

Zhou Xuan, however, is clearly the star of the show. She was then still a teenager, and *Street Angels* is the most celebrated of the forty-something films she would appear in over the course of her career. By 1937, she had already been performing for five years as the member of a famous song-and-dance troupe led by Li Jinhui, and was promoted as "the Golden Voice." Zhou went on to become a major star across Sinophone Asia and southeast Asia, where her songs were on constant rotation for much of the 1940s and 1950s. Her rendition of "Song of the Four Seasons" appears repeatedly as the refrain of old Shanghai in Wang Anyi's 1995 novel *Song of Everlasting Sorrow*. In the 1930s and 1940s, Chinese audiences flocked to the cinema to hear and watch Zhou Xuan sing. (*Sorrows of the Forbidden City*, a high-budget and controversial 1948 production shot in Hong Kong, was her last major hit.) *Street Angels* offers listeners instant gratification, as her first song begins just seven-and-a-half minutes in.

The songstress is a central figure in a lower-class urban cultural tableau. (Zhou Xuan's given name, Xiaohong, is the same Xiao Hong as her character.) In late nineteenth- and early twentieth-century China, the songstress was part of an urban entertainment economy in which one could go to a restaurant, a wineshop, or a teahouse and order a song to go with one's meal or drink. The songstress (or sing-song girl) was a recurring trope in 1930s films. China's first sound-on-disk production, *Songstress Red Peony* (1931), starring Butterfly Wu (Hu Die), was based on the life of a real-life opera singer; it was followed two months later by *The Singing Beauty* (1931). *The Great Road* features a wandering songstress. In *Street Angels*, the songstress's songs do more than just provide a sense of realism. They narrate stories of woe in a lyrical mode, presenting suffering as cyclical, repetitive, and personal.

"Song of the Four Seasons" is a sentimental song of love, parting, and longing. In four stanzas, from spring through winter, it narrates the experience of a maiden who is separated from her lover by a "heartless blow." She flees south of the Yangtze River, where she dreams of home, her parents, and her man, whom she imagines to be suffering in the frozen north. She hopes to send him winter clothing that she has made, and she compares herself to the legendary devoted wife Meng Jiang, whose

husband died as a corvée laborer on the Great Wall and whose weeping caused the Wall to collapse.

As Xiao Hong sings, the sound of her voice is accompanied by images of the young woman she sings of—herself—and of the war she is fleeing (figures 8.1 and 8.2). As she sings, we also see images of the audience in the teahouse who are listening to her, so that we are both listeners *and* spectators watching listeners.

"Songstress at the Ends of the Earth" is another song of love and loss that, like "Song of the Four Seasons," may be enjoyed on its own. But it also has a narrative function as a sonic motif that unites the romantic leads, Xiao Hong and Chen Shaoping, played by heartthrob Zhao Dan.[5] She sings it for him from her window as he accompanies her on the *erhu* from across the alley; visually, each of the two lovers appears alone in the frame, in a shot/reverse-shot sequence, but the sound they make together unites them. They're playing their song, in raptures, but the

FIGURE 8.1 "Song of the Four Seasons": A maiden
Source: Author

FIGURE 8.2 "Song of the Four Seasons": A war
Source: Author

birdcage in Xiao Hong's hands and the lyrics about tears and parting
foreshadow entrapment and pain.

Sure enough, we hear the song again in very different circum-
stances. Shaoping, convinced that Xiao Hong has agreed to marry Mr.
Gu, comes to the teahouse, gets drunk, and orders a song. In his depres-
sion, he perversely reduces their relationship to a commercial trans-
action. In that singing sequence, sound design and image design work
together. Close miking of her voice pairs with close-up shots of each of
them in isolation, as well as superimposed images of their happy duet.
When she sings "My darling," we see Shaoping's face in close-up. As the
song progresses, the camera gets closer and closer to Shaoping's face,
creating a sense of increasing emotional intimacy and anguish. When
she reaches the line, "My darling, hardship only strengthens our bonds
of love," Shaoping abruptly strikes the table with his fists and stands
up to leave. Xiao Hong does not even get to sing "You are the needle
and I am the thread / My darling, threaded together we shall never be

parted." Earlier, when Xiao Hong sang "Song of the Four Seasons," the lyrics "Suddenly, the lovers are separated by a heartless blow" appear against images of war; now, "Songstress at the Ends of the Earth" is cut short by the "heartless blow" of the male lover (figures 8.3–8.5).

A songstress, or *genü*, would take pains to distinguish herself from a prostitute, or *jinü*, by telling customers, "I may sell smiles, but I don't sell my body." Xiao Hong and Xiao Yun, a songstress and a prostitute, are a pair symbolizing the precariousness and vulnerability of women; a captioned production still of the pair in *Star* calls them "two itinerants fallen on hard times."[6] Mr. Gu leers at Xiao Hong as he plucks the petals off a flower in his hand and then tramples them underfoot (as the playboy Dr. Wang does in *New Women*). His presence represents how easily a songstress could be forced to become a prostitute in a place like Shanghai.

Street Angels is also shaped by industry factors. As film historian Jean Ma points out, the beginning of the film focuses attention on Zhou

FIGURE 8.3 "Songstress at the Ends of the Earth," redux: tears
Source: Author

FIGURE 8.4 "Songstress at the Ends of the Earth," redux: memories
Source: Author

FIGURE 8.5 "Songstress at the Ends of the Earth," redux: a heartless blow
Source: Author

Xuan singing: during the first twenty-five minutes of the film, her character speaks only two words.[7] As Xiao Hong sings, animated words also appear at the bottom of the screen along with a bouncing ball that tracks the lyrics. This feature encourages literate moviegoers to learn the words, and perhaps even to go out and buy a copy of the record. One could even read the lyrics and score for "Song of the Four Seasons" in that same issue of *Star*. The prominence of song in *Street Angels* is a product of a close and mutually beneficial industry relationship among cinema, radio, print culture, and the gramophone.

THE SONGSTRESS AND THE STUTTERER

Japan had been encroaching on Chinese territory since the late nineteenth century, and even more aggressively since 1931, when it invaded China's northeast. The montage of battlefield images during "Song of the Four Seasons" alludes to this conflict, personalizing the war by turning it into the backstory of one young woman's romantic longing.

From July 7 to 9, 1937, Chinese and Japanese troops exchanged fire outside Beijing. The Marco Polo Bridge Incident would go down in history as the beginning of China's War of Resistance. On July 21, *Street Angels* premiered at Shanghai's Lyric Theater.[8] The Battle of Shanghai began on August 13, destroying much of the Shanghai film industry and dispersing its personnel. *Street Angels*, which has us listening to the songstress while seeing images of war, represents an epochal moment, a turning point from urban consumer culture to national resistance culture.

Yuan Muzhi, like many artists of his day, used sound—both actual sound and the *idea* of sound—to convey social and political messages. Chinese filmmakers appealed to audience tastes by allowing them to listen to pleasing melodies, but they also used sound to encourage them to think in other ways, especially about: *whom* art should speak for, *what* it should say, and *how* it should give voice to the voiceless.

Leftist critics of the 1930s advocated that literary and artistic production strive for "phonographic realism."[9] This concept held that art should act like a phonograph, recording reality and then playing it back to a broad audience with precision and clarity. The concept combined two ideas: that art should be faithful to reality and not distort it; and that art should use the broadcast power of mass technologies to spread ideology.

Street Angels is replete with arresting sound design. Opening credits are accompanied by a dizzying orchestral piece, the "City Fantasia" that also appeared in *City Scenes*.[10] Three minutes in, we hear the rattle of a snare drum, followed by a marching band and the sound of celebrants shouting out at a bridal parade on the streets of Shanghai. The sequence is inspired by the opening scene in Ernst Lubitsch's musical *The Merry Widow* (1934), in which not one but many young women wave down from the windows at the handsome man in the marching band—in this case, crooner Maurice Chevalier, "China's first talkie superstar,"[11] singing "Girls! Girls! Girls!" (figures 8.6 and 8.7).

Songs transform socio-political critique into sentimental refrain. "Songstress at the Ends of the Earth" sings plaintively of a female figure who could be taken to be a stand-in for the lower classes in general. *Street Angels* follows other leftist films of the 1930s in representing the

FIGURE 8.6 Looking down from the window at a man in a parade in the opening scenes of *The Merry Widow* . . .
Source: Author

FIGURE 8.7 ... and *Street Angels*
Source: Author

plight of marginal and underprivileged figures in society through attractive female leads. Further, this songstress is a war refugee who moves to a new home only to be harmed anew. She sings a lament for herself, for her loved one, and for her homeland. Her plight is presented as being analogous to China's long struggle against exploitation.

Another acoustic theme is the inability to speak out or to be heard. Xiao Hong is an acoustic character in two ways: she is a singer, of course, but she is also a frustrated listener. She strains to hear what Shaoping says during the parade and later strains to hear what he and his friends say from the window across the alley. She is also frustrated by what she hears from her adoptive parents, who treat her as a mere commodity to be exploited and sold. Eavesdropping propels the plot in several scenes, notably when Xiao Hong overhears the plan to sell her to Mr. Gu and she decides to move out (figure 8.8).

Shaoping, Xiao Yun, and even the Three Stooges could be considered acoustic characters because of how they are defined through sounds.

FIGURE 8.8 Xiao Hong as a frustrated listener
Source: Author

Xiao Hong summons Shaoping via a "wireless telegram" (*wuxian dian-bao*), shining light on their window curtain with a mirror; he responds by playing his (dubbed) trumpet. Often, she hears him (as sometimes do we) before she sees him. The sidekicks are inarticulate—they mostly mug and grimace and cross their eyes—but they do make noise, as when Shaoping strikes their heads and we hear drum-like sound effects.

One of the three men has a severe stutter. Stutterers and mutes (and individuals with other disabilities) were stock butts of humor in early twentieth-century China,[12] as familiar to audiences as the quack doctor in *Laborer's Love* (1922). The man can barely get a word out, and Shaoping repeatedly interrupts him with some variation of the admonition: "If you can't speak, then keep quiet!" The exchange becomes a running joke. On the occasion of Shaoping's marriage with Xiao Hong, the youngest member of the group reproaches Shaoping, suggesting that on this happy occasion he should give the man a chance to finish a sentence for once. By the end of the film, the phrase seems to mock all of these

characters, who lack a voice in deciding their fate. Xiao Yun, the silent sister, dies. Should *they* not speak, and risk a similar fate? And if they do not or cannot speak, who should speak for them?

These illiterate and inarticulate characters could be taken metaphorically as standing in for an entire class of people who do not fully understand their predicament, much less have any say about it. In an early scene, the group wants to write down a slogan of solidarity: "Sharing prosperity and facing adversity together."[13] Unfortunately, none of them can remember how to write the character *nan* 難, for "adversity." Wang finds it in a newspaper article pasted to their wall, which mentions the calamity China currently faces due to invasion by the imperialist "enemy" (Japan), the headline reading: "The Nation Faces Adversity. Everyone Must Stand Up and Take Responsibility."

Like *Daybreak* (1933) and *Playthings* (1933), *Street Angels* represents the lives of the urban underclass as essentially tragicomic, with the comedy as a foil to the tragedy. Shaoping's "foreign soldier" uniform, which has only a patch of fabric for the shirt, illustrates his poverty. His magic tricks amuse Xiao Hong while showing us that he really has nothing up his sleeve because he barely has sleeves. (Visual illusions and gags also abound in *City Scenes*.) For his last trick at the wedding banquet, he appears to pop a silver coin out of his mouth (*chukou*), and Wang gives him a title from yesterday's newspaper headline: "Massive Silver Outflows [*chukou*] This Month," referring to China's crisis of capital flight. As Shaoping discovers the next time he tries to pay the rent with a foreign dollar, the government tried to prevent the bleeding by outlawing transactions in anything but paper currency.

The earlier set piece in a lawyer's office is part of this economic parable. Shaoping and Wang think they have actually gone up to heaven because everything in this skyscraper is so clean, but they soon discover that heaven has a high price tag, and they will never be able to come up with the lawyer's fee to save their friend. The scene, played as bumpkin farce, underscores the well-meaning pair's ignorance and poverty. Later, the barbers give their evictor a ridiculous haircut, but they still get evicted.

Shortly before she moves in with them, Xiao Hong's friends across the alley put on a dumb show. They appear as backlit shadows, punching their fists into the air as a swelling musical soundtrack suggests

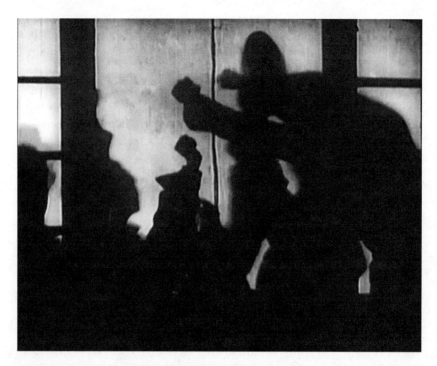

FIGURE 8.9 Dumb-show mimicry of heroism
Source: Author

struggle and triumph (figure 8.9). Yet this is only mimicked heroism. At their unofficial, improvised marriage ceremony, Shaoping borrows a friend's earring and puts it on Xiao Hong's finger as a wedding ring—a mimicry of marriage rights. One night, Shaoping is entertaining Xiao Hong with spooky stories, and just as he is telling about the ghost's approach, Xiao Yun bursts in through the door. The timing suggests that Xiao Yun's nocturnal life, always just one step away from being apprehended by the police, mimics that of a ghost. Like the lawyer's office, these scenes illustrate *Street Angels'* preference for staging irony over prescribing solutions.

Street Angels ends abruptly after the death of Xiao Yun. Her friends gather by her deathbed and agree that there is nothing to be done. ("Can't be done"—*mei banfa*—is also a refrain in *City Scenes*.) The film presents a communal plight but offers no clear answers as to how to solve the problems of these individuals, much less those besetting the

nation. The tone is one of lament rather than radical call to action, or a cri de coeur like the exclamation that bursts from the heroine's mouth on her deathbed in *New Women*: "I want to live!"

Xiao Yun's dying words, "Ants, ants"—seem to refer to not just to her friends but to all little people. They scurry around, but no one hears them, and they only get trampled underfoot. We cut to a shot from outside the room, looking at the ensemble through a window frame that resembles the bars of a birdcage, or a prison. For all the song and clamor of *Street Angels*, a film made on the outbreak of war, its ending is decidedly muted.

NOTES

1. A Chinese actor appears in blackface, like Al Jolson in *The Jazz Singer*, in the musical film *The Orphan of the Storm* (1929), directed by Zhang Huimin, who likely borrowed the title from D. W. Griffith's *Orphans of the Storm* (1921). Griffith's film premiered in Shanghai at the Carlton Theater on October 1, 1923. Notices about showings of the film appear in *Shibao*, September 27, 1923, 4; *The North-China Daily*, October 1, 1923, 16; *Shibao*, November 19, 1923, 4; *Shibao*, April 3, 1924, 4.

2. Yu is quoted in Yingjin Zhang, *Chinese National Cinema* (New York: Routledge, 2004), 109. Screenwriter Huang Jiamo's ice-cream quip is cited in Yomi Braester, *Witness Against History: Literature, Film, and Public Discourse in Twentieth-Century China* (Stanford, Calif.: Stanford University Press, 2003), 86.

3. "Janet Gaynor and Charles Farrell Teamed in Drama: 'Street Angel' to be at Carlton, Capitol on Wednesday," *The China Press* (January 6, 1929), 5. Its title appears in contemporary Chinese advertisements as *Anqi'er* 安琪兒, a transliteration of *Angel*. *Xinwen bao*, January 9, 1929, local news supplement, sec. 8, 30.

4. "Xiao miandian li de tianshimen" 小麵店裏的天使們. *Mingxing banyuekan* (*Star Fortnightly*), issue 195, vol. 8, no. 2 (March 1, 1937), leaf 15. The angel motif also appears in Wu Yonggang's *The Little Angel* (*Xiao tianshi* [1935]), a Wang Renmei vehicle made in response to the New Life Movement. On Wu's film, see Zhiwei Xiao, "Wu Yonggang and the Ambivalence in the Chinese Experience of Modernity: A Study of His Three Films of the Mid-1930s," *Asian Cinema* 9, no. 2 (Spring 1998): 3–15; Jubin Hu, *Projecting a Nation: Chinese National Cinema Before 1949* (Hong Kong: Hong Kong University Press, 2003), 105–106. The opening credits of *Street Angels* include Xie Jun as Young Man Fallen on Hard Times and Liu Liying as Young Woman Fallen on Hard Times, but the characters do not appear in the film, suggesting that a scene featuring these fallen angels was cut.

5. Zhao's comic brilliance is also on display in *Crossroads* (1937) and in *Crows and Sparrows* (1949), which costars Wei Heling.

6. "Tong shi tianya lunluoren" 同是天涯淪落人. *Mingxing banyuekan*, issue 195, vol. 8, no. 2 (March 1, 1937), leaf 14.

7. Jean Ma, *Sounding the Modern Woman: The Songstress in Chinese Cinema* (Durham, N.C.: Duke University Press, 2015), 56.

8. Huge crowds reportedly attended a sneak preview (*shiying* 試映) at Shanghai's Lyric Theater on July 21, 1937. *Shibao* (*The Eastern Times*), July 22, 1937, movie supplement, 8. The film officially opened on July 24. A short note in the magazine *Star China* about this preview mentions that Yuan worked on the film for eight months and that, after some disagreements with the censor, the film was eventually passed by Nationalist propaganda chief Shao Lizi, who considered its representation of the lower classes acceptable. *Xing Hua* (*Star China*), no. 11 (July 1937), 26.

9. Andrew F. Jones, *Yellow Music: Media Culture and Colonial Modernity in the Chinese Jazz Age* (Durham, N.C.: Duke University Press, 2001), 105–136, especially 107–109.

10. For an analysis of music in Chinese films of the era, focusing on the many that "feature musicians as central characters or music as a central framing device," including *City Scenes* and *Street Angels*, see Sue Tuohy, "Metropolitan Sounds: Music in Chinese Films of the 1930s," in *Cinema and Urban Culture in Shanghai, 1922–1943*, ed. Yingjin Zhang (Stanford, Calif.: Stanford University Press, 1999), 200–221, especially 203, 208–209, 215–216.

11. Paul Fonoroff, *Chinese Movie Magazines: From Charlie Chaplin to Chairman Mao, 1921–1951* (Oakland: University of California Press, 2018), 52. *The Merry Widow* premiered at Shanghai's Nanking Theater on December 29, 1934. *The China Press*, December 29, 1934, 8.

12. The monk Sandy has a stutter in the animated film *Princess Iron Fan* (1941), which adapts an episode from the Ming novel *Journey to the West*.

13. This phrase is one of several elements in *Street Angels* that had appeared that February in the Mingxing musical *The New Year's Gift*, which premiered during the Lunar New Year holiday; others include a close-up shot of calligraphy, the plot element of foreign dollars no longer being legal tender, a clearance sale, and fists raised in a dumb show.

SOURCES/FURTHER READING

Chion, Michel. *Film, A Sound Art.* Trans. Claudia Gorbman. New York: Columbia University Press, 2009.

Jones, Andrew F. "Mass Music and the Politics of Phonographic Realism." In *Yellow Music: Media Culture and Colonial Modernity in the Chinese Jazz Age*, 105–136. Durham, N.C.: Duke University Press, 2001.

——. "*Street Angel*: A Translation of the Full Filmscript." http://u.osu.edu/mclc /online-series/street-angel.

Ma, Jean. "A Songstress is Born." In *Sounding the Modern Woman: The Songstress in Chinese Cinema*, 31–70. Durham, N.C.: Duke University Press, 2015.

Ma Ning. "The Textual and Critical Difference of Being Radical: Reconstructing Chinese Leftist Films of the 1930s." *Wide Angle* 11, no. 2 (1989): 22–31.

Tuohy, Sue. "Metropolitan Sounds: Music in Chinese Films of the 1930s." In *Cinema and Urban Culture in Shanghai, 1922–1943*, ed. Yingjin Zhang, 200–221. Stanford, Calif.: Stanford University Press, 1999.

Wang, Anyi. *Song of Everlasting Sorrow: A Novel of Shanghai*. Trans. Michael Berry and Susan Chan Egan. New York: Columbia University Press, 2008.

Yeh, Emilie Yueh-yu. "Historiography and Sinification: Music in Chinese Cinema of the 1930s." *Cinema Journal* 41, no. 3 (Spring 2002): 78–97.

Yuan Muzhi. *Yuan Muzhi quanji* [Complete Works of Yuan Muzhi]. Ed. Yang Xinyu. 4 vols. Shanghai: Shanghai wenhua chubanshe, 2019.

FURTHER VIEWING

Children of the Storm (*Fengyun ernü* 風雲兒女). Xu Xingzhi, director. 1935.
City Scenes (*Dushi fengguang* 都市風光). Yuan Muzhi, director. 1935.
The Merry Widow. Ernst Lubistch, director. 1934.
The New Year's Gift (*Yasui qian* 壓歲錢). Zhang Shichuan, director. 1937.
Plunder of Peach and Plum (*Taoli ji* 桃李劫). Ying Yunwei, director. 1934.
Sorrows of the Forbidden City (*Qinggong mishi* 清宮秘史). Zhu Shilin, director. 1948.
Street Angel. Frank Borzage, director. 1928.

Hua Mu Lan (*Mulan congjun* 木蘭從軍)

Alternative English titles: *Mulan Joins the Army, Maiden in Armor*
Director: Richard Poh (Bu Wancang)
Screenplay: E. C. Ouyang (Ouyang Yuqian)
Studio: Huacheng
Date of release: February 16, 1939
89 minutes
Cast: Nancy Chan (credited as Cheng Yun Shang) (Chen Yunshang),
 Mai Hsi (Mei Xi), L. K. Han (Han Langen), C. C. Liu (Liu Jiqun),
 C. Z. Chong (Zhang Zhizhi), S. C. Ying (Yin Xiucen), N. S. Wong
 (Huang Naishuang), J. Tom (Tang Jie), C. L. Hong (Hong Jingling)

SYNOPSIS

Hua Mulan is a young woman living in a northern village during the
Tang dynasty. An able hunter and rider, she easily outshoots and out-
wits bullies from neighboring Li Village. When her father receives an
imperial summons conscripting him into the army to fight the invading
Huns, she begs to go in his place. Father has already served as a soldier
several times and is now an old man. His eldest son is dead, his other
son is a boy, and Mulan's elder sister is no fighter. Mother objects to
the idea, particularly because Mulan is unmarried, but Mulan impresses

her father with her skill at archery, swordsmanship, and the spear, and he acquiesces. His old armor fits her, and, at his prompting, she adopts a masculine voice to complete the transformation of her appearance. When the ward commander arrives to muster conscripts, she pays her respects to the ancestors and rides off disguised as a man. At a roadside tavern, two fellow Tang soldiers try to intimidate and then attack her, but she disarms them by flicking pebbles. Fellow soldier Liu Yuandu, who had noticed the self-possession of this handsome youth, is further impressed by the feat of prowess, and the two strike up a friendship. Over three years, Mulan leads Tang forces to a string of victories against the invaders, thanks in part to a map provided by her father, and is promoted to commandant. As Mulan and Liu discuss, however, these successes have made the army leader Marshal Zhang complacent and led him to underestimate the enemy. Zhang's treacherous second-in-command, the commander, introduces to Zhang two Hun officers who lie that their army is weak and will surrender. Mulan and Liu, disguised as a barbarian camel trader (Liu) and woman (Mulan), go north of the Great Wall to learn the location and size of the enemy army. Mulan kills three soldiers and intercepts a message that provides evidence that the Huns are planning to attack with a massive force. But when the pair deliver their report, the commander rejects it and one of his enemy guests mortally wounds Marshal Zhang just as he is mounting his horse. Zhang's dying command is to appoint Mulan marshal. She leads a sortie and routs the enemy. The emperor appoints Mulan and Liu to serve as officials, but not together. At the celebratory party, Liu gets drunk and tells Mulan that his only wish is to continue to serve his marshal. They share a duet under the moonlight, and then visit the capital to thank the emperor and beg leave to return home. They arrive in Hua Village to find Mulan's parents well, her sister a mother, and her brother taller. Mother shows her a stack of marriage offers, but Mulan says that she has already made her choice and shocks her comrades by reappearing in female clothes. Liu is delighted, and the two are last seen on their wedding night.

FIRES OF GENRE, CINEMA, AND WAR BURN RED

The story of Hua Mulan (Magnolia Flower) has been adapted into literature, drama, cinema, and folklore with myriad variations. The basic

story has a young woman taking her father's place in the draft and spending several years fighting off invaders before returning home, her army comrades never having discovered that she is a woman. A twelfth-century "Poem of Mulan" (which may date back to the sixth century) sets her story during the northern Wei Dynasty (fourth to sixth centuries). A seventeenth-century novel resituates her story in the Tang dynasty (618–907), when this film is set. In the novel, Mulan commits suicide after the death of her father. In *Hua Mu Lan*, as in most versions of the legend, she is joyfully reunited with her parents.

Mulan is not just a character, but also an archetype straddling the bounds of the fictional, the actual, and the possible. "Real-life Mulans" abound. Qiu Jin (1875–1907), who molded herself into a latter-day knight errant (a lone avenger, as opposed to professional soldier), left her husband and children to go to Japan, where she trained in swordsmanship and archery, then returned to contribute to various reformist enterprises before rebelling against (and being executed by) the Qing government. Notably, this revolutionary celebrity was interested in the "sartorial creation" of identity, posing for studio photographs "in Japanese women's dress (specifically, that of a woman warrior, with sword drawn), Manchu male dress, and Western male dress."[1] Xie Bingying (1906–2000), who began military training in 1926 and wrote extensively about her experiences fighting warlords and later the Japanese, was hailed by her scholarly father as a "second Mulan." Conversely, Asian Gioro Xianyu (1906–1948? 1978?), a cross-dressing female spy and military leader for Manchu and Japanese causes, was reviled in the Chinese press in 1937 as being the opposite of Mulan—not patriot, but traitor.[2]

Filmmakers have found in Mulan a heritage figure whose appeal is evergreen. This chapter discusses three aspects of this 1939 iteration. First, the film offers a mix of genres, including *wuxia* (martial chivalry), costume drama, musical, comedy, romance, and war. Second, its heroine is a consummate master of performance and disguise whose actions project not just martial prowess (*wu*)—a wartime necessity— but also cultural competence (*wen*). For all her costume changes, Mulan remains grounded in values. Third, *Hua Mu Lan* became a box-office smash across a divided nation but was also literally burned in the street. What factors affected such a reception, and what is the film's significance beyond the historical moment of its release?

Opera star Mei Lanfang appeared onscreen as Hua Mulan in a 1924 short—a man playing a woman playing a man. In 1927, Tianyi Studio released *Hua Mulan Joins the Army*, in which Mulan is already betrothed, and her fiancé fails to recognize her in uniform. Tianyi's quickie film (made in two weeks) was followed by a more elaborate production by Minxin Studio, *Mulan Joins the Army* (*Mulan congjun*, 1928; same Chinese title as the 1939 film), in which barbarians force Mulan to marry a girl, from whom she gains information about the invaders before escaping. Its young star, Li Dandan, had appeared in the costume drama *Way Down West* (1927) and later became "the first licensed Chinese aviatrix, returning to the screen one final time in 1939 as a pilot ferrying Dorothy Lamour in the Hollywood-produced *Disputed Passage*."[3]

Filmmakers of the 1920s incorporated Mulan into a new genre that had burned its way from the page to the screen. The term *wuxia* (Japanese: *bukyo*), often translated as martial chivalry, swordsman epic, knight-errantry, or martial arts, appeared in the title of a Japanese adventure novel in 1902 and was reimported into Chinese and applied to stories of gallantry and heroism set in China's imperial past.[4] A key difference between Mulan and most of the woman warriors in this action-adventure genre is that she is not a solo vigilante but a member of the army.

Wuxia drove the most productive period of early Chinese film history. According to Zhang Zhen, "some fifty studios produced about 240 martial arts films and hybrid 'martial arts-magic spirit' films (*wuxia shenguai pian*) . . . comprising about 60 percent of the total film output." During the peak year of 1929, eighty-five such films were released, including several installments of the eighteen-part movie serial *The Burning of Red Lotus Temple* (1928–1931), and no fewer than four "burning" films released by competing studios.[5] The genre was boosted by the Northern Expedition (1926–1928), a successful National Revolutionary Army campaign against militarists. Villains like the ruthless general in *Red Heroine* (1929; sequel 1930) were politically correct crowd pleasers. The "red" heroine fad even attracted parodies, like Xu Zhuodai's comic novel, *Red Pants, the Woman Warrior* (1930).

Hua Mu Lan was part of a second wave of *wuxia* films in 1939–1940, which included sound remakes and re-releases of *Burning of Red Lotus Temple* (1940) and *Red Butterfly* (1941). Mulan again took to the screen when the fires of war were burning red-hot. Screen fighting also raged

between several competing Chinese film industries. Shanghai, where *Hua Mu Lan* was made, became known as an "Orphan Island" (*gudao*) in late 1937 because the "orphaned" concessions remained under Western jurisdiction while the rest of the city was "submerged" (*lunxian*) under Japanese control. This political division continued until December 1941, when the Japanese occupied the entire city. Chinese-language films were also made in the Nationalist capital of Chungking, colonial Hong Kong and Singapore, and the Japanese puppet state of Manchukuo, where the government-funded Manying (Man'ei, 1937–1945) produced more than one hundred films. Stars mattered more than ever, and Huacheng Studio touted Nancy Chan as "Red [popular]! Red! So red she's purple!"[6]

Shanghai saw the most intense filmmaking activity, with production accelerating to a pace not seen since the late 1920s. Shanghai studios released 230 feature films between 1938 and 1941. In contrast, Chungking managed to produce only twenty features and sixty-three documentaries between 1938 and 1945. In late 1937, refugees flooded into the concessions, increasing the population from 1.5 million to around 5 million by the end of the year. The result was an "anomalous economic boom" and a captive audience. Six new cinemas were built in the concessions to meet demand in 1939, leading industry observers to proclaim it the "year of cinema." *Hua Mu Lan* was one of twenty-four films Huacheng Studio (previously known as Xinhua, producer of *Song at Midnight* [1937]) released in 1939, following on the success of *Sable Cicada* (1938; remade by the Shaw Bros. in 1958), a lush period piece about one of the four legendary beauties of ancient China.[7]

The war years were full of cinematic exchanges, negotiations, and peril. From 1938, Japanese operatives actively solicited collaboration from Chinese actors, producers, and studios. Actor Jin Yan, for example, fled to Hong Kong in late 1939 after being courted by the Japanese. Producer S. K. Chang (Zhang Shankun) arranged to register Huacheng as a Delaware company so as to obtain a degree of legal independence from Japanese control. Many stars having fled, Shanghai studios looked to Hong Kong for talent. These included *Hua Mu Lan's* star, Nancy Chan (Chen Yunshang), who had appeared in more than a dozen Cantonese-language productions, and its screenwriter, Ouyang Yuqian.

Costume dramas like *Hua Mu Lan* were a compromise between self-expression and business considerations. With original screenplays

scarce, Shanghai filmmakers recycled old stories and legends. Political line-toeing was imperative. Stories of legendary righteous heroes fighting off invaders were coded so as to pass the censor while drawing crowds. By June 1940, the trend became a "mania," with Shanghai's two major studios turning out costume dramas as fast as possible, Huacheng producing ten within forty-five days.[8] Audiences grew bored with the resultant cheap uniformity, and filmmakers shifted to contemporary topics.

THE *WEN-WU* WOMAN WARRIOR

Why recruit a cinematic Mulan to the war effort? China always wins, of course. Yet other agendas, including genre entertainment and specific types of political messaging, are also at play. Mulan is an individual with a strong sense of familial and national duty who maintains personal integrity while beating the odds on the battlefield. The film presents an eager warrior's triumphs as the epitome of cherished "national" forms, ethical and martial. And the crux of the legend is that it is a woman who performs a dangerous male role successfully, one who keeps herself chaste while keeping her country safe.

In a wartime climate of either-or and us-versus-them, Mulan brings us into the world of both-and. Stephen Teo points out that the "ambivalence" of female martial arts heroes helped *wuxia* films find a space amid wartime polarization.[9] Mulan adopts several identities in order to accomplish deeds. The film also deploys an array of genres to modulate the identity politics—action, music, slapstick, historical drama, undercover espionage, family drama, romance, and a happy ending.

Besting men at their game is part of Mulan's enduring novelty appeal. In the opening hunting scene, Mulan's first arrow downs a goose, and her second rouses a male hunter from the bushes (figures 9.1 and 9.2). A group of men emerges and accuses her of hunting in their territory. Having penetrated the hunter, Mulan tells him that she mistook him for a rabbit, *tuzi*, a slang term for a homosexual man. The rabbit association goes back to the twelfth-century poem, which closes with a stanza noting that male and female rabbits running side by side (note: in action) are indistinguishable. (Nancy Chan is said to have been cast as the lead in part because of her robust physique.[10]) The male hunter's comrade objects to the slight, but Mulan has already demonstrated her

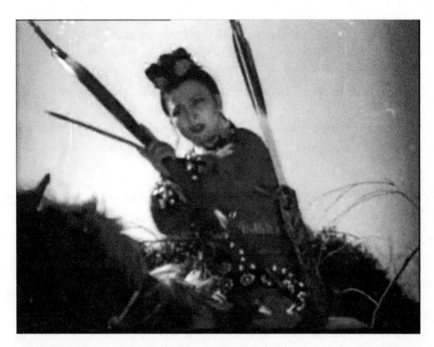

FIGURE 9.1 Mulan shoots . . .
Source: Author

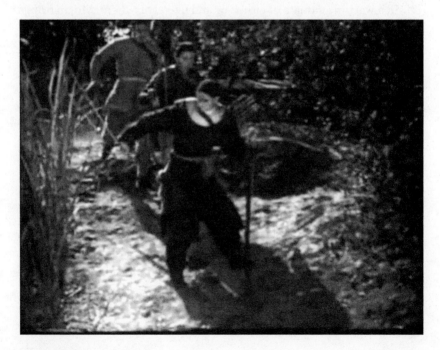

FIGURE 9.2 . . . a "rabbit"
Source: Author

superiority at archery: in contrast to her haul, the men have failed to bag a single animal. They thrust sharp weapons in her face, and the shot hunter pokes her in retaliation, but she manages to outwit them and escape. The scene dramatizes emasculation (the real or symbolic removal of male power, vigor, or effectiveness), as well as Mulan's wisdom: while a formidable fighter, she knows when to use strategy instead of force.

Mulan later encounters four Tang soldiers who mimic the hunters' attempt at intimidation. Their faces would have been immediately recognizable to audiences as belonging to the famous comedians Han Langen (Han Kui), Liu Jiqun (Liu Ying), Yin Xiucen (Goodie), and Zhang Zhizhi (Smoothie; the "Boss" in *Goddess*). Han takes leave of his wife by mounting his donkey backward. Liu hams it up for his baby. Mother chides Zhang for being impulsive (prompting a violent oath) and Goodie for sleeping too much (prompting a yawn). These comedians are not here to inspire confidence in China's army but to act as foils to our heroine.

They also partly defuse the homosexual taboo by displacing confessions of attraction from real men like Mulan's future husband Liu Yuandu (Liu Yuan Toh in the English credits, played by Mei Xi) to the mouths of buffoons. Bao Weihong notes that the "asexual body" of female knights-errant contrasts with Hollywood depictions of the strong, carnal physical presence of female action heroes.[11] But characters repeatedly remind us that Mulan is physically attractive. Han remarks that the lad looks just like a flower and then mocks Mulan as a little "chick," *ji*, a homophone of prostitute. (Han himself is a cuckold: Liu reassures Han that his new wife is sure to find a young man to keep her company.) Han later exclaims, "If he were a woman, I couldn't stand it!" (figure 9.3).

Mulan's first test in soldier sociability occurs at the roadside tavern where she disarms Liu and Han by flicking pebbles. The feat compounds the admiration of the onlookers, including Liu Yuandu and a serving girl. Mulan proves her prowess, while maintaining her attractiveness. At an inn that evening, she is unwilling to wash her feet in front of other soldiers, likely because her feet are bound. (In other versions of the legend, her reluctance is to pee in public.) The allusion to footbinding is anachronistic, as the practice was uncommon in the Tang dynasty.[12] That night, she and Liu have a date of sorts: a manly conversation with fist on hip, gazing at the stars. Their manner of interaction is polite, even

FIGURE 9.3 Han cannot stand Mulan's attractiveness
Source: Author

courtly. As he goes off to bed, a matte image of her old parents indicates that her mind is on them, not romance. Her comrades sleep side by side, she sitting at a table.

When Mulan and Liu dress up to infiltrate enemy territory, a second type of costume drama ensues (figure 9.4). In Kristine Harris's words, the scene "draws our attention back to the layers of disguise; the southern star Chen Yunshang—as a Shanghai actress—plays the filial daughter Mulan playing a male soldier now playing a barbarian woman,"[13] seducing and then killing the enemy. A woman using sex for espionage appears in *Daybreak* (1933) and *The Great Road* (1934) (both played by Li Lili), and in *Girl Martyr of an Isolated City* (1936) (played by Chen Yanyan). The trope reappears in Ding Ling's story "When I Was in Xia Village" (1940), in which communists send a young woman named Doubly Chaste (Zhenzhen) to work as a prostitute-spy in Japanese-controlled areas, and in Eileen Chang's novella *Lust, Caution* (1979), in which the female agent seduces a collaborator in occupied Shanghai.

FIGURE 9.4 Mulan's espionage performance
Source: Author

Only in *The Great Road* and *Hua Mu Lan* does the heroine in enemy
territory use sexual attraction while avoiding sexual peril.

The commander whom Mulan condemns as a traitor in the ene-
my's pay, played by comedian Tang Jie, is depicted as a stereotypical
devious court adviser or eunuch. Mulan again has to win the contest
by outwitting instead of outfighting her adversary, who outranks her.
Now the stakes are higher, and she is the object of emasculating insult:
the commander mocks Mulan for dressing up as a woman, saying that
she should go home and sing the part of the operatic female imper-
sonator (*dan*).

Screenwriter Ouyang Yuqian was himself a specialist in the *dan*
role, and cross-dressing, as Liu Yuandu tells Mulan, is justified in service
of the nation. Mulan's indignation is, essentially, Shanghai's response to
Chungking: We have been playing our role in disguise behind enemy
lines, at great personal risk. How dare you question our patriotism!
Nancy Chan—who as Marshal Hua poses in front of a tiger skin—wrote

Hua Mu Lan (Mulan congjun 木蘭從軍) 185

after the film's release that Shanghai filmmakers deserved respect for surviving in the tiger's lair.[14]

While calling upon viewers to reject despicable archetypes of masculinity, such as the coward and the traitor, the film begs a question of men in the audience: Can't you do better than a woman? Indeed, a month after the film's premiere, the script was "staged as a spoken drama by propaganda theater troupes traveling through China with the goal of mobilizing the masses and 'shaming' men into action."[15]

Sound is also part of the film's gender politics. After Mulan changes into armor, Father remarks that while she looks like a young lad, her voice is wrong. Back in her room, she practices a lower register: "I wish to devote my life to my country / I shall face the blade, cut off from my loved ones. *Kill!!!*" The next morning, she calls to her parents from outside the door and they fail to recognize her voice.

Mulan talks like a man, but sings like a woman. As in *Street Angels* (1937), the first song begins just after minute 7, when a group of children welcome her home from hunting. Mulan sings the second song a capella in female disguise while seducing enemy soldiers. The third song occurs after the victory celebration. After Liu's coded confession of devotion, she tells him to go to sleep and then begins a sword dance in her tent while singing "Where Is the Moon?" Lyrics tell of the moon (i.e., the object of longing) shining on the battlefield, on her bed, and on her sweet home. She thinks she is alone and sings in a female voice. Then his voice chimes in from outside the tent, making the song a male–female duet. Their convergence is represented through song and cinematography: at first, each singer is shown in isolation; only with the final couplet do they sing together in the same shot. As in 1930s Chinese musicals, songs are accompanied by animated lyrics. The songs highlight three of Mulan's functions: create goodwill, conduct espionage, and fulfill romance.

Cross-dressing "costume romance," which features in only some versions of the legend, has links to a literati tradition. In the tale of Liang Shanbo and Zhu Yingtai, known as "The Butterfly Lovers" (and made into the 1963 hit film *The Love Eterne*), a young woman dresses up as a man and accompanies a young scholar on the journey to the civil service examinations. As in *Hua Mu Lan*, one principal struggles to maintain her disguise while the other comes to terms with his nonplatonic attraction to a male companion.

Whereas the Liang–Zhu romance ends with the lovers' transformation into butterflies, *Hua Mu Lan* ends with a change of clothes. As Shiamin Kwa and Wilt Idema point out, Mulan is an outlier among Chinese legends, in that the transformations are *not* supernatural.[16] The 1939 film, too, emphasizes bodily performance, as opposed to the trick cinematography used in 1920s *wuxia* films to simulate magical skills. Due in part to financial constraints, most of the film (except for the hunting scene) is shot on a studio set. Such backdrops representing villages and borderlands of China's rivers and lakes were to be elaborated in color in the Shaw Brothers' midcentury epics.

The shallow depth of field keeps the focus on performance. Nancy Chan and Mei Xi have extensive close-ups and fight unseen foes in medium shots that emphasize expression, costume, and weapon. Mulan's hand gestures mimic those of Chinese opera, and she brandishes weapons in a space as confined as a theater stage (figure 9.5).

FIGURE 9.5 Operatic staging of a weapons demonstration
Source: Author

Armor, uniforms, and helmets (which are as anachronistic as the dialogue's mix of vernacular and classical Chinese or the reference to foot-binding), too, draw attention to facial expressions.

Singing, operatic fighting, and cross-dressing are all types of virtuoso performance, expressions of cultural competence, known as *wen*. The hunters harass in verse—two share a couplet—and brag that the men of the Li Village are consummate scholars (*wen*) and fighters (*wu*). Having determined that they consider their rhyme *wen*, she challenges them to a competition of *wu*. *Wen* and *wu*, as Louise Edwards writes, "were traditionally the twin preserves of men in their performance of ideal masculinity."[17] One hunter brags that he can hit a flying goose on a specific part of its body; Mulan asks him to do it single-handed. Her behind-the-back archery method, a type of super-*wen*, compounds the novelty image of Mulan herself. Mulan's *wen* is also on display in her interactions with her parents; her weapons demonstration (which is set to music); her letter home written in perfect calligraphy; and her duet with Liu Yuandu.

Opinions differ about the meaning of the ending. Upon Mulan's triumphant return home, Father's first command is that she change clothes. Mulan looks in the mirror and, in a dissolve, transforms back into her old feminine, coquettish self (figure 9.6). The final shot shows Mulan sitting at a table in front of the bed. Her groom comes in and she leans against him affectionately in response to his remark "Tonight, I'm not letting you sneak off anywhere!"

Poshek Fu remarks that "it seems that women's service is needed only when the nation is in crisis, and that once the emergency is over, they should go back home where they belong, like Mulan."[18] Kwa and Idema write that Mulan is "ultimately not a role model to women, who are expected to stay at home to serve the family as her sister does, but a role model to men."[19] Harris's interpretation moves beyond utility, to possibility: "The normative resolution seems designed to suggest that joining in the war effort or working underground using an assumed identity will not threaten society or diminish a woman's eligibility. But in presenting the marriage as Mulan's choice, it suggests that her wartime experiences have only enhanced her prospects and allowed the young woman a vivifying measure of self-determination."[20] *Hua Mu Lan*'s heroine is *wen* and *wu*, traditional and modern, public

FIGURE 9.6 Hua Mulan's final costume change
Source: Author

and domestic, serving her family and fulfilling her own desires, earning recognition of deeds from on high and looking forward to domestic bliss.

HUA MU LAN GOES TO WAR

Mulan, like all icons, is a figure onto which audiences can project desires. This version of her story seems crafted to please specific audiences. Patriots could find a ready allegory of resistance against an invader. Occupiers could approve a harmless costume drama. Fans could see Nancy Chan's glamour shine through her many costume changes as she acts, fights, sings, and speaks perfect Mandarin. Social progressives could find a role model who succeeds in all endeavors and finds fulfillment in career and love. Traditionalists could approve of Mulan's devotion to family and ruler and her return to home life after an escapade occasioned by national emergency. Residents of the occupied areas

could identify with the heroism of living in disguise. Migrants to the Greater Rear Area could cheer a plucky expression of defiance by their countrymen to the east. Artists could see in this film, which foregrounds performance itself, a valorization of cultural production.

Hua Mu Lan was released for the Lunar New Year holiday, on February 16, 1939, at the Astor, a brand new cinema specializing in first-run Chinese movies, in Shanghai, and three days later at the Central Theater in Hong Kong. Two other new films had competing premieres, both based on legendary figures: *The Autocrat of Chou* and *Lady Meng-jiang*, starring Zhou Xuan. *Hua Mu Lan* emerged as the queen of the box office. The film ran for almost three months in Shanghai, setting a record and making Nancy Chan the year's "hottest star nationwide."[21]

Huacheng followed with the musical extravaganza *The Cloud-Dress Immortal* (1939), whose title could also be translated as *The Divine Nancy Chan* (figure 9.7). Chan appeared in a Cantonese version of *Hua Mu Lan* produced in Hong Kong later that year. The film inspired a cycle of historical costume dramas, including *The Invisible Woman Warrior* (1940). Child actor Hu Rongrong appeared as *The Young Heroine* (1939) and was also tapped for a feature (not produced) entitled *The Birth of Mulan*.[22]

Hua Mu Lan illustrates the fraught nature of wartime production and exhibition. In mid-1939, S. K. Chang and heads of the other two major Shanghai studios agreed to a deal with the Japanese authorities that allowed them to distribute films in occupied regions and have access to film stock, on the condition that films be submitted to Japanese censorship. Japanese secret agents had objected that *Hua Mu Lan* was anti-Japanese, but entrepreneur Kawakita Nagamasa persuaded the authorities that the film was mere entertainment.

In fact, references to current events are thinly veiled. Mother wonders why the enemy "would come and attack us for no reason," and Father replies, "They're bandits—what else is there to say?" (This exchange did not appear in the original script.) When Mulan is accosted by fellow soldiers, she remarks that they should be uniting in their efforts against the enemy, instead of squabbling among themselves. (Similar calls for unity against a common enemy appear in *Daybreak* and *Bloodshed on Wolf Mountain* [1936].) Marshal Zhang wants to fight the invaders, while the commander wants to make a peace deal; the resemblance to Chiang

FIGURE 9.7 *The Cloud-Dress Immortal*
Source: *Qingqing dianying* (*Chin-Chin Screen*) 4, no. 8 (1939). Courtesy of the C.V. Starr East Asian Library, University of California, Berkeley.

Kai-shek and Wang Jingwei "would have been obvious to anyone in the audience."[23]

Hua Mu Lan opened in occupied Nanking in July 1939 and was a huge commercial success. The film was then sent to Chungking, where it passed Nationalist censorship and premiered in January 1940. During an afternoon screening on January 27, a man took the stage and condemned the filmmakers as traitors. Plants in the audience then led inflamed moviegoers to seize the film from the projection room and then to the street, where they burned not just one print of the film, but also a second brought over from another cinema.[24]

Amid the controversy, leftist playwright and screenwriter Xia Yan wrote an editorial vouching for Ouyang Yuqian's patriotism, but condemning S. K. Chang and Richard Poh as traitors, prompting front-page rebuttals. The government vowed to jail the riot leaders and allowed the film to continue screening.

Xia Yan, like the riot leaders, had not seen the entire film.[25] The objection was not to what it contained, but rather how it was made. Xia claimed that Chang's dealings with the Japanese constituted a "loss of chastity" (*shi jie*), an emasculating phrase that alludes to the importance of female chastity in the Mulan legend, and weaponizes it. In the end, the film was screened in many jurisdictions, including in Japan in 1942, becoming a wartime crossover success. In 1943, Poh and Chan worked together again on another controversial blockbuster, *Eternity*, commemorating the centennial of the first Opium War.[26] Li Xianglan, Chan's costar in that Shanghai–Manchukuo coproduction, was discovered after the war to be herself a real-life master of "passing." Having made many propagandistic films for the invaders, she was spared execution for treason when she disclosed that she was a Japanese national.

Hua Mu Lan is part of a long genealogy of Chinese films dealing with limitations, expectations, and possibilities for women. Mulan films made in ensuing decades include a Cantonese musical (Hong Kong, 1950–1951), a Henan opera (China, 1956), and an Amoy-dialect version (Taiwan, 1960–1961). New China filmmakers conscripted Mulan, along with the doughty heroines of *Third Sister Liu* (1960) and *Li Shuangshuang* (1962), to bolster the story of the communist revolution. In *The*

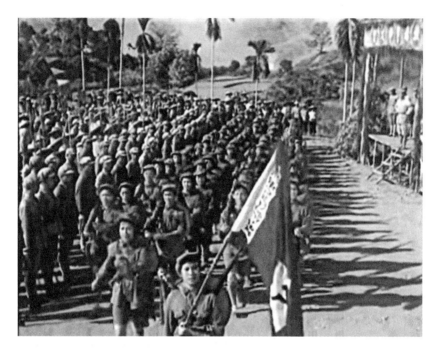

FIGURE 9.8 Singing the Communist army into the Mulan legend
Source: Author

Red Detachment of Women (1960) (figure 9.8), the woman warriors sing of parallel myths: "Long ago, Hua Mulan went to war in place of her father / Nowadays, the Women's Army serves the people."

Virtuosic gender-bending performance became one of the outstanding features of Hong Kong cinema. Ivy Ling Po (Huang Yujun), a cross-dressing superstar thanks to her role as the male lover in *The Love Eterne*, had an award-winning turn as Mulan in the Shaw Brothers' 1964 Huangmei opera film.

In the United States, the legend has resonated across generations, most famously in Maxine Hong Kingston's book *The Woman Warrior* (1976) and the 1998 hit Disney animated film (which had a 2004 sequel). For *Mulan* (2020), Disney recruited *wuxia* veteran Liu Yifei to bring a flesh-and-blood Asian heroine to the screen to fight for box office supremacy against the computer-enhanced superheroes of the Marvel pantheon.

NOTES

1. Shiamin Kwa and Wilt L. Idema, trans., *Mulan: Five Versions of a Chinese Legend, with Related Texts* (Indianapolis, Ind.: Hackett, 2010), xxvi; see 53–102 for Shiamin Kwa's translation of Ouyang Yuqian's 1939 screenplay.

2. Louise Edwards, *Woman Warriors and Wartime Spies of China* (Cambridge: Cambridge University Press, 2016), 71, 103 and passim on the differences between these and other women warriors and spies of modern China. The date of Asian Gioro Xianyu's death is disputed.

3. Paul Fonoroff, *Chinese Movie Magazines: From Charlie Chaplin to Chairman Mao, 1921–1951* (Oakland: University of California Press, 2018), 28.

4. Stephen Teo, *Chinese Martial Arts Cinema: The Wuxia Tradition*, 2nd ed. (Edinburgh: Edinburgh University Press, 2009), 2.

5. Zhang Zhen, *An Amorous History of the Silver Screen: Shanghai Cinema, 1896–1937* (Chicago: University of Chicago Press, 2005), 199; Weihong Bao, *Fiery Cinema: The Emergence of an Affective Medium in China, 1915–1945* (Minneapolis: University of Minnesota Press, 2015), 455.

6. "紅! 紅! 紅得發紫!" *Shenbao* 23332 (February 11, 1939), 18. The same page includes an ad for *Lady Mengjiang*. Another Mulan, surnamed Yao, appeared the same year in Lin Yutang's English-language novel *Moment in Peking* (1939), written in Paris and set partly during the Anti-Japanese War.

7. This paragraph draws on Poshek Fu, *Between Shanghai and Hong Kong: The Politics of Chinese Cinemas* (Stanford, Calif.: Stanford University Press, 2003), 4, 35, 37, 39.

8. Poshek Fu, *Between Shanghai and Hong Kong*, 31.

9. Stephen Teo, *Chinese Martial Arts Cinema*, 46–47.

10. The last line of the poem, "Who can distinguish whether I am male or female?" appears in advertisements for the film. See *Shenbao* 23336 (February 15, 1939), 15. For a full translation of the poem, see Shiamin Kwa and Wilt L. Idema, *Mulan*, 1–3. By coincidence, the film's premiere coincided with the Year of the Rabbit, which began on February 19. On casting, see Poshek Fu, *Between Shanghai and Hong Kong*, 12.

11. Weihong Bao, *Fiery Cinema*, 45–46.

12. My thanks to Dorothy Ko and Wilt Idema for confirming the footbinding allusion in this scene as well as its historical inaccuracy, in response to my queries. Footbinding was most widely practiced in the Qing dynasty (several hundred years after *Hua Mu Lan* is set), but as early as the nineteenth century many people believed, incorrectly, that the practice had always been common. See Dorothy Ko, *Cinderella's Sisters: A Revisionist History of Footbinding* (Berkeley: University of California Press, 2007).

13. Kristine Harris, "Modern Mulans: Reimagining the Mulan Legend in Chinese Film, 1920s–1960s," in *The New Woman International: Representations in Photography and Film from the 1870s through the 1960s*, eds. Elizabeth Otto and Vanessa Rocco (Ann Arbor: University of Michigan Press, 2011), 315.

14. Poshek Fu, *Between Shanghai and Hong Kong*, 46.

15. Kristine Harris, "Modern Mulans," 318.

16. Shiamin Kwa and Wilt L. Idema, *Mulan*, xi.

17. Edwards cites Xie Bingying as a real-life exemplar of these qualities. Edwards, *Woman Warriors and Wartime Spies of China*, 66.

18. Poshek Fu, *Between Shanghai and Hong Kong*, 20.

19. Shiamin Kwa and Wilt L. Idema, *Mulan*, xxx.

20. Kristine Harris, "Modern Mulans," 317.

21. *Qingqing dianying* (*Chin-Chin Screen*) 4, no. 16 (July 18, 1939), 2. The advertisement for *Hua Mu Lan*'s Shanghai opening at the Astor (Huguang da xiyuan) says that Chan and Mai Hsi would sing a duet in person at all three screenings. *Shenbao* 23337 (February 16, 1939), 15. The Hong Kong premiere at the Central Theater (Zhongyang xiyuan, established 1930) is advertised in *Shenbao* 347 (February 13, 1939), Hong Kong edition, 1, which highlights "Nancy Chan starring in her first Mandarin picture since going north." Beside it is an ad for *The Autocrat of Chou*'s premiere at the Peace Theater (Ping'an xiyuan).

22. *Chin-Chin Screen* reports that the Cantonese version (shown at six different theaters) triumphed over the Mandarin version (at the Capitol Theatre, where it was retitled *General Mulan* [*Mulan jiangjun*]) when both were shown simultaneously in Singapore in July 1939. "Guoyu pian *Mulan congjun* shouru zai Xingzhou" 國語片木蘭從軍受辱在星洲 [Mandarin-language *Hua Mu Lan* slighted in Singapore]), *Chin-Chin Screen* 4, no. 22 (August 29, 1939), 10. *Xiao xianü* and *Mulan chushi* are mentioned in *Chin-Chin Screen* 4, no. 8 (May 23, 1939), 10.

23. Poshek Fu, *Between Shanghai and Hong Kong*, 19.

24. See Weihong Bao, *Fiery Cinema*, 1–7, 381–382 on this "provocative and self-conscious intermedia event" involving Hong Shen, He Feiguang and several other artist-agitators.

25. Poshek Fu, *Between Shanghai and Hong Kong*, 45.

26. See Poshek Fu's analysis (*Between Shanghai and Hong Kong*, 110–116) of how the Chinese filmmakers subverted the anti-Western propaganda value of this film commissioned by the occupation authorities. Poh, who made more than twenty films during the war period, was later ostracized by many filmmakers for such collaborations and moved his career to Hong Kong.

SOURCES/FURTHER READING

Allan, Joseph R. "Dressing and Undressing the Chinese Woman Warrior." *positions* 4, no. 2 (1996): 343–350.

Bao, Weihong. *Fiery Cinema: The Emergence of an Affective Medium in China, 1915–1945*. Minneapolis: University of Minnesota Press, 2015.

——. "From Pearl White to White Rose Woo: Tracing the Vernacular Body of *Nüxia* in Chinese Silent Cinema, 1927–1931." *Camera Obscura* 20, no. 3 (60) (2005): 193–231.

Ding Ling. "When I Was in Xia Village" [1940]. Trans. Gary J. Bjorge. In *The Columbia Anthology of Modern Chinese Literature*, 2nd ed., ed. Joseph S. M. Lau and Howard Goldblatt, 132–146. New York: Columbia University Press, 2007.

Edwards, Louise. *Woman Warriors and Wartime Spies of China*. Cambridge, UK: Cambridge University Press, 2016.

Fu, Poshek. *Between Shanghai and Hong Kong: The Politics of Chinese Cinemas*. Stanford, Calif.: Stanford University Press, 2003.

——. "Projecting Ambivalence: Chinese Cinema in Semi-occupied Shanghai, 1937–1941." In *Wartime Shanghai*, ed. Wen-hsin Yeh, 86–110. London: Routledge, 1998.

Harris, Kristine. "Modern Mulans: Reimagining the Mulan Legend in Chinese Film, 1920s–1960s." In *The New Woman International: Representations in Photography and Film from the 1870s Through the 1960s*, eds. Elizabeth Otto and Vanessa Rocco, 309–330. Ann Arbor: University of Michigan Press, 2011.

Hung, Chang-tai. "Female Symbols of Resistance in the Chinese Wartime Spoken Drama." *Modern China* 15, no. 2 (1989): 149–177.

Judge, Joan. "The Chinese Woman Warrior and the Western Heroine." In *The Precious Raft of History: The Past, the West, and the Woman Question in China*, 143–187. Stanford, Calif.: Stanford University Press, 2008.

Kingston, Maxine Hong. *The Woman Warrior: A Childhood Among Ghosts*. New York: Knopf, 1976.

Kwa, Shiamin, and Wilt L. Idema, trans. *Mulan: Five Versions of a Chinese Legend, with Related Texts*. Indianapolis, Ind.: Hackett, 2010.

Ouyang Yuqian. "Mulan congjun: Yousheng dianying juben" 木蘭從軍：有聲電影劇本 (*Mulan Joins the Army*: Script of the sound film). *Xingqi wenzhai* 1, no. 46 (1940): 120–127; 1, no. 78 (1940): 150–159; and 2, no. 12 (1940): 28–29.

Teo, Stephen. "Reactions Against the *Wuxia* Genre." In *Chinese Martial Arts Cinema: The Wuxia Tradition*, 2nd ed., 37–55. Edinburgh: Edinburgh University Press, 2009.

Tian Yuan. *Images of "Hua Mulan" in Films of the Past Century*. Beijing: Social Sciences and Humanities Press, 2019.

Wang, Zhuoyi. "Cultural 'Authenticity' as a Conflict-Ridden Hypotext: *Mulan* (1998), *Mulan Joins the Army* (1939), and a Millennium-Long Intertextual Metamorphosis," *Arts* 9, no. 3 (July 2020): no pagination. Open access: https://www.mdpi.com/2076-0752/9/3/78

Zhang Zhen. "The Anarchic Body Language of the Martial Arts Film." In *An Amorous History of the Silver Screen: Shanghai Cinema, 1896–1937*, 199–243, 387–397. Chicago: University of Chicago Press, 2005.

FURTHER VIEWING

Confucius (*Kong fuzi* 孔夫子). Fei Mu, director. 1940.

Eternity (*Wanshi liufang* 萬世流芳). Richard Poh (Bu Wancang), Ma-Xu Weibang, Zhang Shankun, and Dumas Young (Yang Xiaozhong), directors. 1943.

Lady General Hua Mu-lan (*Hua Mulan* 花木蘭). Yueh Feng (Yue Feng), director. 1964.

Mulan. Tony Bancroft and Barry Cook, directors. 1998.

Mulan. Niki Caro, director. 2020.

Mulan II. Darrell Rooney and Lynn Sutherland, directors. 2004.

Princess Iron Fan (*Tieshan gongzhu* 鐵扇公主). Wan Laiming and Wan Guchan, directors. 1941.

The Red Heroine (*Hong xia* 紅俠). Weng Yih Ming (Wen Yimin), director. 1929.

Sable Cicada (*Diaochan* 貂蟬). Richard Poh (Bu Wancang), director. 1938.

The Soul of China (*Guohun* 國魂). Richard Poh (Bu Wancang), director. 1948.

Long Live the Missus!
(*Taitai wansui* 太太萬歲)

Alternative English titles: *Long Live the Wife, Long Live the Wives*
Director: Sang Hu
Screenwriter: Eileen Chang (Zhang Ailing)
Studio: Wenhua
Date of release: December 13, 1947
112 minutes
Cast: Shangguan Yunzhu, Shi Hui, Wang Yi, Zhang Fa, Lu Shan, Jiang
 Tianliu, Han Fei, Cheng Zhi

SYNOPSIS

Chen Sizhen, a young woman from a wealthy family, is newly married
and lives in the house of her husband's family in Shanghai. Her marriage
to Tang Zhiyuan, who works in a bank, is humdrum and having not yet
produced a son adds to the pressure she feels to be a good housewife
and a dutiful daughter-in-law. Zhiyuan hopes to borrow money from
Sizhen's eccentric father to start a business but is rebuffed, so he goes
with an acquaintance, Mr. Zhao, to Hong Kong in search of business
opportunities. Meanwhile, Sizhen's younger brother, Chen Siduan, who
has just returned from working in Taiwan, grows close to Zhiyuan's
younger sister, Zhiqin. Sizhen persuades her father to give Zhiyuan a

loan by lying to him that her in-laws have a hoard of gold bars, knowing that he will view this as security for the loan. Once his business is up and running, the newly confident Zhiyuan falls for the seductions of the gold digger Shi Mimi, whom he met through Mr. Zhao. Mimi becomes his mistress, though it turns out that she is already married and her husband has been using her to scam money from men. When Zhiyuan's deputy embezzles the company's money and flees, all of the family relationships fall apart. The elder Tangs and Chens fight; Zhiyuan blames Sizhen for having duped her father into lending him money, and says he wants a divorce; and Mimi's husband shows up at Sizhen's house to extort money. Claiming to be Mimi's brother, he tells Sizhen that Zhiyuan has gotten Mimi pregnant. Sizhen sees through the ruse and counters it with one of her own. She visits Mimi and pretends to be delighted by the pregnancy, suggesting that Mimi join the family as Zhiyuan's concubine and all live together despite their newly straitened circumstances. Mimi refuses and blurts out the truth that she is not pregnant. Sizhen, having saved Zhiyuan, then tells him that she wants a divorce. At the lawyer's office, they encounter their newly married younger siblings, and at the last minute Sizhen changes her mind. Sizhen and Zhiyuan celebrate their reconciliation by going to a café, where they spot Shi Mimi at a nearby table plying her seductions on a new man.

THE RISE AND FALL AND RISE OF THE MISSUS

Long Live the Missus! is one of the best comedies of the civil war era. With a screenplay by the celebrated writer Eileen Chang, the film offers a stylish, satirical, and ironic depiction of the lives of women, of male–female relationships, and of the contemporary institution of marriage. *Long Live the Missus!* was Chang's second collaboration with director Sang Hu, closely following *Love Everlasting* (1947), a bittersweet romantic drama involving a young tutor (Chen Yanyan) and an unhappily married man (Liu Qiong). Sang's directorial debut, now lost, was a satirical comedy called *Long Live the Teacher!* (1944), starring Wang Danfeng, Ouyang Shafei, and Han Fei. Much of the same cast from *Long Live the Missus!* (as well as plot elements like teachers, remarriage, and a wireless radio) reappear in Sang's *Bittersweet Middle Age* (1949), in which a

widower principal pressured into retirement by his family renews his vitality and his vocation when he marries a former student. Between 1957 and 1964, Eileen Chang wrote eight more screenplays that were produced by the Hong Kong film studio MP&GI, including the comedies *June Bride* (1960), *The Greatest Wedding on Earth* (1962), and *The Greatest Love Affair on Earth* (1964).

Long Live the Missus! did well at the box office and garnered extensive, if mostly negative, reviews. Chang was vilified for her politics, and male critics especially criticized the ending, opining that the heroine should have been stronger and divorced her unfaithful husband. "Long live the missus!" nevertheless became a trendy phrase in the late 1940s.[1] Like several other Shanghai films, its Chinese title was reused in Hong Kong after the civil war. In the 1968 Hong Kong version (English title: *Darling, Stay at Home*), directed by Shanghai emigré Wong Tin-Lam, domestic conflict occurs because of the husband's chauvinistic view that a wife's proper place is at home. She turns out to be so much more capable in the workforce that he fails to recognize her when he meets her in public. *Taitai wansui* is also the title of a 2015 TV drama, *Vive les femmes*.

Chang was one of the most famous writers of Japanese-occupied Shanghai, but she was blacklisted from publishing after Japan's defeat because she had married a collaborator (in 1944; they divorced in 1947), and she turned to writing film screenplays for a living. *Long Live the Missus!* bears marks of Chang's signature style, including witty dialogue, tragicomic misunderstandings between the sexes, and a "little reunion" (instead of a grand finale), in which the female protagonist gets her straying man back, even if she does not necessarily live happily ever after.

In 1947, Japan was defeated, but civil war had resumed between the Nationalists and the Communists, and it was unclear who would win. The era was one of military conflict and economic hardship, especially due to hyperinflation. Despite the chaos, the period from 1947 to 1952 is sometimes referred to as Chinese cinema's "second golden age." The Nanking government invested heavily in film production starting in 1947, and reconsolidation sustained the industry through the founding of the People's Republic in 1949. New political mandates drastically changed filmmaking and other cultural industries in 1952.

Many of the best films of the late 1940s were comedies dramatizing present-day economic desperation. They include *Phony Phoenixes*

(1947), an equilibrium farce about marriage scammers written by Sang Hu and starring Shi Hui and Li Lihua. *An Ideal Son-in-Law* (1947) and *Diary of Homecoming* (1947) show the disappointed expectations of people returning to Shanghai from the wartime capital of Chungking. *Wanderings of Three-Hairs the Orphan* (1949) represents Shanghai's streets as filled with war orphans. *Crows and Sparrows* (1949) shows urbanites struggling to keep their families sheltered and safe during a period of hyperinflation. (Shangguan Yunzhu, who plays Mimi, reappears in *Crows* as Mrs. Hua, the meek wife of a schoolteacher, who is molested by a predatory Nationalist official.)

Long Live the Missus! is set in 1947, the year it was made, and a few plot elements allude to present conditions. Old Mrs. Tang frets that she does not know how much to tip a servant who has given her a birthday gift because "the price of everything has gone up." The maidservant Mama Zhang cites the same reason in asking for a raise, prompting Sizhen to agree to slip her extra money behind Mrs. Tang's back. Sizhen's father and another rich pal later discuss how to lend out their (depreciating) Chinese currency at interest. When Mimi's husband tries to extort money from Zhiyuan for "child support," he sets the price of adultery at $200 million.

Then there is Sizhen's younger brother, Siduan, who has just returned to Shanghai after two years in Taiwan. Taiwan had reverted to Chinese control in 1945 after Japan's defeat, and it was common for Chinese civil servants and other workers to take up temporary assignments on the island following retrocession. Siduan meets Zhiqin, his future wife, while buying pineapples as a birthday gift for Sizhen's mother-in-law (figure 10.1).[2] Pineapples are a Taiwan specialty, and Siduan takes up his sister's suggestion to follow the custom of giving the local product, even though—continuing the theme of deception—he actually buys them in Shanghai. Overall, *Long Live the Missus!* deals with wartime realities obliquely and mostly restricts its gaze to the domestic situation of two upper-class families and ethical dilemmas of a few individuals.

Films centering on the status of women in modern society had been popular in China since the 1930s. *Goddess* (1934), *Daybreak* (1933), *New Women* (1935), and *Street Angels* (1937) cast women as iconic unfortunates—the prostitute, the songstress, the single mother, and the frustrated professional. *Long Live the Missus!*, made a decade—and a war—later,

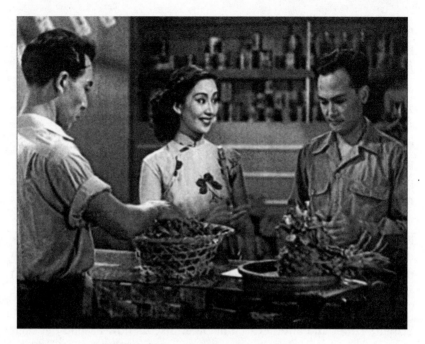

FIGURE 10.1 A shop counter negotiation leads to romance
Source: Author

centers on a woman coping with pressures and expectations to conform to familial roles of dutiful daughter-in-law, son-bearer, and good wife.[3]

The title character is the *taitai*, a generic term for wife or wives, which can also be a title or honorific, like Mrs. In social contexts like the one represented in this film, the term denotes a certain type of married woman: one who is respectably middle or upper class, or who at least has pretension to such status. A *taitai* can even be a figure of power.

In *Distant Love* (1947), a maid-turned-soldier reencounters her corrupt intellectual husband in wartime Hankow and, disgusted with his attempts to involve her in his life of luxury consumption, exclaims, "I didn't come back to be a *taitai!*" Jiang Tianliu, who plays Chen Sizhen, would reappear as a different type of wife entirely in *Between Husband and Wife* (1951): a poor peasant who discovers irreconcilable differences with her Shanghai-intellectual husband. (Zhao Dan plays the retrograde husband in both films.) Later Communist-era films would focus on the domestic sphere as a key ideological battleground, notably *Husband*

and Wife on the March (1951) and *Li Shuangshuang* (1962), which mocks husband self-superiority as laughably passé.

Ten years or so after writing this screenplay, Eileen Chang began writing the novella *Lust, Caution* (first published in 1978, and adapted into a film by Ang Lee in 2007), which begins with a group of *taitai*—and one female secret agent—sitting around a table playing mah-jongg in 1940s Shanghai, when the city was occupied by the Japanese. The scene, set just a few years before the story of *Long Live the Missus!*, suggests that to be a *taitai* is to be prosperous, smugly domestic, even decadent. The politically charged scenario of wives of wartime collaborators engaged in social gambling implies that the perks of *taitai* status might be obtained through insincerity, scheming, and immoral behavior. Sizhen's name sounds like "seems true."

Mah-jongg appears conspicuously in an early scene. Before we see Sizhen's husband Zhiyuan (played by Zhang Fa, "post-war cinema's most popular leading man"[4]), we hear about him: he has invited Mr. and Mrs. Yang over for mah-jongg but forgotten to keep the date. His quick acquiescence to join Mr. Zhao on a jaunt to Hong Kong the next day suggests that he is easily led, as does his playing along with Sizhen's lie that he is traveling by boat rather than air. Later, after a tryst with his mistress, he lies to Sizhen that he had been playing mah-jongg late with Zhao. The lipstick-stained handkerchief in his pocket, as Mimi planned, shows Sizhen otherwise. Mah-jongg—a game, a social pastime, and a form of gambling—is emblematic of the risk, chance, and skill involved in the *taitai*'s social world. We do not know who has won until the winner shows her hand.

Indeed, the film is not just about husbands versus wives, devoting more screen time to relationships between women, including a maid (Mama Zhang), a widow (Mrs. Tang), a newlywed (Sizhen), a young woman in love (Zhiqin), a rich lady (Mrs. Chen), and the "other woman" (Shi Mimi). The domestic environment is full of pressures, misunderstandings, negotiations, and compromises that, over the course of the plot, reveal the family structure to be precarious.

Deception and its consequences in a domestic environment emerge as a central theme in the very first scene, in which Sizhen lies to her mother-in-law several times in an attempt to keep Mrs. Tang happy on her birthday (figure 10.2). When the maid breaks a bowl, Sizhen lies to cover up the inauspicious omen. Despite Sizhen's attempts to hide the

FIGURE 10.2 The first of many lies
Source: Author

evidence, Mrs. Tang eventually discovers the deception and reproaches her daughter-in-law. The pattern of lying and exposure repeats, as when Sizhen asks Zhiyuan to lie that he will be traveling to Hong Kong by boat. Again, the missus is forced to admit the truth when Mrs. Tang spots a newspaper headline saying the ship sank.

As Sizhen is seeing Zhiyuan off to the airport, and just before things start to go bad in their relationship, she points out to him a brooch (or pin) she wants in the window of a store. He promises to buy it for her when he has money. She responds that perhaps a wireless radio would be more useful. At the airport, a low-angle shot shows the missus at her happiest moment (figure 10.3).

The brooch becomes a symbol of Zhiyuan's promise and his betrayal. When Zhiyuan returns from his movie date with Mimi, Sizhen finds the tickets in his pocket. Realizing that the token of affection now belongs to another woman, she puts the tickets into the brooch case, as if into a coffin (figure 10.4).

FIGURE 10.3 The missus at her happiest
Source: Author

FIGURE 10.4 A cinematic encoffining of the missus's hopes
Source: Author

We seem headed toward a tragedy of spousal abandonment. But, in a twist, the wife redirects her deceptive skills to outwit the con woman. Seeing through Mimi's sham pregnancy, Sizhen plays the missus card to the fullest. Why doesn't Mimi move into their house to be cared for and watched over as a concubine? (In *Love Everlasting*, a similar proposition is rejected by an "outside woman" who is presented sympathetically.) Better yet, how about if the family moves into Mimi's apartment? As both women realize, the threat of either domestic arrangement is material. The "outside woman" (and her child) will become property of the family, as will her clothes. When Sizhen touches her dresses, Mimi cracks and beats a hasty retreat.

The missus's move duly gets rid of the mistress, but Mimi, despite the setback, remains at large. In the final scene, the reunited couple is having a drink together in the café where Mimi first hooked Zhiyuan only to watch her pull the same ploy on a new man. In the final shot, her coquettish, smiling face fills the screen and she gives us a conspiratorial wink. This one couple may be rescued, but the broader game of love and deception continues.

BITTER BACKSTORIES AND (SOMEWHAT) HAPPY ENDINGS

Sizhen attempts to distract her mother-in-law from the broken bowl by suggesting that they go see a new Shaoxing-style play, a weepie. The old lady responds enthusiastically: "I simply adore tragedies (*ku xi*)—the bitterer (*ku*) the better!" Later, Sizhen is telling her brother about her new social obligations as a wife, including keeping her husband's guests company playing mah-jongg, and her sister-in-law calls it her "bitter duty" (*ku chaishi*). Before long, Sizhen's bitterness comes not from a game of mah-jongg but a game of seduction. Her gullible husband is hooked by Mimi's tale of woe, which Mimi also calls a "tragedy (*ku xi*), so bitter that if it were made into a film, anyone who watched it would cry." Sob stories sell.

Long Live the Missus! incorporates elements of a film genre known variously as the "screwball comedy" and the "comedy of remarriage." Films like *The Awful Truth* (1937) and *The Philadelphia Story* (1940) feature an estranged or divorced couple who, having fallen out of love, are

jaded about the institution of marriage and wary of romance. Experienced and urbane, they trade barbs and witticisms, and their verbal (and sometimes physical) sparring—and lingering mutual attraction—grows more intense as the ex-wife gets closer and closer to marrying someone else. At the last minute, the new wedding is called off and the divorcees remarry each other.

At the center of the comedy of remarriage is the wife or ex-wife, who must be persuaded, despite past betrayals or misunderstandings, to take her man back. Reconciliation and redemption triumph. The ideology underlying this narrative template could be summed up as: the institution of marriage is imperfect, but its virtues outweigh its vices. The genre on the whole is socially conservative, showing an unruly woman being tamed and brought back where she belongs. Hollywood also parodied this convention; in *Bluebeard's Eighth Wife* (1938), Gary Cooper's character reads *Taming of the Shrew* and then tries—and fails—to tame his estranged wife, first with violence, then with charm.

Chinese films dealing with the modern institution of divorce—usually critically—date back to the 1920s. (One lost comedy from 1927, *Man in the Moon Gets a Divorce*, refers to the folk matchmaking deity.) *Don't Change Your Husband* (1928) (a title borrowed from a 1919 Cecil B. DeMille film) is sympathetic to the husband, who magnanimously takes back his straying wife. That film, whose title might be translated literally as "Kissed Again in a Sea of Passion," like *Missus!*, features a spousal showdown in a lawyer's office, a scene which ends farcically with the husband's mother signing the divorce paper for him and the wife's boyfriend holding her hand to guide her signature. *Love and Duty* (1931), *Two Stars* (1931), *Spring in the South* (1932), *Divorce* (1933), *National Customs* (1935), and *Love Everlasting* also have divorce plot lines.

Leo Ou-fan Lee has observed the comedy of remarriage genre conventions at work in literary works by Eileen Chang, notably *Love in a Fallen City* (1943).[5] In that famous story, a young Shanghai widow meets a rich bachelor and, much to the chagrin of her dead husband's unmarried sisters, follows him to Hong Kong. There they have an on-again, off-again courtship, but as soon as they consummate it, the man announces that he is going overseas and the woman realizes that she is expected to remain behind as a kept woman. Then the Japanese bomb Hong Kong, preventing his ship from sailing, and they end up getting married after

all. His eyes turn to other women, but she finds some satisfaction in having become his missus.

Chang once observed that Chinese audiences loved plots with a lot of twists and turns—the more convoluted the better. She delivers this in *Long Live the Missus!,* in part by moving beyond the screwball comedy's tight focus on the couple to encompass a broader domestic family sphere. The hide-the-evidence-in-the-cushions scene that opens the film recalls the bowler hat hiding in *The Awful Truth,* but Chang's version involves three women instead of a woman and two men. At stake is not just one couple's happiness but the integrity of the household and the fate of an alliance between families. And individual family members have their own narratives.

Even Sizhen's buffoonish father has his own sad backstory. As Siduan tells it, his father once loved a woman named Orchid, who died, and he has been pining for her ever since. Zhiyuan's younger sister, Zhiqin, bursts out laughing at the incongruous thought of the old man as a romantic, but Siduan informs her that his father used to be quite dashing. (Shi Hui's hilarious performance as Mr. Chen shows why he was one of the biggest stars of the 1940s.) Later, when Zhiqin reveals Zhiyuan's infidelity to Sizhen's parents, Sizhen's mother advises her to take her husband firmly in hand—just as she did, successfully, when her own husband strayed years ago. But before one can shout, "Long live *this* missus!," Sizhen's father decides to recapture his romantic vigor by taking up with Mimi's friend and advising Zhiyuan to fob off Sizhen with a few promises. The scene reveals a conspiracy of husbands who put their own pleasure first (figure 10.5).

The two men's escapades end when Zhiyuan's deputy manager absconds with the company's capital, leaving it bankrupt—a deus ex machina of moral justice that would seem to be punishing the irresponsible Zhiyuan. But the event strains relations between the two families, as Sizhen's father and Zhiyuan's mother blame each other for raising unreliable children. The parents prohibit the younger siblings from seeing each other any longer—the old lady now thinks Siduan is just after her (nonexistent) riches—and Sizhen faces the prospect of having ruined another couple's happiness. Then Zhiyuan blames her for having persuaded her father that his family was secretly rich and says he'll divorce her. "Yes, I lied," Sizhen admits, "but I did it for your well-being!"

FIGURE 10.5 A conspiracy of husbands
Source: Author

The pattern of fibbing having major unexpected consequences extends to "good" characters like Siduan. His oral account of his perilous airplane landing in Shanghai—and his unruffled demeanor as his fellow passengers panicked, for example, is first presented as comical bragging. But the old lady's agitation at this tall tale prompts Sizhen later to lie that Zhiyuan is going to Hong Kong by boat, which results in further misunderstandings, awkwardness, and contrition. Sizhen's compulsive lying ends up making her a pariah in her family, as her parents and her in-laws stop believing anything she says.

One of the most striking editing sequences in the film occurs when Mimi's crook of a husband decides to extort money from Zhiyuan. In one shot, he is in Mimi's apartment telling her his plan to press Zhiyuan; then abruptly, he is at the Tang residence, telling Sizhen that Mimi is pregnant. At the beginning of both conversations, the woman is on the left-hand side of the frame and the man is on the right (figure 10.6 A–B). Graphic matching draws a parallel between the two women, who are

FIGURE 10.6 Graphic matching of Mimi and Sizhen
Source: Author

being victimized by the same man. The abrupt cut (an elliptical edit) also makes it seem like the women are sharing the same conversation with the same man: Mimi asks "What if he can't come up with the money?," and her husband—now speaking to Sizhen at the Tangs'—replies "Even if he can't come up with the money, he'll have to find a way."

This scene, in which one missus visually resembles another, represents the moment when Sizhen's lying starts to turn her fortunes yet again. Having gotten the extortionist-husband to leave by lying that Zhiyuan is not home but that she will give him the message, she then sets off to confront the extortionist-wife. At Mimi's apartment, Sizhen prepares to put on her act, only to be momentarily taken aback when she spots the brooch and the wireless radio. These luxury commodities, tokens of male affection transferred from one woman to another, reappear on the cusp of the final showdown. The lighting, makeup, and close-ups emphasize Sizhen's expressive face as she blanches but then puts her smile back on and perseveres with her best performance yet.

If husbands treat their wives like commodities, here Sizhen bargains to redeem Mimi for the Tangs on the cheap, and invites her to eat "bitterness" (*ku fan*) with their impoverished family. The last straw for Mimi is when Sizhen remarks on how much nicer Mimi's clothes are; Mimi slams shut the wardrobe, and its mirror suddenly turns two missuses into four (figure 10.7). The shot suggests that both are playing with appearances, and that the complexity of the game has doubled. Sizhen's lying finally extorts the truth: there is no baby, and Mimi's "brother" is actually her husband.

Will she take him back? Zhiyuan, his other-woman problem solved, wants to make up, but Sizhen tells him, "Matters of the heart are not so simple." "I won't lie anymore, and I won't be your missus anymore," she vows. He asks: "Is there no way to make amends?," but she shakes her head and turns away.

As Sizhen packs to leave, Zhiyuan finds the movie tickets in the brooch case. But this sentimental moment of remorse is undercut by the brutal commodity exchange in the next scene. Zhiyuan goes back to Mimi's to ask her for the brooch back, but she refuses even to sell it to him, and when he tries to grab it from her by force she scratches his face—a threatened woman's last defense against a male aggressor.

FIGURE 10.7 Doubling missuses at the showdown
Source: Author

Just before Zhiyuan resorts to violence, we see a shot of him reflected in two mirrors, as he pleads with Mimi. He, too, has many faces, and the image seems to symbolize his hypocrisy. He leaves empty-handed but, encountering Mimi's husband in the hallway, negotiates to trade his wristwatch for the brooch (figure 10.8).[6] The exchange is carried out as a dumb show, with each man communicating through gestures. The only diegetic sounds we hear are Mimi resisting and getting slapped several times on the other side of the door. Zhiyuan winces, but leaves satisfied. Men are shown as happy to victimize women for their own personal benefit.

Mimi, the female predator who is herself exploited, might be viewed as a scapegoated version of Chen Sizhen. The well-meaning missus is in the habit of telling white lies in an attempt to help or protect family members; the woman on the outside is a con woman who seduces men in an attempt to extract money from them. One is an overeager "good wife"; the other is a stereotypical "bad woman." Both engage in serial deception to please an unworthy husband.

FIGURE 10.8 A dumb-show commodity exchange between husbands
Source: Author

Some critics see Chang's own bitter backstory reflected in the plot of her screenplay. The story of a disloyal husband and a suffering woman was one that Chang was to write again and again over the course of her subsequent career in novels like *Little Reunions* (1979). Here, repeated references to the cinema—the movie date, the ticket stubs, and Mimi's film-worthy story—create an ironic distance.

The final shot of the con woman turning her seductive charm toward the audience compounds the irony (figure 10.9). Shi Mimi, and not Chen Sizhen, is the last "missus" we see in *Long Live the Missus!* Mimi's tale of woe, told with a wink and a smile, warns us that plays for sympathy are not to be trusted. But this smiling victimizer is indeed a victim herself. Mimi is a *fake* missus (of Zhiyuan's) but a *real* missus of her pimp-husband. She *does* lead a life of woe, even if we only hear—and do not see—her suffering. In the end, the filmmakers are as coy with viewers as Mimi is with the men she targets. Both capable women—Sizhen

FIGURE 10.9 The last missus shown in *Long Live the Missus!*
Source: Author

and Mimi—may yet live long, but we have to look beyond Mimi's stagey smile to realize that those lives might not be happy ones.

NOTES

1. The film premiered simultaneously at four Shanghai cinemas on December 13, 1947, according to ads in *Shenbao* 25081 (December 11, 1947), 10. On contemporary reviews, as well as Chang's comments on her own film, see Poshek Fu, "Eileen Chang, Woman's Film, and Domestic Shanghai in the 1940s." *Asian Cinema* 11, no. 1 (Spring/Summer 2000), 110–111; Chen Zishan, "Weirao Zhang Ailing *Taitai wansui* de yichang lunzheng" 圍繞張愛玲《太太萬歲》的一場論爭 [Debates surrounding Eileen Chang's *Long Live the Missus!*], in *Shuobujin de Zhang Ailing* [Endless talks on Eileen Chang] (Taipei: Yuanjing, 2001), 77–87.

2. Henry Jenkins pointed out to me that this encounter is reminiscent of the first meeting between a man and a woman who later marry in *Bluebeard's Eighth Wife* (1938). The man is trying to purchase just the top of a set of pajamas, while the store insists on selling the set. The problem is solved when a woman offers to buy

the pants. (Director Ernst Lubitsch's acting debut was in *The Ideal Wife* [1913].)
Lubitsch's adaptation of *Lady Windermere's Fan* (1925) inspired a Chinese adaptation, *The Young Mistress's Fan* (1939). The fan, a significant prop in *Long Live the Missus!*, also appears in innumerable movie star photos in *Chin-Chin Screen*.

3. Tu Guangqi directed a pair of features for Far East Films (Yuandong) starring Ouyang Shafei: the Mandarin-language *A Modern Woman* (1945) and the Cantonese-language *Modern Wives* (1951). The former, viewed today, comes across as a retrograde and misogynistic satire of women who seek a public career while failing to be good mothers. Extant print materials suggest that *Wife Problems* (1950), a satire focused on a materialistic wife who spends her well-remunerated husband into debt in order to impress a relative, is in the same vein.

4. Paul Fonoroff, *Chinese Movie Magazines: From Charlie Chaplin to Chairman Mao, 1921–1951* (Oakland: University of California Press, 2018), 251.

5. Leo Ou-fan Lee, *Shanghai Modern: The Flowering of a New Urban Culture in China, 1930–1945* (Cambridge, Mass.: Harvard University Press, 1999), 267–308.

6. Actor Cheng Zhi reprises a thuggish role in *The Watch* (1949) and in the spy film *Decay* (1950), which features several other cast members from *Long Live the Missus!*

SOURCES/FURTHER READING

Cavell, Stanley. *Pursuits of Happiness: The Hollywood Comedy of Remarriage*. Rev. ed. Cambridge, Mass.: Harvard University Press, 1984.

Chang, Eileen. *Love in a Fallen City*. Trans. Karen S. Kingsbury. New York: NYRB Classics, 2006.

——. *Lust, Caution*. Trans. Julia Lovell. Afterword by Ang Lee. New York: Anchor, 2007.

Conner, Alison W. "Don't Change Your Husband: Divorce in Early Chinese Movies." *Connecticut Law Review* 40, no. 5 (July 2008): 1245-1260.

Fu, Poshek. "Eileen Chang, Woman's Film, and Domestic Shanghai in the 1940s." *Asian Cinema* 11, no. 1 (Spring/Summer 2000): 97–113.

Iovene, Paola. "Phony Phoenixes: Comedy, Protest, and Marginality in Postwar Shanghai." In *China on the Margins*, ed. Sherman Cochran and Paul Pickowicz, 267–287. Ithaca, N.Y.: Cornell University Press, 2010.

Lee, Leo Ou-fan. "Eileen Chang: Romances in a Fallen City." In *Shanghai Modern: The Flowering of a New Urban Culture in China, 1930–1945*. Cambridge, Mass.: Harvard University Press, 1999, 267–305.

Lin, Pei-yin. "Comicality in *Long Live the Mistress* and the Making of a Chinese Comedy of Manners." *Tamkang Review* 47, no. 1 (December 2016): 97–119.

Ng, Kenny K. K. "The Screenwriter as Cultural Broker: Travels of Zhang Ailing's Comedy of Love." *Modern Chinese Literature and Culture* 20, no. 2 (Fall 2008): 131–184.

Rao Shuguang. *Zhongguo xiju dianying shi* [A history of Chinese film comedy]. Beijing: Zhongguo dianying chubanshe, 2005.

Sikov, Ed. *Screwball: Hollywood's Madcap Romantic Comedies.* Foreword by Molly Haskell. New York: Crown, 1989.

Zhang Ailing. *Dianmao juben ji* [Eileen Chang's MP&GI screenplays]. 4 vols. Hong Kong: Hong Kong Film Archive, 2010.

Zhang, Yingjin. "Gender, Genre, and Performance in Eileen Chang's Films: Equivocal Contrasts Across the Print-Screen Divide." In *Chinese Women's Cinema: Transnational Contexts*, ed. Lingzhen Wang, 255–273. New York: Columbia University Press, 2011.

FURTHER VIEWING

The Awful Truth. Leo McCarey, director. 1937.

Between Husband and Wife (*Women fufu zhijian* 我們夫婦之間). Zheng Junli, director. 1951.

Bittersweet Middle Age (*Ai le zhongnian* 哀樂中年). Sang Hu, director. 1949.

Bluebeard's Eighth Wife. Ernst Lubitsch, director. 1938.

Darling, Stay at Home (*Taitai wansui* 太太萬歲). Wong Tin-Lam (Wang Tianlin), director. 1968.

Diary of Homecoming (*Huanxiang riji* 還鄉日記). Zhang Junxiang, director. 1947.

Don't Change Your Husband (*Qinghai chongwen* 情海重吻). Xie Yunqing, director. 1928.

The Greatest Love Affair on Earth (*Nanbei xi xiangfeng* 南北喜相逢). Wong Tin-Lam (Wang Tianlin), director. 1964.

The Greatest Wedding on Earth (*Nanbei yijia qin* 南北一家親). Wong Tin-Lam (Wang Tianlin), director. 1962.

Husband and Wife on the March (*Fufu jinxingqu* 夫婦進行曲). Hong Mo, director. 1951.

An Ideal Son-in-Law (*Chenglong kuaixu* 乘龍快婿). Yuan Jun, director. 1947.

June Bride (*Liuyue xinniang* 六月新娘). Tang Huang, director. 1960.

Lady Windermere's Fan. Ernst Lubitsch, director. 1925.

Lights of Myriad Homes (*Wanjia denghuo* 萬家燈火). Shen Fu, director. 1948.

Love Everlasting (*Buliao qing* 不了情). Sang Hu, director. 1947.

Modern Wives (*Modeng taitai* 摩登太太). Tu Guangqi, director. 1951.

The Philadelphia Story. George Cukor, director. 1940.

Phony Phoenixes (*Jiafeng xuhuang* 假鳳虛凰). Huang Zuolin, director. 1947.

The Young Mistress's Fan (*Shao nainai de shanzi* 少奶奶的扇子). Li Pingqian, director. 1939.

Spring River Flows East (*Yi jiang chunshui xiang dong liu* 一江春水向東流)

Directors/screenplay: Cai Chusheng and Zheng Junli
Studio: Kunlun
Date of release: October 9, 1947
Part 1: *Eight Years of Separation and Chaos* (*Banian liluan* 八年離亂)
96 minutes
Part 2: *Before and After the Dawn* (*Tianming qianhou* 天亮前後)
91 minutes
Cast: Bai Yang, Tao Jin, Wu Yin, Yan Gongshang, Gao Zheng, Shu Xiu-
 wen, Shangguan Yunzhu

SYNOPSIS

Part 1

The scene opens in Shanghai at the Shunhe Silk Factory, soon after
September 18, 1931. Japanese operatives have sabotaged a rail line in
northern China and blamed it on Chinese terrorists, then used the
incident as a pretext to annex northeastern China. A pretty young
woman, Sufen, finishes her shift and heads to the factory's eve-
ning school, where she meets and falls in love with a handsome
teacher, Zhang Zhongliang. On October 10, National Day, she and

her coworkers watch an entertainment program, which begins with a Spanish dance performed by Miss Wang Lizhen. Zhongliang then delivers an inspiring speech calling for aid for soldiers fighting in the northeast. Zhongliang and Sufen soon marry. Their son, Kang'er, is born on the date China begins its War of Resistance Against Japan: July 7, 1937. Zhongliang throws himself into relief efforts, gathering donations for the troops. His rounds take him to the house of He Wen-yan, Wang Lizhen's cousin, who is married to the factory manager, Mr. Wen. Lizhen is on her way to Hankou to find a certain Director Pang Haogong, introduced by Manager Wen. Zhongliang soon leaves for the front, and Sufen takes her infant son and elderly mother-in-law back to the Zhangs' village, which falls under Japanese control. There she lives with her child, parents-in-law, and Zhongliang's younger brother, Zhongmin. Two years pass, and Zhongliang, working for the ambulance corps, has reached Nanchang, a little over 600 kilometers west of Shanghai. The war is taking its toll at the battlefront and in the occupied areas. Come 1940, the flow of refugees continues unabated and famine is rampant. Having slaughtered all the oxen, the Japanese now force peasants to pull the plow. Zhongliang is captured and forced into slave labor. He eventually escapes and makes his way to the Nationalists' wartime capital of Chungking (Chongqing), in Szechuan (Sichuan) province, where he seeks out Wang Lizhen. She invites the destitute man to move into her mansion and persuades her adoptive father, Director Pang, to give Zhongliang a sinecure at his trading company. Zhongliang becomes disgusted at the indolent and hedonistic behavior of the Chungking set and complains to Lizhen about the lack of resistance spirit, but she laughs and tells him that he will get used to it. Meanwhile, the Japanese have hanged Zhongliang's father for speaking up on behalf of the starving villagers; his brother has become a guerrilla fighter; and Sufen has gone back to Shanghai with her son and mother-in-law. There, they live in a shack at the top of an apartment block, and she thrives working at a relief shelter-cum-orphanage. Zhongliang, though increasingly filled with self-loathing about his life of idle luxury, begins sleeping with Lizhen. That very night, a rainstorm hits Shanghai, and Sufen rushes out into the deluge.

Part 2

Part 2 opens in Chungking in the spring or summer of 1945, during "the final phase of the Anti-Japanese War." Zhongliang marries Lizhen and is appointed personal secretary to Director Pang. Zhongliang prospers as a wartime profiteer, working by day and partying by night. Soon, he sports the slick hairdo and smug mustache, double-breasted suit and cigar of the tycoon, holding court and cutting hard deals. After Japan's defeat, Zhongliang flies back to Shanghai with Pang, leaving Lizhen behind. Manager Wen, who collaborated with the Japanese, seeks to remain free on Pang's influence but is promptly arrested. Zhongliang begins an affair with Wen's wife, He Wenyan. Sufen, desperate for money, begins working as a maidservant at Wenyan's mansion. Lizhen arrives in Shanghai (with a paramour of her own), and on the car ride from the airport, Kang'er, now a newspaper boy, is injured while competing to sell a paper to the man in the car—his father. As Zhongliang and Wenyan carry on behind Lizhen's back, it is Sufen who washes and presses their laundry. Wenyan invites Lizhen to a cocktail party on National Day, a massive fête, at which the newlyweds Zhongliang and Lizhen are called upon to dance a tango. Sufen, serving drinks, recognizes her husband, and collapses on the dance floor. An uproar ensues: Zhongliang is struck dumb; Lizhen rages; Pang accuses Sufen of extortion; and Wenyan seeks to remove the woman causing a scene; but Sufen tells everyone the truth: she and Zhongliang have been married for ten years and have a nine-year-old son. Sufen runs out and, despite the martial law curfew, eventually finds her way back to the rooftop shack, where she pours out the truth to her mother-in-law and son. Old Mrs. Zhang is incredulous and leads them all back to the mansion to confront her son, but faced with a hysterical and violent Lizhen, Zhongliang fails to make a decision. Sufen, still distraught, runs out again with her son and ends up at the riverbank. She sends Kang'er away to buy food and, during his absence, throws herself into the river and drowns, leaving behind a note written on the back of a photo of Zhongmin's family, urging Kang'er to emulate his uncle. Old Mrs. Zhang comes to the riverside to bewail the tragedy and denounce her son. The film ends with Zhongliang, just arrived by car with Lizhen and Wenyan, undecided

what to do, and Old Mrs. Zhang wailing, "Why in Heaven's name does it have to be like this?"

BRINGING THE WAR HOME

Spring River Flows East, like *Gone with the Wind* (1939), presents a melodramatic story of war, love, opportunism, and betrayal, set against a nation-defining conflict and narrated in two parts on an epic scale. Victor Fleming's film was made some seventy years after the American Civil War; *Spring River* was made during the aftermath of the war it depicts and in the midst of resumed civil war.[1] The production followed Kunlun Studio's first wartime saga, *Eight Thousand Li of Clouds and Moon* (1947), released in Shanghai on February 21, in which the same stars, Bai Yang and Tao Jin, play a pair of married members of a drama troupe doing anti-Japanese agitation following the Mukden Incident. Both films include extensive depictions of refugees, a focus on the family unit, excoriation of wartime profiteering, and documentary war footage.

Spring River added three new features, which are the focus of this chapter: a methodical presentation of the war through categorical form; a rhetorical form that contrasts virtue and vice through parallel editing; and the leitmotif of poetry. These elements helped *Spring River* to become China's first domestic blockbuster of the civil war era, screening hundreds of times in Shanghai to an audience of more than seven hundred thousand.[2]

The film's Shanghai release was timed for the eve of the "Double-Ten" National Day (the tenth day of the tenth month), an anniversary that appears at two significant points in the plot. In part 1, Zhongliang's National Day appeal for war relief wins the heart of Sufen. In part 2, after both return to Shanghai from their wartime travels, it is at a National Day party that Sufen discovers her husband's betrayal. The film, which ends with the suicide of the heroine and an uncertain future for the shattered family left behind, is cathartic rather than celebratory.

The film shows the violence and corruption of the war and its impact on one family. Bai Yang (as Sufen, whose surname we never learn) stars as a beautiful and dutiful woman. Married to a handsome, patriotic man, she struggles to keep her family together through eight years of strife, only to suffer crushing betrayal.

Spring River is emblematic of a trend in late-1940s films about the Anti-Japanese War to represent "victory as defeat."[3] Films like *An Ideal Son-in-Law* (1947), *Diary of a Homecoming* (1947), and *Spring in a Small Town* (1948) express a sense of letdown, disillusionment, frustration, depression, and melancholy. The nation's infrastructure was broken, the economy was in ruins, and the state was too weak to govern effectively or to maintain law and order. For the tens of millions of civilians who had been forced to move, "the journey home was an education in disappointment."[4] This directorial debut by veteran actor Zheng Junli (collaborating with Cai Chusheng, who reportedly wrote most of the script) struck a chord and went on to become a major commercial success. *Spring River* was still being screened when Zheng's second film, *Crows and Sparrows* (1949), premiered in early 1950.

Spring River demonstrates that the domestic film industry, scattered by invasion to Hong Kong and the interior, had reconsolidated its talent.[5] The Nationalist government, which returned to Nanking in 1946, invested heavily in film production, which began to pay dividends in 1947. *Spring River* boasts a strong cast and is tightly edited, with brisk montages to convey the chaos and excitement of war and dissolves to compress fourteen years of story (1931–1945) into three hours. The government was pleased with the film it underwrote, awarding *Spring River* the Chiang Kai-shek Film Prize for 1947.

Spring River employs a categorical form (dividing a topic into distinct subcategories) to present the war in chronological sections (with a few flashbacks). Part 1 is subtitled "Eight Years of Separation and Chaos," referring to the years of declared war (1937–1945), but it actually begins in 1931 and ends in 1941. (Between 1931 and 1937, China and Japan were in a state of undeclared war.) Captions walk us through the years: September 1931 (the Mukden Incident); July 1937 (the Marco Polo Bridge Incident); August 1937 (the Japanese attack on Shanghai); and 1939, 1940, and 1941 (when the Japanese occupied all of Shanghai following the December attack on Pearl Harbor). Part 2 opens in Chungking during "the final phase of the Anti-Japanese War" (likely 1945); another caption announces "August 1945: Japan Surrenders to the Allies!" (figure 11.1). The four-year time gap between part 1 and part 2, 1941 to 1945, comprising about half of the war, is left to the imagination.

FIGURE 11.1 Representing war through categorical form
Source: Author

Categorical form is a term more often applied to documentary, and this feature film selectively adopts a documentary style. Newsreel images are intercut with acted shots for a sense of journalistic immediacy. Battles explode before our eyes. The August 1937 Battle of Shanghai, for example, is represented with a montage of war footage—of the city ablaze, of thousands of refugees running through the streets, buildings collapsing, and marching troops. We see the results of the attack, including wounded soldiers, neighborhoods in rubble, and corpses on the streets.

One distinctive formal feature of *Spring River* is its interweaving of two types of shots: staged footage of the actors and stock historical footage of the actual war. Newsreel shots of airplanes dropping bombs or of refugees fleeing are followed by reaction shots of Sufen and Old Mrs. Zhang (figure 11.2). Stock footage is also used to structure sections of narrative: the caption about Japan's surrender, for example, appears over newsreels of massive crowds at a victory parade.

FIGURE 11.2 Newsreel footage and acted shots
Source: Author

The footage enhances the film's documentary quality, with a stirring soundtrack uniting the two types of image sonically to create a sense of continuity.

The film also catalogues iconic sights (fleeing villagers, refugees piled on trains, street fighting), experiences (separation, danger, economic hardship), and social types (volunteers, profiteers, collaborators, commoners). Scenes of economic realism include a landlady pressuring her tenant for rent and Sufen being unable to mail a letter because the cost of postage has skyrocketed. The scene of a starving boy being run over and then berated is an iconic symbol of social injustice repeated in *Wanderings of Three-Hairs the Orphan* (1949). *Spring River* shows how the other half lived during the war, be they men or women, soldiers or civilians, rich or poor, traitors or patriots, villagers or urbanites.

BITTER VIRTUE, BITTER VICES

Through categorical form, *Spring River* gives a chronological account of the war and enumerates its effects. The film also offers catharsis through identification and condemnation. In representing the travails of a vulnerable trio—a married woman, her son, and her aged mother-in-law—the film testifies to a common experience of bitter suffering, or *ku*, which is both shown and spoken of. The film also encourages audiences to deplore wartime opportunists and (in fewer scenes) Japanese collaborators who speak, hypocritically, of how *ku* their life is. The war is presented as a trial, which magnifies inherent virtue or depravity, and corrupts the morally weak.

Spring River's rhetorical form praises virtue and condemns vice by alternating depictions of moral and immoral behavior. Rhetorical form is present even in naming. Zhang Zhongliang's 張忠良 name, Faithful and Good, becomes ironic when he betrays his devoted wife. His son's name, Kangsheng 抗生, means Resistance-Born, or Resistance for Survival, as his father puts it. His mother calls him Kang'er 抗兒, which might be translated literally as Son of the Resistance. Eyeline is also part of rhetorical form. Whereas Zhongliang often looks down and offscreen, the shifty gaze of a troubled conscience, Sufen tends to look offscreen to the side and up, as if with aspiration or anticipation.

FIGURE 11.3 Zhongliang throws a letter from home into the eastward-flowing river
Source: Author

Parallel editing organizes larger sections of narrative by repeatedly juxtaposing vice and virtue, dissipated consumption and selfless labor, selfish opportunism and united mutual aid. Even as Sufen and her mother-in-law are deprived of their last rice by the Japanese and forced into a watery ditch, Zhongliang and Lizhen celebrate their wedding at an opulent, drunken banquet. At the banquet, Zhongliang receives a pair of letters that Sufen mailed to him three years ago, but when his new wife demands to see them, he rips them up and throws them out the window into the river, as if tearing up his original family ties (figure 11.3).

Bai Yang, who plays the film's focal moral paragon, was at the peak of her stardom. She had appeared in *Crossroads* (1937) and starred in *Diary of a Homecoming* and *Eight Thousand Li of Clouds and Moon*. In *Eight Thousand Li*, she defies her parents and runs off to join a patriotic drama troupe. In *Spring River*, she is achingly filial, a modern-day exemplar of the Confucian "virtuous wife and good mother" who could have walked out of a propaganda campaign for the New Life Movement. In

repeatedly moving her family members to safety, she even comes across as a wartime version of Mencius's mother (see chapter 4), who moved house several times to protect her child. The film's conservative presentations of ideal womanhood are reminiscent of those in *Goddess* (1934).

One scene elevates Sufen to symbolic mother of the nation. The image of Sufen at a relief center mending children's clothes would remind viewers of Madame Chiang Kai-shek posing for propaganda photographs stitching a soldier's uniform (figure 11.4). Sufen feeds and comforts war orphans, putting in long hours with a smile on her face. The scene closes with a shot of her looking down lovingly at a child as the camera zooms in for an angelic close-up.

A second moral paragon is the principled intellectual. Scenes in the Zhangs' village introduce a theme that had resounded for decades: threats against intellectual freedom. Zhongmin, a student, and his classmates are accused of being "thought criminals" (*sixiang fan*) and escape to join their former principal (presumably displaced by a Japanese appointee), who now leads a band of guerrilla fighters.

During the war against Japan, thousands of teachers and students were forced to flee from their schools, some traveling thousands of miles from occupied cities in the north down to Kunming in the south. *Spring River* alludes to this history, while creating a revenge fantasy led by a scholar turned warrior—an expression of the cultural/martial (*wen/wu*) ideal discussed in chapter 9. *Crows and Sparrows* represents things as bleaker during the civil war: the principal is fired and protesting teachers are arrested, tortured, and executed.

Elders appear as another type of moral ballast. In the climax of part 1, the Japanese army hangs the grandfather for having the temerity to plead on behalf of starving villagers. The final Japanese atrocity of the film is to shoot an old lady attempting to escape from a watery ditch. This melodramatic rhetoric of excess has those who have suffered the longest—including Sufen, who has suffered for eight years—dying the most pitiable deaths.

Spring River's rhetorical form contrasts virtue with appalling vice. The hard work of resistance patriots is juxtaposed with the self-serving behavior of the moneyed classes. A montage of Chinese troops defending Shanghai and civilians fleeing in August 1937 includes a shot of men rushing to load a truck of the Shanghai Municipal Relief Association with boxes sporting the

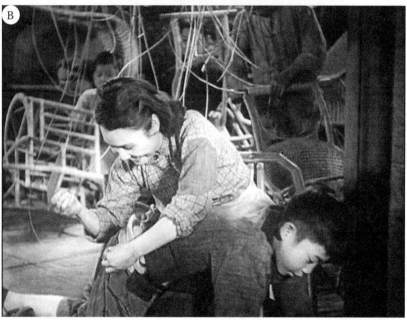

FIGURE 11.4 Wartime stitching by (*A*) Madame Chiang Kai-shek and (*B*) Sufen
Source: Author

slogan "Vanquish the Japanese Devils!" as a prosperous-looking business-man in a suit looks on smilingly from the doorway of a shop (figure 11.5). Wartime profiteering existed from the very beginning.

The scene in which Pang introduces Zhongliang to his senior staff at a party itemizes the excesses of the corrupt Chungking set: one manager handles cars, others cosmetics, rice, and silk. The centerpieces at a banquet are lobsters flown in from Calcutta and crabs flown in from Shanghai. The cosmetics manager quips that "If this is how the War of Resistance is going, we could resist a few more years!"

Zhongliang's moral drama turns upon his arrival at Lizhen's house in Chungking. He is in a wretched state and assumes that his family is dead. For four years, he has been working at the frontlines, enslaved as a prisoner of war, or a refugee. Yet while waiting for the servant to prepare the bedroom, Zhongliang discovers on the floor a ripped photograph of Lizhen and a man, smiles, and settles back comfortably into the arm-chair. Already, he seems to envision himself as the man of the house.

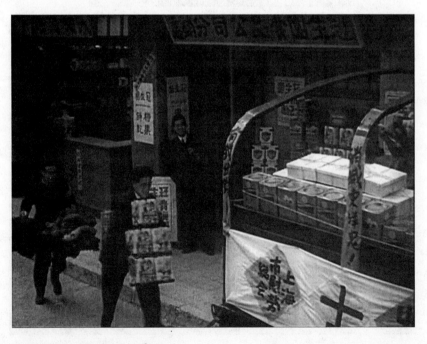

FIGURE 11.5 Wartime profiteer
Source: Author

Early on in his moral decline, Zhongliang still has a conscience: he draws self-mocking cartoons at his desk and laments that he has gone from being a *hero* (*yingxiong*) to being a *bear show* (*gouxiong*), emasculated by Lizhen's bewitching eyes. That very day he hits his nadir, drunkenly raving to the personnel manager that his "family, parents, brother, wife—all my hopes, future, will to struggle—everything has been washed away (*fuzhu dongliu*)."

The vice that leads to all others is lust. Zhongliang is smoking in bed in Chungking when we see a vision of his thoughts: a superimposed close-up of Sufen's alluring face. When Lizhen returns home, he feigns sleep, but watches her legs as she walks upstairs. Sex is the beginning of his *xialiu* 下流, literally downward flow, a moral degeneration that progresses as quickly and relentlessly as a river.

The representation of Wang Lizhen (played by Shu Xiuwen[6]) is complex and dynamic. Her dance performance at the factory marks her as outgoing, if (by the standards of the day) vulgar bordering on wanton. She asks Zhongliang for help descending from the stage, a physical contact that foreshadows their later relationship, and a clown mimics her affected cry for help in falsetto tones. When she and Zhongliang meet by chance in Hankow, her warm and forthright personality contrasts with the haughty reserve of her companions. Only later is her social extroversion shown to be an expression of corruption, as when she laughs at Zhongliang, shoves cash into his pocket, and urges him to forget his scruples at the theater and (ironically) the movies. Lizhen is something of a combination of two negative female archetypes (found to a degree in *Long Live the Missus!* [1947]): the peevish, manipulative, and vulgar yet seductive mistress and the rich, smug, and jealous *taitai* (wife). In contrast to the "fallen" women of *Goddess* and *New Women* (1935), Lizhen is an empowered femme fatale whom men fall for. Though she is blindsided by Zhongliang's bigamy, our sympathy evaporates with her callous response to Sufen's death.

Sufen's own sensuality, mostly sublimated into her roles as good mother and filial daughter-in-law, bursts through in one striking juxtaposition. When Zhongliang reencounters He Wenyan in Shanghai after the war, they immediately have sex. A cut shows Sufen lying in bed in medium close-up, with soft side lighting. She smiles and nuzzles her sleeping son as (we see in a flashback) she remembers the moment

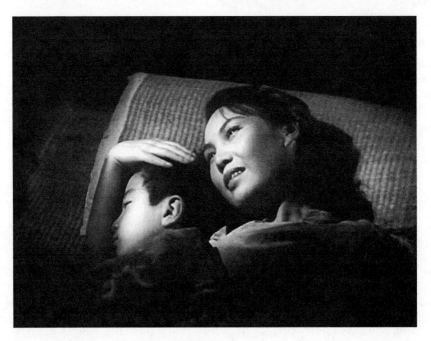

FIGURE 11.6 Sufen in bed thinking of Zhongliang
Source: Author

when Zhongliang put a ring on her finger. The tender memory makes
her shed tears. Bret Sutcliffe notes in his 1998 article that 1930s Chinese
films "often represented class conflict and national salvation in terms of
men's choices between the 'good' proletaria[n] girl and the 'bad' bour-
geois woman," but in this 1940s film, the lower-class woman exudes her
own latent desire (figure 11.6).

The film devotes less attention to Japanese collaborators, except to
indulge a simple fantasy of summary justice: Manager Wen is jailed and
loses his wife and illicit fortune. His wife, He Wenyan (played by Shangguan
Yunzhu, who plays Shi Mimi in *Long Live the Missus!*), is glamourous but
absurd. Whereas Zhongliang's comrades make many sets of clothing for
the war effort, Wenyan manages to produce a single vest, which, she assures
him, is "in the latest fashion." Later, Wenyan visits her husband in jail only
to find him talking to his mistress. Back home, Zhongliang tells her that he
has put all of Manager Wen's accounts in her name, and she responds that
since he already has a "wartime wife . . . I'll be your *secret* wife!"

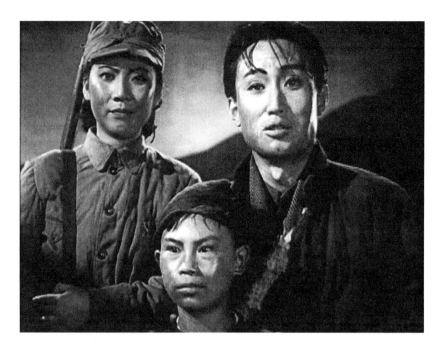

FIGURE 11.7 A portrait of a family united in resistance
Source: Author

As Sufen is leaving the Zhangs' village, we see an alternative family model: Zhongmin, his fiancée (sporting a soldier's uniform and a rifle), and young Xiaosan are off to continue the fight from "the mountains." The war slogan had been "united resistance" (*quanmin kangzhan*); this film specifically extols resistance by a united family (*quanjia kangzhan*). The cinematography is iconic, with the trio framed, (adoptive) son in center (figure 11.7)—a foreshadowing of the studio portrait on which Sufen writes her suicide note. This idealized image presents both the desirability and difficulty of keeping the family together during wartime.

THE RIVER FLOWS EVER ON

The wars of the mid-twentieth century were the making of poets, a phenomenon that scholar David Der-wei Wang in his 2015 book calls "the lyrical in epic time." Artists in multiple spheres turned to classical sources of inspiration. Writers, dramatists and filmmakers, like

the makers of *Hua Mu Lan* (1939), turned to historical allegory. Cartoonists put down the pen and picked up the brush. Old-style verse flourished.

Spring River Flows East takes its title from the final couplet of "The Beautiful Lady Yu" ("Yu meiren"), a tenth-century poem by Li Yu (937–978):

How much sorrow can one person bear?	問君能有幾多愁
As much as a spring river flowing east.	恰似一江春水向東流

The poem expresses a ruler's lament for the fall of the Southern Tang state to the Song dynasty. *Spring River*, too, pours out the sorrows (*chou* 愁) precipitated by crippling foreign invasion. The river, a metaphorical image of a rushing torrent of emotion heading toward the boundless sea, becomes a leitmotif that frames the drama and appears at key moments in the plot.

The couplet appears following the opening credits over several shots of a river, including an extreme long shot of a lone boat sailing down the river between mountains, and is sung by a chorus in a fevered crescendo. The sequence repeats at the ends of part 1 and part 2.

The river shown is China's longest: the Yangtze. Like the Yellow River, the Yangtze is often invoked as a cradle of Chinese civilization and an ethno-national symbol. Here it also appears as a grand symbol of the epic flows of time and people. Between 1937 and 1945, the number of Chinese refugees was an estimated 95 million, or more than one-quarter of the population.[7] It is up the Yangtze that the Nationalist army retreated from Shanghai and Nanking past Hankow to Chungking. The first time Zhongliang's colleagues take him out partying at night, he begs off dancing and returns alone to Lizhen's opulent home to gaze out the window at the Yangtze River, which flows eastward toward where his family should be. In Shanghai, Sufen's mother-in-law wonders aloud where Chungking is. Sufen points to the Huangpu River, which connects to the Yangtze, and thus to Zhongliang, over a thousand miles away.

The ever-flowing river is one lyrical connection device (as opposed to the comic connection devices in *Laborer's Love* [1922]). Another is the moon. Zhongliang tells Sufen before they part that he will think of them on nights when the moon is full. His first glimpse of the full moon occurs while he is tied up on a chain gang. Zhongliang also looks out at

FIGURE 11.8 Sufen shows Zhongliang an ancient poem
Source: Author

the moon over the river just before he has sex with Lizhen. The scene cuts back to Sufen looking at the moon and remembering his promise to her, only for the wind to arise and cover the moon with dark clouds.

The poetic lines and tropes of *Spring River* establish moral archetypes, some with classical roots, such as the benevolent mother, the dutiful daughter-in-law, the patriot who laments for a fallen nation, and the faithful lovers who pine for each other from afar. On the eve of Zhongliang's departure for the front, his mother stays up late sewing him a cotton vest. This labor of love occurs literally in the shadows. Her embodiment of a Confucian ideal is underscored by the ancient poem that Sufen shows Zhongliang (figure 11.8):

The benevolent mother, thread in hand,	慈母手中線
sewing a garment for her wandering son.	遊子身上衣
His departure nearing, she makes each stitch tight,	臨行密密縫
as if afraid he will be slow to return.	意恐遲遲歸

In one interlude during Wenyan's party, Sufen goes outside looking for Kang'er, while a singing beggar-girl comes by leading a blind old man. The song the girl sings—as we see images of Old Mrs. Zhang, Shanghai neon lights, and the beggar couple—brings together the trope of the moon, the thematic focus on the family, and the sorrow or pining (*chou*) of the title poem. The contrast it evokes recalls one of the most famous couplets of the Tang dynasty "poet-immortal" Du Fu: "Behind vermillion gates, wine and meat grow rank / On the streets lie bones of the frozen dead":

The moon slants down on provinces nine	月兒彎彎照九洲
Oh! How many families celebrate while others pine?	幾家喲歡樂幾家愁
Some in mansions drink fine wine	幾家高樓飲美酒[8]
Oh! Others on the streets in wretched decline	幾家喲流落在街頭

Social critique, while persistent, is ultimately subordinated to the grander lyricism of deluge. At the end of part 1, a rainstorm pummels their leaky rooftop shack, and as the storm climaxes, Sufen braves thunder, lightning, and torrential rain to repair the window and protect her family. A shot shows Shanghai seemingly drowning, consistent with the leitmotif of the war as a torrent of suffering. At the end of part 2, Sufen, in a pathetic gesture of oblivion, quenches her sorrow with a watery suicide. In 1947 war was still raging, and the film's ending implies that suffering, like a river, flows ever on.

NOTES

1. The copy of *Spring River* discussed in this chapter was "re-edited" (*chongjia zhengli*) and re-released in 1956, during a cultural thaw of the early Mao Zedong era known as the Hundred Flowers Movement. As the original version of the film seen by audiences in 1947 is not available, this chapter does not delve into differences between editions, which might be significant. A novel adaptation of *Spring River* was published in Shanghai in 1949 (crediting Cai Chusheng as sole author) and in Hong Kong (crediting Cai and Zheng) in 1963. A screenplay appears in a 2016 edition of Zheng Junli's complete works.

2. "*A Spring River Flows East* was screened 137 times in Shanghai in 1949 and 135 times in 1950." Paul G. Pickowicz, *China on Film: A Century of Exploration, Confrontation, and Controversy* (Lanham, Md.: Rowman and Littlefield, 2012), 192.

3. See "Victory as Defeat," in Pickowicz, *China on Film*, esp. 127–128, 137–142.

4. Historian Hans van de Ven notes that at war's end "only 10 percent of China's rail network was operational . . . and many rivers had been mined," so tens of millions of people made much of the journey by foot. Hans van de Ven, *China at War: Triumph and Tragedy in the Emergence of the New China* (Cambridge, Mass.: Harvard University Press, 2018), 222.

5. As Bret Sutcliffe describes, this occurred in three phases: "The ruling KMT confiscated the Japanese studio properties, moving its wartime film production company (Central Motion Picture Company) to Shanghai and Beijing and became the largest studio in terms of facilities, personnel and output (fourteen films in 1947). The second stream was the establishment of three studios by private entrepreneurs that maintained a semi-fixed production staff and studio premises—Wenhua, Kunlun and Cathay film production companies. The third stream consisted of the 'independent' production companies: small ventures that organized for the production of one or two films then collapsed or disbanded, renting studio space and equipment from the more established studios."

6. *Chin-Chin Screen* praised Shu Xiuwen as "this year's best actor" for her role in the Ouyang Yuqian film *Wildfire in the Spring Wind* (1948) and featured her on the cover. *Qingqing dianying* (*Chin-Chin Screen*) 16, no. 18 (June 27, 1948).

7. These approximate statistics appear in Diana Lary, *The Chinese People at War: Human Suffering and Social Transformation, 1937–1945* (New York: Cambridge University Press, 2010), 175–176.

8. In the 1949 novel version, this line reads "In some families, husband and wife reunite" (幾家夫妻團圓聚), while other families on the streets suffer a wretched plight.

SOURCES/FURTHER READING

Cai Chusheng. *Yijiang chunshui xiang dong liu* [Spring river flows east]. Shanghai: Zuojia shuwu, April 1949.

Cai Chusheng, and Zheng Junli. *Yijiang chunshui xiang dong liu* [Spring river flows east]. Hong Kong: Xianggang yingye chubanshe, 1963.

Lary, Diana. *The Chinese People at War: Human Suffering and Social Transformation, 1937–1945.* New York: Cambridge University Press, 2010.

Pickowicz, Paul G. "Victory as Defeat: Postwar Visualizations of China's War of Resistance." In *China on Film: A Century of Exploration, Confrontation, and Controversy*, 121–156. Lanham, Md.: Rowman and Littlefield, 2012.

Sutcliffe, Bret. "*A Spring River Flows East*: Progressive Ideology and Gender Representation." *Screening the Past* 5 (December 1998). http://www.screening thepast.com/2014/12/a-spring-river-flows-eastprogressive-ideology-and-gender -representation.

van de Ven, Hans. *China at War: Triumph and Tragedy in the Emergence of the New China*. Cambridge, Mass.: Harvard University Press, 2018.

Wang, David Der-wei. *The Lyrical in Epic Time: Modern Chinese Intellectuals and Artists Through the 1949 Crisis*. New York: Columbia University Press, 2015.

Zheng Junli. "Dianying *Yi jiang chunshui xiang dong liu*" [The film *Spring River Flows East*]. In *Zheng Junli quanji* [Complete works of Zheng Junli]. Ed. Li Zhen. 4:51–419. Includes two drafts of a literary treatment of the plot, screenplay, shooting schedule (with select facsimile copies on handwritten notes), and Zheng's essay "Why I Made *Spring River Flows East*," originally published in *People's Daily* on September 23, 1956.

FURTHER VIEWING

Crossroads (*Shizi jietou* 十字街頭). Shen Xiling, director. 1937.

Crows and Sparrows (*Wuya yu maque* 烏鴉與麻雀). Zheng Junli, director. 1949.

Eight Thousand Li of Clouds and Moon (*Baqian li yun he yue* 八千里雲和月). Tomsie Sze (Shi Dongshan), director. 1947.

Gone With the Wind. Victor Fleming, director. 1939.

Spring in a Small Town
(*Xiaocheng zhi chun* 小城之春)

Alternative English titles: *When Spring Comes, Springtime in a Small City*
Director: Fei Mu
Screenplay: Li Tianji
Studio: Wenhua
Date of release: September 25, 1948
99 minutes
Cast: Wei Wei, Shi Yu, Li Wei, Zhang Hongmei, Cui Chaoming

SYNOPSIS

The Anti-Japanese War has just ended and China is in ruins. Zhou Yuwen lives in a small town in the south with her husband, Dai Liyan, his teenaged sister, Dai Xiu, and a family servant, Old Huang. The marriage is an unhappy one, and Yuwen spends much of her free time wandering on the city wall, while Liyan spends his brooding over the decline in the family's fortunes and trying to repair their bombed-out home. One day, Liyan's childhood friend Zhang Zhichen, a doctor who has been working in the interior during the war, arrives. Zhichen's joy at the reunion is tempered by the discovery that his friend is married to his old flame: Zhichen and Yuwen were in love once and had planned to get married.

Their former passion starts to rekindle. Dai Xiu is more optimistic than her melancholic brother. She takes a fancy to Zhichen and, amid the joys of reunion, tensions start to develop within the group. Liyan is suffering from illness, which Zhichen diagnoses as tuberculosis and a weak heart, but which Yuwen attributes to neurosis. Liyan confides to Zhichen that his marriage is in trouble: he and Yuwen have been sleeping in separate rooms for years. Zhichen encourages his friend to get outside more, but group excursions also bring Zhichen and Yuwen closer together. During a drinking party on the night of Dai Xiu's sixteenth birthday, Yuwen and Zhichen's mutual attraction becomes evident to Liyan, who retreats in dismay. After the party, Yuwen makes her way to Zhichen's room, where they come close to consummating their passion. But Zhichen leaves the room and locks Yuwen inside. She breaks a window, cutting her hand, and he rushes back inside and treats her wound. Shocked into sobriety, Yuwen goes back to her room, but neither she nor Zhichen can sleep. Each of them visits Liyan separately later that night to ask for a sleeping pill. Liyan asks Yuwen if she is still in love with Zhichen. The next day, Yuwen stops just short of jumping off the city wall and killing herself. Zhichen tells Liyan that he plans to leave and admits his near transgression. Later that day, Liyan observes Zhichen and Yuwen talking from afar, and then goes to his room and tries to take an overdose of sleeping pills. Old Huang later finds Liyan passed out on his bed, and summons the others. Liyan survives, but the incident convinces Zhichen to leave and Yuwen to stay with her husband. In the final scene, Dai Xiu and Old Huang take Zhichen back to the train station while Yuwen stands on the wall with Liyan and points into the distance.

THE BEST OF THE BEST?

In 2005, to mark the symbolic centennial of Chinese filmmaking (the 1905 film *Dingjun Mountain*), the Hong Kong Film Critics Association sponsored a vote on the best Chinese films of the past hundred years. Fei Mu's *Spring in a Small Town* was voted number one. *Spring in a Small Town* (originally marketed as *When Spring Comes*[1]) tells a story of five people in a small town in southern China reuniting in the aftermath of a war, coping with loss, and undecided about what to do next. What is it about this modest film, released to a mixed reception during the

Chinese civil war,[2] that has led to it being regarded as the most classic film in Chinese cinema history?

Fei Mu had a background in the theater and had directed several films for Lianhua Studio, including *City Nights* (1933), *Song of China* (1935), and *Bloodshed on Wolf Mountain* (1936). During the war, he made several anti-Japanese propaganda films, and the costume drama *Confucius* (1940). *Spring in a Small Town* was reportedly made in spring 1948 during a pause in the production of *A Wedding in the Dream* (1948), also known as *Everlasting Regret*, China's first full-length color film, featuring a Peking opera performance by Mei Lanfang.[3] *Spring in a Small Town*, which involves only five people in one place over a limited period of time, seems like a stage play with a small cast. As events unfold, the intimacy starts to seem claustrophobic, especially as the scenes move into nocturnal settings and the emotional intensity of the drama ratchets up.

Spring in a Small Town was written under Fei's tutelage by a screenwriting novice, a young actor in his twenties named Li Tianji. In 1947, Li appeared in *Diary of a Homecoming* (1947), giving a buffoonish performance incongruous with the poetic masterpiece he was writing for Fei at the time. Li's most significant performance is as the sinister and grotesque Nationalist official who terrorizes the residents of a Shanghai apartment building in *Crows and Sparrows* (1949). *Diary*, *Crows*, and *An Ideal Son-in-Law* (1947) are three of many late 1940s films set in the present day featuring people dealing with the aftermath of the Anti-Japanese War.

A POETICS OF MELANCHOLY

Spring in a Small Town begins, subtly, at the end of the story. The first people we see, during the opening credits, are Zhang Zhichen leaving town, accompanied by Dai Xiu and Old Huang (figure 12.1). This blink-and-you'll-miss-it shot is the first visual clue that this film's storytelling is not straightforward.

Sound then grabs our attention. As Yuwen walks alone on an old city wall (figure 12.2), her internal monologue in voice-over tells us about "living in a small town, living a life that never changes." She links her mental state to a place: "As I walk along the city wall, I feel like I've left

FIGURE 12.1 Beginning at the end
Source: Author

this world behind. My eyes see nothing. My mind is blank. If it weren't for the basket of vegetables in my hand, and the medicine I bought for my sick husband, I might spend the whole day away from home."

These words turn the wall into more than just a location: it seems to symbolize her character's uncertainty and hesitation, her desire for refuge. This city wall was originally a defensive fortification, presumably against attack from the outside, but it has fallen into disrepair over the centuries and is overgrown with weeds. As an object of long-term decline, the wall seems to externalize Yuwen's emotional state.

Walls also resonate with the mental and physical condition of Yuwen's husband, Dai Liyan. When we first see Liyan (played by Shi Yu, who had a minor role in *Eight Thousand Li of Clouds and Moon* [1947]), he is trying to repair a hole in a wall of his home, laboriously stacking brick upon brick (figure 12.3). Art historian Wu Hung points out that the two walls represent different time registers: whereas the city wall decayed gradually, Liyan's home has been literally blown apart by war—neglect

FIGURE 12.2 Yuwen on the city wall
Source: Author

versus trauma.[4] The hole we see is bigger than Liyan and, given his poor health, it seems unlikely he will repair it fully by himself. When Zhang Zhichen arrives in town, he makes his way directly to the rear entrance of the Dai compound, which he knows well from childhood, and he climbs through the hole in the wall to greet his old friend (figure 12.4).[5] The moment is fraught with symbolism. Exuding energy, health, and enthusiasm, this charismatic figure literally climbs through the gap in the Dai home. Will he be able to fill a gap in their lives?

Later, we see other barriers within the household. These include walls, doors, and windows made of paper and glass. When lying in bed, Liyan is often overshadowed by light shining through the paper windows casting shadows on the wall. Following the drunken revelry of Dai Xiu's birthday party, Yuwen tries to visit Zhichen in the study that has been converted into a bedroom for him. She forces her way in, and, though momentarily tempted to follow her lead, Zhichen goes outside to cool off, locking Yuwen in the room.[6] In desperation, she punches

FIGURE 12.3 Liyan trying to repair a hole in the wall
Source: Author

through the glass in the door and tries to open it using the handle on the outside, but in doing so she cuts her hand. At this dramatic moment, Yuwen breaks through a barrier, and experiences trauma in doing so. Though Zhichen bandages her hand, he cannot repair the wound, and the moment marks the beginning of their separation.

Fei Mu's mise-en-scène involves a concentric structure of walls within walls, and barriers within barriers: the city wall, the wall to the family compound, the walls between rooms. At times, such barriers symbolize the divisions between characters. Shortly before Liyan tries to kill himself, Yuwen closes a double door between them. Later that day, Liyan asks Old Huang to close the doors, before changing his mind—he still retains hope. Then he then sees Yuwen walk by and follows her outside where he sees her, at a distance, talking to Zhichen and crying. The gaping hole in the wall behind him is like a hole in his heart. He goes to Yuwen's room for the first time in three years, and then returns to his own room and lies down on his bed to die.[7]

FIGURE 12.4 Zhichen returns and fills a gap
Source: Author

Yet walls can be more than barriers. Dai Xiu once tells Zhichen that to her the wall is like "a road that one will never finish walking," one that might lead to her future. Yuwen once contemplates using the wall to end her life, by jumping off it. At the end of the film, the wall reappears as a place of redemption where the estranged couple, Liyan and Yuwen, come back together.

Other visual motifs also resonate with the psychological and emotional states of the characters. When Zhichen is getting ready for bed in his first night in the converted study, Yuwen visits him, ostensibly to deliver bedding and a thermos of hot water, and they have a conversation in the room. The scene has a stagey quality, perhaps influenced by Fei Mu's background as a theater director. The set is bare, like a stage, with only a few props: a painting on the wall, a light bulb hanging from the ceiling, a thermos on a table, a candle. The tension is palpable. In her hands Yuwen holds a handkerchief (a prop associated with the female *dan* role in Chinese opera[8]), which she twists and fidgets with. The conversation

is formal and halting. At one point, Zhichen leans toward Yuwen and puts his hands on the hot water thermos she delivered to him—an object suggestive of heat beneath the surface.[9] The electricity is about to go out, as it does every night due to energy-saving measures, and Yuwen lights a candle for Zhichen (figure 12.5)—a gesture that seems to symbolize her interest in rekindling their relationship. (Immediately following Yuwen's aborted affair with Zhichen, Liyan has her light a candle for him.) All of her fiddling with the light switch, too, suggests that she will take the initiative in what follows. Even the naked light bulb that hangs above them seems to symbolize that, for all that is left unspoken in this scene, it has laid passions bare.

Yuwen's voice-over is perhaps the film's most powerful lyrical element, because it creates such a strong sense of subjectivity. She tells us her thoughts and feelings, and we can hear her uncertainty in the tenor of her voice. The sound of her voice, speaking directly to us, turns us into her confidants and brings us inside her mind. It directs our eyes

FIGURE 12.5 Yuwen lights a candle for Zhichen
Source: Author

and affects how we interpret what we see. Her voice is close-miked, so we hear her words distinctly. It is also significant that the narrator is female and that we hear about events from a feminine perspective. In the contexts of both Chinese narrative and Chinese filmmaking this was an innovation.[10] Yuwen's internal monologue creates an atmosphere—or "air" (*kongqi*), to use Fei Mu's term— that cannot be constrained by barriers, be they physical, mental, or emotional.

Visual and acoustic design work together in the scene in which Zhichen joins the three family members for a boat ride on the river. All four characters are literally in the same boat, even closer together and more confined than they were in the earlier nighttime scene of Dai Xiu singing for everyone in Liyan's bedroom. We see them in a series of shots at long, medium, and close-up distance that reveal meaningful blocking. Liyan and Dai Xiu sit in front facing the camera, while the erstwhile lovers Yuwen and Zhichen are in the back, unseen by brother

FIGURE 12.6 Yuwen's backward glance
Source: Author

and sister. As sister and brother sing a song about passersby "looking back longingly" at a beautiful girl, a tracking shot follows the sitting Yuwen's gaze back to Zhichen (figure 12.6). As he stands rowing, he maintains a steady gaze forward, as if he is trying hard not to look at her. Fei Mu makes a choice here not to cut between the two characters, dividing them into separate shots, and instead to link them together in one space. The sound of brother and sister's singing together up front, looking cheerful about this rare opportunity for outdoor recreation, reminds us of their presence and puts into relief the mute struggle going on behind them.[11]

THE POET-DIRECTOR

Mise-en-scène, cinematography, and sound design are three of several elements that have led critics to call Fei Mu "the poet-director" and *Spring* a work of lyricism. "Lyricism," a term sometimes taken as synonymous with "poetic," may be defined as the quality of expressing subjective emotion. The most common modern Chinese term for lyricism, *shuqing*, literally means to unravel or release feeling, but also suggests its weaving, as on a loom (*shu*).[12] A lyrical work of art does not necessarily narrate a linear set of events in a logical, rational fashion; instead it might intensify emotions, which may be illogical, inconsistent, and uncontrollable.

Lyrical associations shared by many languages and traditions include the natural world, which follows its own rhythms, such as the cycling of the seasons, the flow of water, the alternating rising and setting of the sun and moon. *Spring in a Small Town* often uses such visual motifs to symbolize the emotional lives of the characters. Chinese lyrical traditions emphasize the value of restraint, including the repression of emotion. When Yuwen goes to visit Zhichen on the night of the birthday party, for example, she is in a particularly fluid state: she is intoxicated, amorous, and uninhibited. Her advance toward Zhichen's room is intercut with shots of the moon, a traditional trope often used to symbolize the mutual longing of lovers separated by space but conscious that the same moon shines upon them both. We also see the fragrant orchid that Yuwen earlier delivered to Zhichen's room. The expression of her regard for him had provoked the jealousy of Dai Xiu, who presents a competing token to Zhichen: a homemade *penjing* (or bonsai). The shot reminds us

of those earlier moments of "using an object to convey feelings" (*yi wu chuan qing*).

The movement of Fei's camera is also lyrical. Slow tracking shots reveal people within a landscape in a manner similar to the gradual unrolling of a handscroll. The movement is deliberate and measured, an expression of conscious observation that seems reflective. The camera travels or wanders horizontally (*you*) at a contemplative pace. Whereas Yuwen's voice-over takes us inside her feelings, the traveling gaze adds an aestheticizing subjectivity that views the scene from the outside.

The theme that return does not equal repair also seems to echo national trauma. People were returning home from refugeedom and trying to pick up the pieces of their lives and cope with the fragmentation and losses caused by the war. Liyan's return to find a home in ruins resembles a predicament depicted in 1946 by the artist Feng Zikai (figure 12.7).[13] Fei Mu's film captures an indeterminate moment in modern China's trajectory. It expresses no certainty that a broken home can or will be made whole again, offering a poetics of hesitation and contemplation rather than a declaration of certainty about reconstruction.

Fei Mu was drawing on the poetics of both Su Shi's 11th century song lyric "Butterfly Loves Flower" (蝶戀花), which invokes a girl inside a wall and a man walking outside, and Du Fu's eighth-century "Spring Gazing" (春望):[14]

Nation shattered, mountains and rivers remain;	國破山河在
City in spring time, grasses and trees grow thick.	城春草木深
Moved by the times, flowers draw forth tears;	感時花濺淚
Loath to part, birds startle the heart.	恨別鳥驚心
Beacon fires, alight three months running;	峰火連三月
And a letter from home is worth a fortune.	家書抵萬金
White hairs, fewer for the scratching,	白頭搔更短
Soon too few to hold up a hatpin.	渾欲不勝簪

Du Fu's poem alludes to a rebellion that had forced the Emperor to flee the capital, and which marked the beginning of the decline of the Tang dynasty. It draws a contrast between human suffering and the indifference of nature: flowers and birds care nothing for the empire. Human affairs have reached a nadir, yet the seasons continue to turn. Signs of

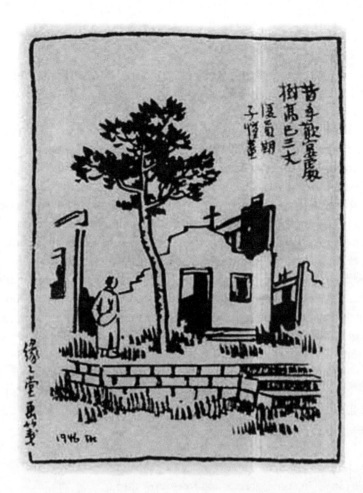

FIGURE 12.7 *Where Once We Enjoyed Banquets, a Tree Has Grown Thirty Feet High* (1946), by Feng Zikai

renewal—the blooming of flowers, the chirping of birds—bring to the poet not joy but sadness and anxiety. The poet's concern for his nation is expressed bodily in a final, self-mocking image of decline: his hair has gone white and is falling out.

In 1948, the Japanese had been defeated, but China was still in the midst of the chaos of civil war, and its future was uncertain. Whereas other films present suffering and disappointed expectations in a melodramatic (*Spring River Flows East*) or comedic (*Diary of a Homecoming*) key, *Spring in a Small Town*'s mode is melancholy and hesitant.

The film could be viewed as presenting a modernized version of the "talented scholar and beautiful woman" (*caizi jiaren*) plot formula.[15] Scholar–beauty plots were popular in premodern drama and literature and were widely adapted in middlebrow-genre fiction through the 1940s. Typically, a young man is a candidate for the civil service examinations, and on his way to the exams he falls in love with a beautiful woman, perhaps a courtesan or a woman of high birth. They fall in love, part from and pine for each other, but he eventually returns in triumph, having taken first place on the exams. Scholar and Beauty marry and live happily ever after.

Zhang Zhichen is a modern scholar—a medical doctor—and Zhou Yuwen is certainly a beauty, so the premise fits. In this film, however, Beauty already has a husband. Liyan is not an ideal match. He's sickly, calling to mind a negative trope about China common since the late-nineteenth century: the sick man of Asia. Nor is his illness purely physical: he suffers from melancholia and depression. His family fortunes have been ruined by war, but Liyan blames himself. China's trajectory for much of the late-nineteenth century, and early-twentieth century too, was one of disruption and decline. Yuwen's choice thus could be interpreted as one between a modern, talented, Westernized scholar (Zhichen always wears a suit) and a traditional scion of a once well-off family whose days are numbered. Liyan (who always wears a Chinese gown) seems to recognize the dilemma when he attempts to take his own life. So if *Spring in a Small Town* is a modern scholar–beauty story, it does not follow the traditional comic trajectory, because not all ends well. The course of love does not run smooth, and Scholar and Beauty part in the end.

An allegorical reading of the ending could yet result in a more optimistic, even patriotic interpretation of the film's ideology—one missed by its 1940s critics. Yuwen chooses fidelity over passion and chooses to honor the commitment she made to her husband. (Fei Mu's restraint includes his decision not to have Yuwen kill herself, as she does in Li Tianji's script.) Her man might be laid low now, but she will stay with him for life. Like her ailing husband, this broken country might yet be fixed.

Fei Mu's film, of course, cannot be reduced to national allegory, because to do so would ignore its concern with the lives and feelings of individuals. We hear Yuwen's voice and we watch her cut her hand on

the window. The motifs of the crumbling wall and the broken walls of the Dai household are but the most conspicuous externalizations of the fragile physical and emotional states of the characters.

The drama begins with an arrival and ends with a departure. The sense of symmetry, however, is destabilized by all that has happened in between. What will happen to these five people? Zhichen leaves town, presumably to continue his medical career. Dai Xiu has her future ahead of her and may well end up going to a school that Zhichen recommends for her in Shanghai. Old Huang will no doubt continue to serve the Dai household until he retires. The future of Liyan and Yuwen is less certain. Liyan's health may or may not improve, and this may depend on his relationship with Yuwen. Yuwen has already expressed her unextinguished passion for Zhichen as well as her affection and sense of duty toward Liyan. In one of the final shots of the film, she stands next to Liyan on the wall where she first appeared alone, and points ahead to the distance, and possibly into their future together (figure 12.8).

FIGURE 12.8 Yuwen with Liyan looking out from atop the city wall
Source: Author

SPRING ANEW

Fei Mu died just three years after completing *Spring in a Small Town*, but his aesthetic of ruins has been influential, particularly during recent decades of Chinese cinema history. Jia Zhangke, Tian Zhuangzhuang, Wong Kar-wai, and Zhang Yimou are among the contemporary filmmakers who have cited *Spring in a Small Town* as an inspiration to their own work.

Tian Zhuangzhuang, a member of the so-called Fifth Generation of filmmakers who attended the Beijing Film Academy after the end of the Cultural Revolution, remade Fei Mu's film in 2002. Tian had earlier directed *The Blue Kite* (1993), which showed the disastrous effects of Mao-era political movements on one family. The film was banned upon release, and the authorities prohibited Tian from directing films for ten years. *Springtime in a Small Town*, as it is known in English, was Tian's comeback vehicle. The film sticks closely to the original story and re-creates most of the scenes that appear in Fei Mu's version. But in contrast to Fei Mu, who uses a range of camera distances and angles and dynamic editing, with numerous dissolves, Tian's film is dominated by extreme long shots and long-take tracking shots. The boat scene, for example, is done as one continuous take with the camera positioned on the shore. Such shots suggest continuity of time and space while also imbuing the film as a whole with a voyeuristic quality. We lose some of the emotional intensity that comes from seeing the medium and close-up shots of faces. Gone too is Yuwen's voice-over and with it much of the feeling that this is *her* story. The combined effect is a greater distance from the characters, such that their struggles appear melodramatic.

Tian seems to have wanted to convey his own sense of loss as a filmmaker by turning Fei Mu's film itself into an object of lament. If Fei Mu's film represents a high point in the history of Chinese film artistry, Tian's cinematography expresses a feeling of distance from that bygone age. Extreme long shots, which track behind objects, frustrating our desire for a clear view, seem designed to make us feel distance and detachment. If Fei Mu's film expresses melancholy over the personal and collective losses of the war, Tian's expresses meta-melancholy over the loss of Fei's poetics, and identification with a poet-director's courage to buck the artistic trends of his era.

One other twenty-first-century filmmaker who uses an aesthetics of ruins is Jia Zhangke. *Still Life* (2006) is set in the ruins of a condemned city along the Yangtze; *24 City* (2008) is set in a Chengdu munitions factory slated to be torn down for a housing development; *I Wish I Knew* (2010) includes shots of Shanghai rubble. In these films, Jia's mise-en-scène shows ruins upon ruins. The places where people lived and worked are in various states of demolition and decay: some are to be inundated by the reservoir created by the Three Gorges Dam; others will vanish to be replaced by high-rise condominiums. In Jia's work, an aesthetics of ruins recurs as a critique of and a lament for what has been lost in contemporary China and what have been the costs of rapid economic growth. Now we are dealing with loss created not by war but by prosperity and obsolescence. Jia mounts a cinematic salvage operation to preserve traces of the past and the dignity of its inhabitants.

Since the early 2010s, the pace of demolition has been so rapid that people have referred to China as *Chai-nar*, "Where to demolish next?" The meme, born of an age of widespread forced evictions, indicates that unwanted destruction of homes and communities remains a proximate issue in China today and that individuals and families around the country are struggling to cope with loss. Fei Mu's film also continues to resonate, not least because it acknowledges that loss and grief are common to the human condition and that a way forward, though never easy, is possible.

NOTES

1. The film premiered simultaneously at three Shanghai cinemas on September 25, 1948, according to an advertisement in *Shenbao* 25362 (September 24, 1948), 8. It was marketed under this English title in the Shanghai magazine *Dianying feng* (*Movie Trends*), no. 1 (September 30, 1948); Paul Fonoroff, *Chinese Movie Magazines: From Charlie Chaplin to Chairman Mao, 1921–1951* (Oakland: University of California Press, 2018), 228. *When Spring Comes* is advertised as showing same day at the Coliseum in Kuala Lumpur on November 11, 1949 (*Singapore Free Press*); at the Cathay in Hong Kong on February 21, 1951 (*The China Mail*); and at the Odeon in Singapore on September 6, 1953 (*The Straits Times*).

2. Negative reviews of *Spring in a Small Town* tend to complain about its restricted scope and gloominess. One reviewer found it hard to identify with the "petty sentiments" (狭小的感情) of loneliness and melancholy. A mixed assessment

praised Fei's technique but found the mood to be a downer and the film overall "disappointing," asking "Just where is the spring?" Another reviewer lamented the "waste of [Fei's] talent" (才華的浪費). Conversely, *Chin-Chin Screen*'s review-er praised *Spring* as a "lyrical masterpiece" (詩意化的聖品), "an unprecedented artistic accomplishment" (空前的藝術大作), and claimed that it had a long, suc-cessful run. See, respectively: Xiangqian 向前, "Ping *Xiaocheng zhichun*" 評 "小城之春" [Review of *Spring in a Small Town*], *Juying chunqiu* 1, issue 3 (1948), 107; Hai Qing 海情, *Xiaocheng zhi chun* chun zai nali? "小城之春" 春在哪裏 [Just where is the spring in *Spring in a Small Town*?], *Yingju congkan* 2 (1948), 31–32; An E 安娥, "Kanle *Xiaocheng zhi chun*" 看了"小城之春" [I watched *Spring in a Small Town*], *Yuanfeng* 3, no. 1 (1948), 29–30; Ding Lie 丁烈, "Tantan *Xiaocheng zhi chun*" 談談"小城之春" [About *Spring in a Small Town*], *Qingqing dianying* 16, no. 33 (1948).

3. David Der-wei Wang, *The Lyrical in Epic Time: Modern Chinese Intellectuals and Artists Through the 1949 Crisis* (New York: Columbia University Press, 2015), 297.

4. Wu Hung, *A Story of Ruins: Presence and Absence in Chinese Art and Visual Culture* (Princeton, N.J.: Princeton University Press, 2012), 181.

5. *Diary of a Homecoming* (1947) also features, in an early scene, a man jumping through a hole in a wall after Japan's defeat.

6. Earlier, a shot shows Dai Xiu coming to the same door looking for Zhichen, who is hiding from her somewhere else. So this scene is the second time this particu-lar barrier causes frustration, this time with the woman on the inside.

7. An ambiguity arises here: Yuwen's voice-over had told us earlier that Zhichen replaced Liyan's sleeping pills with vitamin pills. Liyan passes out in this scene as if he did indeed consume an overdose of sleeping pills. But later, when Dai Xiu asks what is wrong with her brother, Zhichen points to his heart.

8. Hu Jubin, Projecting a Nation: *Chinese National Cinema Before 1949* (Hong Kong: Hong Kong University Press, 2003), 188–189. Handkerchiefs also appear in *Laborer's Love* (1922), *Love and Duty* (1931), *Street Angels* (1937), *Begonia* (1943), *Love Everlasting* (1947), and *A Wedding in the Dream*.

9. A thermos—which is broken inside—appears in another nighttime scene involv-ing an ill-fated romantic pair, one of whom is married to someone else, in *Love Everlasting* (1947).

10. In *Love Everlasting*, internal monologue occurs in a couple of late scenes, includ-ing when we hear the female protagonist wish for the death of a rival in love.

11. The song, "That Faraway Place" ("Zai na yaoyuan de difang"), has been reinter-preted by pop stars like Karen Mok.

12. "The Chinese character *shu* 抒 (unravel, release) of *shuqing* 抒情, or 'lyricism,' is interchangeable with the character 杼, which is pronounced *zhu* and literally

means 'loom'" (a prop appearing in *A Wedding in the Dream*), an etymological association which points to "the bifurcated faculty inherent in Chinese lyricism: to unravel, and at the same time to weave, the tapestry of feeling." David Der-wei Wang, *The Lyrical in Epic Time*, 288.

13. Wu, *A Story of Ruins*, 178.

14. David Der-wei Wang, *The Lyrical in Epic Time*, 298–302. "Fei Mu and Li Tianji concurred that Su Shi's song lyric best summarizes the tenor of *Spring in a Small Town*" (300).

15. On the history of the genre, see Mengjun Li, "In the Name of a Love Story: Scholar-Beauty Novels and the Writing of Genre Fiction in Qing China (1644–1911)" (PhD diss., The Ohio State University, 2014).

SOURCES/FURTHER READING

Daruvala, Susan. "The Aesthetics and Moral Politics of Fei Mu's *Spring in a Small Town*." *Journal of Chinese Cinemas* 1, no. 3 (September 2007): 171–188.

Fan, Victor. "Fey Mou: The Presence of an Absence." In *Cinema Approaching Reality: Locating Chinese Film Theory*, ed. Victor Fan, 109–152. Minneapolis: University of Minnesota Press, 2015.

FitzGerald, Carolyn. "Between Forgetting and the Repetitions of Memory: Fei Mu's Aesthetics of Desolation in *Spring in a Small Town*." In *Fragmenting Modernisms: Chinese Wartime Literature, Art, and Film, 1937–49*, 169–216. Leiden: Brill, 2013.

——. "*Spring in a Small Town*: Gazing at Ruins." In *Chinese Films in Focus II*, ed. Chris Berry, 205–211. Basingstoke: British Film Institute/Palgrave MacMillan, 2008.

Jones, Andrew F. "*Spring in a Small Town*: A Translation of the Full Filmscript." https://u.osu.edu/mclc/online-series/spring.

Lei Qinfeng (Christopher G. Rea). " 'Zuori fei jinri': Tian Zhuangzhuang *Xiaocheng zhi chun* lishi yuwang de youling zaixian" [Hauntings of historical desire in Tian Zhuangzhuang's *Springtime in a Small Town*). In *Xiangxiang de benbang: xiandai wenxue 15 lun* [National imaginaries: 15 perspectives on modern Chinese literature], ed. David Der-wei Wang and Kim Chew Ng, 161–180. Taipei: Rye Field Publishing, 2005.

Li, Cheuk-to. "Le Printemps d'une petite ville, un film qui renouvelle la tradition chinoise." In *Le Cinema Chinois*, eds. Marie-Claire Quiquemelle and Jean-Loup Passek, 73–76. Paris: Centre Georges Pompidou, 1985.

——. "*Spring in a Small Town*: Mastery and Restraint." *Cinemaya* 49 (2000): 59–64.

Li, Jie. "Home and Nation Amid the Rubble: Fei Mu's *Spring in a Small Town* and Jia Zhangke's *Still Life*." *Modern Chinese Literature and Culture* 21, no. 2 (Fall 2009): 86–125.

Schultz, Corey Kai Nelson. "Ruin in the Films of Jia Zhangke." *Visual Communication* 15, no. 4 (2016): 439–460.

Wang, David Der-wei. "Fei Mu, Mei Lanfang, and the Poetics of Screening China." In *The Lyrical in Epic Time: Modern Chinese Intellectuals and Artists Through the 1949 Crisis*, 271–310. New York: Columbia University Press, 2015.

Wong Ain-ling. "Fei Mu: A Different Destiny." *Cinemaya* 49 (2000): 52–58.

——, ed. *Shiren daoyan Fei Mu* [Poet-director Fei Mu]. Hong Kong: Hong Kong Film Critics Association, 1998.

Wu Hung. *A Story of Ruins: Presence and Absence in Chinese Art and Visual Culture*. Princeton, N.J.: Princeton University Press, 2012.

FURTHER VIEWING

24 City (*Ershisi cheng ji* 二十四城記). Jia Zhangke, director. 2008.

Bloodshed on Wolf Mountain (*Langshan diexue ji* 狼山喋血記). Fei Mu, director. 1936.

Confucius (*Kong fuzi* 孔夫子). Fei Mu, director. 1940.

I Wish I Knew (*Haishang chuanqi* 海上傳奇). Jia Zhangke, director. 2010.

Love Everlasting (*Buliao qing* 不了情). Sang Hu, director. 1947.

Song of China (*Tianlun* 天倫). Fei Mu, director. 1935.

Springtime in a Small Town (*Xiaocheng zhi chun* 小城之春). Tian Zhuangzhuang, director. 2002.

Still Life (*Sanxia haoren* 三峽好人). Jia Zhangke, director. 2006.

A Wedding in the Dream (*Shengsi hen* 生死恨). Fei Mu, director. 1948.

Wanderings of Three-Hairs the Orphan (*Sanmao liulang ji* 三毛流浪記)

Alternative English titles: *An Orphan on the Streets, Wanderings of Sanmao, The Winter of Three-Hairs, The Adventures of Sanmao the Waif*
Directors: Zhao Ming and Yan Gong
Original story: Zhang Leping
Screenplay: Yang Hansheng
Studio: Kunlun
Date of release: October 30, 1949
70 minutes
Cast: Wang Longji, Lin Zhen, Du Lei, Cheng Mo, Meng Shufan

SYNOPSIS

Three-Hairs (Sanmao) is an orphan boy around eight to ten years old living on the streets of Shanghai in 1948. One night he beds down in a wheelbarrow and is awakened before dawn by a garbage collector shoveling trash onto him. He gets up and starts looking for food, first through shop windows and then at a street market, but he has no money. Daydreaming of food, he gets run down by a car and berated by the driver. He discovers a squashed bun beneath him and devours it, but has to throw a second one to a dog whose owner sics it on him. Still hungry, he drinks from a can of paste being used to post bills, only to be chided

for not observing proper hygiene. He joins a scrum of street children grabbing rice handouts, but they accuse him of stealing "their" food and attack him. He fights them off, attracting the attention of the head of a street gang. Sanmao runs away and tries out other methods to earn money for food, such as selling newspapers, collecting used cigarette butts, and pushing pedicabs up a bridge. Eventually, he ends up with the gang boss, who feeds him and gives him new clothes in return for learning to pick pockets. Sanmao finds camaraderie with the other boys, who now work together for pedicab tips. They also experience mistreatment together, as when they are driven out of a Children's Day parade. When Sanmao picks his first pocket, he feels guilty and returns the wallet to its distressed owner. As punishment, the gang imprison him without food for three days. The gang boss and his woman dress Sanmao up like their son and steal cloth from a department store, only to flee when discovered. Sanmao walks by a school whose gatekeeper tells the "little bum" to keep moving. Sanmao comes across some money, but he turns over the bread he bought to another street child even more wretched than he is. Seeing a man selling children on the street for cheaper than a foreign doll in a shop window, Sanmao tries to sell himself at an even lower price. A woman offers to feed and clothe him if he will be obedient. Sanmao goes along and is scrubbed clean to be presented to a fat, rich lady who adopts him and renames him "Tom." She plans a lavish party to present the "young master" to upper-class society. In preparation, a governess forces him to wear uncomfortable clothing and suffer lessons in etiquette and music. At the party, guests shower "Tom" with gifts and flattery, but he disappears before his scheduled singing performance and secretly lets his homeless buddies into the basement larder. When his adoptive mother discovers them, the boys scatter through the mansion and throw the party into chaos. They are driven out, and Sanmao decides to leave with them. Spring comes to Shanghai in 1949, and with it the People's Liberation Army (PLA), and Sanmao and his friends are invited to join the dancing in the victory parade.

CARTOON CHILDREN FOR REALISM AND PROPAGANDA

Wanderings of Three-Hairs the Orphan is a live-action feature film adapted from a comic strip of the same title by Zhang Leping.[1] Zhang

had invented Three-Hairs (Sanmao, which also means "thirty cents") in the 1930s, but it was in the 1940s, shortly after World War II, that Sanmao became a household name, thanks to the success of the series *Three-Hairs Joins the Army* (1946) and *Wanderings of Three-Hairs the Orphan* (1947), which appeared in two of China's highest-circulation newspapers, *Shun Pao* and *L'Impartial* (aka *Ta Kung Pao*, which appears in the film).

Starring an orphan boy, bald except for the three long hairs on his forehead, the comic proved popular with both grown-ups and children. The film, too, has crossover appeal, its running time of seventy minutes amenable to shorter attention spans. The film links several of the vignettes and iconic images from Zhang's original comic strips into a single picaresque narrative about the travails of a Shanghai street urchin. Like *Crows and Sparrows* (1949), *Wanderings* is an epochal film. Development reportedly began in October 1948 and shooting on March 15, 1949. The PLA entered Shanghai in May, filming ended in August, the People's Republic was proclaimed on October 1, and the film premiered in Ningbo (with a guest appearance by star Wang Longji) on October 30.[2] The ending "Liberation" parade sequence represents the filmmakers' hasty response to the changing political landscape.

Playing the supporting band of street children are students from the Home and School for Children, a charitable organization for orphans. *The Watch* (1949), in which an orphaned boy steals a watch and ends up exposing an orphanage's corrupt finance manager, also features singing by a real orphanage choir.[3] Through such casting, filmmakers showed that they practiced the economic and social progressivism they preached. In making a movie about an orphan, they were also following a tried-and-true box-office formula popularized by child star Shirley Temple, who had played an orphan in over a dozen films, dating back to *Bright Eyes* (1934).[4]

In the late 1930s and early 1940s, several films were made based on Ye Qianyu's *Mr. Wang* (*Wang xiansheng*), the first long-running, popular Chinese-drawn comic strip, with Tang Jie (who plays a villain in *Hua Mu Lan*) in the title role. Earlier Chinese children's films include Cai Chusheng's *Lambs Astray* (1936) and the animated *Princess Iron Fan* (1941). *Wanderings* alludes to its origins in its opening title, which appears below an animated outline of Sanmao's profile. Opening credits appear in front of a collage of Zhang Leping's drawings. Animation also

appears in the scene where the gang boss grabs Sanmao and the dragon tattoo on the man's forearm comes alive.

The plot hones closely to scenarios from Zhang's comic strips, including the rude awakening by the garbage man (figures 13.1 and 13.2); Sanmao chugging from a can of glue crawling with flies and his homeless friends being kicked out of a Children's Day parade.

The comic strip also influenced the film's form in other explicit as well as implicit ways, including: the exaggerated hair, nose, and skinniness of its hero, the picaresque episodic structure of the narrative, dumb shows set to a soundtrack, and the overall flatness of the characters and set design. The rendering of the hero—bulbous prosthetic nose, bald cap with three strands of hair, penciled eyebrows, a grime-smeared face, a slight frame, and picturesque rags—alludes to his cartoon origins while attempting to avoid making him so unrealistic as to be unsympathetic. The cartoonishness is heightened through cinematography, including low-angle point-of-view shots to represent Sanmao's perspective,

FIGURE 13.1 From comic strip . . .
Source: Zhang Leping lianhuan manhua quanji

FIGURE 13.2 . . . to live-action film
Source: Author

canted framings, and extreme close-up shots during action sequences. Characterizations present a simple moral universe of the good, the bad, and the ridiculous.

The cartoon realism of *Wanderings*, inspired by the popular lore of the streets, offers a representational politics of not discovery but recognition. Cultural production since the nineteenth century conditioned both locals and visitors to "know" Shanghai's iconic traits, including its "extremes of wealth and poverty."[5] In Sanmao, audiences would recognize the familiar sight of a homeless child, while also seeing things they had perhaps heard of, such as gang bosses exploiting children.

The film also remains true to the original comic strip in that many scenes have no dialogue. Like E. O. Plauen's *Vater und Sohn* (1934–1937) (figure 13.3), one of the enduring strengths of Zhang Leping's cartoons is that they contain few words.[6] (Cartoons of the Mao Zedong era, as in *Cartoon Monthly* [1950–1960], typically came with an excess of explanatory text, to make sure that the meaning of the image was not

FIGURE 13.3 E. O. Plauen's *Vater und Sohn*
Source: Wikimedia Commons

misconstrued.) Dumb shows include street scuffles and Sanmao's adop-
tive mother's search for him all over the mansion.

The narrative mimics the serial format and flexible plotting of a
comic strip, its episodic structure representing the seemingly ran-
dom nature of the vagabond life, full of small adventures and chance
encounters. The film catalogues various ways one might survive a scav-
enger existence. A street urchin's life is, by necessity, opportunistic.

Sanmao picks up a newspaper falling off a bicycle and, running after the newsboys out onto the Bund, follows their example in trying to sell it. It turns out to be yesterday's, and the buyer comes back immediately to strip Sanmao of his windfall just as he is about to spend the bill on food. Sanmao immediately catches sight of another boy picking up discarded cigarette butts, which he sells to an old man who rolls salvaged tobacco into new cigarettes. Sanmao promptly rolls yesterday's newspaper into a cone and launches his own search. This endeavor, like the others, ends prematurely when an unextinguished cigarette sets the paper ablaze.

Liulang, or wandering, is an aquatic metaphor whose vehicle is the flow and waves of water. The camera wanders along with Sanmao from event to event. As cinematography, *liulang* could be considered a contrast to the *you* (horizontal traveling, or journeying) of the camera in *Spring in a Small Town* (1948). Whereas Fei Mu's *you* is purposeful and contemplative, *liulang* (lit. "flowing with the waves") suggests passive movement compelled by the vicissitudes of fate. The two films present a contrast in affective strategies: *liulang* conveys the movement of an objectified protagonist wandering mostly in search of the basic necessities food and shelter, while *you* creates a subjective, aestheticizing gaze.

Wanderings presents homeless unfortunates like Sanmao as both proximate and distant, readily visible, yet living a completely different existence. The cinematography emphasizes this so-near-yet-so-far feeling with shots framed by windows, bars, and other barriers that separate Sanmao from food, warmth, fun, and safety (figure 13.4).

Like the comic strip, the film's hero maintains self-dignity despite his sufferings. Though vulnerable to exploitation, he picks himself up when pushed down and fights back when he can. In one scene, Sanmao knocks down a larger street urchin with a single punch. Canted framing shows Sanmao throwing apples at attackers, followed by a frontal medium close-up of his defiant bite of an apple (figure 13.5). His fearlessness, however, invites the attention of the burly gang boss (who carries a birdcage, a motif of entrapment seen in *New Women* [1935], *Street Angels* [1937] and *Diary of a Homecoming* [1947]). While Sanmao can never catch a break, he is also a symbol of freedom and integrity, as when he abandons a bourgeois life and returns to the streets, preferring his rags to the constraining uniform of the young master.

FIGURE 13.4 So near and yet so far
Source: Author

FIGURE 13.5 A defiant Sanmao
Source: Author

The repeated scenes of people laughing at Sanmao, which add insult to injury, indict a Chinese attitude toward urban poverty that dubs unfortunates as, in historian Janet Chen's words, "guilty of indigence."[7] The garbage man laughs at his wretchedness. The butcher laughs at his hunger. The rich guests laugh at his embarrassment. Sanmao fights back with fists and curses. "Mother's!" (*ta made*), an oath akin to "dammit," is the first line of dialogue in a film filled with cursing. Sanmao curses the car that blackens his face with exhaust, and often spits "*Pei!*" at the retreating backs of those who harm him.

Writer Lu Xun's famous story "Diary of a Madman" (1918) ends with the madman's plaintive appeal to "Save the children!," and many later intellectuals echoed this call. As in many other countries, especially in the wars of the 1930s and 1940s, children appeared in Chinese visual propaganda as vulnerable innocents to be protected. *Wanderings*, made at a moment of regime change, appeals for children to be empowered as masters of their own—and the nation's—future.

The Children's Day parade specifically indicts the failure of government policy in this regard by showing the emptiness of the highlighted slogan (which appears in *Playthings* [1933]) "Children are the future masters of the nation." In fact, only middle-class children, driven in cars, or the Scouts of China (see chapter 3), get to join the parade. When Sanmao and his fellow homeless boys try to participate, the scout leader and a policeman unceremoniously pull them out of line and use clubs to scatter their attempt to mount their alternative parade of poverty, as if suppressing a riot.

On the Children's Day that preceded the release of the film, April 4, 1949, Zhang Leping collaborated with Soong Ching-ling, the widow of "father of the nation" Sun Yat-sen, to raise funds for Shanghai's real-life "Sanmaos." Thirty of Zhang's watercolors were auctioned off, and attendees could "adopt" a homeless child by pledging funds for their financial support through a "Sanmao Paradise Club." The situation was desperate, and winter deadly. Over 8,000 children's corpses were reportedly collected from the streets on Shanghai during the first fourth months of 1947; almost 7,000 in the first three months of 1948; and nearly 6,000 by mid-winter, in January 1949.[8] The film further broadcast the implicit argument of the cartoon, made clear in the charitable appeals, that child poverty is a public scandal.

Yet, in the end, the film sidesteps the opportunity for an explicit call to activism. Instead, it offers a panacea based on faith: the new regime will change everything. Even the lowliest street urchin is one of the People, an adoptive child of the Communist Party. Every citizen, no matter how lowly, can contribute to New China. Sanmao, no longer an excluded subaltern, takes his place within the parade, enjoying a respite from his daily drudgery. The parade is a gesture of optimism: if Sanmao can be empowered, anyone can. Yet the film's narrative pattern begs the question: given that Sanmao's earlier moments of joy have all been followed by disappointment, what will happen when this party ends?

BEDLAM BALLROOM

When Sanmao first appeared as a cartoon character in the 1930s, he was primarily a vehicle for slapstick humor. Only in the 1940s did Zhang Leping turn to social critique, developing series with specific topical foci: *Three-Hairs Joins the Army* (1946) showed the pathos, cruelties, and absurdities of life as a soldier; *Wanderings* (1947) focused on the sufferings of war orphans. Other series and adaptations (discussed later) followed the founding of the People's Republic. Of the various Sanmao series, *Wanderings* maintains the best tragicomic frisson, the others tending toward the frivolous, the maudlin, and the politically subservient.

Perhaps with young viewers in mind, the film leavens its critiques with comedic bedlam. We see crowd-around spectacles involving voyeurism of violence and excitement; topsy-turvy inversions, especially the climactic scene in which the streets invade the mansion and the starving gorge themselves; visual entropy, such as the dispersal of colliding bodies through screen space; and mimicry of war. Bedlam is part of the politics of Sanmao—an underdog hero who is literally attacked by dogs, who once sleeps on the streets in a place previously occupied by a dog, and who, in one famous cartoon, freezes in rags as a dog struts by in a snug sweater.

Situation comedy, visual gags, hijinks, and the scurrying, fighting, and chaotic groups of bodies conveys an aesthetic of excitement known as *re'nao*, literally "heat and uproar" or "hot uproar." (*Nao* can also mean "make noise," so the binome implies synesthesia.) *Re'nao* is a temporary phenomenon involving a crowd. The idea bears some similarity to

the concept of carnival—a scheduled, periodic, and festive communal break from normal rules and restrictions—but can be impromptu. Its positive associations include liveliness, high spirits, good cheer, and enervating stimulation: a mode that affirms a positive social or communal relationship. Its negative implications include disorder, unruliness, social breakdown, and chaos. To *kan re'nao*, or watch the excitement, is not just to be a spectator but to approve of disruption and to egg the disruptors on.

In *Wanderings*, the cinematography of *kan re'nao* includes long shots of group scenes, often involving a ring of spectators watching, laughing, cursing, and applauding. During a scuffle between the street urchin gang and Sanmao, a high-angle shot shows a dozen grown-ups watching ten youths beating up a single child (figure 13.6). (No grown-ups help the apple vendor whose wares have been strewn all over the ground.) A man at a window, seeing Sanmao picking up cigarette butts

FIGURE 13.6 *Kan re'nao*—watching the excitement
Source: Author

from the sidewalk, throws more butts out of his ashtray one by one just for the fun of watching him hunt and peck. Beggar children, to these onlookers, are mere spectacles for amusement or scorn. Moral condemnation of those who *weiguan* (encircle and watch) or *kan re'nao* without lifting a finger to prevent injustice, is a trend that dates back to the 1920s, most famously in Lu Xun's account of feeling revolted by a lantern slide of Chinese people looking on apathetically as one of their countrymen is being beheaded.

Topsy-turvy visuals imply that society has an inverted value system. A Western boy doll in a shop window is advertised for 10 million gold yuan (a currency introduced in 1948 in a failed attempt to stem hyperinflation); outside, Sanmao puts himself up for sale for one hundred thousand. His adoptive mother is childish, first seen throwing a hysterical fit. As a young "master," Sanmao is treated as an object for display and denied a will of his own, dressed in ridiculous outfits and spanked for hugging his teacher.

The party for "Master Tom" crowds hundreds of guests into a ballroom, the centerpiece of which is a massive white staircase. Sanmao walks down the staircase in between his new adoptive parents, to the applause of the fashionable crowd. Guests shower him with gold and American dollars, shown in close-up, as if to emphasize his status as a commodity. Guests break into hysterics when a little girl, Mary, throws her arms around Tom and gives him a kiss.[9] As on the streets, Sanmao is treated like a plaything.

The film climaxes with a set piece of *da nao* (uproar), in which street children disrupt the high society party. The sequence begins with the fat adoptive mother climbing the massive white staircase with servants in tow to go hunt for "Tom." She then descends to cellar and finds it overrun with urchins. (The goose and the sausages Sanmao pulls out of the larder are the very foods he daydreamed about in the marketplace.) The kids freeze, and then swarm out the door like rats, making the enormous woman swoon.

A montage of the chaos shows the servants returning with canes to beat the children, goaded on by the master of the house. A soundtrack of booming tubas and cascading strings enhances the vertigo. A ritual to bring Sanmao into the fold of high society ends with the lower classes wreaking havoc in its hallowed space. Their entrance into the ballroom

is replete with canted framings of the horrified reactions of rich guests in close-up.

The father, who keeps exhorting his servants to beat the children, is repeatedly bowled over by children running up and down the stairs (figure 13.7). The motif of the staircase appears in films such as *Laborer's Love* (1922), *Sports Queen* (1934), and *Diary of a Homecoming*, and Hollywood films from *The Haunted House* (1921) and *The Electric House* (1922) to *Hellzapoppin'!* (1941) and *Heaven Can Wait* (1943). Unlike the Scouts of China marching in orderly rows, poor children scurry upstairs and slide down the bannisters, becoming literally upwardly and downwardly mobile.

The pitched battles on the streets and in the mansion offer a different type of mass conflict than the grim battle recreations viewers recently saw in films like *Eight Thousand Li of Clouds and Moon* (1947) or *Spring River Flows East* (1947). This civil war pits a chaotic street population against the cozy domestic sphere.

FIGURE 13.7 Upward and downward mobility on the staircase
Source: Author

The bedlam ballroom climax is a comedic expression of a broader cinematic trend of bringing the war home. In *Diary of a Homecoming*, a married couple's postwar search for housing eventually, after many disappointments, takes them to rented rooms in the mansion of a man who unbeknownst to them is a traitor (as Chinese who collaborated with the Japanese were branded) and an attempted rapist. Yet this heavy thematics collapses unexpectedly into travesty near the end of the film during an extended fight sequence involving landlord and tenants, husband and wife, and their auxiliaries. As they lay waste to the entry hall at the base of the stairs (with a dog in the mix), firecrackers create the aura of gunfire and smoke, and special effects enhance the degeneration of the battle into a chaotic food fight, with the sound effect of a buzzing bomber accompanying the flight of a turnip (figure 13.8).

Sanmao makes his final stand in the mansion by refusing to sing someone else's song, rejecting his adoptive parents, casting off his young master uniform, and redonning his burlap sack like a badge of

FIGURE 13.8 Turnip bomber: Civil war as domestic food fight in *Diary of a Homecoming*
Source: Author

honor.[10] The moment recalls *The Adventures of Huckleberry Finn*, starring the most famous vagabond child in American literature, which ends with Huck fleeing from domestication: "But I reckon I got to light out for the Territory ahead of the rest, because Aunt Sally she's going to adopt me and sivilize me, and I can't stand it. I been there before." Just as Huck represents a rebellious, independent streak in the American self-image, Sanmao seems to characterize China itself as a noble underdog: a proud, spirited subject that retains its integrity despite poverty and hardship.

The ending that follows Sanmao's departure from the mansion is abrupt: winter changes into spring (we see blooming flowers on a tree), and one of Sanmao's friends wakens him from his habitual garbage cart with news of Liberation. The stunned Sanmao and his friends watch posters of Mao Zedong and Commander Zhu De pass, then accept the invitation of a "big sister" dancer to join in the festivities (figure 13.9).

FIGURE 13.9 A big sister invites Sanmao into the Communist victory parade
Source: Author

The final shot, to the sound of female choral singing, is of people with red flags marching through the city, singing the praises of the PLA.

The film industry was quick to sing along. Issues of *Chin-Chin Screen* from late 1949 and 1950 show stars marching in celebratory parades and, in the 1950 New Year's issue, playing the waist-drums seen in the victory parade in *Three-Hairs*.[11] Earlier Chinese films about homeless children, such as Cai Chusheng's *Lambs Astray*, merely diagnosed the problem of child poverty; *Wanderings* implies that the Party will be the solution.

Revolution is an extreme form of bedlam—one that does not just wreak temporary havoc within a room but tears down the entire structure, or, alternatively, installs a new master of the house. After 1949, the Communist state promoted and regulated comic strips and cartoons as media for shaping the minds of all members of society, including children and the semiliterate. New China (Xinhua) Books, a state-run publisher and distributor, gained a monopoly over book distribution, forcing innumerable private publishers out of business, while circulating hundreds of millions of new comic books. Artists had to conform to new ideological strictures, and Zhang Leping duly produced *Three-Hairs' Diary* (*Sanmao riji*, 1950), which shows the orphan enjoying all of the delights he was denied in the Old Society. *Three-Hairs Now and Then* (*Sanmao jinxi*, 1959) made the contrast explicit by pairing new cartoons with those from the 1940s. Two new Sanmao films announced in 1951—Kunlun's *Three-Hairs' Protest* and Changjiang's *Three-Hairs' New Life*—were never made.[12] Two films were produced in 1958: a puppet version of *Wanderings* and the live-action film *Three-Hairs Learns Business*, which uses Shanghai dialect (with some Hangzhou and Yangzhou dialect) and stars an adult performer in the title role.[13]

Sanmao has had staying power, reinvented for new generations. In recent decades, and especially since Zhang Leping's death in 1992, new Three-Hairs have proliferated in comic strips, textbooks, animated cartoons, live-action TV shows and films, and as merchandise. Like Alfonso Wong's *Old Master Q* (*Lo Fu Gee*, est. 1962) (whose title character borrows some of his look from Ye Qianyu's *Mr. Wang*), Three-Hairs has become a lucrative intellectual property, his future now controlled by a Shanghai Sanmao Image Development Corporation, Ltd.

NOTES

1. Tomsie Sze (Shi Dongshan) is reported to have been Kunlun's original choice for director. "Shi Dongshan choubei pai *Sanmao*" 史東山籌備拍《三毛》 [Shi Dongshan preparing to shoot *Three-Hairs*], *Qingqing dianying* (*Chin-Chin Screen*) 16, no. 20 (July 11, 1948), 3.

2. Filming and premiere dates from "Yingtan jianshi ji" 影壇尖事記 [Chronology of major film world events in 1949], *Chin-Chin Screen* 18, no. 1 (January 1, 1950), 12–13. Wang Longji appears on the cover of *Chin-Chin Screen* 17, no. 12 (April 30, 1949).

3. Earlier films, such as *Street Angels* (1937), also feature main characters who have been orphaned by war or become bereft of or estranged from their families.

4. Photographs of Shirley Temple appear in several issues of *Chin-Chin Screen* (e.g., December 1, 1934, and September 20, 1935) opposite those of Chinese child stars such as Li Keng and Chen Juanjuan.

5. Alexander Des Forges, *Mediasphere Shanghai: The Aesthetics of Cultural Production* (Honolulu: University of Hawaii Press, 2007), 1. Several of the same typical experiences and occupations of street children also appear in *The Watch*.

6. Zhang Leping also took inspiration from Plauen in drawing his own *Life and Times of Father and Son* (*Fuzi chunqiu*) to promote the Great Leap Forward.

7. Janet Y. Chen, *Guilty of Indigence: The Urban Poor in China, 1900–1953* (Princeton, N.J.: Princeton University Press, 2012).

8. On the five-day charity event, proceeds from which went to the Shanghai Children's Program of Soong's China Welfare Fund, and the grim news reports on child mortality, see Maura Elizabeth Cunningham, "Shanghai's Wandering Ones: Child Welfare in a Global City, 1900–1953" (PhD diss., University of California, Irvine, 2014), 137–138, 143–144. Cunningham (147) reports that the United Nations International Children's Emergency Fund (UNICEF) had been gradually taking over the work of Soong's Fund since 1947, but only managed to establish its China division fully in January 1949. The new PRC government moved the holiday from April 4 to June 1 and renamed it International Children's Day.

9. Mary is played by Yao Yao, the daughter of playwright Yao Ke and Shangguan Yunzhu, who makes a cameo in this scene, along with Wu Yin, Huang Zongying, and Zhao Dan.

10. The gesture contrasts with the pathetic ending of *Playthings* (1933), in which the destitute Sister Ye admires a young bourgeois boy without realizing that he is her lost son.

11. The photo spread "Movie Personnel Diligently Practice the Waist-Drum" ("Yingren qinlian yaogu" 影人勤練腰鼓) includes images of Huang Zongying learning the art from Wu Yin. *Chin-Chin Screen* 18, no. 1 (January 1, 1950), 3.

12. The Kunlun film, based on a Zhang Leping comic strip serialized in *Ta Kung Pao*, was to star Wang Longji. "Sanmao de kongsu" 三毛的控訴 (Three-Hairs' Protest), *Chin-Chin Screen* 19, no. 7 (April 1, 1951), 14; "Zhang Leping bianxie *Sanmao fanshen ji* dianying juben" 張樂平編寫《三毛翻身記》電影劇本 (Zhang Leping writes screenplay *Three Hairs' New Life*), *Chin-Chin Screen* 19, no. 11 (June 1, 1951), 12. The April 15 issue featured Wang Longji on the cover and mentions three of his upcoming films, including *Celebrate Children* (1952), directed by Zhao Dan, and costarring Huang Zongying and Jiang Tianliu.

13. The film, and the Fan Haha stage play from which it was adapted, were performed by the ensemble of the Masses Comic Theater Troupe (Dazhong huaji jutuan), and starred Wen Binbin in the title role.

SOURCES/FURTHER READINGS

Bi Keguan, and Huang Yuanlin. *Zhongguo manhua shi* [History of Chinese cartoons]. Beijing: Wenhua yishu chubanshe, 2006.

Chen, Janet Y. *Guilty of Indigence: The Urban Poor in China, 1900–1953*. Princeton, N.J.: Princeton University Press, 2012.

Collins, Ross F. *Children, War and Propaganda*. New York: Peter Lang, 2011.

Cunningham, Maura Elizabeth. "Shanghai's Wandering Ones: Child Welfare in a Global City, 1900–1953." PhD diss., University of California, Irvine, 2014.

Des Forges, Alexander. *Mediasphere Shanghai: The Aesthetics of Cultural Production*. Honolulu: University of Hawaii Press, 2007.

Farquhar, Mary Ann. *Children's Literature in China: From Lu Xun to Mao Zedong*. New York: Sharpe, 1999.

Hung, Chang-tai. *War and Popular Culture: Resistance in Modern China, 1937–1945*. Berkeley: University of California Press, 1994.

Jones, Andrew F. "The Child as History in Republican China: A Discourse on Development." In *Developmental Fairy Tales: Evolutionary Thinking and Modern Chinese Culture*, 99–125, 223–228. Cambridge, Mass.: Harvard University Press, 2011.

Kucherenko, Olga. *Little Soldiers: How Soviet Children Went to War, 1941–1945*. New York: Oxford University Press, 2011.

Macdonald, Sean, introduction and trans. "Two Texts in Defense of 'Comics' from China, ca. 1932: 'In Defense of "Comic Strips" ' by Lu Xun and 'Comic Strip Novels' by Mao Dun." *ImageTexT: Interdisciplinary Comic Studies* 6, no. 1 (2011). http://imagetext.english.ufl.edu/archives/v6_1/macdonald.

Plauen, E. O. *Father and Son*. Trans. Joel Rotenberg. Lettering by Jeremy Sorese. Afterword by Elke Schulz. New York: New York Review Comics, 2017.

Pozzi, Laura. "'Chinese Children Rise Up!': Representations of Children in the Work of the Cartoon Propaganda Corps During the Second Sino-Japanese War." *Cross-Currents: East Asian History and Culture Review* 4, no. 1 (May 2015): 333–363. Citations are from online version: https://cross-currents.berkeley.edu/sites /default/files/e-journal/articles/pozzi_0.pdf.

Rea, Christopher, and Henry Jenkins. "The Ancient Art of Falling Down: Vaudeville Cinema Between Hollywood and China." MCLC Resource Center Publication, August 2017. http://u.osu.edu/mclc/online-series/rea-jenkins.

Twain, Mark. *The Adventures of Huckleberry Finn* (1885). Project Gutenberg. https:// www.gutenberg.org/files/76/76-h/76-h.htm.

Xu, Lanjun. "Save the Children: Problem Childhoods and Narrative Politics in Twentieth-Century Chinese Literature." PhD diss., Princeton University, 2007.

Zhang Leping. *Adventures of Sanmao the Orphan*. Trans. W. J. F. Jenner and C. M. Chan. Hong Kong: Joint Publishing Company, 1981.

——. *Zhang Leping lianhuan manhua quanji* [Complete comic strips of Zhang Leping]. Ed. Wang Yiqiu. Beijing: Zhongguo lianhuanhua chubanshe, 1998 [1994].

FURTHER VIEWING

Bright Eyes. David Butler, director. 1934.

Lambs Astray (*Mitu de gaoyang* 迷途的羔羊). Cai Chusheng, director. 1936.

Old Master Q Comics. https://oldmasterq.com.

Princess Iron Fan (*Tieshan gongzhu* 鐵扇公主). Wan Laiming and Wan Guchan, directors. 1941.

Sanmao Cartoon Web (Sanmao manhua wang 三毛漫畫網). http://www.sanmao .com.cn.

The Watch (*Biao* 錶). [Huang] Zuolin, director. 1949.

Three-Hairs Learns Business (*Sanmao xue shengyi* 三毛學生意). Huang Zuolin, director. 1958.

Wanderings of Three-Hairs the Orphan (*Sanmao liulang ji* 三毛流浪記) (puppet animation). Zhang Chaoqun, director. 1958.

Crows and Sparrows
(*Wuya yu maque* 烏鴉與麻雀)

Alternative title: *Fangzi yu dingfei* 房子與頂費 (*House and Tea Money*)
Director: Zheng Junli
Screenplay: Chen Baichen, Shen Fu, Xu Tao, Zhao Dan, Zheng Junli
Studio: Kunlun
Cast: Zhao Dan, Wu Yin, Wei Heling, Shangguan Yunzhu, Sun Daolin,
 Li Tianji, Huang Zongying, Li Baoluo
Year of release: 1950
106 minutes

SYNOPSIS

Shanghai 1948, winter. As the Chinese civil war is turning in favor of Communist forces, smaller battles for survival are being waged by several families inhabiting a Shanghai rowhouse. On the ground floor live Mrs. and "Boss" Xiao, a gossip also known as "Little Broadcast," who support their three sons by buying and selling canned goods; across the hall lives Mr. Kong Youwen, an old man who owns the building and has had no news for years from his soldier son. In the second-floor "pavilion room" above Kong lives Mr. Hua, a school teacher, Mrs. Hua, and their young daughter. The apartment above the Xiaos (and a half

flight up from the Huas) is inhabited by Miss Yu Xiaoying, the kept woman of a Nationalist official named Hou Yibo. Mr. Hou has appropriated the entire building from Mr. Kong and is now trying to sell it. When the other residents see Yu showing around a prospective buyer, they realize that they all face eviction and encourage Kong to assert his right of title. But Kong has seen a lifetime of bad news in his work at a publishing house and has little hope. He points out that the traitorous Hou has wormed his way back into the central government and had Kong's son, a patriot who fought the Japanese, branded a communist as a pretext to confiscate their property. The others ask Yu for moving expenses, but she orders them to leave. Hua considers moving his family to an apartment at school, even though a staff protest is on and teachers are being arrested. The acting principal offers to help him in exchange for informing on his colleagues. Meanwhile, Yu hints to Xiao that Hou might be willing to sell the building to him for three gold bars. Mrs. Hua, overhearing their conversation, goes to Yu's apartment but encounters Hou, who invites in this beautiful housewife and reassures her that her family will not have to move. Later, Mrs. Xiao brings Yu a deposit for the apartment of jewelry, penicillin, and other valuables, and then drags Mrs. Hua over to Yu's apartment for a game of mah-jongg. Hou arrives unexpectedly and continues to ingratiate himself with Mrs. Hua. Meanwhile, the principal offers an ideal apartment at school to Mr. Hua, who turns it down when the principal asks him to retract a protest letter from the teachers. Hua is livid when he returns home to discover that his wife has been gambling with Hou and neglecting their daughter. Hua goes to school the next day during a teacher's strike and is arrested along with over two dozen others. Hou sends thugs to smash up Kong's room and evict him; Xiao negotiates an extra week for Kong. Mrs. Hua tries in vain to seek help for her husband from a lawyer, the Shanghai Department of Education, and the regional military garrison. Finally, she approaches Hou, who agrees to help; instead, he tries to force himself on her. The Xiaos, seeking to exchange their assets for gold, get seriously injured during a riot outside the bank. The Huas' daughter falls critically ill with tuberculosis, but Ah Mei, the Hous' maidservant, saves her by stealing the penicillin back from her employers. The next morning, things are looking up. The Xiaos have recovered and read news of peace: Chiang Kai-shek has stepped down

as president, and they expect Hou will leave soon. Then they read that the price of gold has more than tripled due to the imposition of a "stability fee." Mrs. Xiao's attempt to get her deposit back fails, and Hou plans to evict them all tomorrow. Kong and his neighbors defy Hou, just as Hou receives a call ordering him to flee to Guangdong with the money he has been hoarding for his superior. He instead books plane tickets for him and Yu to Hong Kong. On the outskirts of town, his car passes a van that disgorges Hua, released from prison, who is ordered at gunpoint to walk home without turning around. Hua stumbles back to join the festivities at the apartment, saying that he no longer fears even the spy who followed him home. The next day, January 28, 1949, this extended family of neighbors together celebrate the arrival of the Lunar New Year.

TAKING THE FIGHT TO A HOUSE OF A DOZEN TENANTS

Crows and Sparrows dramatizes a parable of power: tiny sparrows, if they band together, can drive off a larger crow, which might harm them individually. The film, made at a turning point in modern Chinese political history, is epochal in its themes and in its production. Plot events take place between late 1948 and January 1949, during the later part of the Chinese civil war, and several months before Mao Zedong would proclaim the founding of the People's Republic on October 1, 1949.

The film began shooting in April 1949 but was shut down by Nationalist censors in May due to alleged problems with the script. The People's Liberation Army (PLA) entered Shanghai later that month, on May 25. Filming resumed in September with Zheng Junli replacing Xu Wei as director and, according to one film magazine, working with writer Xu Tao "to strengthen the content of the script."[1] An advertisement for the new film on the back cover of the December 15 issue of *Chin-Chin Screen* magazine touts "Kunlun's first attempt to move towards the People's art!" and does not fail to mention that production was repeatedly shut down by "the Chiang Kai-shek bandit clique." The film, which premiered in early 1950, proved to be popular, screening "577 times in Shanghai in 1950 to an audience of 287,000."[2]

Crows is an exaltation of collective resistance that dovetailed (to stick with the bird metaphors) with the contemporary communist

ideology of popular uprising. The film proffers an allegory supportive of the civil war's victors: China's masses had risen up to drive off their oppressors and again become masters of their own house.

An ideology of collective production is self-consciously projected from the opening credits. The screenplay is credited as a "collective work" by six industry veterans, led by Chen Baichen, a noted playwright and author of the stage hit *Promotion Scheme* (1945), a farce about the machinations of corrupt government officials modeled on Nikolai Gogol's *The Government Inspector*.

In terms of form, *Crows* is structured like a stage play that keeps the national drama offstage. War is presented obliquely, without the battle-field explosions and street fighting depicted in films like *Spring River Flows East* (1947). Domestic conflicts—above all a fight over housing—occupy center stage. The spatial and social milieu is signaled in the opening credits, which appear over charcoal illustrations of dark Shanghai alleyways, an iconic urban setting familiar from earlier sociopolitical dramas like *Street Angels* (1937). A title card in front of an illustration of the Bund then frames the story in castigatory terms:

> Winter, 1948. Our People's Liberation Army has completely wiped out the enemy in the Huaihai region. At this time, in Nanjing and in Shanghai, lackeys of the thuggish Chiang Kai-shek clique, in their death throes, intensify their oppression of the people, even as they make their preparations to scatter like chickens and flee like running dogs . . .

The first shot of the opening scene brings us down to the level of micro-history, as the camera zooms in on a newspaper advertisement:

> FOR SALE, CHEAP: Superior two-level shikumen rowhouse, with fully installed telephone and utilities, offered by Mr. Hou at 23 Renkang Alley, Linsen Road.

A man responding to the ad rings the front doorbell (figure 14.1), and the next shot takes us inside. A book appears in close-up, and the camera tracks back to reveal Yu Xiaoying reading on the couch with Ah Mei reading over her shoulder (figure 14.2). From this room, a tracking

FIGURE 14.1 Prospective buyer as narrative device
Source: Author

shot takes us down to the first floor, where Mrs. Xiao parallels the cam-
era's descent by climbing down a ladder from the loft to her family's
busy apartment. The mobile framing presents one half of the building
in cross-section, while the sound design contrasts the idle upstairs with
the cacophony downstairs. The prospective buyer then becomes a nar-
rative device to show us the other rooms of the building, introducing the
main characters one by one and establishing their physical relationship
in a few minutes.

The use of the apartment building to structure a narrative is con-
nected to the housing pressures caused by modern urban migration.
The end of the Anti-Japanese War in 1945 saw waves of returnees from
the interior flood into cities formerly under Japanese control. Between
1945 and 1948, Shanghai's total population grew from 3.3 million to 5.4
million, an increase of more than 60 percent.[3] The housing shortage was
acute and poverty rife, exacerbated by runaway inflation. Many tenants

FIGURE 14.2 A leisurely moment in a fast-paced film
Source: Author

were one missed rent payment away from the type of street destitution represented in *Wanderings of Three-Hairs the Orphan* (1949). It was the era of subdivided apartments and subdivided rooms. "Sublandlords" or "second landlords" (*er fangdong*), which the Xiaos aspire to become, were the main collectors of rents and popularly viewed as "the most scheming people in Shanghai."[4]

Films like *Diary of a Homecoming* (1947) dramatize the high hopes and disappointed expectations of people returning to Shanghai after the war, like the married couple who ends up in an overcrowded attic accessible only by ladder and sleeping underneath a bed. *Crows* exported the narrative premise of many families under one roof to colonial Hong Kong and Singapore, where it screened circa 1950–1951, in Singapore under the title *House and Tea Money*.[5] The device reappears in *The House of 72 Tenants* (a stage play made into films in mainland China in 1963 and Hong Kong in 1973), in which a group of tenants

band together to defy those who try to exploit them. The scenario was revived yet again in Stephen Chow's *Kung Fu Hustle* (2004) and Eric Tsang's *72 Tenants of Prosperity* (2010). Generations of dramatists and filmmakers have recognized that the multifamily apartment, in its very form as a refuge for people from all walks of life, harbors narrative potential.

The apartment-drama form tends to focus on the typicality of quotidian life in multifamily housing. These films exhibit proximate concerns, while offering windows into varied domestic situations, the Shanghai version of which historian Hanchao Lu calls the "*Shikumen* mélange."[6] Film historian Jubin Hu writes that, with a few exceptions, in late-1940s China "the only popular film genre was family melodrama," and Paul Pickowicz notes that films of the day presented stories of how families experienced the war as national allegories.[7]

Apartment films offer multiple family dramas for the price of one. The space concentrates not just people, but also stories and secrets. In cramped spaces, collisions and conflicts abound, and eavesdropping propels action. Mr. Hua wants to burn magazines that could get him arrested, while Mrs. Hua wants to sell them to the paper recycler she hears outside the window. Residents downstairs overhear conversations upstairs, such as Hou on the phone booking plane tickets to Hong Kong. Ah Mei, who sleeps on the second floor landing, is often first to share news about her employers. Working primarily with interiors, the filmmakers make extensive use of high-angle and low-angle shots to convey the power relationship between "upstairs" and "downstairs," as well as motivated camera movements (prompted by character actions) such as rapid tracks and pans. Like *Spring in a Small Town* (1948), *Crows and Sparrows* also makes skillful use of deep space and multiple planes of action to create dramatic irony.

The ensemble cast acts out a collective story of the age. All of the principals—even the villains—are in a state of economic desperation. The Xiaos live hand to mouth and risk ruin daily as commodity speculators. The Huas are dependent on a teacher's salary in a school where teachers are on strike. Kong has lost his property and is barely hanging onto his editing job. A servant like Ah Mei could find herself dismissed and homeless in a heartbeat. Hou, meanwhile, is in a rush to grab what he can and convert it all into portable wealth (such as gold and jewelry)

before making an escape. As time runs out for Hou and his ilk, the deadline he sets for eviction creates a second level of temporal pressure.

These neighbors offer a concentrated variety of backgrounds, motivations, and personalities. Boss Xiao and Mrs. Xiao are schemers and petty businesspeople. The canned goods they sell include Carnation products (likely evaporated milk), Texsun oranges, and Atlantic Coast herring—all allusions to the massive American economic presence in late 1940s China. They also hoard expensive drugs such as penicillin. Though not so unscrupulous as to hurt people intentionally, they are willing to make self-serving deals with shady characters. Their hoarding is symptomatic of an age of inflation and uncertainty, in which commodities hold their value better than currency.

When the Xiaos are walking through the rain at night to get in line at the Central Bank so that they can change their currency for gold the next morning, they pass a line of blind men walking in the same direction. Little Broadcast exclaims: "Hey, look: even the blind are going to speculate in gold!" Xiao might as well be speaking of himself: in an age of rumors and wild speculation, the Xiaos are as blind as anyone else.

One of Zhao Dan's best scenes has Boss Xiao rocking in his chair daydreaming of a future windfall until, with the guffaw, "I'm rich!," his chair collapses and he is showered with cans. (The tilt up from stocking feet to a self-satisfied man in a chair is an encore of a shot in *Distant Love* [1947], in which Zhao Dan, co-starring with Wu Yin, also plays a Mr. Xiao.) Wu Yin delivers a dynamic and compelling performance as the harassed, exasperated, sharp-tongued, calculating, capable, moody, and strongminded Mrs. Xiao. Shangguan Yunzhu transforms from the glamorous seductress roles she played in *Long Live the Missus!* (1947) and *Spring River Flows East* into the meek and fetching housewife of a bookish intellectual. Wei Heling, who played newspaper seller Wang in *Street Angels*, appears as the scholarly Kong Youwen.

The old widower who is the true owner of the rowhouse has the ponderous name of Kong Youwen (Cultured Confucius). Kong is a proofreader at a publishing house who now sees in every newspaper story two words: "chaos" (*luan*) and "inflation" (*zhang*). This property owner is played as a member of the class of dispossessed commoners, a vulnerable victim. A veteran witness to injustice, he is jaded, cynical, and pessimistic, beaten down by decades of misfortune, including the political

persecution of his son. Old and physically frail, he seethes with righteous indignation and curses Hou's retreating back once the residents of his home finally stand behind him. He is an object of sympathy and estimation, a survivor. Like Old Mrs. Zhang in *Spring River Flows East*, he provides ballast to the moral drama as a long-suffering, stoic elder.

Hua dramatizes the harried state of intellectuals under the Republic of China, cowed by the paranoia of anti-communist and other ideological purges (figure 14.3). The magazines he burns include *The Observer*, a nonpartisan intellectual magazine shut down by the Nationalists in December 1948 (roughly when the story begins),[8] and *The Outlook Weekly* (*Zhanwang*). Other residents look up to Hua as an educated man, but he is at first timid and passive, given to talk rather than action. He encourages Kong not to be so pessimistic and advises him that his day will come. When Boss Xiao nominates him to confront Hou about moving expenses, he tells Xiao to take the lead with the rest of them as

FIGURE 14.3 The harried intellectual
Source: Author

"backup." At school, Hua lends oral support to the teacher's protest but is reluctant to sign his name. Notably, he and the other teachers, when alone, declare themselves (twice) to be not communists but "non-partisan liberals" (*wudang wupai de ziyou fenzi*).

Though partly an ensemble piece, the film benefits from strong performance by its stars. Zhao Dan, who starred in *Crossroads* (1937) and *Street Angels*, reappears as part of a charismatic comic couple. Wu Yin had notable roles in *Distant Love* (1947) and *Lights of Myriad Homes* (1948) and starred in *Spring River Flows East* in the somewhat clichéd role of Old Mrs. Zhang. In *Crows*, the pair create fantastic chemistry with their nonstop repartee of bickering, negotiating, scheming, and interacting with neighbors (figure 14.4).

Besides enumerating types of people, *Crows and Sparrows* also pursues a documentary agenda of showing the incriminating paper evidence of the economic and political villainy of the recently vanquished

FIGURE 14.4 The aspiring sublandlords
Source: Author

FIGURE 14.5 Incriminating government documents
Source: Author

regime. Various texts fill the film, from major newspapers, such as *L'Im-partial* (*Ta Kung Pao*), to intellectual magazines, to government letters and documents (figure 14.5). We see the Nanking government tearing down maps and burning its military defense plans before fleeing south. Amid the small collective drama of a group of neighbors, at regular intervals, close-up shots linger on documentary evidence of the larger drama afoot.

MONKEY FLIES THE COOP

Crows and Sparrows interweaves stories of dwelling and exodus. By winter 1948, the civil war had turned decisively against the Nationalists. The Huaihai Campaign, mentioned in the opening title card (which gets slightly ahead of the historical chronology), lasted from November 6, 1948, to January 10, 1949, and brought the Communist army to the northern

banks of the Yangtze. As the Nationalist army was being routed, a "White Terror" prevailed in major cities like Shanghai, where law and order was weak, and assassins, gangs, and other criminals ran amok.[9]

Among midcentury political films, *Crows and Sparrows*, like *Spring River Flows East* and *Decay* (1950), is notable for the amount of screen time it devotes to the villains. *Spring River* offers an extended exposé of wartime profiteers, particularly the industrialists who turn Chungking into a center of decadence. *Crows*, made two years later, targets government representatives and institutions, focusing on one Nanking official's work–life arrangements. Though Hou Yibo is caricatured as a beast (crow, monkey), the settings and acting are on the whole naturalistic, the cinematography only occasionally employing bottom lighting and extreme close-up techniques to render him grotesque.

Hou, a midranking section chief at the Ministry of Defense, is played by Li Tianji, most famous today as the screenwriter of *Spring in a Small Town*. Li had recently appeared in *Diary of a Homecoming* as a different buffoon named Hou. (In his first appearance, he applies DDT to a wound on his boss's head, assuring him "Of course it works—it's foreign!") *Crows* allots less screen time to the slimy acting principal of the school (brilliantly played by Li Baoluo) where Hua teaches, but both are agents of corruption and violence.

Hou's entrance is perhaps the most meticulous character introduction in Republican cinema (figure 14.6). The camera focuses on Yu Xiaoying attending to him as he lies offscreen in the curtained bed, and we hear him clear his throat. She hands him a handkerchief and a dish into which he noisily expectorates. In a later scene, we see a framed portrait of Chiang Kai-shek inscribed to Hou, then a photographic portrait of Hou in uniform, the graphic match suggesting that Hou emulates, or apes, the Generalissimo.[10] We then see his back, and his reflection in the mirror in which he is adjusting his uniform. Only then does he turn to face the viewer. Step by step, Hou Yibo passes from absence through layers of sonic and visual abstraction to corporeal presence. His jutting chin, bulging eyes, ready leer, and military rigidity are almost cartoonish, accentuated by the square uniform and multiple close-up shots. Hou's middling status in the Kuomintang hierarchy is conveyed by the small size of his perch—he terrorizes only the sparrows of one apartment building—but he symbolizes the thuggishness of the average Nationalist official.

FIGURE 14.6 Introducing a villain, from abstraction to physical presence
Source: Author

FIGURE 14.6 (CONT.) Introducing a villain, from abstraction to physical presence
Source: Author

Hou Yibo's 侯義伯 name is a pun on *hou yibo* 猴義薄, "Unprincipled Monkey." The Xiao children and Ah Mei chant a rhyme about him as they dance on the apartment rooftop around Mr. Kong, as lyrics appear onscreen:

Monkey, monkey—he's not poor	猴子猴 有來頭
Traitor on the second floor	當漢奸 住二樓
Living upstairs doing tricks	住了二樓 翻筋斗
Stealing property's his fix	翻筋斗 有接收
Living the official life	做大官 不發愁
Complete with a car and even a wife!	汽車老婆都有嘍

The cinematic settling of scores deploys not only puns and mocking doggerel, but also mimicry and invective, as when Boss Xiao mimics Chiang Kai-shek and Mrs. Xiao curses the "bastard government" (*hunzhang zhengfu*) that ruined her by raising the price of gold.

Yu Xiaoying (wonderfully rendered by Huang Zongying[11]) is a handmaiden to villainy. Though a painted lady made up to the point of caricature, her character is part of the realist tableau of Shanghai apartment living. She, too, has a daily routine, much of which involves killing time with her maid while waiting for Hou's weekly visit. She is introduced with a close-up of a pocket cartoon edition of *Legend of White Snake*—the type of disposable pulp entertainment reading material that flourished during civil-war hyperinflation. Hou treats her as equally cheap and expendable. She is utterly dependent on Hou and sticks with him despite her humiliation when he moves in on Mrs. Hua.

The film exudes a fin-de-siècle aesthetics, but of what sort is debatable. At a 1957 film awards event, communist critics lauded the film as unmitigated "realism" that captures the dark days before Liberation. Scholar Leo Ou-fan Lee considers the film to be in a mode of "socialist realism" that focuses on representing the negative conditions that led up to the revolution. In 1950, Zheng Junli wrote that his film succeeded only partially as a realistic "record" of the times, but, ironically, criticized the scenarios and characters as being *too far removed* from orthodox models, for focusing on narrow-minded urbanites rather than workers and peasants, and for underrepresenting both the centrality of the maid and residents' spontaneous enthusiasm for the PLA.[12]

Crows and Sparrows employs stock melodramatic devices, such as the child's life-threatening illness. That crisis is quickly resolved thanks to the member of the apartment community with the lowest status, Ah Mei, who takes back the exorbitantly expensive medicine from the villains. This healthy girl from the countryside is a prototype for many subsequent servant girl-heroines, like Wu Qionghua in *The Red Detachment of Women* (1960), who escapes from bondage to join the army. Ah Mei cheerfully agrees with Xiao that, with Hou gone, she faces a bright future of going back to till the land instead of working for someone else. Writer Eileen Chang was later to represent this rosy picture as a lie. In her novel *The Rice-Sprout Song* (1955), Shanghai homemakers urge their maids to go back to the countryside of their own accord (since Communist policy forbids firing domestic help), where they find only starvation.

While containing communist themes, *Crows and Sparrows* does not go so far as to advocate abolishing private property. Speculation is shown to be ruinous, and kleptocracy is put to flight. But the capitalist system is left intact, with a benevolent patriarch presiding over an utopian domestic arrangement of multiple families. Property rights are asserted, not deplored, and in the end, Kong resumes his status as a landlord.

Hua emerges from his ordeal of torture physically broken but stronger in spirit—an intellectual with backbone. In the didactic denouement, he sounds a note of warning: the big villains are gone, but many smaller villains remain. Yet, though only released for show—all of his comrades were executed—he has been cleansed of fear.[13] Hua Jiezhi's 華潔之 very name could be interpreted as Clean Up China, or China the Purified.

The film also shows the senior member of the community overcome his habitual pessimism. At the Lunar New Year celebration, Kong Youwen pastes "an old couplet" in his calligraphy on the doors to the building:

Firecrackers explode, driving away the old　　　　爆竹一聲除舊
With a door couplet on view, families welcome the new　　桃符萬戶更新

He declares to his fellow residents, "The New Year is here, and a new society will be here soon," and Hua chimes in: to fit into the new society, "We'll need to adopt a new way of thinking. Living in the old society,

FIGURE 14.7 Two generations of intellectuals talk about the future
Source: Author

we've picked up a lot of bad habits that we'll have to fix. That's why it's time for 'out with the old, in with the new'—we need to start afresh! We need to learn how to become new *ourselves!*" Mindful of their own future status, the filmmakers imbue two generations of intellectuals, Hua and Kong, with the moral authority of a class that has been purified by suffering and will contribute to the New China (figure 14.7). With joyful clamor, the group heads back inside to celebrate, and the camera pans to show children playing with lanterns and sparklers in the street.

In the landmark New China film *The White-Haired Girl* (1950), the villain is isolated and overthrown. In *Crows and Sparrows* he is only sent packing, not punished with mass justice. The film presents an atomized threat personified by an individual, Hou Yibo, who is represented in the film poster as a black bird of prey with formidable talons. In doing so, the filmmakers avoid the question of what recourse the weak have when *many* crows band together. The tenants have essentially won a war of attrition, their most effective action being to defy, stall, and let history

大家都来打麻雀

FIGURE 14.8 "Everybody come to kill the sparrows" (1958)
Source: Courtesy of the International Institute of Social History/Stefan R. Landsberger Private
Collection

run its course. As Hua notes—sounding an ominous refrain that was to crescendo during China's Cold War—spies are still out there. And spies cannot simply be outwaited.

As film historian Yiman Wang notes, in 1952 Kong's apartment building would have been collectivized for public use and peddlers like the Xiaos would have been phased out.[14] In 1958, Mao Zedong announced a campaign to "Eliminate the Four Pests" (*chu si hai*): rats, flies, mosquitos, and sparrows (figure 14.8). The "Kill Sparrows Movement" (*xiaomie maque yundong*), which lasted until 1960 (and was replaced by a campaign against bedbugs), had citizens harassing the birds by banging on pots and pans, shooting them with slingshots and airguns, destroying nests, and stealing eggs.[15] The near extinction of the birds, which eat more insects than grain, exacerbated the Great Famine that killed tens of millions of people. Zheng Junli himself died in prison as a political prisoner in 1969.

NOTES

1. The interruption and resumption of filming, as well as the change in director, are mentioned in brief notices in *Qingqing dianying* (*Chin-Chin Screen*) 17, no. 12 (April 30, 1949): "*Wuya yu maque* tingpai" 烏鴉與麻雀停拍 [*Crows and Sparrows* halts filming]; and no. 14 (June 20, 1949), "Xinpian: *Wuya yu maque* xupai 新片:烏鴉與麻雀續拍 [New film: *Crows and Sparrows* resumes filming]. Xu Wei is not mentioned in the film's credits.

2. Premiere mentioned in Bao Yong 保勇, "1950 nian Shanghai gongying guochanpian tongjibiao" 一九五0年上海公映國產片統計表 (Table of domestic films screened in Shanghai in 1950), *Chin-Chin Screen* 19, no. 1 (January 1, 1951), 18. Release dating of "early 1950" from Wu Yigong, ed. *Shanghai dianying zhi* [Historical records of Shanghai cinema] (Shanghai: Shanghai shehui kexue chubanshe, 1999), 269. Audience statistics from Paul G. Pickowicz, *China on Film: A Century of Exploration, Confrontation, and Controversy* (Lanham, Md.: Rowman and Littlefield, 2012), 192.

3. Christian Henriot, Lu Shih, and Charlotte Aubrun, *The Population of Shanghai (1865–1953)* (Leiden: Brill, 2018), 95. From 5.4 million in 1948, Shanghai's population declined to 5.1 million in 1949 and 5.0 million in 1950 before rising again. Statistics are indicative but not definitive.

4. Hanchao Lu, *Beyond the Neon Lights: Everyday Shanghai in the Early Twentieth Century* (Berkeley: University of California Press, 1999), 166. The Xiaos are

technically seeking to purchase not the building itself but the right to rent out the rooms at a profit, having paid a "takeover fee" (*dingfei*), which by the 1940s, Hanchao Lu notes (164), tended to be equal to the purchase price of the building. Lu's explanation perfectly describes the conversation between the Xiaos starting at minute 28:30 and Boss Xiao's calculations after minute 51: "A shrewd tenant saw the fee as an investment, because the rental was not only his or her own residence but also a business opportunity, he or she could sublet rooms, and out of the rents collected from the subletting could soon recoup the takeover fee." The sublandlord was a major figure of the era's art. Two cinematic examples: in *Lights of Myriad Homes*, a nuclear family in Shanghai becomes critically pressed for space when a horde of relatives from the countryside arrive to stay with them, temporarily occupying a vacant unit but later being evicted. The landlady in *Spring River Flows East* threatens to evict Mrs. Zhang from a rooftop shack, which the landlady claims she can lease out for half a gold bar.

5. See the movie novelette cover reprinted in Paul Fonoroff, *Chinese Movie Magazines: From Charlie Chaplin to Chairman Mao, 1921–1951* (Oakland: University of California Press, 2018), 233.

6. Lu, *Beyond the Neon Lights*, 167.

7. Hu Jubin, *Projecting a Nation: Chinese National Cinema Before 1949* (Hong Kong: Hong Kong University Press, 2003), 184; Pickowicz, *China on Film*, 142.

8. Founded and edited by Chu Anping, the Shanghai-based *Observer* was an encore to Chongqing's *Objective Views* (*Keguan*, 1945–1946) and claimed to "comment on but not participate in politics." Following censorship by the Kuomintang it revived as a semi-monthly on November 1, 1949, only to be closed down by the Communists on May 16, 1950.

9. After their takeover, Communist authorities employed Nationalist and puppet policemen because "throughout all of China, there were only eighty thousand police officers in 1949–50." Frederick Wakeman Jr., " 'Cleanup': The New Order in Shanghai," in *Dilemmas of Victory: The Early Years of the People's Republic of China*, ed. Jeremy Brown and Paul G. Pickowicz (Cambridge, Mass.: Harvard University Press, 2007), 38. Cinematic representations of lawlessness in 1940s and early 1950s Shanghai from the Mao era include *Sentinels Under the Neon Lights* (1964) and Xie Jin's *Two Stage Sisters* (1964). See Yomi Braester, *Painting the City Red: Chinese Cinema and the Urban Contract* (Durham, N.C.: Duke University Press, 2010), 56–94; Gina Marchetti, "*Two Stage Sisters*: The Blossoming of a Revolutionary Aesthetic," *JumpCut: A Review of Contemporary Media* 34 (March 1989): 95–106, http://www.ejumpcut.org/archive/onlinessays/JC34folder/2stageSisters.html.

10. A similar progression occurs around minute 12 in *Decay*.

11. Huang Zongying, like Li Lili, was promoted as a "sweet big sister" (*tian jie'r*). (See, e.g., *Chin-Chin Screen* 16, no. 4 [February 10, 1948], 13.) Huang, who was

married to Zhao Dan when *Crows* was filmed, adopted Shangguan Yunzhu's children after Shangguan's suicide in 1968.

12. Lee's and Zheng's views are summarized in Yiman Wang, "*Crows and Sparrows*: Allegory on a Historical Threshold," in *Chinese Films in Focus II*, ed. Chris Berry (Basingstoke: British Film Institute/Palgrave MacMillan, 2008), 82–83. For Zheng's response to criticisms in 1950, see Zheng Junli, "Dianying *Wuya yu maque*," in *Zheng Junli quanji* [Complete works of Zheng Junli], ed. Li Zhen (Shanghai: Shanghai wenhua chubanshe, 2016), 5:293–305.

13. For a political prisoner just released from jail, Hua's news is quite up to date. On January 27, 1949, he remarks that Li Tsung-jen (Li Zongren) has taken power and castigates him for "duping people with the flag of peace." Li became acting president on January 21, so Hua must have picked up a newspaper on his stumble home. *Crows'* representation of intellectuals becoming resolute and empowered differs starkly from *Distant Love* (1947), which contrasts their empty talk and hypocrisy with the selfless, militarized patriotism of a former maid.

14. Wang, "*Crows and Sparrows*," 88.

15. See Judith Shapiro, *Mao's War Against Nature: Politics and the Environment in Revolutionary China* (New York: Cambridge University Press, 2001), 86–89. Propaganda posters from the "Eliminate the Four Pests Campaign" are viewable at: https://chineseposters.net/themes/four-pests.php. In the film *Tunnel Warfare* (1965), Chinese guerrillas use a "sparrow strategy" (*maque zhanshu*) of scattering themselves and using noise to "peck at" (disorient and intimidate) the Japanese invaders. My thanks to Jie Li for the *Tunnel Warfare* reference.

SOURCES/FURTHER READING

Bao, Weihong. "Diary of a Homecoming: (Dis-)Inhabiting the Theatrical in Postwar Shanghai Cinema." In *A Companion to Chinese Cinema*, ed. Yingjin Zhang, 376–399. Hoboken, N.J.: Wiley-Blackwell, 2012.

Chang, Eileen. *The Rice-Sprout Song*. Berkeley: University of California Press, 1998 [1955].

Chen Baichen. *Shengguan tu* [Promotion scheme]. Shanghai: Qunyi chubanshe, 1948 [1945].

Lu, Hanchao. "The Homes of the Little Urbanites." In *Beyond the Neon Lights: Everyday Shanghai in the Early Twentieth Century*, 138–188, 364–371. Berkeley: University of California Press, 1999.

Pickowicz, Paul G. "Zheng Junli, Complicity, and the Cultural History of Socialist China, 1949–1976." In *China on Film: A Century of Exploration, Confrontation, and Controversy*, 189–212. Lanham, Md.: Rowman and Littlefield, 2012.

Wakeman, Frederick, Jr. " 'Cleanup': The New Order in Shanghai." In *Dilemmas of Victory: The Early Years of the People's Republic of China*, eds. Jeremy Brown and Paul G. Pickowcz, 21–58. Cambridge, Mass.: Harvard University Press, 2007.

Wang Anyi. *Song of Everlasting Sorrow: A Novel of Shanghai*. Trans. Michael Berry and Susan Chan Egan. New York: Columbia University Press, 2008.

Wang, Yiman. "Crows and Sparrows: Allegory on a Historical Threshold." In *Chinese Films in Focus II*, ed. Chris Berry, 82–89. Basingstoke: British Film Institute/Palgrave MacMillan, 2008.

Zhang, Yingjin. "Zhao Dan: Spectrality of Martyrdom and Stardom." In *Chinese Film Stars*, eds. Mary Farquhar and Yingjin Zhang, 86–96. Abington, U.K.: Routledge, 2010.

Zheng Junli. "Dianying *Wuya yu maque*" [The film *Crows and Sparrows*]. In *Zheng Junli quanji* [Complete works of Zheng Junli]. Ed. Li Zhen. 8 vols. Shanghai: Shanghai wenhua chubanshe, 2016. 5:115–305. Includes screenplay, shooting schedule, facsimile copies of set design diagrams, and a 1950 report by the director that the editors "cleaned up" from a handwritten manuscript, which is reprinted in facsimile.

FURTHER VIEWING

72 Tenants of Prosperity (*72 jia zuke* 72家租客). Eric Tsang (Zeng Zhiwei), director. 2010.

Between Husband and Wife (*Women fufu zhijian* 我們夫婦之間). Zheng Junli, director. 1951.

Decay (*Fushi* 腐蝕). [Huang] Zuolin, director. 1950.

Distant Love (*Yaoyuan de ai* 遙遠的愛). Chen Liting, director. 1947.

Kung Fu Hustle (*Gongfu* 功夫). Stephen Chow (Zhou Xingchi), director. 2004.

The House of 72 Tenants (*Qishi'er jia fangke* 七十二家房客). Wang Weiyi, director. 1963.

The House of 72 Tenants (*Qishi'er jia fangke* 七十二家房客). Chor Yuen (Chu Yuan), director. 1973.

Lights of Myriad Homes (*Wanjia denghuo* 萬家燈火). Shen Fu, director, 1948.

Lin Zexu 林則徐 (aka *The Opium Wars*). Zheng Junli and Cen Fan, directors. 1959.

Spring River Flows East (*Yijiang chunshui xiang dong liu* 一江春水向東流). Cai Chusheng and Zheng Junli, directors. 1947.

Abbreviations

* Original English name appearing in films or in official publications.

CHINESE FILM STUDIOS

Asiatic	Yaxiya yingxi gongsi 亞細亞影戲公司 (*Asiatic Film Company)
Bayi	Ba-yi dianying zhipianchang 八一電影製片廠 (August First Film Studio)
Changcheng	Shanghai Changcheng huapian gongsi 上海長城畫片公司 (*The Great Wall Film Company, Shanghai)
Changchun	Changchun dianying zhipianchang 長春電影製片廠 (Changchun Film Studio)
Changjiang	Changjiang yingpian gongsi 長江影片公司 (Yangtze River Film Co.)
Da guangming	Da guangming yingye gongsi 大光明影業公司 (The Dawn Film Company)
Dadi	Dadi yingye gongsi 大地影業公司 (*Great Earth Film Company)
Diantong	Diantong yingpian gongsi 電通影片公司 (*Denton Film Company)
Guohua	Guohua yingye gongsi 國華影業公司 (Guohua Film Co.)
Guotai	Guotai yingye gongsi 國泰影業公司 (*Cathay Film Co.)
Huacheng	Huacheng zhipianchang 華成製片廠 (*Hwa Cheng Studio) [incorporated into Zhonglian in 1939]

Huaju	Huaju yingpian gongsi 華劇影片公司 (Chinese Drama Film Co.)
Huaxin	Huaxin yingye gongsi 華新影業公司 (Huaxin Film Company)
Huayi	Huayi yingpian gongsi 華藝影片公司 (China Arts Film Co.)
Huaying	Zhonghua dianying lianhe gufen youxian gongsi 中華電影聯合股份有限公司 (China Film Joint Stock Co., Ltd.)
Kunlun	Kunlun yingye gufen youxian gongsi 崑崙影業股份有限公司 (*The Peak Film Industries Corp., Ltd.)
Langhua	Langhua yingpian gongsi 郎華影片公司 (Langhua Film Company)
Lianhua	Lianhua yingye youxian gongsi 聯華影業有限公司 (*United Photoplay Service, Ltd.)
Lilium	Da Zhonghua baihe yingpian gongsi 大中華百合影片公司 (*Great China Lilium Pictures)
Minhua	Shanghai Minhua yingpian gongsi 上海民華影片公司 (*Ming Hwa Motion Picture Co.)
Minxin	Shanghai Minxin yingpian gufen youxian gongsi 上海民新影片股份有限公司 (*The China Sun Motion Picture Producing Co., Ltd.)
Mingxing	Shanghai Mingxing dianying gongsi 上海明星電影公司 (*The Star Motion Picture Co., Ltd.)
Shanghai meishu	Shanghai meishu dianying zhipianchang 上海美術電影製片廠 (Shanghai Animation Film Studio)
Shanghai yingxi	Shanghai yingxi gongsi 上海影戲公司 (Shanghai Shadowplay Company)
Tianma	Shanghai Tianma dianying zhipianchang 上海天馬電影製片廠 (Tianma Film Studio, Shanghai)
Tianyi	Tianyi yingpian gongsi 天一影片公司 (*Unique Film Production Co.)
Wenhua	Wenhua yingye gongsi 文華影業公司 (*Wen Hwa Film Company)
Xinhua	Xinhua yingye gongsi 新華影業公司 (*Hsin Hwa Film Company) [incorporated into Zhongdian in 1942]
Yihua	Yihua yingye gongsi 藝華影業公司 (*Yi Hwa Film Company)
Yonghua	Xianggang Yonghua yingye gongsi 香港永華影業公司 (Yonghua Film Company, Hong Kong)
Youlian	Youlian yingpian gongsi 友聯影片公司 (*U. Luien Film Co.)
Yuandong	Yuandong yingpian gongsi 遠東影片公司 (Far East Film Company)
Zhonghua	Zhonghua dianying lianhe gufen youxian gongsi 中華電影聯合股份有限公司 (China Film Joint Stock Co., Ltd.)

Zhongying	Zhongguo dianying zhipianchang 中國電影製片廠 (China Film Studio)
Zhonglian	Zhonghua lianhe yingye gongsi 中華聯合影業公司 (China United Film Co.)
Zhongdian	Zhongyang dianying qiye gufen youxian gongsi 中央電影企業股份有限公司 (Central Motion Picture Stock Co., Ltd.)

Appendix 1: Other Significant Extant Chinese Films, 1927–1949

A selective list, organized by year of production or release.

Titles and names are given as they appear in original English credits, if any, of the film itself. Chinese characters for cast and crew appear in appendix 2. Films are sound films, unless otherwise noted.

THE CAVE OF THE SILKEN WEB (*PANSI DONG* 盤絲洞) (1927)

Alternative English title: *The Cave of Spiders*
Director: Dan Duyu
Screenplay: Guan Ji'an
Studio: Shanghai yingxi
Over 60 minutes (incomplete), silent
Cast: Pearl Ing (Yin Mingzhu), Wu Wenchao, Zhou Hongquan, Zhan Jiali
Summary: In this story adapted from *Journey to the West*, the monk Tripitaka is trapped in a cave and forced to marry a spider-woman, only to be saved at the last minute by Monkey, Piggy, and Sandy. A partial copy of this formerly lost film (with Chinese and Norwegian intertitles) recovered in Norway gives a taste of the special effects-intensive supernatural films of the 1920s, including scandalous (for the era) costuming and the chilling sight of a woman turning into an enormous spider.

WAY DOWN WEST (*XIXIANG JI* 西廂記) (1927)

Alternative English title: *Romance of the Western Chamber*
Director/screenplay: Hou Yao
Studio: Minxin
Over 60 minutes (incomplete), silent
Cast: Lim Cho Cho (Lin Chuchu), Lee Dan Dan (Li Dandan), T. K. Kar (Ge Cijiang), Lee Wha Ming (Li Huamin)
Summary: An adaptation of the love comedy *Romance of the Western Chamber* (also known as *The Story of the Western Wing*), with Lin Chuchu as Cui Yingying, Ge Cijiang as Scholar Zhang, and Li Dandan as the matchmaker-maid Scarlet. The *wuxia* fad inspired the filmmakers to add to the traditional garden and boudoir romance extensive mass action sequences on location. Notable special effects include Scholar Zhang dreaming of the magical growth of his writing brush, which he rides through the air in pursuit of a kidnapper and then uses as a weapon to kill him. Given the English title *Way Down West* to capitalize on the popularity of D. W. Griffith's *Way Down East*. One partial extant copy (42 min.) has French intertitles.

POOR DADDY (*PA LAOPO* 怕老婆) (1929)

Alternative Chinese title: *Erzi yingxiong* 兒子英雄
Alternative English titles: *The Hen-Pecked Husband, The Heroic Son, My Son Was a Hero*
Director: Dumas Young (Yang Xiaozhong)
Screenplay: C. C. Chen (Chen Zhiqing)
Studio: Changcheng
71 minutes, silent
Cast: Zhang Zhede, Liu Jiqun, Xu Jingzhen, Gao Weilian, Hong Jingling
Summary: A slapstick comedy about a boy who helps his boatman father fight back against his shrewish wife and beat the rap when dad is framed for a stabbing committed by her lover. Don't miss the climactic scene of the teeter-totter over a cliff. Original Chinese-English intertitles by C. Y. Sun (Sun Yu).

THE RED HEROINE (*HONG XIA* 紅俠) (1929)

Director: Weng Yih Ming (Wen Yimin)
Screenplay: San Kwan Wu (Shang Guanwu)
Studio: Youlian
95 minutes, silent

Cast: Van Shih Bong (Fan Xuepeng), Hsu Ko Hui (Xu Guohui), Wang Chu Ching (Wang Chuqin), Mayor Chen (Chen Meiyan), Weng Yih Ming (Wen Yimin), San Kwan Wu (Shang Guanwu), Chu Sao Chuan (Zhu Shaoquan), Chou Tai San (Zhao Taishan), Jui Yih Fong (Qu Yifeng)

Summary: A "Western" army of Tartars invades a village, resulting in the death of a young woman's grandmother and the scattering of her family and neighbors. She is saved from being raped at the general's stronghold by the magical kung fu master White Monkey, who whisks her away and trains her in martial arts. She returns to take revenge on the general, free his captives, and act as matchmaker for her cousin. Displays tropes of the 1920s *wuxia* (martial-chivalry) genre craze, including a revenge plot, crosscut action sequences on location, sexploitation scenes, and special effects to represent magic, including a flying swordswoman. Original Chinese-English intertitles.

LOVE AND DUTY (*LIAN'AI YU YIWU* 戀愛與義務) (1931)

Director: Richard Poh (Bu Wancang)
Screenplay: Chu Shek Lin (Zhu Shilin)
Studio: Lianhua
152 minutes, silent
Cast: Lily Yuen (Ruan Lingyu), Raymond King (Jin Yan), Lay Ying (Li Ying), Chen Yen Yen (Chen Yanyan), Liu Chi Chuen (Liu Jiqun), Lily Chow (Zhou Lili), Kao Wei-Lien (Gao Weilian), Sze Ko Fei (Shi Juefei)

Summary: Two students, Li Tsu Yi and Yang Nei Fan, fall in love on their daily walk to school, but Yang's father marries her off to a rich man. Years later, they reunite when Li saves one of Yang's children from drowning; he eventually persuades her to run away with him. They fall on hard times, he dies of illness, and she raises their daughter alone, all the while yearning for the two children she left behind. This epic melodrama features charismatic performances by its leads, a swordfight, color tinting, and Ruan Lingyu playing young and old roles in split-screen scenes. This well-restored film, adapted from a novel, has excellent original Chinese-English intertitles.

TWO STARS (*YINHAN SHUANGXING* 銀漢雙星) (1931)

Alternative English titles: *Twin Stars of the Silver Screen, Two Stars of the Milky Way, An Actor and an Actress*
Director: Tomsie Sze (Shi Dongshan)
Original story: Chang Hen Shui (Zhang Henshui)
Screenplay: Chu Shih Ling (Zhu Shilin)

Studio: Lianhua

86 minutes, 12 reels, dubbed sound (sound is not extant)

Cast: Violet Wong (Ziluolan), Raymond King (Jin Yan), Kao Chien Fei (Gao Zhan-fei), Yeh Chuen Chuan (Ye Juanjuan), V. K. Chung (Zong Weigeng), Chen Yen Yen (Chen Yanyan), Liu Chi Chuen (Liu Jiqun), and the U.P.S. Follies

Summary: The daughter of a Cantonese composer becomes a singing movie star thanks to his composition talents and her voice and beauty. She costars in costume dramas with a handsome male actor, and the two fall in love. Their romance blossoms onscreen, but he already has a wife from an arranged marriage. He breaks with her and both return home—he to his wife, she to her father—to fulfill their family duties. This meta-cinematic film contains extended sequences of characters singing or listening to music, but the original sound-on-disk does not survive.

YIHJANMAE (YI JIAN MEI 一剪梅) (1931)

Alternative English title: *A Spray of Plum Blossoms*
Director: Richard Poh (Bu Wancang)
Screenplay: Jeffrey Y. C. Huang (Huang Yicuo)
Studio: Lianhua
105 minutes, silent

Cast: Lily Yuen (Ruan Lingyu), Lim Chocho (Lin Chuchu), Wang Tse-lung (Wang Cilong), Raymond King (Jin Yan), Kao Chien Fei (Gao Zhanfei), Chen Yen Yen (Chen Yanyan), Liu Chi-chuen (Liu Jiqun), Wang Kwei-ling (Wang Guilin), Sze Ko Fei (Shi Juefei), Lily Chow (Zhou Lili)

Summary: An adaptation of *The Two Gentlemen of Verona*, set in a modern-day military academy in Canton, starring Jin Yan as Valentine (who becomes the dart-throwing "Plum Flower Bandit"), Wang Cilong as Proteus, Ruan Lingyu as Julia (who disguises herself as a soldier to discover Proteus' treachery), and Lin Chuchu as Silvia. The film features extensive location scenes on horseback and original Chinese-English intertitles.

WILD ROSE (YE MEIGUI 野玫瑰) (1932)

Director/screenplay: Sun Yu
Studio: Lianhua
80 minutes, silent

Cast: Jin Yan, Wang Renmei, Ye Juanjuan, Zheng Junli, Han Langen, Zhang Zhizhi, Yan Gongshang

Summary: A vivacious country lass, Xiao Feng, catches the attention of Jiang Bo, a rich young man from the city who is out painting in the countryside. The two fall

in love, and after disaster befalls her father, Jiang brings the now-homeless Xiao Feng to Shanghai, where her uninhibited behavior ruffles the feathers of upper-class urbanites. Defying his father, the couple moves into an apartment, but Jiang falls ill and is wrongfully jailed. Xiao Feng begs Jiang's father for help in return for her giving up his son. The couple is eventually reunited when Jiang leaves his pampered life to join the army, where he reencounters his love. *Wild Rose*, released shortly after the Japanese bombing of Shanghai, features a charismatic, and at times hilarious, performance by Wang Renmei.

SPRING SILKWORMS (CHUN CAN 春蠶) (1933)

Director: Cheng Bugao
Original story: Mao Dun
Screenplay: Xia Yan (credited as Cai Shusheng)
Studio: Mingxing
94 minutes, dubbed soundtrack
Cast: Xiao Ying, Zhang Minyu, Gong Jianong, Zheng Xiaoqiu, Ai Xia
Summary: In the wake of the Mukden Incident, a silkworm farmer and his family learn the hard way that their traditional village industry cannot compete with foreign modern capitalist silk firms. This silent film (with dubbed soundtrack) features lyrical location shots of a southern river town, a methodical introduction to the silkworm-raising process, and psychological depiction of the stresses on an agricultural community. Adapted from a 1932 short story (the first in a trilogy) by Mao Dun.

THE PLUNDER OF PEACH AND PLUM (TAOLI JIE 桃李劫) (1934)

Alternative English title: *The Fate of Graduates*
Director: Ying Yunwei
Screenplay: Yuan Muzhi
Studio: Diantong
101 minutes
Cast: Yuan Muzhi, Chen Bo'er, Zhou Boxun, Tang Huaiqiu
Summary: Two promising graduates marry and set out to contribute to society, only to encounter corruption and harassment in the workforce. Their youth, energy, and idealism are ground down by an unremittingly harsh reality, and they reach a crisis when the husband resorts to crime to provide for his ailing postpartum wife. A melodramatic social exposé framed in an extensive flashback sequence.

SONG OF THE FISHERMEN (*YUGUANG QU* 漁光曲) (1934)

Director/screenplay: Cai Chusheng
Studio: Lianhua
57 minutes, dubbed soundtrack
Cast: Wang Renmei, Han Langen, Tang Tianxiu, Tan Ying, Luo Peng, Shang Guanwu, Hong Jingling, Wang Moqiu
Summary: A hit musical, with dubbed soundtrack, and reportedly the highest-grossing Chinese film of the 1930s. Han Langen costars with Wang Renmei as fishermen on the brink of ruin due to hardship, misfortune, prejudice, and competition from large corporations. Features two renditions of the title song.

TWIN SISTERS (*ZIMEI HUA* 姊妹花) (1934)

Director/screenplay: Zheng Zhengqiu
Studio: Mingxing
81 minutes
Cast: Hu Die, Zheng Xiaoqiu, Tan Zhiyuan, Xuan Jinglin, Gu Meijun
Summary: Butterfly Wu (Hu Die) plays double roles in this talkie as a pair of sisters separated at birth, who are reunited (including in a few split-screen scenes) when the impoverished country girl becomes a servant in the home of her younger sister, now the wife of a warlord. The truth comes out when their mother arrives, and the servant-sister, trying to help her, ends up jailed for theft and manslaughter. The melodrama ends in family reconciliation, as the rich woman leaves with her mother and elder sister.

CITY SCENES (*DUSHI FENGGUANG* 都市風光) (1935)

Alternative English titles: *Scenes of City Life, Cityscapes*
Director/screenplay: Yuan Muzhi
Studio: Diantong
99 minutes
Cast: Zhang Xinzhu, Tang Na, Zhou Boxun, Bai Lu, Lan Ping, Cai Ruohong, Wu Yin, Yuan Muzhi
Summary: In this story about migrants to Shanghai, a poor young writer falls in love with the daughter of a pawnshop owner, a materialistic young woman who instead marries a business owner. Following a farcical courtship competition between the two men, she ends up losing both, and her family leaves Shanghai. Yuan's innovative directing debut, which influenced *Street Angels*, features brilliant situation comedy, songs, extensive sonic and visual gags and a frame

in which the filmmaker, in a cameo, presents the city as a Western peep show. Scenes featuring Lan Ping, later better known as Jiang Qing (Mao Zedong's fourth wife), are cut in some recent copies of the film.

WAVES WASH OVER THE SAND (LANG TAO SHA 浪淘沙) (1936)

Alternative English titles: *The Desert Island, Two Skeletons*
Director/screenplay: Wu Yonggang
Studio: Lianhua
68 minutes
Cast: Jin Yan, Zhang Zhizhi
Summary: A murderer and a detective are marooned on a desert island and end their days shackled together. An existentialist and expressionist parable about how the vicissitudes of life can turn foes into friends, with strong performances by Jin Yan and Zhang Zhizhi. Opening credits are written on the sand and washed away by waves.

CROSSROADS (SHIZI JIETOU 十字街頭) (1937)

Director/ screenplay: Shen Xiling
Studio: Mingxing
103 minutes
Cast: Zhao Dan, Bai Yang, Lü Ban, Wu Yin, Sha Meng, Yi Ming
Summary: A tragicomedy about the travails of young intellectuals struggling to find employment, romance, and purpose after graduating from university. A break-out role for Bai Yang, and a significant appearance by Lü Ban, who became an important director of satirical comedies in the 1950s.

CONFUCIUS (KONGFUZI 孔夫子) (1940)

Director/screenplay: Fei Mu
Studio: Minhua
97 minutes
Cast: Tang Huaiqiu, Zhang Yi, Sima Yingcai, Pei Chong, Xu Li
Summary: A historical drama about the travails of Confucius and his disciple Zilu during his search for patronage during the Warring States period. Made in "Orphan Island" Shanghai, Fei Mu's restrained film portrays a sage's integrity and resolve amid crisis. A print of this formerly lost film was restored and subtitled by the Hong Kong Film Archive.

PRINCESS IRON FAN (*TIESHAN GONGZHU* 鐵扇公主) (1941)

Alternative English title: *The Princess with the Iron Fan*
Directors: Wan Laiming and Wan Guchan
Screenplay: Wang Ganbai
Animators: Wan Laiming, Wan Guchan, Wan Chaochen, Wan Dihuan
Studio: Zhongguo Lianhe
Cast: Bai Hong, Yan Yueling, Jiang Ming, Han Langen, Yin Xiucen
73 minutes
Summary: China's first full-length animated film adapts an episode from the Ming dynasty novel *Journey to the West*, in which Monkey King and his traveling companions Tripitaka, Piggy, and Sandy battle against the Princess and the Bull Demon King to cross the Mountain of Flames.

ETERNITY (*WANSHI LIUFANG* 萬世流芳) (1943)

Alternative English titles: *The Opium War, A Good Name for Generations, Glory to Eternity*
Directors: Richard Poh (Bu Wancang), Ma-Xu Weibang, Zhang Shankun, Dumas Young (Yang Xiaozhong)
Screenplay: Zhu Shilin
Studio: Zhonglian
Cast: Gao Zhanfei, Chen Yunshang, Yuan Meiyun, Li Xianglan, Wang Yin
143 minutes
Summary: A big-budget epic costume drama commissioned by the Japanese authorities to commemorate the centennial of the Opium War and stir up anti-Western sentiment. The Chinese filmmakers diluted the propaganda value of the film by opting to focus not on the opium-suppressing activities of Qing official Lin Zexu but instead on a (fictional) love triangle between Lin, his soulmate, and his wife. Harnesses the star power of Nancy Chan (Chen Yunshang) and Manchukuo film star and songstress Li Xianglan, and includes entertaining whiteface depictions of Western opium traders.

ALONG THE SUNGARI RIVER (*SONGHUA JIANG SHANG* 松花江上) (1947)

Alternative English title: *On the Songhua River*
Director/screenplay: Jin Shan
Studio: Changchun
102 minutes

Cast: Zhang Ruifang, Pu Ke, Wang Renlu, Zhou Diao, Zhu Wenshun

Summary: A landmark production of the new Changchun Studio, founded after Japan's World War II defeat. When a prosperous communal way of life in northeast China is disrupted by the brutal Japanese occupation of 1931, a young couple lead a revolt at a Japanese-run coal mine and join the guerrilla resistance. Features fantastic location shots, meticulous attention to customs in the rural northeast, a charismatic performance by Zhang Ruifang (later the title character in *Li Shuangshuang*), and some of the most exciting action sequences in Republican Chinese cinema.

DIARY OF A HOMECOMING (*HUANXIANG RIJI* 還鄉日記) (1947)

Director/screenplay: Zhang Junxiang
Studio: Zhongguo Dianying (first studio)
112 minutes
Cast: Bai Yang, Geng Zhen, Lü En, Yang Hua, Zhang Zhizhi, Zheng Min, Li Tianji

Summary: One of several films set in the present day that dramatize the frustrations encountered by people trying to rebuild their lives after World War II. The high hopes of a young couple returning to Shanghai from Chungking (Chongqing) after the war are dashed by the unavailability of housing. Features an extended comedic sequence in a traitor's mansion in which civil war is reenacted as a domestic travesty involving a food fight.

LOVE EVERLASTING (*BULIAO QING* 不了情) (1947)

Alternative English titles: *Unending Love, Love Without End*
Director: Sang Hu
Screenplay: Eileen Chang
Studio: Wenhua
93 minutes
Cast: Chen Yanyan, Liu Qiong, Lin Zhen, Cao Wei, Lu Shan, Peng Peng, Ye Ming, Yan Su, Sun Yi, Zhang Wan

Summary: Chen Yanyan stars opposite Liu Qiong as an unemployed professional woman in Shanghai who becomes the in-home tutor of a factory manager's young daughter. In a changing domestic arrangement she finds unexpected romance, but also encounters ill will and meddling. This collaboration between Eileen Chang and Sang Hu, like their next, *Long Live the Missus!*, centers on affairs of the heart, and shows social pressures putting a woman in an impossible situation. Chang adapted her screenplay into the novella *How Much Regret* (*Duoshao hen* 多少恨, 1947).

EIGHT THOUSAND LI OF CLOUDS AND MOON (BAQIAN LI YUN HE YUE 八千里雲和月) (1947)

Director/screenplay: Tomsie Sze (Shi Dongshan)
Studio: Lianhua (production), Kunlun (distribution)
124 minutes
Cast: Bai Yang, Tao Jin, Shi Yu, Gao Zheng, Zhou Feng, Huang Chen
Summary: The first of two 1947 wartime epics starring Bai Yang and Tao Jin. Following the outbreak of war, a young woman defies her family's wishes and, with her boyfriend, joins a patriotic theater troupe that travels around China rallying citizens to the anti-Japanese cause. Having endured years of hardship and mortal peril, the couple returns home after China's victory to encounter relatives' profiteering. They choose honorable poverty rather than a corrupt easy life, only to suffer further hardships.

PHONY PHOENIXES (JIAFENG XUHUANG 假鳳虛凰) (1947)

Alternative English title: *Barber Takes a Wife*
Director: Huang Zuolin
Screenplay: Sang Hu
Studio: Wenhua
91 minutes
Cast: Li Lihua, Shi Hui, Yan Su, Lu Shan, Ye Ming, Zhang Wan
Summary: In this farcical comedy, a debt-ridden single mother hatches a gold-digging marriage scam, only to net a poor barber pretending to be the general manager of a corporation. Despite discovering each other's poverty and fraudulent behavior, they decide they are compatible and stay together. The film provoked a protest by barbers, who felt their profession was being insulted.

LIGHTS OF MYRIAD HOMES (WANJIA DENGHUO 萬家燈火) (1948)

Alternative English title: *A Myriad of Lights*
Director: Shen Fu
Screenplay: Yang Hansheng, Shen Fu
Studio: Kunlun
115 minutes
Cast: Shangguan Yunzhu, Lan Ma, Qi Heng, Gao Zheng
Summary: A family drama about the harsh economic realities of the late 1940s. A family's struggles to make ends meet in inflation-racked Shanghai are compounded

when relations from the countryside move in, and the father—betrayed by his childhood friend-turned-boss—is fired from the foreign firm he has served so selflessly. This down-and-out man's family helps him to realize finally that it's just "the age that's wrong," and that they have to stick together.

SORROWS OF THE FORBIDDEN CITY (QINGGONG MISHI 清宮秘史) (1948)

Alternative English title: *Secret History of the Qing Court*
Director: Zhu Shilin
Screenplay: Yao Ke
Studio: Yonghua Film Co. (Hong Kong)
89 minutes
Cast: Shu Shi, Zhou Xuan, Tang Ruoqing, Hong Bo
Summary: A high-budget musical costume drama, shot in Hong Kong, featuring songstress Zhou Xuan in one of her last significant roles. Depicts the political awakening of the Daoguang emperor, supported by his loyal concubine and inspired by reformist courtier Kang Youwei, and his valiant but doomed attempts to overcome the power of the Empress Dowager, Cixi. Screened in Beijing and Shanghai, and criticized by Mao Zedong for its politics.

BITTERSWEET MIDDLE AGE (AILE ZHONGNIAN 哀樂中年) (1949)

Alternative English titles: *The Sorrows and Joys of Middle Age, Miserable at Middle Age*
Director: Sang Hu
Screenplay: Sang Hu, Eileen Chang (uncredited)
Studio: Wenhua
103 minutes
Cast: Shi Hui, Zhu Jiashen, Shen Yang, Li Wanqing, Han Fei
Summary: A romantic drama centering on an idealistic educator, Chen Shaochang, who defies social stigma to find a new lease on life and renew his vocation in middle age. A widowed school principal raises three children only to have them pressure him into a premature retirement from the job he loves, and buying their "old" father a grave site. His protégée, Liu Minhua, the daughter of a friend, takes over as principal, but his children conspire to force her out. Liu persuades Chen that he is not old yet, and they get married, use the grave site for a new school, and start a family together.

Appendix 2: Selective Name List of Film Personnel

A selective list of Chinese film industry individuals mentioned in this book, alphabetical by Hanyu pinyin. Hanyu pinyin did not become the standard in mainland China until the late 1950s, so earlier texts use other spellings. English names, sometimes multiple, appear in original film credits or print materials of the era, including those listed in the Source column. The name given in pinyin and characters is the one the person used most often professionally and is typically not their birth name. For variant film titles, see the filmography.

Pinyin	Chinese	Years	English	Source*
Ai Xia	艾霞	1912–1934		
Bai Hong	白虹	1919–1992	Rainbow White	*CMM*, 132
Bai Lu	白璐	ca. 1916–1947		
Bai Yang	白楊	1920–1996		
Bao Tianxiao	包天笑	1876–1973		
Bu Wancang	卜萬蒼	1903–1974	Richard Poh	*Yihjanmae, Hua Mu Lan*
Cai Chusheng	蔡楚生	1906–1968		
Cai Ruohong	蔡若虹	1910–2002		
Cai Shusheng	蔡叔聲	See Xia Yan		
Cen Fan	岑范	1926–2008		

(*continued*)

Pinyin	Chinese	Years	English	Source*
Chen Baichen	陳白塵	1908–1994		
Chen Bo'er	陳波兒	1907–1951		
Chen Juanjuan	陳娟娟	1929–1976		
Chen Kaige	陳凱歌	1952–		
Chen Kengran	陳鏗然	1905–1958		*CMM*, 55
Chen Liting	陳鯉庭	1910–2013		
Chen Meiyan	陳梅喦		Mayor Chen	*Red Heroine*
Chen Yanyan	陳燕燕	1916–1999	Chen Yen Yen, Ch'en Yen-yen, Chen Yen-Yen	*Love and Duty, Yihjanmae, Two Stars, Song of China*
Chen Yunshang	陳雲裳	1919–2016	Nancy Chan, Cheng Yun Shang, Chan Wan-Seung	*Hua Mu Lan, CMM,* 92, 133, 288
Chen Zhiqing	陳趾青		C. C. Chen	*Poor Daddy*
Cheng Bugao	程步高	1898–1966		
Cheng Mo	程漠			
Cheng Zhi	程之	1926–1995		
Chu Minyi	褚民誼	1884–1946		
Chu Yuan	楚原	1934–	Chor Yuen	
Chuanxi Duochangzheng	川喜多長政	1903–1981	Kawakita Nagamasa	
Cui Chaoming	崔超明	1918–2010		
Dan Duyu	但杜宇	1897–1972	Dan Do-yu, Darwin Dann	*CMM,* 29
Ding Hao	丁皓	1939–1967	Kitty Ting	
Du Lei	杜雷			
Fan Haha	范哈哈	1907–1987		
Fan Xuepeng	范雪朋	1908–1974	Van Shih Bong	*Red Heroine*
Fei Mu	費穆	1906–1951	Fey Mou, Fei Mou	*Song of China*
Gao Weilian	高威廉		Wei-Lien Kao, William Kolland	*Love and Duty*
Gao Zhanfei	高占非	1904–1969	Kao Chien Fei	*Yihjanmae, Two Stars*

Pinyin	Chinese	Years	English	Source*
Gao Zheng	高正	1922–2015		
Ge Cijiang	葛次江	1908–1966	T. K. Kar	*Way Down West*
Ge Xin	葛鑫	1917–2000		
Geng Zhen	耿震	1917–1989		
Gong Jianong	龔稼農	1902–1993	Robert Kung	*CMM*, 158
Gu Meijun	顧梅君	1915–1989		
Gu Menghe	顧夢鶴	1904–1991		
Guan Ji'an	管際安	1892–1975		
Guan Jinpeng	關錦鵬	1957–	Stanley Kwan	
Han Fei	韓非	1919–1985		
Han Langen	韓蘭根	1909–1982	Han Lan Kun, Han Lan-ken, L. K. Han	*The Orphan of the Storm, The Peach Girl, Hua Mu Lan*
He Feiguang	何非光	1913–1997		
He Mengfu	賀孟斧	1911–1945		
Hong Bo	洪波	1921–1968		
Hong Ji	洪濟			
Hong Jingling	洪警鈴	1893–1963	C. L. Hong	*Hua Mu Lan*
Hong Mo	洪謨	1913–2014		
Hong Shen	洪深	1894–1955		
Hou Yao	侯曜	1903–1942		
Hu Die	蝴蝶	1907–1989	Butterfly Wu	
Hu Ping	胡萍	1910– ?		
Hu Rongrong	胡蓉蓉	1929–2012		
Huang Chen	黃晨			
Huang Jiamo	黃嘉謨	1916–2004		
Huang Liushuang	黃柳霜	1905–1961	Anna May Wong, Wong Liu Tsong	
Huang Naishuang	黃耐霜	1912–1967	N. S. Wong, Nansong Wong	*Hua Mu Lan, CMM*, 56
Huang Yicuo	黃漪磋		Jeffrey Y. C. Huang, Y. C. Jeffrey Huang	*Yihjanmae, Love and Duty*

(*continued*)

Pinyin	Chinese	Years	English	Source*
Huang Yujun	黃裕君	1939–	Ivy Ling Po, Huang Yu-chun	
Huang Zongying	黃宗英	1925–		
Huang Zuolin	黃佐臨	1906–1994		
Jia Zhangke	賈樟柯	1970–		
Jiang Ming	姜明	1910–1990		
Jiang Qing	江青	See Lan Ping		
Jiang Tianliu	蔣天流	1921–2012		
Jin Shan	金山	1911–1982		
Jin Yan	金焰	1910–1983	Raymond King, Y. King	*The Peach Girl, Yihjanmae*
Lan Ma	藍馬	1915–1976		
Lan Ping	藍萍	1914–1991		
Li Baoluo	李保羅	1911–1997		
Li Dandan	李旦旦	1912–1998	Lee Dan Dan Li Ya-ching (Li Xiaqing 李霞卿)	*Way Down West, CMM*, 28
Li Hanxiang	李翰祥	1926–1996	Richard Li Han Hsiang	
Li Huamin	理化民		Lee Wha Ming	*Way Down West*
Li Jinhui	黎錦暉	1891–1967		
Li Junpan	李君磐			
Li Keng	黎鏗	1928–1965	Henry Lai, Lai Hang	*CMM*, 127, hkmdb.com
Li Lihua	李麗華	1924–2017		
Li Lili	黎莉莉	1915–2005	L. L. Lay, Lily Lee	*Twin Stars, CMM*, 61
Li Minwei	黎民偉	1892–1953	Lai Man-Wai, Lay Min Wei, M. W. Ray	*CMM*, 27, *The Peach Girl, Love and Duty*
Li Pingqian	李萍倩	1902–1984	Jack Li	*CMM*, 57
Li Tianji	李天濟	1921–1995		
Li Wanqing	李浣青	1923–1987		
Li Wei	李緯	1919–2005		

Pinyin	Chinese	Years	English	Source*
Li Wenguang	李文光		T. K. Lee	*Poor Daddy*
Li Xianglan	李香蘭	1920–2014	Ri Kōran, Yoshiko (Shirley) Yamaguchi	
Li Ying	黎英		Lay Ying	*Love and Duty*
Li Zeyuan	李澤源		C. Y. Lee	*The Pearl Necklace*
Lin Chuchu	林楚楚	1905–1979	Lim Cho Cho Lim Chocho, Lim Cho-Cho, Florence Lim	*Way Down West, Yihjanmae, Song of China*
Lin Zhen	林榛	1921–1977		
Liu Enjia	劉恩甲	1916–1968		
Liu Jiqun	劉繼群	1908–1940	Liu Chi Chuen, Liu Chi-chuen, C. C. Liu, Liu Chi Chun	*Two Stars, The Pearl Necklace, The Peach Girl, Yihjanmae, Love and Duty*
Liu Li	劉犁			
Liu Liying	劉莉影	1913–1993		
Liu Qiong	劉瓊	1913–2002		
Liu Yifei	劉亦菲	1987–		
Liu Zhaoming	劉兆明			
Lü Ban	呂班	1912–1976		
Lü En	呂恩	1920–2012		
Lu Ren	魯韌	1912–2002		
Lu Shan	路珊	1918–2005		
Lu Tie[min?]	陸鐵 [民?]		T. M. Loh	*Laborer's Love*
Luo Bin	羅斌	1923–2012	Law Bun, Law Ban, Lo Pin	
Luo Jun	羅軍			
Luo Mingyou	羅明佑	1900–1967	Lo Ming-yau, Lo Ming Yau	*The Peach Girl, Yihjanmae*
Luo Peng	羅朋	1909–1937		
Mao Dun	茅盾	1896–1981	Mao Tun	

(continued)

Pinyin	Chinese	Years	English	Source*
Ma-Xu Weibang	馬徐維邦	1905–1961	V. P. Marsh	*CMM*, 96
Mei Lanfang	梅蘭芳	1894–1961		
Mei Xi	梅熹	1914–1983	Mai Hsi	*Hua Mu Lan*
Mei Xuechou	梅雪儔			
Meng Shufan	孟樹範			
Nie Er	聶耳	1912–1935	George Njal	*Diantong banyue huabao*, no. 7 (August 15, 1935)
Ouyang Shafei	歐陽莎菲	1923–2010	Auyeung Siao-Fei (and 10 other romanizations)	hkmdb.com
Ouyang Yuqian	歐陽予倩	1889–1962	E. C. Ouyang	*Hua Mu Lan*
Pei Chong	裴沖			
Pu Ke	浦克			
Qi Heng	齊衡			
Qian Qianli	錢千里	1915–2009		
Qian Zhenzhen	錢蓁蓁	See Li Lili		
Qin Yi	秦怡	1922–		
Qu Yifeng	瞿一峰		Jui Yih Fong	*Red Heroine*
Ren Qingtai	任慶泰	1850–1932		
Ren Xudong	任旭東	1924–2017		
Ruan Lingyu	阮玲玉	1910–1935	Lily Yuen, Yuen Ling-yuk	*The Peach Girl, Yihjanmae, Center Stage*
Sang Hu	桑弧	1916–2004		
Sha Meng	沙蒙	1907–1964		
Shang Guanwu	尚冠武	?–1938	San Kwan Wu, Shang Kwah-Wu	*Red Heroine, Song of China*
Shangguan Yunzhu	上官雲珠	1920–1968		
Shao Lizi	邵力子	1882–1967		
Shao Renmei	邵仁枚	1901–1985	Runme Shaw	
Shao Yifu	邵逸夫	1907–2014	Run Run Shaw, Siu Yat-fu	

Pinyin	Chinese	Years	English	Source*
Shen Fu	沈浮	1905–1994		
Shen Xiling	沈西苓	1904–1940		
Shen Yang	沈揚			
Shi Chao	施超	1913–1944	Sze-Chow	*Diantong banyue huabao*, no. 6 (August 1, 1935), *CMM*, 91
Shi Dongshan	史東山	1902–1955	Tomsie Sze	*Two Stars*
Shi Hui	石揮	1915–1957		
Shi Juefei	時覺非		Sze Ko Fei	*Yihjanmae*
Shi Yu	石羽	1914–2008	Shek Yu	*China Mail* (February 21, 1951)
Shu Shi	舒適	1916–2015		
Shu Xiuwen	舒繡文	1915–1969	Shu Hsiu-wen	
Shui Hua	水華	1916–1995		
Sima Yingcai	司馬英才			
Su Li	蘇里	1919–2005		
Sun Daolin	孫道臨	1921–2007		
Sun Jinglu	孫景璐	1923–1989		
Sun Shiyi	孫師毅	1904–1966		
Sun Yu	孫瑜	1900–1990	C. Y. Sun	*Poor Daddy*
Tan Ying	談瑛	1915–2001		
Tan Youliu	譚友六	1904–1972		
Tan Zhiyuan	譚志遠			
Tang Huaiqiu	唐槐秋	1898–1954		
Tang Huang	唐煌	1916–1976		
Tang Jie	湯杰	1899? 1902?–1953	J. Tom	*Hua Mu Lan, CMM*, 73
Tang Na	唐納	1914–1988		
Tang Ruoqing	唐若青	1918–1983	Rhoqing Tang	
Tang Tianxiu	湯天綉		T. S. Tong	*Don't Change Your Husband*
Tao Jin	陶金	1916–1986		
Tian Han	田漢	1898–1968	T'ien Han	

(continued)

Pinyin	Chinese	Years	English	Source*
Tian Zhuang-zhuang	田壯壯	1952–		
Tu Guangqi	屠光啟	1914–1980		
Wan Chaochen	萬超塵	1906–1992	Wan Chao-Chan	
Wan Dihuan	萬滌寰	1907–?	Irving Wan	*CMM*, 30
Wan Guchan	萬古蟾	1900–1995	James Wan	*CMM*, 30
Wan Laiming	萬籟鳴	1900–1997		
Wang Ban	王斑			
Wang Bin	王濱	1912–1960		
Wang Chuqin	王楚琴		Wang Chu Ching	*Red Heroine*
Wang Cilong	王次龍	1907–1941	Wang Tse-lung	*Yihjanmae, CMM*, 96
Wang Danfeng	王丹鳳	1924–2018		
Wang Ganbai	王乾白		Wong Gon-bok	
Wang Guilin	王貴林		Wang Kwei-ling	*Yihjanmae*
Wang Hao	王豪	1917–1991	Wang Howe	*CMM*, 189
Wang Jiaxi	王家禧	1923–2017	Alfonso Wong, Wong Chak	*Old Master Q*
Wang Jiting	王吉亭	1901–?		
Wang Longji	王龍基	1940–		
Wang Moqiu	王默秋			
Wang Naidong	王乃東	ca. 1902–?	Lyton Wang	*Don't Change Your Husband, CMM*, 92
Wang Ping	王苹	1916–1990		
Wang Renlu	王人路			
Wang Renmei	王人美	1914–1987	Juanita Wang	*CMM*, 35
Wang Tianlin	王天林	1928–2010	Wong Tin-Lam	*Darling, Stay at Home*
Wang Weiyi	王為一	1912–2013		
Wang Yi	汪漪	1925–2012		
Wang Zhengting	王正廷	1882–1961	Cheng-ting Thomas Wang	
Wei Heling	魏鶴齡	1907–1979		
Wei Wei	韋偉	1922–		
Wen Binbin	文彬彬	1915–1972		

Pinyin	Chinese	Years	English	Source*
Wen Yimin	文逸民	1890–1978	Weng Yih Ming	*Red Heroine*, *CMM*, 46
Wu Cun	吳村	1904–1972		
Wu Wenchao	吳文超		Wu Wen-chao	
Wu Yin	吳茵	1909–1991		
Wu Yonggang	吳永剛	1907–1982		
Xia Yan	夏衍	1900–1995		
Xian Xinghai	冼星海	1905–1945	Sinn Sing Hoi	
Xiao Ying	蕭英	1890–?		
Xie Bingying	謝冰瑩	1906–2000	Hsieh Ping-ying	
Xie Jin	謝晉	1923–2008		
Xie Jun	謝俊	1914–2003		
Xie Yunqing	謝雲卿	1906–?	Che Wan-Hing	hkmdb.com
Xu Changlin	徐昌霖	1916–2001		
Xu Guohui	徐國輝		Hsu Ko Hui	*Red Heroine*
Xu Jingzhen	許靜珍			
Xu Li	徐立	1918–1960		*CMM*, 206
Xu Manli	許曼麗	1918–1997		
Xu Tao	徐韜	1910–1966		
Xu Wei	徐緯			
Xu Xingzhi	許幸之	1904–1991	S. T. Hsu	
Xu Zhuodai	徐卓呆	1880–1958		
Xuan Jinglin	宣景琳	1907–1992		
Yan Ciping	嚴次平			
Yan Gong	嚴恭	1914–2010		
Yan Gongshang	嚴工上	1872–1953		
Yan Su	嚴肅			
Yan Yueling	嚴月玲			
Yan Zhong[ying?]	嚴仲[?]		Nieh Chung Ying	*Laborer's Love*
Yang Hansheng	楊翰笙	1902–1993		
Yang Hua	陽華	1915–1978		
Yang Xiaozhong	楊小仲	1899–1969	Dumas Young	*Poor Daddy*

(continued)

Pinyin	Chinese	Years	English	Source*
Yao Ke	姚克	1905–1991		
Yao Sufeng	姚蘇鳳	1906–1974		
Yao Yao	姚姚	1944–		
Ye Juanjuan	葉娟娟	1908–1937	Yeh Chuen Chuan	*Two Stars*
Ye Ming	葉明	1919–2000		
Ye Qianyu	葉淺予	1907–1995		
Yi Ming	伊明	1913–1995		
Yin Mingzhu	殷明珠	1904–1989	Pearl Ing, Miss F. F.	
Yin Xiucen	殷秀岑	1911–1979	S. C. Ying	*Hua Mu Lan*
Yin Xu	殷虛			
Ying Yunwei	應雲衛	1904–1967		
Yu Jingzi	虞靜子			
Yu Rentai	于仁泰	1950–	Ronny Yu Yan-Tai	
Yu Ying	余瑛			
Yuan Congmei	袁叢美	1904 or 1905–2005[1]	James Yuan, Yuan Tsung-Mei	*The Secret Agent of Japan*
Yuan Jun	袁俊			
Yuan Muzhi	袁牧之	1909–1978	M. T. Yuan	*Diantong banyue huabao*, no. 10 (October 1, 1935)
Yuan Qiufeng	袁秋楓	1924–	Chau Feng Yuen	
Yuan Shaomei	袁紹梅	1915–1948		
Yue Feng	岳楓	1910–1999	Griffin Yueh, Feng Yueh, Yuek Feng, Yuen Fang	*CMM*, 94
Zeng Zhiwei	曾志偉	1953–	Eric Tsang, Tsang Chi-wai	
Zhan Jiali	詹嘉利			
Zhang Ailing	張愛玲	1920–1995	Eileen Chang	
Zhang Chaoqun	張超群			
Zhang Fa	張伐	1919–2001		

Pinyin	Chinese	Years	English	Source*
Zhang Henshui	張恨水	ca. 1895–1967	Chang Hen Shui	*Two Stars*
Zhang Hongmei	張鴻眉	1927–2005		
Zhang Huimin	張惠民		Whitman Chant	*Woman Warrior White Rose*
Zhang Jianya	張建亞	1951–		
Zhang Jiwu	章輯五	1891–1975		
Zhang Junxiang	張俊祥	1910–1996		
Zhang Leping	張樂平	1910–1992		
Zhang Minyu	張敏玉			
Zhang Ruifang	張瑞芳	1918–2012		
Zhang Shankun	張善琨	1905–1957	Chang Shan-Kun, S. K. Chang	*Hua Mu Lan*
Zhang Shichuan	張石川	ca. 1890–1954		
Zhang Wan	張婉			
Zhang Xinzhu	張新珠			
Zhang Yi	張翼	1909–1983	Chang Yih	*Song of China*
Zhang Zhede	張哲德			
Zhang Zhizhi	章志直	1901–1970	C. Z. Chong	*Hua Mu Lan*
Zhao Dan	趙丹	1915–1980		CMM, 65
Zhao Huishen	趙慧深	1911–1967[2]		
Zhao Ming	趙明			
Zhao Taishan	趙泰山		Chou Tai San	*Red Heroine*
Zheng Junli	鄭君里	1911–1969	Chen Chun-Li	*Song of China*
Zheng Min	鄭敏			
Zheng Xiaoqiu	鄭小秋	1910–1989		
Zheng Zhegu	鄭鷓鴣	1880–1925	Cheng Cheh Ku	*Laborer's Love*
Zheng Zhengqiu	鄭正秋	1889–1935		
Zhou Boxun	周伯勛	1911–1987	P. S. Chow	*Diantong banyue huabao*, no. 6 (August 1, 1935), CMM, 91
Zhou Diao	周凋	1908–1956		

(continued)

Pinyin	Chinese	Years	English	Source*
Zhou Feng	周峰			
Zhou Hongquan	周鴻泉			
Zhou Lili	周麗麗		Lily Chow	*Yihjanmae,* *Love and Duty*
Zhou Manhua	周曼華	1922–2013		
Zhou Wenzhu	周文珠	?–1940		
Zhou Xingchi	周星馳	1962–	Stephen Chow	
Zhou Xuan	周璇	1918? 1920?–1957[3]	Chow Hsuan	
Zhu Shaoquan	朱少泉	1902–1969	Chu Sao Chuan	*Red Heroine*
Zhu Shilin	朱石麟	1899–1967	Chu Shih Ling, Chu Shek Lin	*Two Stars,* *Love and Duty*
Zhu Wenshun	朱文順	1920–1995		
Ziluolan	紫羅蘭	1915–?	Violet Wong	*Two Stars, CMM,* 56
Zong Weigeng	宗惟賡		V. K. Chung	*Two Stars*
Zuolin	佐臨	See Huang Zuolin		

*CMM: Paul Fonoroff, *Chinese Movie Magazines: From Charlie Chaplin to Chairman Mao, 1921–1951.* Oakland: University of California Press, 2018.

[1]CMM, 82 gives birth date as 1904. The Taiwan Film and Audiovisual Institute gives birth date as 1905. http://www.ctfa.org.tw/filmmaker/content.php?id=568.

[2]CMM, 63; Baidu and Wikipedia give birth date as 1914.

[3]CMM, 63 gives birth date as ca. 1920. Other sources, such as Andrew D. Field (1999), give birth year as 1918. Baidu and Wikipedia give birth date as August 1, 1920.

Filmography

An asterisk (*) indicates that the film contains original English and Chinese interti-
tles. Year is of completion, not necessarily release. (*Two Stage Sisters*, for example,
was released decades after completion.) Characters for names of Chinese directors
appear in appendix 2. Names of studios, including some not mentioned elsewhere
in this book, are given in short form. Duration not given if unknown. Running times
are approximate. Films from recent decades, especially, often have different lengths
for domestic, international, festival release, DVD, director's cut, and so on, not all
of which are listed here.

1895
The Sprinkler Sprinkled. (*L'Arroseur arrosé*). Lumière. 1 min. One of several versions.
1905
Dingjun Mountain (*Dingjun shan* 定軍山). Ren Qingtai, director. Fengtai Photo Studio.
1912
A Trip Through China. Benjamin Brodsky, director. Multipart film; latest part pro-
 duced in 1916.
1913
The Ideal Wife (*Die ideale Gattin*). Hanns Heinz Ewers, director. Deutsche Bioscop
 GmbH. 24 min.
New Camellia (*Xin chahua* 新茶花). Zhang Shichuan, director. Asiatic.
1915
The Birth of a Nation. D. W. Griffith, director. David W. Griffith Corp. 133–193 min.
 Multiple cuts.

1919

Damaged Goods. Alexander Butler, director. G. B. Samuelson Productions.

Don't Change Your Husband. Cecil B. DeMille, director. Paramount. 86 min.

1920

Way Down East. D. W. Griffith, director. David W. Griffith Corp. 145 min.

Why Change Your Wife? Cecil B. DeMille, director. Paramount. 90 min.

1921

The Four Horsemen of the Apocalypse. Rex Ingram, director. Rex Ingram Productions. 134 min. (edited), 156 min. (complete)

The Haunted House. Edward F. Cline and Buster Keaton, directors. Metro Pictures. 21 min.

Never Weaken. Fred C. Newmeyer and Sam Taylor, directors. Rolin. 19 min.

Orphans of the Storm. D. W. Griffith, director. D. W. Griffith, Inc. 150 min.

The Sheik. George Melford, director. Famous Players-Lasky. 80 min.

1922

The Electric House. Buster Keaton and Edward F. Cline, directors. First National. 22 min.

Laborer's Love (*Laogong zhi aiqing* 勞工之愛情), aka *A Fruit-Flinging Romance* (*Zhiguo yuan* 擲菓緣). Zhang Shichuan, director. Mingxing. 22 min.

Nosferatu: A Symphony of Horror (*Nosferatu, eine Symphonie des Grauens*). F. W. Murnau, director. Prana Film. 94 min.

1923

The Hunchback of Notre Dame. Wallace Worsley, director. Universal. 102 min.

1924

The Marriage Circle. Ernst Lubitsch, director. Warner Bros. 85 min.

1925

Cyrano de Bergerac. Augusto Genina, director. Unione Cinematographia Italiana. 104 min.

A Lady of Shanghai (*Shanghai yi furen* 上海一婦人). Zhang Shichuan, director. Mingxing. 90 min.

Lady Windermere's Fan. Ernst Lubitsch, director. Warner Bros. 120 min. (Denmark), 89 min. (United States).

The Phantom of the Opera. Rupert Julian, director; Lon Chaney, Edward Sedgwick, and Ernst Laemmle, uncredited codirectors. Universal. 107 min.

Stella Dallas. Henry King, director. Samuel Goldwyn Productions. 110 min.

1926

The Pearl Necklace (*Yi chuan zhenzhu* 一串珍珠). C. Y. Lee (Li Zeyuan), director. Changcheng. 100 min.

The Strange Lover (*Qingchang guairen* 情場怪人). Ma-Xu Weibang, director. Langhua.

1927

The Cave of the Silken Web (*Pan si dong* 盤絲洞). Dan Duyu, director. Yihua. Over 60 min.

**A Flapper's Downfall* (*Langnü qiongtu* 浪女窮途). Mei Xuechou and Liu Zhaoming, directors. Changcheng.

Hua Mulan Joins the Army (*Hua Mulan congjun* 花木蘭從軍). Li Pingqian, director. Tianyi. 100 min.

The Jazz Singer. Alan Crosland, director. Warner Bros. 89 min.

Man in the Moon Gets a Divorce (*Yuelao lihun* 月老離婚). Hou Yao, director. Minxin. 100 min.

New Camellia (*Xin chahua* 新茶花). Li Pingqian, director. Tianyi. 105 min.

Sunrise: A Song of Two Humans. F. W. Murnau, director. Fox. 95 min.

**Way Down West* [Romance of the Western Chamber] (*Xixiang ji* 西廂記). Hou Yao, director. Minxin. 56 min. (incomplete)

1928

The Burning of Red Lotus Temple (*Huoshao hongliansi* 火燒紅蓮寺). Zhang Shichuan, director. Mingxing. Film serial in 18 parts, released 1928–1931.

**Don't Change Your Husband* (*Qinghai chongwen* 情海重吻). Xie Yunqing, director. Lilium. 60 min.

Mulan Joins the Army (*Mulan congjun* 木蘭從軍). Hou Yao, director. Minxin.

The Road to Ruin. Norton S. Parker, director. Cliff Broughton Productions. 60 min.

Storm Over Asia. Vsevolod Pudovkin, director. Mezhrabpomfilm. 125 min.

The Stranger of Dark Night (*Heiye guairen* 黑夜怪人). Ma-Xu Weibang and Hong Ji, directors. Langhua.

Street Angel. Frank Borzage, director. Fox. 102 min.

1929

**The Orphan of the Storm* (*Xue zhong guchu* 雪中孤雛). Zhang Huimin, director. Huaju. 75 min.

**Poor Daddy* (*Pa laopo* 怕老婆), aka *The Heroic Son* (*Erzi yingxiong* 兒子英雄). Dumas Young (Yang Xiaozhong), director. Changcheng. 72 min.

**The Red Heroine* (*Hong xia* 紅俠). Weng Yih Ming (Wen Yimin), director. Youlian. 95 min.

**Woman Warrior White Rose* (*Xianü bai meigui* 俠女白玫瑰). Whitman Chant (Zhang Huimin), director. Huaju. 27 min. (incomplete)

1930

The Primrose Path. William O'Connor, director. Willis Kent. 71 min.

1931

The Cheat. George Abbott, director. Paramount. 74 min.

City Lights. Charles Chaplin, director. United Artists. 87 min.

Love and Duty (*Lian'ai yu yiwu* 戀愛與義務). Richard Poh (Bu Wancang), director. Lianhua. 152 min.

Marius. Alexander Korda, director. Paramount. 127 min.

The Peach Girl [Peach Blossoms Weep Tears of Blood] (*Taohua qixue ji* 桃花泣血記). Richard Poh (Bu Wancang), director. Lianhua. 100 min.

The Singing Beauty (*Yu meiren* 虞美人). Chen Kengran, director. Youlian.

Songstress Red Peony (*Genü Hong Mudan* 歌女紅牡丹). Zhang Shichuan, director. Mingxing. 180 min.

Two Stars (*Yinhan shuangxing* 銀漢雙星). Tomsie Sze (Shi Dongshan), director. Lianhua. 86 min.

Yihjanmae [A Spray of Plum Blossoms] (*Yi jian mei* 一剪梅). Richard Poh (Bu Wancang), director. Lianhua. 105 min.

1932

Blonde Venus. Joseph von Sternberg, director. Paramount. 93 min.

Fate in Tears and Laughter (*Tixiao yinyuan* 啼笑因緣). Zhang Shichuan, director. Mingxing. Part 1: 69 min. Series of six films.

If I Had a Million. Ernst Lubitsch, Norman Taurog, Stephen Roberts, Norman Z. McLeod, James Cruze, William A. Seiter, H. Bruce Humberstone, Lothan Mendes (uncredited), directors. Paramount. 88 min.

The Kid From Spain. Leo McCarey, director. Samuel Goldwyn Productions. 118 min.

Shanghai Express. Joseph von Sternberg, director. Paramount. 80 min.

Tarzan the Ape Man. W. S. Van Dyke, director. MGM. 99 min.

Trouble in Paradise. Ernst Lubitsch, director. Paramount. 83 min.

Wild Rose (*Ye meigui* 野玫瑰). Sun Yu, director. Lianhua. 70 min.

1933

Angry Tide of the China Sea (*Zhongguo hai de nuchao* 中國海的怒潮). Yue Feng, director. Yihua.

City Nights (*Chengshi zhi ye* 城市之夜). Fei Mu, director. Lianhua. 100 min.

Daybreak (*Tianming* 天明). Sun Yu, director. Lianhua. 96 min.

Dinner at Eight. George Cukor, director. MGM. 113 min.

Footlight Parade. Lloyd Bacon, director. Warner Bros. 102 min.

Maternal Radiance (*Muxing zhi guang* 母性之光). Richard Poh (Bu Wancang), director. Lianhua. 92 min.

A Modern Woman (*Xiandai yi nüxing* 現代一女性). Li Pingqian, director. Mingxing. 100 min.

Playthings (*Xiao wanyi* 小玩意). Sun Yu, director. Lianhua. 103 min.

Spring in the South (*Nanguo zhi chun* 南國之春). Cai Chusheng, director. Lianhua. 80 min.

Spring Silkworms (*Chun can* 春蠶). Cheng Bugao, director. Mingxing. 94 min.

Three Modern Women (*Sange modeng nüxing* 三個摩登女性). Richard Poh (Bu Wancang), director. Lianhua.

Torrent (*Kuangliu* 狂流). Cheng Bugao, director. Mingxing. 80 min.

1934

Bright Eyes. David Butler, director. Fox. 83 min.

Goddess (*Shennü* 神女). Wu Yonggang, director. Lianhua. 85 min.

The Great Road (*Da lu* 大路). Sun Yu, director. Lianhua. 103 min.

Living Immortal (*Renjian xianzi* 人間仙子). Dan Duyu, director. Yihua. 90 min.

The Merry Widow. Ernst Lubitsch, director. MGM. 99 min.

Orchid of the Empty Valley (*Konggu lan* 空谷蘭). Zhang Shichuan, director. Mingxing. 120 min.

Plunder of Peach and Plum (*Taoli jie* 桃李劫). Ying Yunwei, director. Diantong. 102 min.

The Road to Ruin. Dorothy Davenport (credited as Mrs. Wallace Reid) and Melville Shyer, directors. True-Life Photoplays and First Division Pictures. 62 min.

Song of the Fishermen (*Yuguang qu* 漁光曲). Cai Chusheng, director. Lianhua. 57 min.

Sports Queen (*Tiyu huanghou* 體育皇后). Sun Yu, director. Lianhua. 85 min.

1935

Children of the Storm (*Fengyun ernü* 風雲兒女). Xu Xingzhi, director. Diantong. 89 min.

City Scenes (*Dushi fengguang* 都市風光). Yuan Muzhi, director. Diantong. 92 min.

The Little Angel (*Xiao tianshi* 小天使). Wu Yonggang, director. Lianhua. 100 min.

National Customs (*Guo feng* 國風). Luo Mingyou and Zhu Shilin, directors. Lianhua. 94 min.

New Women (*Xin nüxing* 新女性). Cai Chusheng, director. Lianhua. 106 min.

Song of China (*Tianlun* 天倫). Fei Mu, director. Lianhua. 65 min.

1936

Back to Nature (*Dao ziran qu* 到自然去). Sun Yu, director. Lianhua.

Bloodshed on Wolf Mountain (*Langshan diexue ji* 狼山喋血記). Fei Mu, director. Lianhua. 70 min.

Girl Martyr of an Isolated City (*Gucheng lienü* 孤城烈女). Wang Cilong, director. Lianhua. 88 min.

Hearts United in Life and Death (*Shengsi tongxin* 生死同心). Ying Yunwei, director. Mingxing. 83 min.

Lambs Astray (*Mitu de gaoyang* 迷途的羔羊). Cai Chusheng, director. Lianhua. 90 min.

Modern Times. Charles Chaplin, director. United Artists. 87 min.

Waves Wash Over the Sand (*Lang tao sha* 浪淘沙). Wu Yonggang, director. Lianhua. 68 min.

1937

The Awful Truth. Leo McCarey, director. Columbia. 90 min.

Crossroads (*Shizi jietou* 十字街頭). Shen Xiling, director. Mingxing. 103 min.

Lianhua Symphony (*Lianhua jiaoxiangqu* 聯華交響曲). Situ Huimin, Fei Mu, Tan Youliu, Shen Fu, and He Mengfu, directors. Lianhua. 102 min.

March of Youth (*Qingnian jinxingqu* 青年進行曲). Tomsie Sze (Shi Dongshan), director. Xinhua. 105 min.

The New Year's Gift (*Yasui qian* 壓歲錢). Zhang Shichuan, director. Mingxing. 90 min.

Song at Midnight (*Yeban gesheng* 夜半歌聲). Ma-Xu Weibang, director. Xinhua. 120 min.

Street Angels (*Malu tianshi* 馬路天使). Yuan Muzhi, director. Mingxing. 90 min.

1938

Bluebeard's Eighth Wife. Ernst Lubitsch, director. Paramount. 80 min.

Olympia. Leni Riefenstahl, director. Olympia-Film. Part 1: 126 min.; part 2: 100 min.

Sable Cicada (*Diaochan* 貂蟬). Richard Poh (Bu Wancang), director. Xinhua. 87 min.

1939

The Autocrat of Chou (*Chu bawang* 楚霸王). Wang Cilong, director. Yihua. 90 min.

Disputed Passage. Frank Borzage, director. Paramount. 87 min.

Gone with the Wind. Victor Fleming, director. MGM. 221 min. (238 min. with additional music)

Hua Mu Lan (*Mulan congjun* 木蘭從軍). Richard Poh (Bu Wancang), director. Huacheng. 89 min.

Lady Mengjiang (*Mengjiang nü* 孟姜女). Wu Cun, director. Guohua. 92 min.

Orphan Island Paradise (*Gudao tiantang* 孤島天堂). Cai Chusheng, director. Dadi. 93 min.

The Young Heroine (*Xiao xianü* 小俠女). Zhang Shichuan and Zheng Zhengqiu, directors. Guohua. 73 min.

The Young Mistress's Fan (*Shao nainai de shanzi* 少奶奶的扇子). Li Pingqian, director. Huaxin. 92 min.

1940

The Burning of Red Lotus Temple (*Huoshao hongliansi* 火燒紅蓮寺). Zhang Shichuan, director. Yihua.

Confucius (*Kong fuzi* 孔夫子). Fei Mu, director. Minhua. 97 min.

The Invisible Woman Warrior (*Yinshen nüxia* 隱身女俠). Wu Wenchao, director. Yihua.

The Philadelphia Story. George Cukor, director. MGM. 112 min.

Pinocchio. Ben Sharpstein and Hamilton Luske, directors. Disney. 88 min.

Romance of the Western Chamber (*Xixiang ji* 西廂記). Zhang Shichuan, director. Guohua / Mingxing. 110 min.

1941

Hellzapoppin'. H.C. Potter, director. Universal. 84 min.

Princess Iron Fan (*Tieshan gongzhu* 鐵扇公主). Wan Laiming and Wan Guchan, directors. Zhonglian. 73 min.

Red Butterfly (*Hong hudie* 紅蝴蝶). Wu Wenchao, director. Yihua.

1942

Secret Agent of Japan. Irving Pichel, director. 20th Century Fox. 72 min.

1943

Begonia (*Quhaitang* 秋海棠). Ma-Xu Weibang, director. Zhonghua. 202 min.

Eternity (*Wanshi liufang* 萬世流芳). Richard Poh (Bu Wancang), Ma-Xu Weibang, Zhang Shankun, Dumas Young (Yang Xiaozhong), directors. Zhonglian. 143 (?) min.

Heaven Can Wait. Ernst Lubitsch, director. 20th Century Fox. 112 min.

Secret Agent of Japan (*Riben jiandie* 日本間諜). Yuan Congmei, director. Zhongying. 90 min.

1944

Long Live the Teacher! (*Jiaoshi wansui* 教師萬歲). Sang Hu, director. Huaying.

1945

A Modern Woman (*Modeng nüxing* 摩登女性). Tu Guangqi, director. Yuandong. 68 min.

1947

Along the Sungari River (*Songhua jiang shang* 松花江上). Jin Shan, director. Changchun. 102 min.

Diary of a Homecoming (*Huanxiang riji* 還鄉日記). Zhang Junxiang, director. Zhongdian. 112 min.

Distant Love (*Yaoyuan de ai* 遙遠的愛). Chen Liting, director. Zhongdian. 125 min.

Eight Thousand Li of Clouds and Moon (*Baqian li yun he yue* 八千里雲和月). Tomsie Sze (Shi Dongshan), director. Lianhua/Kunlun. 124 min.

An Ideal Son-in-Law (*Chenglong kuaixu* 乘龍快婿). Yuan Jun, director. Zhongdian. 81 min.

Long Live the Missus! (*Taitai wansui* 太太萬歲). Sang Hu, director. Wenhua. 112 min.

Love Everlasting (*Buliao qing* 不了情). Sang Hu, director. Wenhua. 93 min.

Phony Phoenixes (*Jiafeng xuhuang* 假鳳虛凰). Huang Zuolin, director. Wenhua. 91 min.

Spring River Flows East (*Yi jiang chunshui xiang dong liu* 一江春水向東流). Cai Chusheng and Zheng Junli, directors. Kunlun.

Part 1: *Eight Years of Separation and Chaos* (*Banian liluan* 八年離亂). 96 min.

Part 2: *Before and After the Dawn* (*Tianming qianhou* 天亮前後). 91 min.

1948

Lights of Myriad Homes (*Wanjia denghuo* 萬家燈火). Shen Fu, director. Kunlun. 115 min.

Sorrows of the Forbidden City (*Qinggong mishi* 清宮秘史). Zhu Shilin, director. Yonghua. 90 min.

The Soul of China (*Guohun* 國魂). Richard Poh (Bu Wancang), director. Yonghua. 141 min.

Spring in a Small Town (*Xiaocheng zhi chun* 小城之春). Fei Mu, director. Wenhua. 99 min.

A Wedding in the Dream (*Shengsi hen* 生死恨). Fei Mu, director. Huayi. 60 min.

Wildfire in the Spring Wind (*Yehuo chunfeng* 野火春風). Ouyang Yuqian, director. Da guangming. 105 min.

1949

Bittersweet Middle Age (*Ai le zhongnian* 哀樂中年). Sang Hu, director. Wenhua. 105 min.

Crows and Sparrows (*Wuya yu maque* 烏鴉與麻雀). Zheng Junli, director. Kunlun. 106 min.

Hope in the Human Realm (*Xiwang zai renjian* 希望在人間). Shen Fu, director. Kunlun. 110 min.

Wanderings of Three-Hairs the Orphan (*Sanmao liulang ji* 三毛流浪記). Zhao Ming and Yan Gong, directors. Kunlun. 70 min.

The Watch (*Biao* 錶). [Huang] Zuolin, director. Wenhua. 105 min.

1950

Decay (*Fushi* 腐蝕). [Huang] Zuolin, director. Wenhua. 146 min.

The White-Haired Girl (*Baimao nü* 白毛女). Wang Bin and Shui Hua, directors. Changchun. 116 min.

Wife Problems (*Taitai wenti* 太太問題). Xu Changlin, director. Guotai.

1951

Between Husband and Wife (*Women fufu zhijian* 我們夫婦之間). Zheng Junli, director. Kunlun. 93 min.

Husband and Wife on the March (*Fufu jinxingqu* 夫婦進行曲). Hong Mo, director. Changjiang. 99 min.

The Life of Wu Xun (*Wu Xun zhuan* 武訓傳). Sun Yu, director. Kunlun. 208 min.

Modern Wives (*Modeng taitai* 摩登太太). Tu Guangqi, director. Yuandong.

1952

Celebrate Children (*Wei haizimen zhufu* 為孩子們祝福). Zhao Dan, director. Changjiang and Kunlun.

1957

Woman Basketball Player No. 5 (*Nülan wuhao* 女籃五號). Xie Jin, director. Shanghai Film Studio. 84 min.

1958

Sable Cicada [*Diau Charn*] (*Diaochan* 貂蟬). Li Han Hsiang (Li Hanxiang), director. Shaw Bros. 87 min.

Three-Hairs Learns Business (*Sanmao xue shengyi* 三毛學生意). Huang Zuolin, director. Tianma. 75 min.

Wanderings of Three-Hairs the Orphan (*Sanmao liulang ji* 三毛流浪記) (puppet animation). Zhang Chaoqun, director. Shanghai meishu. 47 (?) min.

1959

The Lin Family Shop (*Lin jia puzi* 林家鋪子). Shui Hua, director. Beijing Film Studio. 82 min.

Lin Zexu 林則徐 (aka *The Opium Wars*). Zheng Junli and Cen Fan, directors. Shanghai Film Studio. 103 min.

1960

June Bride (*Liuyue xinniang* 六月新娘). Tang Huang, director. MP&GI. 102 min.

The Red Detachment of Women (*Hongse niangzi jun* 紅色娘子軍). Xie Jin, director. Shanghai Film Studio. 110 min.

Third Sister Liu (*Liu Sanjie* 劉三姐). Su Li, director. Changchun. 117 min.

1961

Beauty Parade (*Tiyu huanghou* 體育皇后). Tang Huang, director. MP&GI. 104 min.

1962

The Greatest Wedding on Earth (*Nanbei yijia qin* 南北一家親). Wong Tin-Lam (Wang Tianlin), director. MP&GI. 107 min.

Li Shuangshuang 李雙雙. Lu Ren, director. Shanghai Film Studio. 98 min.

Mid-Nightmare (*Yeban gesheng* 夜半歌聲). Chau Feng Yuen (Yuan Qiufeng), director. Shaw Bros. 96 min.

1963

The House of 72 Tenants (*Qishi'er jia fangke* 七十二家房客). Wang Weiyi, director. Pearl River. 80 min.

The Love Eterne (*Liang Shanbo yu Zhu Yingtai* 梁山伯與祝英台). Li Han Hsiang (Li Hanxiang), director. Shaw Bros. 122 min.

1964

The Greatest Love Affair on Earth (*Nanbei xi xiangfeng* 南北喜相逢). Wong Tin-Lam (Wang Tianlin), director. MP&GI. 111 min.

Lady General Hua Mu-lan (*Hua Mulan* 花木蘭). Yueh Feng (Yue Feng), director. Shaw Bros. 106 min.

Sentinels Under the Neon Lights (*Nihongdeng xia de shaobing* 霓虹燈下的哨兵). Ge Xin and Wang Ping, directors. Tianma. 115 min.

Two Stage Sisters (*Wutai jiemei* 舞台姊妹). Xie Jin, director. Tianma. 114 min.

1965

Tunnel Warfare (*Didao zhan* 地道戰). Ren Xudong, director. Bayi. 96 min.

1968

Darling, Stay at Home (*Taitai wansui* 太太萬歲). Wong Tin-Lam (Wang Tianlin), director. MP&GI. 94 min.

1973

The House of 72 Tenants (*Qishi'er jia fangke* 七十二家房客). Chor Yuen (Chu Yuan), director. Shaw Bros. and TVB. 98 min.

1991

Center Stage (*Ruan Lingyu* 阮玲玉). Stanley Kwan (Guan Jinpeng), director. Golden Way Films Ltd. 146 min. Multiple cuts.

1992

San Mao Joins the Army (*Sanmao congjun ji* 三毛從軍記). Zhang Jianya, director. Shanghai Film Studio. 90 min.

1993

The Blue Kite (*Lan fengzheng* 藍風箏). Tian Zhuangzhuang, director. Beijing Film Studio. 140 min.

Farewell, My Concubine (*Bawang bieji* 霸王別姬). Chen Kaige, director. Beijing Film Studio. 171 min.

1995

The Phantom Lover (*Xin Yeban gesheng* 新夜半歌聲). Ronny Yu Yan-tai (Yu Rentai), director. Mandarin Films Ltd. 100 min.

1998

Mulan. Tony Bancroft and Barry Cook, directors. Walt Disney Pictures. 87 min.

2002

Springtime in a Small Town (*Xiaocheng zhi chun* 小城之春). Tian Zhuangzhuang, director. Beijing Film Studio, Orly Films, and Fortissimo Films. 116 min.

2004

Kung Fu Hustle (*Gongfu* 功夫). Stephen Chow (Zhou Xingchi), director. Beijing Film Studio and Hong Kong Star Overseas. 98 min.

Mulan II. Darrell Rooney and Lynn Sutherland, directors. Walt Disney Pictures. 79 min.

2006

Still Life (*Sanxia haoren* 三峽好人). Jia Zhangke, director. Shanghai Film Group and Xstream Pictures. 108 min.

2007

Lust, Caution (*Se jie* 色戒). Ang Lee, director. River Road, Haishang, and Sil-Metropole. 158 min. Multiple cuts.

2008

24 City (*Ershisi cheng ji* 二十四城記). Jia Zhangke, director. Shanghai Film Group, Xstream Pictures, and China Resources. 107 min.

2010

72 Tenants of Prosperity (*72 jia zuke* 72家租客). Eric Tsang (Zeng Zhiwei), director. Shaw Bros., TVB, Sil-Metropole, and Sun Wah. 99 min.

I Wish I Knew (*Haishang chuanqi* 海上傳奇). Jia Zhangke, director. Bojie Media, NCU Group, Shanghai Film Group, Xstream. 116 min. and 125 min. (China), 138 min. (France)

2020

Mulan. Niki Caro, director. Disney. 115 min.

Bibliography

Web links are current as of date of publication.

PERIODICALS

Published in Shanghai, unless indicated otherwise. Asterisks indicate original English titles.

*China Critic, The (*Zhongguo pinglun zhoubao* 中國評論週報, 1928–1940, 1945)

*China Mail, The (*Dechen xibao* 德臣西報, also *Zhongguo youbao* 中國郵報, 1845–1974). Hong Kong

China Press, The 大陸報 (**Ta-lu pao*, 1911–1949)

Dagongbao 大公報 (**L'Impartial*; aka **Ta Kung Pao*, 1902–1949). Tianjin

Diantong banyue huabao 電通半月畫報 (**Denton Gazette Semi-monthly Pictorial*, 1935)

Dianying feng 電影風 (*Movie Trends*, 1948–1949)

Dianying huabao 電影畫報 (*Film Pictorial*, 1946–1949)

Furen huabao 婦人畫報 (*The Women's Pictorial*, 1933–1937)

Guancha 觀察 (**The Observer*, 1946–1948, 1949–1950) (formerly *Keguan* 客觀)

Jian li mei 健力美 (*Health, Power, Beauty*, 1941–1944, 1946–1949)

Jianmei yuekan 健美月刊 (*Healthy Beauty Monthly*, 1934–1935)

Juying chunqiu 劇影春秋 (*Theater and Film Chronicle*, 1948)

Keguan 客觀 (*Objective Views*, November 1945–April 1946) (later *Guancha* 觀察)

Lianhua huabao 聯華畫報 (*UPS Pictorial*, 1933–1937)

Liangyou huabao 良友畫報 (**The Young Companion*, 1926–1945)

Libailiu 禮拜六 (**The Saturday*, 1914–1916, 1921–1923)

Linglong funü tuhua zazhi 玲瓏婦女圖畫雜誌 (**Lin Loon Ladies' Magazine*, 1931–1937)

Manhua yuekan 漫畫月刊 (*Cartoon Monthly*, 1950–1960)

Manzhou yinghua 滿洲映畫 (*Manchurian Film*, 1937–1941). Hsinking (Changchun)

Mingxing banyuekan 明星半月刊 (*Star Fortnightly*, 1935–1937)

**North-China Daily News* (*Zilin xibao* 字林西報, 1864–1941, 1945–1950)

Qingqing dianying 青青電影 (**The Chin-Chin Screen*, 1934–1935, 1937–1938, 1939–ca. 1941, 1944–1945, 1947–1951)

Shenbao 申報 (**The Shun Pao*, 1872–1949)

Shibao 時報 (**The Eastern Times*, 1904–1939)

**Singapore Free Press, The* (1835–1869, 1884–1962). Singapore

**Straits Times, The* (1845–). Singapore

Xiandai dianying 現代電影 (**Modern Screen*, 1933–1934)

Xiandai xuesheng 現代學生 (*Modern Student*, 1930–1933)

Xin yingxin yu tiyu 新影星與體育 (**Silverland Sports World*, 1930–1931)

Xing Hua 星華 (*Star China*, 1936–1937)

Xingqi wenzhai 星期文摘 (*Readers' Weekly Digest*, 1940–?). Chungking

Xinwen bao 新聞報 (**Sin Wan Pao*, 1893–1949)

Yingju congkan 影劇叢刊 (*Film and Theater Digest*, 1948–1949)

Ying yin 影音 (**Film & Radio*, 1942–1948) (*Dianying yu boyin yuekan* 電影與播音月刊 [*Film and Radio Monthly*]). Chengdu (1942–1945), Nanking (1946–1948)

Yisheng dianying yu yinyue 藝聲電影與音樂 (**Nee Sung Movie and Music Monthly*, 1935–1936)

Yuanfeng banyuekan 遠風半月刊 (*Distant Winds Semi-Monthly*, 1947–1948)

Zhenxiang huabao 真相畫報 (**The True Record*, 1912–1913)

BOOKS AND ARTICLES

Allan, Joseph R. "Dressing and Undressing the Chinese Woman Warrior." *positions* 4, no. 2 (1996): 343–350.

Altman, Rick. *Silent Film Sound*. New York: Columbia University Press, 2004.

Anderson, Edward, and Robin Baker. "Boxers and Barbers: Filming in the Late Qing Dynasty." In *Electric Shadows: A Century of Chinese Cinema*, ed. James Bell, 14–15. London: British Film Institute, 2014.

Bao, Weihong. "Diary of a Homecoming: (Dis-)Inhabiting the Theatrical in Postwar Shanghai Cinema." In *A Companion to Chinese Cinema*, ed. Yingjin Zhang, 376–399. Hoboken, N.J.: Wiley-Blackwell, 2012.

——. *Fiery Cinema: The Emergence of an Affective Medium in China, 1915–1945*. Minneapolis: University of Minnesota Press, 2015.

——. "From Pearl White to White Rose Woo: Tracing the Vernacular Body of *Nüxia* in Chinese Silent Cinema, 1927–1931." *Camera Obscura*, 20, no. 3 (60) (2005): 193–231.

Barmé, Geremie R. *An Artistic Exile: A Life of Feng Zikai (1898–1975)*. Berkeley: University of California Press, 2002.

Berry, Chris, ed. *Chinese Films in Focus II*. London: British Film Institute/Palgrave Macmillan, 2008.

——. "The Sublimative Text: Sex and Revolution in *Big Road* [The highway]." *East-West Film Journal* 2, no. 2 (1988): 66–86.

Bi Keguan 畢克官, and Huang Yuanlin 黃遠林. *Zhongguo manhua shi* 中國漫畫史 [History of Chinese cartoons]. Beijing: Wenhua yishu chubanshe, 2006.

Braester, Yomi. *Painting the City Red: Chinese Cinema and the Urban Contract*. Durham, N.C.: Duke University Press, 2010.

——. *Witness Against History: Literature, Film, and Public Discourse in Twentieth-Century China*. Stanford, Calif.: Stanford University Press, 2003.

Cai Chusheng 蔡楚生. *Yijiang chunshui xiang dong liu* 一江春水向東流 [Spring river flows east]. Shanghai: Zuojia shuwu, April 1949.

Cai Chusheng 蔡楚生, and Zheng Junli 鄭君里. *Yijiang chunshui xiang dong liu* 一江春水向東流 [Spring river flows east]. Hong Kong: Xianggang yingye chubanshe, 1963.

Campbell, Russell. " 'Fallen Woman' Prostitute Narratives in the Cinema." *Screening the Past*, uploaded November 12, 1999. https://web.archive.org/web/20110308080040/http://www.latrobe.edu.au/screeningthepast/firstrelease/fr1199/rcfr8b.htm.

——. *Marked Women: Prostitutes and Prostitution in the Cinema*. Madison: University of Wisconsin Press, 2006.

Cavell, Stanley. *Contesting Tears: The Hollywood Melodrama of the Unknown Woman*. Chicago: University of Chicago Press, 1997.

——. *Pursuits of Happiness: The Hollywood Comedy of Remarriage*. Rev. ed. Cambridge, Mass.: Harvard University Press, 1984.

Chang, Eileen. *Little Reunions*. Trans. Jane Weizhen Pan and Martin Merz. New York: NYRB Classics, 2018.

——. *Love in a Fallen City*. Trans. Karen S. Kingsbury. New York: NYRB Classics, 2006.

——. *Lust, Caution*. Trans. Julia Lovell. Afterword by Ang Lee. New York: Anchor, 2007.

——. *The Rice-Sprout Song*. Berkeley: University of California Press, 1998 [1955].

Chang, Michael G. "The Good, the Bad, and the Beautiful: Movie Actresses and Public Discourse, 1920s–1930s." In *Cinema and Urban Culture in Shanghai, 1922–1943*, ed. Yingjin Zhang, 129–159. Stanford, Calif.: Stanford University Press, 1999.

Chen Baichen 陳白塵. *Shengguan tu* 陞官圖 [Promotion scheme]. Shanghai: Qunyi chubanshe, 1948 [1945].

Chen, Janet Y. *Guilty of Indigence: The Urban Poor in China, 1900–1953*. Princeton, N.J.: Princeton University Press, 2012.

Chen Zishan 陳子善. *Shuobujin de Zhang Ailing* 說不盡的張愛玲 [Endless talks on Eileen Chang]. Taipei: Yuanjing, 2001.

Cheng Jihua 程季華. *Zhongguo dianying fazhan shi* 中國電影發展史 [A history of the development of Chinese cinema]. 2 vols. Beijing: Zhongguo dianying chubanshe, 1963.

Chion, Michel. *Film, A Sound Art*. Trans. Claudia Gorbman. New York: Columbia University Press, 2009.

Cho, Pock-rey. "The Emperor of Shanghai Movies of the 1930s: Jin Yan (1910–1983)." *Asian Cinema* 14, no. 2 (Fall/Winter 2003): 206–214.

Chow, Eileen, trans. Film script of *New Woman*. MCLC Resource Center Publication, 2004. http://u.osu.edu/mclc/online-series/new-woman.

Chua, John. "Something Borrowed, Something New: *Ye Ban Ge Sheng* (Song at Midnight) and the Cross-Cultural Reinterpretation of Horror in Twentieth Century China." *Asian Cinema* 16, no. 2 (Fall/Winter 2005): 122–146.

Clark, Paul. *Chinese Cinema: Culture and Politics Since 1949*. Cambridge: Cambridge University Press, 1987.

Collins, Ross F. *Children, War and Propaganda*. New York: Peter Lang, 2011.

Conner, Alison W. "Don't Change Your Husband: Divorce in Early Chinese Movies." *Connecticut Law Review* 40, no. 5 (July 2008): 1245–1260.

Cui Shuqin. *Women Through the Lens: Gender and Nation in a Century of Chinese Cinema*. Honolulu: University of Hawai'i Press, 2008.

Cunningham, Maura Elizabeth. "Shanghai's Wandering Ones: Child Welfare in a Global City, 1900–1953." PhD diss., University of California, Irvine, 2014.

Daruvala, Susan. "The Aesthetics and Moral Politics of Fei Mu's *Spring in a Small Town*." *Journal of Chinese Cinemas* 1, no. 3 (September 2007): 171–188.

Denton, Kirk A. *The Problematic of the Self in Modern Chinese Literature: Hu Feng and Lu Ling*. Stanford, Calif.: Stanford University Press, 1998.

Des Forges, Alexander. *Mediasphere Shanghai: The Aesthetics of Cultural Production*. Honolulu: University of Hawaii Press, 2007.

Ding Ling. "When I Was in Xia Village" [1940]. Trans. Gary J. Bjorge. In *The Columbia Anthology of Modern Chinese Literature*, 2nd ed., eds. Joseph S. M. Lau and Howard Goldblatt, 132–146. New York: Columbia University Press, 2007.

Dong, Xinyu. "China at Play: Republican Film Comedies and Chinese Cinematic Modernity." PhD diss., Harvard University, 2009.

——. "The Laborer at Play: *Laborer's Love*, the Operational Aesthetic, and the Comedy of Inventions." *Modern Chinese Literature and Culture* 20, no. 2 (Fall 2008): 1–39.

Dou Xingbin 竇興斌. *Lianhua yingye gongsi yu Zhongguo 30 niandai dianying yan-jiu* 聯華影業公司與中國30年代電影研究 [Research on United Photoplay Service and cinema in 1930s China]. Beijing: Zhongguo shehui kexue chubanshe, 2018.

Edwards, Louise. "Localizing the Hollywood Star System in 1930s China: *Linglong* Magazine and New Moral Spaces." *Asian Studies* 1, no. 1 (September 2015): 13–37.

——. *Woman Warriors and Wartime Spies of China*. Cambridge, UK: Cambridge University Press, 2016.

Fan, Victor. "Fey Mou: The Presence of an Absence." In *Cinema Approaching Reality: Locating Chinese Film Theory*, ed. Victor Fan, 109–152. Minneapolis: University of Minnesota Press, 2015.

——. "From the Shadow Play to Electric Shadows." In *Electric Shadows: A Century of Chinese Cinema*, ed. James Bell, 8–13. London: British Film Institute, 2014.

——. "The Cinema of Sun Yu: Ice Cream for the Eye . . . but with a Homo Sacer." *Journal of Chinese Cinemas* 5, no. 3 (November 2011): 219–252.

Farquhar, Mary Ann. *Children's Literature in China: From Lu Xun to Mao Zedong*. New York: Sharpe, 1999.

Farquhar, Mary, and Chris Berry. "Shadow Opera: Toward a New Archaeology of the Chinese Cinema." In *Chinese-Language Film: Historiography, Poetics, Politics*, eds. Sheldon H. Lu and Emilie Yueh-yu Yeh, 27–51. Honolulu: University of Hawai'i Press, 2005.

Farquhar, Mary, and Yingjin Zhang, eds. *Chinese Film Stars*. Abington, U.K.: Routledge, 2010.

Fernsebner, Susan R. "A People's Playthings: Toys, Childhood, and Chinese Identity, 1909–1933." *Postcolonial Studies* 6, no. 3 (2003): 269–293.

Field, Andrew D. "Selling Souls in Sin City: Shanghai Singing and Dancing Hostesses in Print, Film, and Politics, 1920–49." In *Cinema and Urban Culture in Shanghai, 1922–1943*, ed. Yingjin Zhang, 99–127. Stanford, Calif.: Stanford University Press, 1999.

FitzGerald, Carolyn. *Fragmenting Modernisms: Chinese Wartime Literature, Art, and Film, 1937–49*. Leiden: Brill, 2013.

——. "*Spring in a Small Town*: Gazing at Ruins." In *Chinese Films in Focus II*, ed. Chris Berry, 205–211. Basingstoke: British Film Institute/Palgrave MacMillan, 2008.

Fonoroff, Paul. *Chinese Movie Magazines: From Charlie Chaplin to Chairman Mao, 1921–1951*. Oakland: University of California Press, 2018.

Fowler, Simon. *101 Essential Chinese Movies*. Hong Kong: Earnshaw Books, 2010.

Fu Hongxing 傅紅星, ed. *Zhongguo zaoqi dianying yanjiu* 中國早期電影研究 [Studies of early Chinese cinema]. 2 vols. Beijing: Zhongguo guangbo dianshi chubanshe, 2013.

Fu, Poshek. "An Ordinary Shanghai Woman in an Extraordinary Time: A View from Post-war Popular Cinema." In *Visualizing China: Moving and Still Images in Historical Narratives*, eds. Christian Henriot and Wen-hsin yeh, 461–480. Leiden: Brill, 2013.

——. *Between Shanghai and Hong Kong: The Politics of Chinese Cinemas*. Stanford, Calif.: Stanford University Press, 2003.

——. "Eileen Chang, Woman's Film, and Domestic Shanghai in the 1940s." *Asian Cinema* 11, no. 1 (Spring/Summer 2000): 97–113.

——. "Projecting Ambivalence: Chinese Cinema in Semi-occupied Shanghai, 1937–1941." In *Wartime Shanghai*, ed. Wen-hsin Yeh, 86–110. London: Routledge, 1998.

——. "Selling Fantasies at War: Production and Promotion Practices of the Shanghai Cinema, 1937–1941." In *Inventing Nanjing Road: Commercial Culture in Shanghai, 1900–1945*, ed. Sherman Cochran, 187–206. Ithaca, N.Y.: East Asia Program, Cornell University, 1999.

Fu Yongchun. "China's Industrial Response to Hollywood: A Transnational History, 1923–1937." PhD diss., University of Auckland, 2014.

——. "From 'Parrot' to 'Butterfly': China's Hybridization of Hollywood in Distribution Systems in the 1920s and 1930s." *Journal of Chinese Cinemas* 8, no. 1 (2014): 1–16.

——. "Movie Matchmakers: The Intermediaries Between Hollywood and China in the Early Twentieth Century." *Journal of Chinese Cinemas* 9, no. 1 (2015): 8–22.

Gao, Yunxiang. "Sex, Sports, and 'National Crisis,' 1931–1945: The 'Athletic Movie Star' Li Lili (1915–2005)." *Modern Chinese Literature and Culture* 22, no. 1 (2010): 96–161.

——. *Sporting Gender: Woman Athletes and Celebrity-Making During China's National Crisis, 1931–45*. Vancouver: UBC Press, 2013.

Ge, Congmin. "Photography, Shadow Play, Beijing Opera, and the First Chinese Film." *Eras* 3 (June 2002).

Gerth, Karl. *China Made: Consumer Culture and the Creation of the Nation*. Cambridge: Harvard University Asia Center, 2003.

Gunning, Tom. "Crazy Machines in the Garden of Forking Paths: Mischief Gags and the Origins of American Film Comedy." In *Classical Hollywood Comedy*, eds. Kristine Brunovska Karnick and Henry Jenkins, 87–105. New York: Routledge, 1995.

Hamm, John Christopher. *The Unworthy Scholar from Pingjiang: Republican-Era Martial Arts Fiction*. New York: Columbia University Press, 2019.

Han, Qijun. "Melodrama as Vernacular Modernism in China: The Case of D. W. Griffith." *Scope: An Online Journal of Film and Television Studies*, no. 26 (February 2014). https://www.nottingham.ac.uk/scope/documents/2014/february/han.pdf.

Hansen, Miriam Bratu. "Fallen Women, Rising Stars, New Horizons: Shanghai Silent Films as Vernacular Modernism." *Film Quarterly* 54, no. 1 (Fall 2000): 10–22.

——. "The Gender of Vernacular Modernism: Chinese and Japanese Films of the 1930s." *La Valle de l'Eden* (Turin) 9, no. 19 (December 2007): 23–41.

Harris, Kristine. "Modern Mulans: Reimagining the Mulan Legend in Chinese Film, 1920s–1960s." In *The New Woman International: Representations in Photography and Film from the 1870s through the 1960s*, eds. Elizabeth Otto and Vanessa Rocco, 309–330. Ann Arbor: University of Michigan Press, 2011.

——. "*Ombres Chinoises*: Split Screens and Parallel Lives in *Love and Duty*." In *The Oxford Handbook of Chinese Cinemas*, eds. Carlos Rojas and Eileen Cheng-yin Chow, 39–61. Oxford: Oxford University Press, 2013.

——. "Peach Blossom Dreams: Silent Chinese Cinema Remembered." *Griffithiana* 60/61 (October 1997): 126–179.

——. "Silent Speech: Envisioning the Nation in Early Shanghai Cinema." PhD diss., Columbia University, 1997.

——. "*The Goddess*: Fallen Woman of Shanghai." In *Chinese Films in Focus: 25 New Takes*, ed. Chris Berry, 111–119. London: British Film Institute Publishing, 2003.

——. "The *New Woman* Incident: Cinema, Scandal, and Spectacle in 1935 Shanghai." In *Transnational Chinese Cinemas: Identity, Nationhood, Gender*, ed. Sheldon H. Lu, 277–302. Honolulu: University of Hawai'i Press, 1997.

——. "*The Romance of the Western Chamber* and the Classical Subject Film in 1920s Shanghai." In *Cinema and Urban Culture in Shanghai, 1922–1943*, ed. Yingjin Zhang, 51–73. Stanford, Calif.: Stanford University Press, 1999.

——. "Two Stars on the Silver Screen: The Metafilm as Chinese Modern." In *History in Images: Pictures and Public Space in Modern China*, eds. Christian Henriot and Wen-hsin Yeh, 191–244. Berkeley: U.C. Berkeley Institute of East Asian Studies, 2012.

Henriot, Christian. *Prostitution and Sexuality in Shanghai: A Social History, 1849–1949*. Trans. Noël Castelino. Cambridge: Cambridge University Press, 2001.

Henriot, Christian, Lu Shih, and Charlotte Aubrun. *The Population of Shanghai (1865–1953)*. Leiden: Brill, 2018.

Hershatter, Gail. *Dangerous Pleasures: Prostitution and Modernity in Twentieth-Century Shanghai*. Berkeley: University of California Press, 1999.

Hjort, Mette. "Ruan Lingyu: Reflections on an Individual Performance Style." In *Chinese Film Stars*, eds. Mary Farquhar and Yingjin Zhang, 32–49. Abington, U.K.: Routledge, 2010.

Hong, Guo-Juin. "Framing Time: New Women and the Cinematic Representation of Colonial Modernity in 1930s Shanghai." *positions: east asia cultures critique* 15, no. 3 (Winter 2007): 553–580.

——. "Meet Me in Shanghai: Melodrama and the Cinematic Production of Space in 1930s Shanghai Leftist Films." *Journal of Chinese Cinemas* 3, no. 3 (2009): 215–230.

Hu Jubin. *Projecting a Nation: Chinese National Cinema Before 1949*. Hong Kong: Hong Kong University Press, 2003.

Huang Xuelei. *Shanghai Filmmaking: Crossing Borders, Connecting to the Globe, 1922–1938*. Leiden: Brill, 2014.

Huang Xuelei, and Zhiwei Xiao. "Shadow Magic and the Early History of Film Exhibition in China." In *The Chinese Cinema Book*, eds. Song Hwee Lim and Julian Ward, 47–55. London: British Film Institute, 2011.

Hung, Chang-tai. "Female Symbols of Resistance in the Chinese Wartime Spoken Drama." *Modern China* 15, no. 2 (1989): 149–177.

——. *War and Popular Culture: Resistance in Modern China, 1937–1945*. Berkeley: University of California Press, 1994.

Iovene, Paola. "Phony Phoenixes: Comedy, Protest, and Marginality in Postwar Shanghai." In *China on the Margins*, eds. Sherman Cochran and Paul Pickowicz, 267–287. Ithaca, N.Y.: Cornell University Press, 2010.

Jacobs, Lea. *The Wages of Sin: Censorship and the Fallen Woman Film, 1928–1942*. Madison: University of Wisconsin Press, 1991.

Jin Haina. "Intertitle Translation of Chinese Silent Films." *Babel* (Online First copy, published October 2, 2020). https://www.jbe-platform.com/content/journals/10.1075/babel.00183.jin.

Johnson, Matthew. "International and Wartime Origins of the Propaganda State: The Motion Picture in China, 1897–1955." PhD diss., University of California, San Diego, 2008.

Jones, Andrew F. *Developmental Fairy Tales: Evolutionary Thinking and Modern Chinese Culture*. Cambridge, Mass.: Harvard University Press, 2011.

——. "*Spring in a Small Town*: A translation of the full filmscript." https://u.osu.edu/mclc/online-series/spring.

——. "*Street Angel*: A translation of the full filmscript." http://u.osu.edu/mclc/online-series/street-angel.

——. *Yellow Music: Media Culture and Colonial Modernity in the Chinese Jazz Age*. Durham, N.C.: Duke University Press, 2001.

Judge, Joan. *The Precious Raft of History: The Past, the West, and the Woman Question in China*. Stanford, Calif.: Stanford University Press, 2008.

Kingston, Maxine Hong. *The Woman Warrior: A Childhood Among Ghosts*. New York: Knopf, 1976.

Ko, Dorothy. *Cinderella's Sisters: A Revisionist History of Footbinding*. Berkeley: University of California Press, 2007.

Kucherenko, Olga. *Little Soldiers: How Soviet Children Went to War, 1941–1945*. New York: Oxford University Press, 2011.

Kwa, Shiamin, and Wilt L. Idema, trans. *Mulan: Five Versions of a Chinese Legend, with Related Texts*. Indianapolis, Ind.: Hackett, 2010.

Lary, Diana. *The Chinese People at War: Human Suffering and Social Transformation, 1937–1945*. New York: Cambridge University Press, 2010.

Law Kar, and Frank Bren, with the collaboration of Sam Ho. *Hong Kong Cinema: A Cross-Cultural View*. Oxford, U.K.: Scarecrow Press, 2004.

Lee, Leo Ou-fan. *Shanghai Modern: The Flowering of a New Urban Culture in China, 1930–1945*. Cambridge, Mass.: Harvard University Press, 1999.

——. "The Urban Milieu of Shanghai Cinema, 1930–40: Some Explorations of Film Audience, Film Culture, and Narrative Conventions." In *Cinema and Urban Culture in Shanghai, 1922–1943*, ed. Yingjin Zhang, 74–96. Stanford, Calif.: Stanford University Press, 1999.

Lee, Lillian (Li Bihua). *Farewell, My Concubine: A Novel*. Trans. Andrea Lingenfelter. New York: Harper Perennial, 1994.

Lei Qinfeng 雷勤風 (Christopher G. Rea). " 'Zuori fei jinri': Tian Zhuangzhuang *Xiaocheng zhi chun* lishi yuwang de youling zaixian" 昨日非今日: 田莊莊《小城之春》歷史慾望的幽靈再現 [Hauntings of historical desire in Tian Zhuangzhuang's *Springtime in a Small Town*). In *Xiangxiang de benbang: xiandai wenxue 15 lun* 想像的本邦: 現代文學十五論 [National imaginaries: 15 perspectives on modern Chinese literature], eds. David Der-wei Wang 王德威 and Kim Chew Ng 黃錦樹, 161–180. Taipei: Rye Field Publishing, 2005.

Leroux, Gaston. *The Phantom of the Opera* (1909–1910). English translation at Project Gutenberg. http://www.gutenberg.org/files/175/175-h/175-h.htm.

Leyda, Jay. *Dianying/Electric Shadows: An Account of Films and Film Audiences in China*. Cambridge, Mass.: MIT Press, 1972.

Li, Cheuk-to. "Eight Films of Sun Yu: A Gentle Discourse on a Genius." *Cineyama* 11 (1991): 53–63.

——. "Le Printemps d'une petite ville, un film qui renouvelle la tradition chinoise." In *Le Cinema Chinois*, eds. Marie-Claire Quiquemelle and Jean-Loup Passek, 73–76, Paris: Centre Georges Pompidou, 1985.

——. "*Spring in a Small Town*: Mastery and Restraint." *Cinemaya* 49 (2000): 59–64.

Li, Jie. "Home and Nation Amid the Rubble: Fei Mu's *Spring in a Small Town* and Jia Zhangke's *Still Life*." *Modern Chinese Literature and Culture* 21, no. 2 (Fall 2009): 86–125.

Li, Mengjun. "In the Name of a Love Story: Scholar-Beauty Novels and the Writing of Genre Fiction in Qing China (1644–1911)." PhD diss., The Ohio State University, 2014.

Li Suyuan 酈蘇元, and Hu Jubin 胡菊彬. *Zhongguo wusheng dianying shi* 中國無聲電影史 [A history of Chinese silent film]. Beijing: Zhongguo dianying chubanshe, 1996.

Liao Jinfeng 廖金鳳. *Buluosiji yu huobanmen: Zhongguo zaoqi dianying de kuaguo lishi* 布洛斯基與夥伴們: 中國早期電影的跨國歷史 [Brodsky and companies: a transnational history of Chinese early cinema]. Taipei: Rye Field Publishing, 2015.

Lin, Pei-yin. "Comicality in *Long Live the Mistress* and the Making of a Chinese Comedy of Manners." *Tamkang Review* 47, no. 1 (December 2016): 97–119.

Lin Yutang. *Moment in Peking: A Novel of Contemporary Chinese Life*. New York: John Day, 1939.

Lu, Hanchao. *Beyond the Neon Lights: Everyday Shanghai in the Early Twentieth Century*. Berkeley: University of California Press, 1999.

Ma, Jean. *Sounding the Modern Woman: The Songstress in Chinese Cinema*. Durham, N.C.: Duke University Press, 2015.

Ma Ning. "The Textual and Critical Difference of Being Radical: Reconstructing Chinese Leftist Films of the 1930s." *Wide Angle* 11, no. 2 (1989): 22–31.

Macdonald, Sean. "Li Lili: Acting a Lively Jianmei Type." In *Chinese Film Stars*, eds. Mary Farquhar and Yingjin Zhang, 50–66. Abington, U.K.: Routledge, 2010.

——, introduction and trans. "Two Texts in Defense of 'Comics' from China, ca. 1932: 'In Defense of "Comic Strips" ' by Lu Xun and 'Comic Strip Novels' by Mao Dun." *ImageTexT: Interdisciplinary Comic Studies* 6, no. 1 (2011). http://imagetext .english.ufl.edu/archives/v6_1/macdonald.

Mao Dun. *Spring Silkworms and Other Stories*. Trans. Sidney Shapiro. Beijing: Foreign Languages Press, 1956.

Marchetti, Gina. "*Two Stage Sisters*: The Blossoming of a Revolutionary Aesthetic." *JumpCut: A Review of Contemporary Media* 34 (March 1989): 95–106. http:// www.ejumpcut.org/archive/onlinessays/JC34folder/2stageSisters.html.

McDougall, Bonnie S., and Kam Louie. *The Literature of China in the Twentieth Century*. New York: Columbia University Press, 1997.

Melnick, Ross. *American Showman: Samuel "Roxy" Rothafel and the Birth of the Entertainment Industry, 1908–1935*. New York: Columbia University Press, 2014.

Meyer, Richard J. *Jin Yan: The Rudolph Valentino of China*. Foreword by Robert Dallek. Hong Kong: Hong Kong University Press, 2009.

——. *Ruan Lingyu: The Goddess of Shanghai*. Hong Kong: Hong Kong University Press, 2005.

——. *Wang Renmei: The Wildcat of Shanghai*. Hong Kong: Hong Kong University Press, 2013.

Morris, Andrew D. *Marrow of the Nation: A History of Sport and Physical Culture in Republican China*. Berkeley: University of California Press, 2004.

Ng, Kenny K. K. "The Screenwriter as Cultural Broker: Travels of Zhang Ailing's Comedy of Love." *Modern Chinese Literature and Culture* 20, no. 2 (Fall 2008): 131–184.

North, C. J., "The Chinese Motion Picture Market." Trade Information Bulletin, No. 467. Washington, D.C.: U.S. Department of Commerce, Bureau of Foreign and Domestic Commerce, 1927.

Otto, Elizabeth, and Vanessa Rocco, eds. *The New Woman International: Representations in Photography and Film from the 1870s Through the 1960s*. Foreword by Linda Nochlin. Ann Arbor: University of Michigan Press, 2011.

Ouyang Yuqian 歐陽予倩. "*Mulan congjun*: Yousheng dianying juben" 木蘭從軍：有聲電影劇本 (*Mulan Joins the Army*: Script of the sound film). *Xingqi wenzhai* 星期文摘 (Reader's weekly digest) 1, no. 46 (1940): 120–127; 1, no. 78 (1940): 150–159; and 2, no. 12 (1940): 28–29.

Pang, Laikwan. *Building a New China in Cinema: The Chinese Left-Wing Cinema Movement, 1932–1937*. New York: Rowman and Littlefield, 2002.

Pickowicz, Paul G. *China on Film: A Century of Exploration, Confrontation, and Controversy*. Lanham, Md.: Rowman and Littlefield, 2012.

Pickowicz, Paul G., Kuiyi Shen, and Yingjin Zhang, eds. *Liangyou: Kaleidoscopic Modernity and the Shanghai Global Metropolis, 1926–1945*. Leiden: Brill, 2014.

Plauen, E. O. *Father and Son*. Trans. Joel Rotenberg. Lettering by Jeremy Sorese. Afterword by Elke Schulz. New York: New York Review Comics, 2017.

Pozzi, Laura. "'Chinese Children Rise Up!': Representations of Children in the Work of the Cartoon Propaganda Corps During the Second Sino-Japanese War." *Cross-Currents: East Asian History and Culture Review* 4, no. 1 (May 2015): 333–363. Citations are from online version: https://cross-currents.berkeley.edu/sites/default/files/e-journal/articles/pozzi_0.pdf.

Pu Songling. *Strange Tales from a Chinese Studio*. Trans. John Minford. New York: Penguin, 2006.

Rao Shuguang 饒曙光. *Zhongguo xiju dianying shi* 中國喜劇電影史 [A history of Chinese film comedy]. Beijing: Zhongguo dianying chubanshe, 2005.

Rea, Christopher. "A History of Laughter: Comic Culture in Early Twentieth-Century China." PhD diss., Columbia University, 2018.

——, trans. "*Crows and Sparrows* (1949)." MCLC Resource Center Publication, April 2020. https://u.osu.edu/mclc/online-series/crows-and-sparrows.

——, trans. "*Long Live the Missus!* (1947)." MCLC Resource Center Publication, May 2019. http://u.osu.edu/mclc/online-series/long-live-the-missus.

——. *The Age of Irreverence: A New History of Laughter in China*. Oakland: University of California Press, 2015.

Rea, Christopher, and Henry Jenkins. "The Ancient Art of Falling Down: Vaudeville Cinema Between Hollywood and China." MCLC Resource Center Publication, August 2017. http://u.osu.edu/mclc/online-series/rea-jenkins.

Reynaud, Bérénice. "*Centre Stage*: A Shadow in Reverse." In *Chinese Films in Focus II*, ed. Chris Berry, 48–55. London: British Film Institute/Palgrave Macmillan, 2008.

——. "The 'New Woman' Question in Chinese Cinema." In *Electric Shadows: A Century of Chinese Cinema*, ed. James Bell, 94–101. London: British Film Institute, 2014.

Rist, Peter. "Visual Style in the Silent Films Made by the Lianhua Film Company [United Photoplay Service] in Shanghai: 1931–35." In *One Hundred Years of Chinese Cinema: A Generational Dialogue*, eds. Haili Kong and John Lent, 3–27. Norwalk, Conn.: EastBridge, 2006.

Robinson, David. "Return of the Phantom: Maxu Weibang's *Ye Ban Ge Sheng*." In *Fear Without Frontiers: Horror Cinema Across the Globe*, ed. Steven Jay Schneider, 39–43. Goldaming, UK: FAB Press, 2003.

Rojas, Carlos, and Eileen Cheng-yin Chow, eds. *The Oxford Handbook of Chinese Cinemas*. Oxford: Oxford University Press, 2013.

Rostand, Edmond. *Cyrano de Bergerac* [1897]. Ed. and trans. Carol Clark. New York: Penguin Classics, 2006.

Rothman, William. "*The Goddess*: Reflections on Melodrama East and West." In *Melodrama and Asian Cinema*, ed. Wimal Dissanayake, 59–72. Cambridge: Cambridge University Press, 1993.

Schultz, Corey Kai Nelson. "Ruin in the Films of Jia Zhangke." *Visual Communication* 15, no. 4 (2016): 439–460.

Scott, A. O. *Better Living Through Criticism: How to Think About Art, Pleasure, Beauty, and Truth*. New York: Penguin Books, 2017.

Shapiro, Judith. *Mao's War Against Nature: Politics and the Environment in Revolutionary China*. New York: Cambridge University Press, 2001.

Shen, Vivian. *The Origins of Left-Wing Cinema in China, 1932–37*. New York: Routledge, 2005.

Sikov, Ed. *Screwball: Hollywood's Madcap Romantic Comedies*. Foreword by Molly Haskell. New York: Crown, 1989.

Sun Yu 孫瑜. *Yinhai fanzhou: Huiyi wode yisheng* 銀海泛舟:回憶我的一生 [A boat drifting on the seas of cinema: a memoir]. Shanghai: Shanghai wenyi chubanshe, 1987.

Sutcliffe, Bret. "*A Spring River Flows East*: Progressive Ideology and Gender Representation." *Screening the Past* 5 (December 1998). http://www.screeningthepast .com/2014/12/a-spring-river-flows-eastprogressive-ideology-and-gender-repre -sentation.

Teo, Stephen. *Chinese Martial Arts Cinema: The Wuxia Tradition*. 2nd ed. Edinburgh: Edinburgh University Press, 2009.

Tian Yuan. *Images of "Hua Mulan" in Films of the Past Century*. Beijing: Social Sciences and Humanities Press, 2019.

Tseng, Li-Lin. "Electrifying Illustrated News: Zheng Zhengqiu and the Transformation of Graphic Arts Into Dramatic Cinema, 1910–1935." *Twentieth-Century China* 41, no. 1 (2016): 2–28.

Tuohy, Sue. "Metropolitan Sounds: Music in Chinese Films of the 1930s." In *Cinema and Urban Culture in Shanghai, 1922–1943*, ed. Yingjin Zhang, 200–221. Stanford, Calif.: Stanford University Press, 1999.

Twain, Mark. *The Adventures of Huckleberry Finn* (1885). Project Gutenberg. https://www.gutenberg.org/files/76/76-h/76-h.htm.

——. *Following the Equator: A Journey Around the World*. Hartford, Conn.: American Publishing Company, 1888.

van de Ven, Hans. *China at War: Triumph and Tragedy in the Emergence of the New China*. Cambridge, Mass.: Harvard University Press, 2018.

Wakeman, Frederick, Jr. "'Cleanup': The New Order in Shanghai." In *Dilemmas of Victory: The Early Years of the People's Republic of China*, eds. Jeremy Brown and Paul G. Pickowicz, 21–58. Cambridge, Mass.: Harvard University Press, 2007.

Wang, Anyi. *Song of Everlasting Sorrow: A Novel of Shanghai*. Trans. Michael Berry and Susan Chan Egan. New York: Columbia University Press, 2008.

Wang, David Der-wei. *The Lyrical in Epic Time: Modern Chinese Intellectuals and Artists Through the 1949 Crisis*. New York: Columbia University Press, 2015.

——. *The Monster That Is History: History, Violence, and Fictional Writing in Twentieth-Century China*. Berkeley: University of California Press, 2004.

Wang, Yiman. "*Crows and Sparrows*: Allegory on a Historical Threshold." In *Chinese Films in Focus II*, ed. Chris Berry, 82–89. Basingstoke: British Film Institute/Palgrave MacMillan, 2008.

——. "The Phantom Strikes Back: Triangulating Hollywood, Shanghai, and Hong Kong." *Quarterly Review of Film and Video* 21 (2004): 317–326.

——. *Remaking Chinese Cinema Through the Prism of Shanghai, Hong Kong, and Hollywood*. Honolulu: University of Hawai'i Press, 2013.

——. "To Write or to Act, That Is the Question: 1920s to 1930s Shanghai Actress-Writers and the Death of the 'New Woman.'" In *Chinese Women's Cinema: Transnational Contexts*, ed. Lingzhen Wang, 235–254. New York: Columbia University Press, 2011.

Wang, Zhuoyi. "Cultural 'Authenticity' as a Conflict-Ridden Hypotext: *Mulan* (1998), *Mulan Joins the Army* (1939), and a Millennium-Long Intertextual Metamorphosis." *Arts* 9, no. 3 (July 2020): no pagination. https://www.mdpi.com/2076-0752/9/3/78.

Weinbaum, Alys Eve, Lynn M. Thomas, Priti Ramamurthy, Uta G. Poiger, and Madeline Yue Dong, eds. *The Modern Girl Around the World: Consumption, Modernity, and Globalization*. Durham, N.C.: Duke University Press, 2008.

Wong Ain-ling 黃愛玲, ed. *Shiren daoyan Fei Mu* 詩人導演費穆 [Poet-director Fei Mu]. Hong Kong: Hong Kong Film Critics Association, 1998.

——. "Fei Mu: A Different Destiny." *Cinemaya* 49 (2000): 52–58.

Wong, Lily. *Transpacific Attachments: Sex Work, Media Networks, and Affective Histories of Chineseness*. New York: Columbia University Press, 2018.

Wu Hung. *A Story of Ruins: Presence and Absence in Chinese Art and Visual Culture*. Princeton, N.J.: Princeton University Press, 2012.

Wu Yigong 吳貽弓, ed. *Shanghai dianying zhi* 上海電影誌 [Historical records of Shanghai cinema]. Shanghai: Shanghai shehui kexue chubanshe, 1999.

Wu Yonggang 吳永剛. *Wode tansuo yu zhuiqiu* 我的探索與追求 [My explorations and pursuits]. Beijing: Zhongguo dianying chubanshe, 1986.

Xiao, Zhiwei. "American Films in China Prior to 1950." In *Art, Politics, and Commerce in Chinese Cinema*, eds. Ying Zhu and Stanley Rosen, 55–70. Hong Kong: Hong Kong University Press, 2010.

——. "Constructing a New National Culture: Film Censorship and the Issues of Cantonese Dialect, Superstition, and Sex in the Nanjing Decade." In *Cinema and Urban Culture in Shanghai, 1922–1943*, ed. Yingjin Zhang, 183–199. Stanford, Calif.: Stanford University Press, 1999.

——. "Film Censorship in China, 1927–1937." PhD diss., University of California, San Diego, 1994.

——. "Wu Yonggang and the Ambivalence in the Chinese Experience of Modernity: A Study of His Three Films of the Mid-1930s." *Asian Cinema* 9, no. 2 (Spring 1998): 3–15.

Xu, Lanjun. "Save the Children: Problem Childhoods and Narrative Politics in Twentieth-Century Chinese Literature." PhD diss., Princeton University, 2007.

Xu Zhuodai 徐卓呆. *Nüxia Hong kuzi* 女俠紅褲子 [Red pants, the woman warrior]. 2 vols. Shanghai: Zhongyang shudian, 1930.

Yeh, Emilie Yueh-yu, ed. *Early Film Culture in Hong Kong, Taiwan, and Republican China*. Ann Arbor: University of Michigan Press, 2018.

——. "Historiography and Sinification: Music in Chinese Cinema of the 1930s." *Cinema Journal* 41, no. 3 (Spring 2002): 78–97.

Yuan Muzhi 袁牧之. *Yuan Muzhi quanji* 袁牧之全集 [Complete Works of Yuan Muzhi]. Ed. Yang Xinyu 楊新宇. 4 vols. Shanghai: Shanghai wenhua chubanshe, 2019.

Zhang Ailing 張愛玲. *Dianmao juben ji* 電懋劇本集 [Eileen Chang's MP&GI screenplays]. 4 vols. Hong Kong: Hong Kong Film Archive, 2010.

Zhang Leping 張樂平. *Adventures of Sanmao the Orphan*. Trans. W. J. F. Jenner and C. M. Chan. Hong Kong: Joint Publishing Company, 1981.

——. *Zhang Leping lianhuan manhua quanji* 張樂平連環漫畫全集 [Complete comic strips of Zhang Leping]. Ed. Wang Yiqiu 王亦秋. Beijing: Zhongguo lianhuanhua chubanshe, 1998 [1994].

Zhang, Yingjin, ed. *A Companion to Chinese Cinema*. London: Wiley-Blackwell, 2013.

——. "Beyond Binary Imagination: Progress and Problems in Chinese Film Historiography." *Chinese Historical Review* 15 (2008/1): 65–87.

——. *Chinese National Cinema*. New York: Routledge, 2008 [2004].

——, ed. *Cinema and Urban Culture in Shanghai, 1922–1943*. Stanford, Calif.: Stanford University Press, 1999.

——. "Gender, Genre, and Performance in Eileen Chang's Films: Equivocal Contrasts Across the Print-Screen Divide." In *Chinese Women's Cinema: Transnational Contexts*, ed. Lingzhen Wang, 255–273. New York: Columbia University Press, 2011.

——. "Introduction: Film History and Historiography." *Journal of Chinese Cinemas* 10, no. 1 (2016): 38–47.

——. "A Typography of Chinese Film Historiography." *Asian Cinema* 11 (2000/1): 16–32.

——. "Zhao Dan: Spectrality of Martyrdom and Stardom." In *Chinese Film Stars*, eds. Mary Farquhar and Yingjin Zhang, 86–96. Abington, U.K.: Routledge, 2010.

Zhang Zhen. *An Amorous History of the Silver Screen: Shanghai Cinema, 1896–1937*. Chicago: University of Chicago Press, 2005.

Zheng Junli 鄭君里. *Zheng Junli quanji* 鄭君里全集 [Complete works of Zheng Junli]. Ed. Li Zhen 李鎮. 8 vols. Shanghai: Shanghai wenhua chubanshe, 2016.

Zheng Peiwei 鄭培為, and Liu Guiqing 劉桂清. *Zhongguo wusheng dianying juben* 中國無聲電影劇本 [Chinese silent film scripts]. 3 vols. Beijing: Zhongguo dianying chubanshe, 1996.

Zhou Chengren 周承人, and Li Yizhuang 李以莊. *Zaoqi Xianggang dianying shi, 1897–1945* 早期香港電影史, 1897–1945 [History of early cinema in Hong Kong, 1897–1945]. Shanghai: Shanghai renmin chubanshe, 2009.

Index

Figures are indicated by *f* after page numbers.

Butterfly Wu. *See* Hu Die
buy domestic campaigns, 43

Cai Chusheng: mentioned, 9, 42, 117, 125*f*, 217, 258, 306, 313; as screenwriter, 217, 221
Cai Ruohong, 306, 313
Cai Shusheng. *See* Xia Yan
Cen Fan, 313
canons, benefits of and problems with, 4–8
Cao Wei, 309
Cartoon Monthly (*Manhua yuekan*), cartoon texts in, 260–61
categorical form, 221–22, 222*f*, 223*f*, 224
catharsis, in *Spring River Flows East*, 224
Cathay Film Co. *See* Guotai yingye gongsi
Cave of Spiders, The. See *Cave of the Silken Web, The*
Cave of the Silken Web, The (1927), 6, 68, 301
Celebrate Children (1952), 273n12
Cen Fan, 313
censorship, 3, 5, 13–14, 82, 108, 110, 192, 307
Center Stage (1991), 120
Central Film Censorship Committee (CFCC), 13–14
Central Motion Picture Company, 235n5
Chan, Nancy. *See* Chen Yunshang
Chan Wan-Seung. *See* Chen Yunshang
Chaney, Lon, 141
Chang, Eileen. *See* Zhang Ailing
Chang, S. K. *See* Zhang Shankun
Chang Hen Shui. *See* Zhang Henshui
Chang Shan-Kun (S. K. Chang). *See* Zhang Shankun
Chang Yih. *See* Zhang Yi
Changcheng. *See* Shanghai Changcheng huapian gongsi
Changchun dianying zhipianchang (studio, Changchun Film Studio), 308
Chaplin, Charlie, 24, 36n1, 120–21

Che Wan-Hing. *See* Xie Yunqing
Cheat, The (1931), 42, 94n9
Chen, C. C. *See* Chen Zhiqing
Chen, Janet, 264
Chen, Mayor. *See* Chen Meiyan
Chen Baichen, 275, 278, 314
Chen Bo'er, 305, 314
Chen Chun-Li. *See* Zheng Junli
Chen Juanjuan, 314
Chen Kaige, 94n10, 152, 314
Chen Kengran, 156n7, 314
Chen Liting, 314, 331
Chen Meiyan (Mayor Chen), 303, 313
Chen Shaoping (*Street Angels* character), 158–59, 162, 163–64, 166*f*, 169–72
Chen Siduan (*Long Live the Missus!* character), 198, 201, 202*f*, 208–9
Chen Sizhen (*Long Live the Missus!* character), 198–99, 201–4, 204*f*, 205*f*, 206, 208–9, 210*f*, 211–14, 212*f*
Chen Yanyan (Chen Yen Yen, Ch'en Yen-yen, Chen Yen-Yen): films played in, 71, 115n18, 184, 199, 303, 304, 309; in *The Great Road*, 100, 104*f*, 105*f*, 107*f*, 109*f*, 110, 113; in *The Great Road* publicity, 100, 101*f*; Lux Toilet Soap and, 71; on magazine covers, 114–15n16; mentioned, 97, 314
Chen Yen Yen. *See* Chen Yanyan
Chen Yunshang (Nancy Chan, Cheng Yun Shang, Chan Wan-Seung): celebrity and promotion of, 114n7, 114n16, 180, 190, 191*f*; early career of, 12; in *Hua Mu Lan*, 181, 182*f*, 184, 185*f*, 187, 187*f*, 189, 189*f*; mentioned, 176, 192, 308, 314; Shanghai studios, work for, 180
Chen Zhiqin (*Long Live the Missus!* character), 198, 201, 202*f*, 203, 208
Chen Zhiqing (C. C. Chen), 302, 314
Cheng Bugao, 114n10, 305, 314
Cheng Cheh Ku. *See* Zheng Zhegu
Cheng Kung. *See* Zheng Zhengqiu
Cheng Mo, 256, 314

Chu Yuan (Chor Yuen), 314

Chuanxi Duochangzhen. *See* Kawakita Nagamasa

Chun can. See *Spring Silkworms*

Chung, V. K. *See* Zong Weigeng

Chungking. *See* Chongqing

cinema of attraction(s), 22–23, 113

cinema culture, representation in films (metacinema), 204, 205*f*, 213, 229

cinemas. *See* exhibition

cinematography: cinematographic tricks in *Laborer's Love*, 30–35; crane shots, 68; Fei Mu and, 9, 246; *liulang* versus *you* in, 262; point of view shots, 24–25, 25*f*; tracking shots, 50, 68, 103, 246, 247, 251; in *Wanderings of Three-Hairs the Orphan*, 259–60. *See also* framing; special effects

circular blocking, 68, 75n12

"City Fantasia" (orchestral piece), 168

City Lights (1931), 121

City Nights (1933), 239

Cityscapes. See *City Scenes*

City Scenes (1935), 113n3; "can't be done" (*mei banfa*) as refrain in, 172; censorship of, 3, 307; "City Fantasia" in, 168; film credits and summary, 306–7; *The Great Road*, allusion to, 113n3; overhead shots in, 68; *Street Angels*, comparisons with, 161, 168, 171–72, 174n10; visual gags in, 171

civil war, Chinese, 40, 44, 200, 220, 248. See also *Crows and Sparrows*; *Playthings*; *Spring in a Small Town*; *Spring River Flows East*; Warlord Era

Clark, Paul, 11, 14, 16n17

class relations, 63

classics, satirical descriptions of, 4

Cloud-Dress Immortal, The (1939), 190, 191*f*

collaborators. *See* Japanese collaborators

collective labor, 99, 99*f*, 100

comedy(ies): cinematic, 7; comic bedlam of *Wanderings of Three-Hairs the Orphan*, 265–71; in *Hua Mu Lan*, 183, 184*f*; late 1940s, 200–201; screwball comedies (comedies of remarriage), 206–7; silent, 302; in *Sports Queen*, 67. *See also* Chaplin, Charlie; *City Scenes*; *Crows and Sparrows*; *Diary of a Homecoming*; Keaton, Buster; Han Langen; *Laborer's Love*; Lloyd, Harold; *Long Live the Missus!*; *Phony Phoenixes*; *Poor Daddy*

comic strips. See *Wanderings of Three-Hairs the Orphan*

coming-of-age narratives, 62–65

commodity exchanges, 212, 213*f*

Confucius (1940), 7, 239, 307

Confucius, on education, 91

connection devices, 26–27; in *Laborer's Love*, 26–27, 26*f*, 27*f*; in *Playthings*, 40, 48–49; in *Spring River Flows East*, 232–33

consumer culture, 71

Cooper, Gary, 4, 207

countryside, represented in films, 41, 61, 290, 303–6, 309. See also *Daybreak*; *Playthings*; *Song of the Fishermen*; *Spring Silkworms*; *Twin Sisters*; *Wild Rose*

cross-dressing costume romance, 186

Crossroads (*Shizi jietou*, 1937), 53, 225, 307

Crows and Sparrows (1949), 275–96; censorship of, 14, 277; cinematography of, 278–79, 281, 282, 286; civil war, depictions of, 226; collective authorship of, 277–78; ensemble cast of, 281–84; exhibition and promotion of, 221, 277, 280, 293n2; film credits for, 275; films influenced by, 280–81; fin-de-siècle aesthetics of, 289; first scenes of, 278–79, 279*f*, 280*f*; form of, 278; housing and population pressures

Ding, Old (*The Great Road* character), 103, 112

Ding Hao (Kitty Ting), 74, 314

Ding Ling, 184

Ding Xiang. *See* Orchid (*The Great Road* character)

dingfei (takeover fees), 294n4

Dingjun Mountain (1905), 10, 22, 238

Dinner at Eight (1933), 100

disguise, layers of, 184, 185*f*

Disputed Passage (Borzage), 179

dissolves, 68, 84, 91, 130, 142, 149, 188, 221, 251

Distant Love (1947), 202, 282, 295n13

distribution: of Chinese films in southeast Asia, 11; of foreign films in China, 10–11, 14n1. *See also* exhibition

Divine Nancy Chan, The (1939), 190, 192*f*

Divorce (1933), 207

divorce, films dealing with, 207

doctors with bad businesses, as motif, 27

documentary style, 4, 65, 71–73, 72*f*, 73*f*, 222

domestic sphere, as ideological battleground, 202–3

Dong, Xinyu, 30, 37n1

Don't Change Your Husband (1928), 25, 36, 75n6, 134n4, 207

double exposures. *See* matte shots

Double-Ten National Day, 220

Du Fu, 234, 247–48

Du Lei, 256, 314

Dumas, Alexander (fils), 80

Dushi fengguang. See City Scenes

dynamic shapes in motion, 50

eating bitterness (*chi ku*), 134n5

eavesdropping, 169, 170*f*

editing, 5–6, 8, 68, 71, 90–91, 121, 123, 209, 221, 251; elliptical, 44, 211; errors, 35–36, 93n6; match on action, 152; parallel, 45, 75n14,

130, 220, 225; re-editing of *Spring River Flows East*, 3, 234n1. *See also* dissolves; graphic matching; wipes

education without discrimination (*youjiao wulei*), 91

Edwards, Louise, 188

Eight Thousand Li of Clouds and Moon (1947), 220, 225, 240, 268, 310

Electric House, The (1922), 28, 268

Eliminate the Four Pests (*chu si hai*) campaign, 293

ensemble casting, 5, 50, 100, 102–3, 161, 173, 273n13, 281, 284

equilibrium farces, 29

er fangdong (sublandlords), 280, 284*f*, 294n4

erwo tu (two-me's photo) (*fenshen xiang* (split-self photographs)), 32, 33*f*, 34

Erzi yingxiong. See Poor Daddy

Eternity (1943), 192, 308

Everlasting Regret. See Wedding in the Dream, A

exhibition, 8–11, 16n16; Hollywood films in China, 2, 15n9; online and DVD, 2–3; premieres (film release dates), 21, 37n2, 38, 54n1–2, 56, 65, 75n7, 75n13, 78, 79, 93n1, 93n3, 97, 100, 117, 119, 134n2, 139, 140–41, 155n1, 158, 173n1, 173n3, 174n8, 176, 190, 192, 195n21–22, 198, 214n1, 217, 220, 237, 252n1, 256, 272n2, 277m 293n2

eyeglasses, as cinematic motif, 24–25, 24*f*

eyeline, in rhetorical form, 224

F. F., Miss. *See* Yin Mingzhu

"fallen woman" genre, 79–80, 131

Fan Haha, 314

Fan Xuepeng (Van Shih Bong), 303, 314

Fangzi yu dingfei. See Crows and Sparrows

Far Eastern Championship Games, 71–72

Great Wall Film Company, Shanghai.
See Shanghai Changcheng huapian
gongsi

Greatest Love Affair on Earth, The
(1964), 200

Greatest Wedding on Earth, The (1962),
200

Greta Garbo Brand Cigarettes, 86, 87*f*

Griffith, D. W., 15n9, 80, 153, 173n1, 302

Gu, Mr. (*Street Angels* character), 159,
164, 169

Gu Meijun, 306, 315

Gu Menghe, 139, 315

Guan Ji'an, 301, 315

Guan Jinpeng (Stanley Kwan), 120, 315

guangming (bright, dawn), 151

guangming de weiba (bright tail), 151

gudao ("Orphan Island"). *See* Shanghai

gui (devils), 154

guoshu (national arts), 65

Guotai yingye gongsi (studio, Cathay
Film Co.), 235n5

Hamm, John Christopher, 15n6

Han Fei, 198, 199, 202*f*, 311, 315

Han Kui (*Hua Mu Lan* character), 183,
184*f*

Han Langen (Han Lan Kun, Han
Lan-ken, L. K. Han): films played
in, 48, 68, 100, 114n13, 183, 184*f*;
mentioned, 38, 56, 97, 175, 304, 306,
308, 315

handkerchiefs, as romantic tokens, 26,
62, 64, 243

Harris, Kristine, 7, 133, 184, 188

Haunted House, The (1921), 28*f*, 268,
288

He Feiguang, 56, 315

He Wenyan (*Spring River Flows East*
character), 218, 219, 229–30

healthy beauty (*jianmei*, later
bodybuilding), 65

Healthy Beauty Monthly (magazine), 65

Hearts United in Life and Death (1936),
141

Heaven Can Wait (1943), 268

Hellzapoppin' (1941), 28, 268

*Hen-Pecked Husband, The. See Poor
Daddy*

Heroic Son, The. See Poor Daddy

heroism, dumb-show mimicry of,
171–72, 172*f*

heterosexual romance, representations
of, 73

Highway, The. See Great Road, The

history: film historiography, 3–5;
haunting of modern Chinese
literature by, 144

hoarding, 282

homoeroticism and homosexuality,
107–8, 107*f*, 181, 183

Hong (*The Great Road* character), 106

Hong, C. L. *See* Hong Jingling

Hong Bo, 311, 315

Hong Ji, 315

Hong Jingling (C. L. Hong): films
played in, 100, 114n13; in *The Great
Road* publicity, 101*f*, 102; mentioned,
97, 176, 302, 306, 315

Hong Kong: film market in, 8, 195n21,
280; film production in, 3, 4, 11,
12, 180, 311; Hong Kong Film
Awards, 6; Hong Kong Film Critics
Association, 238; representations in
films, 198, 200, 277, 281

Hong Mo, 315

Hong Shen, 9, 11, 315

Hong xia. See Red Heroine, The

Hongkew Cinema (Shanghai), 10

*Hongse niangzi jun. See Red
Detachment of Women, The*

horror: horror genre, 141, 151; horror-
musicals, *Song at Midnight* as,
140–41; politics of, 148–55

Hou Yao, 15n9, 302, 315

Hou Yibo (*Crows and Sparrows*
character), 275–77, 281–82, 286,
287*f*, 288*f*, 289, 291

*House and Tea Money. See Crows and
Sparrows*

House of 72 Tenants, The (stage play and films), 280–81

housing problems, 279; represented in films, 309, 310–11. See also *City Scenes; Crossroads; Crows and Sparrows; Diary of a Homecoming; Goddess; House of 72 Tenants; Kung Fu Hustle; Lights of Myriad Homes*

Hsieh Ping-ying. *See* Xie Bingying

Hsin Hwa Film Company. *See* Xinhua yingye gongsi

Hsu, S. T. *See* Xu Xingzhi

Hsu Ko Hui. *See* Xu Guohui

Hu, Deputy (Hu Bangban, *The Great Road* character), 103, 114n9

Hu, Jubin, 281

Hu Die (Butterfly Wu): in Bright Moon Song-and-Dance Troupe, 57–58; films played in, 7, 162; Lux Toilet Soap and, 71; mentioned, 6, 12, 306, 315

Hu Ping, 139, 151*f*, 315

Hu Rongrong, 190, 315

Hu Shaoyuan (*Sports Queen* character), 63–64

Hua, (Mr.) Jiezhi (*Crows and Sparrows* character), 275–77, 281, 283–84, 283*f*, 290–91, 291*f*, 293

Hua, Mrs. (*Crows and Sparrows* character), 275–76, 281, 289

Hua Mu Lan (1939), 176–97; anachronisms in, 183, 188, 194n12; burning of, 178, 192, 195n24; censorship and, 110; Chen Yunshang (Nancy Chan) in, 180—81, 182*f*, 185*f*, 187*f*, 189, 189*f*; crossdressing and costume performance in, 177, 184–88, 185*f*, 189*f*; current events references in, 190; ending of, 188–89; espionage in, 184–85, 185*f*; exhibition and reception of, 8, 178, 180, 189–92, 195n21–24; film credits, 176; footbinding, allusion to, 58, 183, 194n12; fractured audiences for, 12–13; gender politics of, 181–86;

genres at work in, 181–89; historical allegory in, 232; other Mulan films, 179, 192–93; premiere of, 176, 190, 195n21; rabbit (*tuzi*) symbolism and, 181, 182*f*, 194n10; synopsis, 176–77; wartime context for, 177–81, 189–92; *wen* and *wu* in, 188–89; *wuxia* genre and, 7, 178–80

Hua Mulan (*Hua Mu Lan* character), 176–78, 181, 182*f*, 183–90, 189*f*, 192–93

Hua Mulan Joins the Army (1927), 179

Huacheng zhipianchang (studio, Hwa Cheng Studio, previously Xinhua yingye gongsi), 176, 180, 181, 190

Huaihai Campaign, 285–86

Huang, Jeffrey Y. C. *See* Huang Yicuo

Huang Chen, 310, 315

Huang Jiamo, 315

Huang Liushuang (Anna May Wong, Wong Liu Tsong), 67, 93n2, 315

Huang Naishuang (N. S. Wong, Nansong Wang), 175

Huang Yicuo (Jeffrey Y. C. Huang, Y. C. Jeffrey Huang), 304, 315

Huang Yu-chun. *See* Huang Yujun

Huang Yujun (Ivy Ling Po, Huang Yu-chun), 193, 316

Huang Zongying, 272n9, 272n11, 273n12, 275, 280*f*, 286, 287*f*, 289, 294n11, 316

Huang Zuolin, 310, 316

Huanxiang riji. See *Diary of a Homecoming*

Hunchback of Notre Dame, The (1923), 141

Hundred Flowers Movement, 7, 234n1

Huoshao hongliansi. See *Burning of Red Lotus Temple, The*

Husband and Wife on the March (1951), 202–3

Hwa Cheng Studio. *See* Huacheng zhipianchang

hyperinflation, 13, 201, 224, 279, 282

Li Wenguang (T. K. Lee), 317

Li Xianglan (Ri Koran, Yoshiko [Shirley] Yamaguchi), 192, 308, 317

Li Xiaoxia (Xia, *Song at Midnight* character), 40, 147, 148, 150–51, 151*f*, 153

Li Xiaqing. *See* Li Dandan

Li Ya-Ching. *See* Li Dandan

Li Yu, 232

Li Zeyuan (C. Y. Lee), 317

Li Zongren (Li Tsung-jen), 295n13

Lian'ai yu yiwu. See Love and Duty

Liang Shanbo, 186–87

Lianhua Symphony (1937), 113n3, 160

Lianhua yingye youxian gongsi (studio, United Photoplay Service, Ltd., U.P.S.): creation of, 12; Fei Mu as director for, 239; filmmaking agenda of, 110; *The Great Road*, publicity for, 100, 101*f*, 102; mentioned, 38, 56, 78, 97, 117, 303, 304, 306, 307, 310; *New Women*, promotion of, 119; *Sports Queen* and, 57; themes used by, 50

lies, unexpected consequences of, 209

Life and Times of Father and Son (*Fuzi chunqiu*, Zhang Leping), 272n6

light, as metaphor, 151

Lights of Myriad Homes (1948), 6, 43, 294n4, 310–11

Lim, Florence. *See* Lin Chuchu

Lim Cho Cho. *See* Lin Chuchu

Lin Chuchu (Lin Cho Cho, Lim Chocho, Lim Cho-Cho, Florence Lim), 94n11, 302, 304, 317

Lin Family Shop, The (1959), 43

Lin Loon Ladies' Magazine: photospreads in, 58–59; Ruan Lingyu in, 119

Lin Ying (*Sports Queen* character), 56–57, 61–64, 61*f*, 63*f*, 67, 68, 69*f*, 71, 73

Lin Zhen, 256, 309, 317

Little Angel, The (1935), 152, 173n4

Little Hairy (*Sports Queen* character), 67–68

Little Han the Sixth (*The Great Road* character), 100, 102, 114n13

Little Reunions (Zhang Ailing), 213

Little Toys. See Playthings

Liu Chi Chuen. *See* Liu Jiqun

Liu Enjia, 74, 317

Liu Jiqun (Liu Chi Chuen, Liu Chi-chuen, C. C. Liu, Liu Chi Chun): films played in, 43, 183, 302–4; in *The Great Road* publicity, 101*f*, 102; mentioned, 38, 56, 97, 176, 317

Liu Li, 317

Liu Liying, 173n4, 317

Liu Qiong, 97, 100, 199, 309, 317

Liu Yifei, 193, 317

Liu Yuandu (*Hua Mu Lan* character), 177, 183, 185, 188

Liu Zhaoming, 317, 327

Living Immortal (1934), 68, 75n12

Lloyd, Harold, 23, 23*f*, 24, 27*f*, 36n1

Lo Ming-yau (Lo Ming Yau). *See* Luo Mingyou

Lo Pin. *See* Luo Bin

Loh, T. M. *See* Lu Tie[min?]

Long Live the Missus! (1947), 198–216; allusions to civil war era in, 201; *The Awful Truth*, similarity to, 208; bitterness (*ku*) theme in, 206, 211, 213; *Bluebeard's Eighth Wife*, similarity to, 9, 207, 214n2; conspiracy of husbands in, 208, 209*f*, 212, 213*f*; critical appraisal and reviews of, 6, 200; deception theme of, 199, 203–4, 213, 206, 208–9, 209*f*, 211, 213; Ernst Lubitsch films and, 9, 15n10, 207, 214n2; film credits for, 198; marriage and divorce in, 199, 203–4, 206–7; premiere and reception of, 198, 200, 214n1; representations of women in, 201–3, 229; screwball comedy (comedy of

Ma-Xu Weibang (V. P. Marsh), 9,
94n10, 125*f*, 139, 141, 308, 318
McCarey, Leo, 67
media, in *Sports Queen*, 71
mei banfa ("can't be done"), 172
Mei Lanfang, 152, 179, 239, 318
Mei Xi (Mai Hsi), 176, 183, 187, 318
Mei Xuechou, 318
Melnick, Ross, 8
melodrama, 6, 8, 43, 48, 79, 81, 84, 120,
148, 153, 220, 226, 248, 251, 281, 290,
303, 305, 306
melon splitting. See *po gua*
men: male agency, primacy of, 83; male
domination, framing of, 88, 89*f*;
male–male predation, 94n10; male-
on-female violence in *City Lights*,
121; masculinity, women's portrayals
of, 103, 104*f*; patriarchal systems, 83.
See also *Hua Mu Lan*; *Long Live the
Missus!*
Mencius's mother, legend of, 82, 226
Meng Jiang, 162–63
Meng Shufan, 256, 318
Merry Widow, The (1934), 1, 168,
168*f*
Midnight Song. See *Song at Midnight*
Ming Hwa Motion Picture Co. See
Shanghai Minhua yingpian gongsi
Mingxing Studio. See Shanghai
Mingxing dianying gongsi
Minhua. See Shanghai Minhua yingpian
gongsi
Minxin. See Shanghai Minxin yingpian
gufen youxian gongsi
mirrors: in *Crows and Sparrows*, 286,
288*f*; in *Long Live the Missus!*,
211–12, 212*f*; in *New Women*, 8,
126–28, 127*f*, 128*f*; in *Song at
Midnight*, 149, 149*f*; in *Song of the
Fishermen*, 156n8
mise-en-scène, Fei Mu and, 246
Miserable at Middle Age. See
Bittersweet Middle Age

mobs, in films, 103, 152–55
Modern Student (magazine), 65
Modern Times (1936), 27
Modern Wives (1951), 215n3
Modern Woman, A (Li Pingqian, 1933),
118
Modern Woman, A (Tu Guangqi, 1945),
215n3
Moli. See Jasmine (*The Great Road*
character)
the moon, as trope in films, 142–43,
177, 186, 207, 220, 232–34, 246
morality: moral and immoral behavior,
224; moral archetypes, 233; moral
declines, 228–29
mothers: in *Goddess*, 78–84, 85*f*, 90*f*, 91;
in *Love and Duty*, 45, 93n5; maternal
melodramas, 81; Mencius's mother,
legend of, 82, 226; in *Playthings*,
39, 45–48, 49*f*, 51, 52*f*; single, 117,
131, 201, 310; "virtuous wife, good
mother" ideal, 81–82, 225
motifs, cinematic, 2, 6, 24–27, 30,
35, 36, 53, 86, 88, 94, 123–28, 131,
141, 156n7, 173n4, 243, 246, 262;
definition, 24; leitmotifs, 40, 45,
151, 220, 232, 234; sonic, 132, 163.
See also angels; eyeglasses; flowers;
mirrors; the moon; photographs;
staircases; toys
movie theaters, numbers of, 10–11
Mr. Wang (*Wang xiansheng*, comic
strip), 258, 271
Mukden Incident (September 18
Incident), 40, 221
Mulan (2020), 193
Mulan congjun. See *Hua Mu Lan*;
Mulan Joins the Army (1928)
Mulan Joins the Army (1928), 179
Mulan Joins the Army (1939). See *Hua
Mu Lan*
multiple-exposure photography, 32,
33*f*, 34
Murnau, F. W., 71

Song Jiaoren, 147, 148

Song of China (1935), 71, 115n16, 239

Song of Everlasting Sorrow (Wang Anyi), 162

Song of the Fishermen (1934), 6, 110, 156n8, 160, 306

"Song of the Four Seasons" (*Street Angels*), 106, 162–63, 163f, 164f, 165

"Song of the Great Road, The" (*The Great Road*), 102

Songhua jiang shang. See *Along the Sungari River*

songs and singing: in early sound films, 160; in *The Great Road*, 99–100, 99f; in *Hua Mu Lan*, 186; in *Street Angels*, 162–67

songstresses (sing-song girls, *genü*), 7, 162, 165f, 169, 169f

"Songstress at the Ends of the Earth" (*Street Angels*), 163–64, 165f, 166f, 168

Songstress Red Peony (1931), 12, 162

Soong Ching-ling, 264

Soong's China Welfare Fund, Shanghai Children's Program, 272n8

Sorrows and Joys of Middle Age, The. See *Bittersweet Middle Age*

Sorrows of the Forbidden City (1948), 6, 162, 311

sound films: conversion to, 132; introduction of, 160–61; popularity, 12; sound-on-disk films, 7, 12, 160, 162; spectacle in, 22–23

sound(s): in *Hua Mu Lan*'s gender politics, 186; muteness, 169–71; sound design, 9, 164, 168, 246, 279; in *Street Angels*, 161–71; stutterers, 170, 174n12; as theme of *New Women*, 131–33. *See also* phonographic realism; songs and singing

Southeast Asia. *See* Kuala Lumpur; Manila; Singapore

special effects: fast-forward sequences, 32f, 34–35, 34f; in *Laborer's Love*,

31–32, 32f, 33f, 34f; matte shots, 32, 33f, 34, 87, 88f, 303; in silent films, 31, 32, 32f, 301, 302, 303; split screen, 303; superimpositions, 120, 121f, 123

split-self photographs (*fenshen xiang*) (two-me's photo (*erwo tu*)), 32, 33f, 34

splitting the melon. See *po gua*

sports: politics and, 65–66; sportswomen, 58, 60f, 74. See also *Sports Queen*

Sports Queen (1934), 56–77; China's modern sports culture and, 57–61, 65; comedy in, 67–68; coming-of-age narrative in, 62–65; dynamic shapes in motion in, 50, 68, 71; fiction and documentary in, 71–73, 72f; film credits for, 56; footbinding and, 58–59; government promotion of athletics and, 65–66; Hollywood films, similarities with, 61, 64, 67, 68, 69f, 71, 75n6, 75n14; influence of, 73–74; Li Lili in, 45, 57–58, 61f, 63f, 69f; mass calisthenics in, 73f; matte shots, use of, 34; New Life Movement and, 82; *New Women*, comparison with, 73; news media, representations of, 62, 63f, 65, 71, 72f; politics and entertainment in, 65–71; Scouts of China and, 66, 66f, 72; staircases in, 36, 67, 268; synopsis, 56–57; themes of, 65

Sports Queen (1961), 74

sportswomen, 58, 60f, 74. See also *Sports Queen* (1934)

Spray of Plum Blossoms, A. See *Yihjanmae*

"Spring Gazing" (Du Fu), 247–48

Spring in a Small Town (1948), 237–55; allegorical meanings of, 249–50; barriers in, 241–42; camera-work in, 246–47, 262; critical appraisal and reviews of, 6, 238–39, 252n2; ending of, 249, 250, 250f; exhibition

in Kuala Lumpur, Hong Kong, and Singapore, 252n1; Fei Mu and, 239, 242, 246; film credits for, 237; influence of, 251–52; Li Tianji as screenwriter of, 239, 286; lyricism of, 246–49, 254n14; multiple planes of action in, 281; narrative irresolution in, 53; narrative restraint in, 5; nonlinear structure of, 239, 240f; poetics of melancholy in, 239–46; premiere of, 237, 252n1; props, symbolism of, 243–44, 244f; remake by Tian Zhuangzhuang, 251; scholar–beauty plot of, 249–50; synopsis, 237–38; tone of, 221, 248; visual motifs and designs in, 243–44, 245–46, 245f; voiceover and sound design, 239–40, 244–46; walls and barriers in, 239–43, 241f, 242f, 243f, 250; war and, 238, 247–48

Spring in the South (1932), 207

Spring River Flows East (1947), 217–36; Bai Yang in, 220, 223f, 225, 227f, 230f; battle recreations in, 268; categorical form of, 221; Chinese civil war and, 221–22, 235n5; deluge imagery in, 234; film credits for, 217; *Gone with the Wind*, comparison to, 220; government funding of, 14; melodrama and catharsis in, 220, 226, 248; newsreel footage in, 222, 222f, 223f, 224; novel version of, 3, 234n1, 235n8; poetry as leitmotif of, 231–34, 233f; premiere of, 8, 217, 220; reception of, 6, 220–21, 235n2; re-edited version of, 3, 234n1; rhetorical form of, 220, 224–29, 227f, 228f; rivers in, 232; sexuality, representations of, 229–30, 230f; sublandlords in, 294n4; synopsis, 217–20; title, source of, 232; tone of, 248; villains in, 226, 286; virtue and vice, contrast through parallel editing, 224–26, 227f, 228–31, 228f;

war, depictions of, 220–22, 223f, 224, 228f, 231f, 278; Zheng Junli as co-director of, 131

Spring Silkworms (1933), 43, 118, 305

Springtime in a Small City. See Spring in a Small Town

Springtime in a Small Town (2002), 251

Sprinkler Sprinkled, The (1895), 26

staircases: as cinematic motif, 28, 36, 268, 268f; staircase-slides, 28, 28f, 30–31, 32f

Star China (magazine), on *Street Angels*, 174n8

star culture, 119

Star Fortnightly (fanzine): "Song of the Four Seasons" in, 167; *Street Angels*, still from, 161–62, 165

Star Motion Picture Co., Ltd. *See* Shanghai Mingxing dianying gongsi

Still Life (2006), 252

Storm Over Asia (1928), 113n4

Strange Lover, The (1926), 141

Strange Tales from a Chinese Studio (Pu Songling), 144

Stranger of Dark Night, The (1928), 141

Street Angel (1928), 161

Street Angels (1937), 158–75; birdcages in, 262; *City Scenes*, similarities with, 161, 168, 171, 172, 174n10; critical appraisal of, 6; film credits for, 158; magic tricks as allegory in, 171; *The Merry Widow*, similarities with, 168, 168f, 169f; narrative irresolution in, 53; *The New Year's Gift*, similarities with, 174n13; orphans in, 272n3; phonographic realism and, 167–68; premiere of, 158, 167, 174n8; songs in, 106, 143, 159–67; songstress and acoustic characters in,160, 162–65, 165f, 168–71, 169f; sound design in, 167–73; as sound film, 132; *Street Angel* (1928) and, 161; synopsis, 158–59; urban setting of, 36, 159,

Wan Dihuan, 308, 320
Wan Guchan (James Wan), 308, 320
Wan Laiming, 308, 320
Wanderings of Sanmao. See *Wanderings of Three-Hairs the Orphan* (1949)
Wanderings of Three-Hairs the Orphan (comic strip series, Zhang Leping), 258
Wanderings of Three-Hairs the Orphan (1949), 256–74; child poverty and, 258, 260, 272n8; children's films and, 258; comic bedlam of, 265–70, 268*f*; comic strip sources for, 257–65, 259*f*, 260*f*, 261*f*; costume and makeup, 259, 263*f*; *Crows and Sparrows* and, 280; dialogue, 260, 264; domestic conflict as civil war and, 267–69; film credits for, 256; iconic sights in, 224; narrative mode of, 261–62; politically correct ending of, 3, 258, 270*f*, 270–71; premiere of, 256, 258, 272n2; production of, 258; Scouts of China in, 75n10; Shanghai in, 201; staircases in, 36; synopsis, 256–57; *Trouble in Paradise*, similarity with, 8–9; *Vater und Sohn* (*Father and Son*) and, 260– 61, 261*f*; Zhang Leping and, 257–60
Wanderings of Three-Hairs the Orphan (puppet animation, 1958), 271
Wang, David Der-wei, 144, 231
Wang, Dr. (*New Women* character), 117–18, 120, 121, 121*f*, 126, 127, 131, 133, 165
Wang, Juanita. See Wang Renmei
Wang, Lyton. See Wang Naidong
Wang, Mrs. (*New Women* character), 117, 123, 128–29
Wang, Thomas. See Wang Zhengting
Wang, Yiman, 293
Wang Anyi, 162
Wang Ban, 320
Wang Bin, 320
Wang Chu Ching. See Wang Chuqin

Wang Chuqin (Wang Chu Ching), 303, 320
Wang Cilong (Wang Tse-lung), 304, 320
Wang Danfeng, 199, 320
Wang Ganbai (Wang Gon-bok), 308, 320
Wang Gon-bok. See Wang Ganbai
Wang Guilin (Wang Kwei-ling), 67, 304, 320
Wang Hao, 320
Wang Jiaxi (Alfonso Wong, Wong Chak), 271, 320
Wang Jingwei, 192
Wang Jiting, 158, 320
Wang Kwei-ling. See Wang Guilin
Wang Lizhen (*Spring River Flows East* character), 218–19, 225, 228–29, 233
Wang Longji, 256, 258, 263*f*, 273n12, 320
Wang Moqiu, 56, 73, 306, 320
Wang Naidong (Lyton Wang), 117, 121*f*, 134n4, 320
Wang Ping, 320
Wang Renlu, 308, 320
Wang Renmei (Juanita Wang): in Bright Moon Song-and-Dance Troupe, 57–58; films played in, 6, 67, 173n4, 304, 306; mentioned, 320
Wang Tianlin (Wong Tin-Lam), 200, 320
Wang Tse-lung. See Wang Cilong
Wang Weiyi, 139, 320
Wang xiansheng (*Mr. Wang*, Ye Qianyu), 258, 271
Wang Yi, 198, 202*f*, 320
Wang Yin, 308
Wang Zhengting (Cheng-ting Thomas Wang), 72, 320
Wanjia denghuo. See *Lights of Myriad Homes*
Wanshi liufang. See *Eternity*
War of Resistance Against Japan. See Anti-Japanese War

Warlord Era, 39–40, 44, 106, 115n18, 147

wars: families during wartime, 231, 231f; poetry and, 231–32; respites from, 48; as suffering, 234. *See also* Anti-Japanese War; civil war, Chinese

wartime profiteers, depictions of, 224, 228, 228f, 286.

Watch, The (1949), 215n6, 258, 272n5

Waves Wash Over the Sand (1936), 113n4, 307

Way Down East (1920), 80, 302

Way Down West (1927), 15n9, 34, 179, 302

Wedding in the Dream, A (1948), 239, 253n12

Wei Heling, 158, 275, 282, 291f, 320

Wei Ming (*New Women* character), 117–21, 121f, 122f, 123f, 124, 124f, 126–33, 128f, 130f, 133f

Wei Wei, 237, 241f, 244f, 245f, 250f, 320

weiguan (encircle and watch), 266f, 267

Welcome Danger (Lloyd), 13

wen (cultural competence), 188

Wen, Manager (*Spring River Flows East* character), 218, 219, 230

Wen Binbin, 273n13, 320

Wen Hwa Film Company. *See* Wenhua yingye gongsi

Wen Yimin (Weng Yih Ming), 125f, 302, 303, 321

Weng Yih Ming. *See* Wen Yimin

Wenhua yingye gongsi (studio, Wen Hwa Film Company), 198, 235n5, 237, 309, 310

"When I Was in Xia Village" (Ding Ling), 184

When Spring Comes. See Spring in a Small Town

"Where Is the Moon?" (song), 186

White, Rainbow. *See* Bai Hong

"White Terror," 286

White-Haired Girl, The (1950), 111, 291

Why Change Your Wife? (1920), 156n7

wife (wives). *See taitai*

Wife Problems (1950), 215n3

Wild Rose (1932), 6, 41, 54n2, 67, 304–5

Wildfire in the Spring Wind (Ouyang Yuqian, 1948), 235n5

Winter of Three-Hairs, The. See Wanderings of Three-Hairs the Orphan

wipes, 50, 68, 120, 130

Woman Basketball Player No. 5 (1957), 74

Woman Warrior, The (Kingston), 193

Woman Warrior White Rose (1929), 28

women: as agents or objects of consumption, 126; collective female exercise, 74; double standards for, 123–26; fallen woman figures, 79, 80; female martial arts heroes, 181; female narrators, 245; as fetish objects, 119; films on modern society status of, 201–2; male-on-female violence, 121; masculinity, women's portrayals of, 103, 104f; negative female archetypes, 229; new conspicuousness of, 119; predatory media culture and, 120; representations in *Long Live the Missus!*, 201–3, 229; sexually transgressive, 80; as single mothers, 131; sportswomen, 58, 60f, 74; virtuous wife and good mother (*xianqi liangmu*), 81–82; woman in white figure, 150, 150f, 151f. *See also Goddess*; mothers; *New Women*; *taitai*

women's dormitories, 68, 69f

Women's Pictorial, The (magazine), 58

women's sports academies, 68

Wong, Alfonso. *See* Wang Jiaxi

Wong, Anna May. *See* Huang Liushuang

Wong, N. S. *See* Huang Naishuang

Wong, Violet. *See* Ziluolan

Wong Chak. *See* Wang Jiaxi